The Monotype. *The History of a Pictorial Art*

To Julian and Daria

Carla Esposito Hayter

The Monotype
The History of a Pictorial Art

Design
Marcello Francone

Editorial Coordination
Paola Gribaudo

Editing
Timothy Stroud

Layout
Antonio Carminati

Translations
Scriptum, Rome

First published in Italy in 2007 by
Skira Editore S.p.A.
Palazzo Casati Stampa
via Torino 61
20123 Milano
Italy
www.skira.net

Photographic Credits
Agence RMN, Paris
(Thierry Le Mage and R.G. Ojeda)
Alan Cristea Gallery, London
The Annex Galleries, Santa Rosa,
California
Archivio Afro, Rome
Campigli Archive, Saint-Tropez
Atelier Franck Bordas, Paris
Milton Avery Trust, New York
Fabio Benzi, Rome
Bibliothèque de l'INHA, Collection
Jacques Doucet, Paris
Bibliothèque nationale de France,
Paris
Thomas Bouchard, New York
Blue Moon Gallery, New York
Bowdoin College, Museum of Art,
Brunswick
Cabinet Cantonal des Estampes,
Vevey
Guglielmo Capogrossi, Rome
Cincinnati Art Museum, Cincinnati
Gérald Cramer, Geneve
Crown Press Point, San Francisco
Fondation Georges Rouault, Paris
Galerie Maeght, Paris
Galleria Carlina, Turin
Galleria degli Uffizi, Florence
Galleria La Scaletta,
San Polo d'Enza, Reggio Emilia
Adolph and Esther Gottlieb
Foundation Inc., New York
Nancy Graves Foundation,
New York
Greg Heins, Georgetown,
Massachusetts
Herzog Anton Ulrich-Museum,
Braunschweig
Leo Hocub, San Francisco
Istituto Nazionale per la Grafica,
Rome
William Kentridge Foundation, Sud
Africa
E.W. Kornfeld e Klipstein, Berne
Marsha Mateyka Gallery,
Washington, D.C.
Paul Mellon Collection, Center
for British Art
The Metropolitan Museum of Art,
New York
Musée des Arts Africains
et Océaniens, Paris
Musée Estève, Bourges
Musée National du Château,
Compiègne
Museo Biblioteca e Archivio
di Bassano del Grappa
National Gallery of Art, Washington,
D.C.
National Gallery of Australia,
Canberra
Arnold Newman, New York
O'Hara Gallery, New York
Pace Editions Inc., New York
Paul Prouté S.A., Paris
Gordon Samuel, London
Schlemmer Estate, Stuttgard
Smithsonian American Art Museum,
Washington, D.C.
Mary Ryan Gallery, New York
Mark Rosen Fine Art, New York
Marialba Russo, Rome
Tate Gallery, London
The San Francisco Museum of Fine
Arts, San Francisco
The Santa Cruz Sentinel, Santa Cruz
Elisabeth Tullis, New York, Garner
Tullis e Richard B. Tullis II, Santa
Barbara
Joan T. Washburn Gallery e Robert
Miller Gallery, New York
Whitney Museum of American Art,
New York
Ziegler Fine Arts, New York
Zentrum Paul Klee, Berne

First and foremost, I wish to thank Paolo Piasenza and Joann Moser, conservator at the Graphic Department of the National Museum of American Art, Washington: the former for his patient rereading of the text, constant support and invaluable advice; the latter for generously providing information to guide my research on the monotype in the USA and for the article 'Monotype in America', written on the occasion of this work. My thanks also go to the master printers Maurice Sanchez, Alberto Serighelli, Giorgio Upiglio and Franck Bordas, to Bill Hall of Pace Editions Inc., Valter Rossi of 2RC and Crown Press Point. I am particularly grateful to the legendary master Garner Tullis for his generous and unflagging support and to the artists Will Barnett, Michael Mazur, Matt Phillips, Pat Steir, Emilio Vedova, Dennis Olsen, Milton Gendel, Marco del Re, Jean-Baptiste Sécheret, William Kentridge, Giorgio Vigna and Felicity Williams.

I thank Fabio Fiorani, Ginevra Mariani and Filippo Trassari of the Istituto Nazionale per la Grafica, Anna Maria Graziani and the Afro Foundation, Rome, Bruno Mantura, Fabio Benzi, Guglielmo Capogrossi, Enzo Di Martino, Valeria Gramiccia, Valerio Rivosecchi, Vincenzo and Giorgia Sanfo, the Galleria Carlina, Turin, the Galleria Lia Rumma, Giorgio Chierici of the Galleria La Scaletta, Reggio Emilia,the Galleria d'arte Soave, Alessandria, and Elisabetta and Piero Ceretti.

In Paris, thanks to Claude Bouret and Valérie Sueur of the Cabinet des Estampes, Bibliothèque nationale de France, to Simon-André Deconchat of the Bibliothèque Doucet, the Rouault Foundation, the Galerie Lelong, the Galerie Maeght, Paul Prouté S.A., Hughes Wilhelm and Christina Burrus.

Though acquainted only with his writings, I owe a great deal also to Michel Melot for his essential insight into Impressionist and modern French prints. In France, Switzerland and Germany, my thanks go to Jean-François Garmier of the Musée Estève, Bourges, to Monique Proudhomme-Estève, to Nicola Campigli, to Nicole Minder and Lauren Laz of the Cabinet Cantonal des Estampes, Musée Jenisch, Vevey, and to Herzog Anton of the Ulrich-Museum, Braunschweig.

Particular thanks to Ruth Ziegler Fine Arts, to Linda Kramer, director of the Nancy Graves Foundation, and to Leia Jervert, Lawrence Saphire, Ruth O'Hara Fine Arts, the Mary Ryan Gallery, Mark Rosen Fine Art, the Gagosian Gallery, Brooke Alexander, Joan Washburn, the Pollock-Krasner Foundation Inc., New York, the personnel of the National Museum of Graphic Art, Smithsonian Institution, Washington, to Marsha Mateyka, Washington, the Annex Gallery, Santa Rosa, California, to Frances Carey of the British Museum, Samuel Gordon, Ian McKenzie and Alan Cristea, London.

Many thanks to Giancarlo and Angela Zampollo and Litho Art New, Turin, to Carlo Coen, Victor de Circasia, Paola Lurasco and Katie Ruggero, Luisella Negro, Luigi Cesare Maletto and to the Italianist Enza Perdichizzi for kind and useful help.

I am indebted to Paola Gribaudo for her warm-hearted support and incomparable advice on aspects regarding graphics and publishing.

Finally, I wish to express my heartfelt thanks to my unfailing comrade-in-arms Giorgio Negro, who provided the original idea and driving force for this project.

Monotypes were made in three stages: the delicate inking
of the copper plate, the creation of a spontaneous design, which
could not be altered, and the moment of printing, with the risk
of destroying the work. The most thrilling point came
at the end of these three operations, when the impression
on the sheet of paper was revealed.

Marguerite Matisse

Contents

In the present-day world of culture and publishing, reading this work means embarking on a very particular journey. At a time when publications are required to provide a generic, exemplifying simplicity, often focusing on artistic movements and almost exclusively on their leading figures, it is seldom that we encounter a volume of both historical depth and breadth.

In this book Carla Esposito Hayter undertakes an extraordinary journey tracing the development, richness and passion of a technique and medium as it progresses from its initially classical nature through ever-greater degrees of experimentation. Presenting the fruits of her in-depth studies, the author accompanies us along a unique and complex pathway as she eschews simplification to illuminate a history that might at first appear secondary, but whose richness and variety gradually emerge through this text and impressive array of illustrations.

In a world submerged by an unprecedented, undifferentiated and ceaseless flow of images—using every type of support and channel of dissemination in the media-inundated world of digital and virtual technology—this pathway "around" and *towards* the monotype can be considered an opportunity to "see" the image once again as a field of experimentation and manual dexterity, as a desire for the visual experience of the act of creation.

This history of the monotype is far more than a technical overview or manual. It provides a detailed description of the approaches taken by those "image makers" responsible, right up to the present, for the mysterious and magical world that starts with the drawing of lines and ends with an image on paper.

The subject addressed in the pages to come is characterised by great depth and relevance. The loss of uniqueness of images in the contemporary world, the speed and impersonal nature of the means of photographic production and the loss of "physicality" of image-based artworks have recently brought many artists back to techniques and methods of creativeness long considered outmoded and largely unknown. The interest shown in monotyping by some contemporary artists has become emblematic of a new conception of painting and the figure, as well as of the processes by which it is created.

The author discusses this growing interest in a procedure that was addressed and interpreted by many great artists during the last century. The work offers crucial insight into this area of study, providing a clear idea of the mono-

type—a technique generally veiled by confusion and ambiguity—and of the great masters it has served over the years as a vehicle for creativity.

It is with passionate lucidity that the author leads us through one of the most ambiguous, indeterminate and often scarcely definable areas of experimentation. A medium often favoured by great creators exploring the relationship between sign and paper, painting and print, the monotype has once again been recognised in the contemporary world as a wholly original work, a complex way of creating a unique image through a procedure of image reversal and pressure. As the author points out, the defining characteristic of the monotype is that it has no matrix and therefore cannot be serially reproduced, and in consequence, the monotype has become as sought-after and valuable as a painting or drawing. It is this pursuit of uniqueness that we discover in the pages of this volume: the obsession of the artist-creator with the intricate process through which the monotype image is born, the direct and active creation of a unique work through pressure on paper, the generation of an image reversed with respect to the one actually drawn.

It is through these fascinating byways that we are introduced to the world of the print and its traditional techniques. We are then guided through the history of its development, during which we are presented with a host of unexpected figures. We are surprised by the almost archaeological nature of the study carried out into the magnificent work of William Blake and his mysterious combinations of images and poetry. We discover the history, fortunes and applications of the print and the monotype, witnessing the proliferation of an art that verged on commercialisation in nineteenth-century Paris. We observe the evolution of monotyping on either side of the Atlantic in the late nineteenth century, with figures of crucial importance like Degas and Gauguin, who referred to their monotypes as printed drawings, or simply drawings. Across the ocean, we see the birth and definition of the term "monotype" and the way in which the new technique successfully took root to make that open and experimental land one of the ongoing workshops of monotyping. A constellation of artists illuminates our path through the pages and the images used by the author to illustrate and compare the different techniques.

Somehow inured to mechanical reproduction as an art historian, I am constantly amazed to discover the extraordinary quality of the images produced by artists using this complex but never artificial technique. This volume is the history of an art of a different character, one more laborious and solitary by nature, and only apparently on a smaller scale. It is, however, an art driven by the artists' passion and readiness to accept the "mirroring" of their work. Drawing or painting a design on a support with the idea of it appearing in reversed form on the paper is an almost intellectual way of challenging oneself and guiding one's thought as an artist. Monotyping means conceiving your work and dedicating it to the sheet of paper to which it will belong after printing, losing its preparatory stage in order to obtain an original image. It is hardly surprising to learn that Picasso, the great "centaur" of artistic techniques and expressive possibilities, took an interest in monotyping as early as the beginning of the twentieth century. This irrepressible giant explored its potential in 1905 and again in the 1930s, followed by an unexpectedly high number of other artists.

The author goes on to describe how the monotyping process, invented and initially researched in Europe, became known in the United States, and how a dialogue commenced on the subject between the two artistic communities.

The Europe of the early twentieth century had to make way politically and artistically for the great post-war power. Almost inevitably, the year 1946 is marked by a monotype from Jackson Pollock, the enchanting narrator of new spaces and above all the tormented creator of a new form of painting. Fascinated by the ambiguity of the "painterly print", a sort of hybrid between a painting and a print, American artists of the new post-war generations adopted it as a means of experimentation to reach peaks and depths of virtuosity. The dark fields of Cy Twombly stand alongside the phantasmal evanescence of Robert Rauschenberg, the suspended planes of Richard Diebenkorn, and the chromatic explosions of Sam Francis and Adolph Gottlieb. Nor is there any lack of heroic figures in this battle of the monotype image, this drive to transpose the self through the precision of the hand and the press, this desire to see the "other self" emerge in the new original: for example, Jim Dine worked alongside James Brown, one of the most extraordinary experimenters in the field of artworks on paper, and Jasper Johns symbolically preceded the apparently tribal Basquiat, and both engaged in dialogue through the monotype—despite their styles and perhaps despite themselves—with other artists travelling the same path.

The new tradition of the monotype that developed in the United States returned to Europe in a sort of temporal loop, as reflected in the serene classicism of Campigli, the rarefaction of Capogrossi, Toti Scialoja and Mirko and Afro Basaldella, and the symbolic storm of imprints left by Antoni Tàpies. Similarly, we discover the secret experiments of Crippa and Cagli as well as a very rare work by Novelli in the Italian tradition of the recent past.

And these rarities of monotyped perception and documents of passion are captured in the precision and the narration of Carla Esposito Hayter, who ushers us into the temples where these works were conceived and executed. The great legendary presses, lecture halls and workshops come back to life in the chapter almost paradoxically entitled "The Disintegration of the Traditional Model". Under her guidance we come to see and know the impassioned masters, the great workbenches, the cradle of the image, the moment in which it is conceived, takes shape and materialises.

One of my recent "encounters" with monotypes was in the work of Emilio Vedova, a master and another indefatigable explorer of signs and meaning. It was my good fortune to be accompanied by the keen eye and interest of my friend Giorgio Mastinu, who made those sheets of paper sing for me, who immersed me in the world of the graphic arts, engraving and the monotype, which that master saw as an extreme form of painting, a piercingly painful challenge, his ultimate heroic quest. With Giorgio, as I hope it is for you readers of the textual images in this volume, I was able to "see" the colour, the pressure, the grain, the operations and the creation of the image on one surface so it can be born on the paper in what Vedova described as the monotype's "opposite space". An endless, sensual, first-hand immersion in which vision becomes touch, pressure and contact.

I rediscovered all this in this enthralling book, for which I must thank the author, and hope that it will not fail to enable you, in your travels through images, to rediscover what a Turkish poet expressed in these words: "the duration of an image is linked to the will of its creator and the effort of the process with which he creates it".

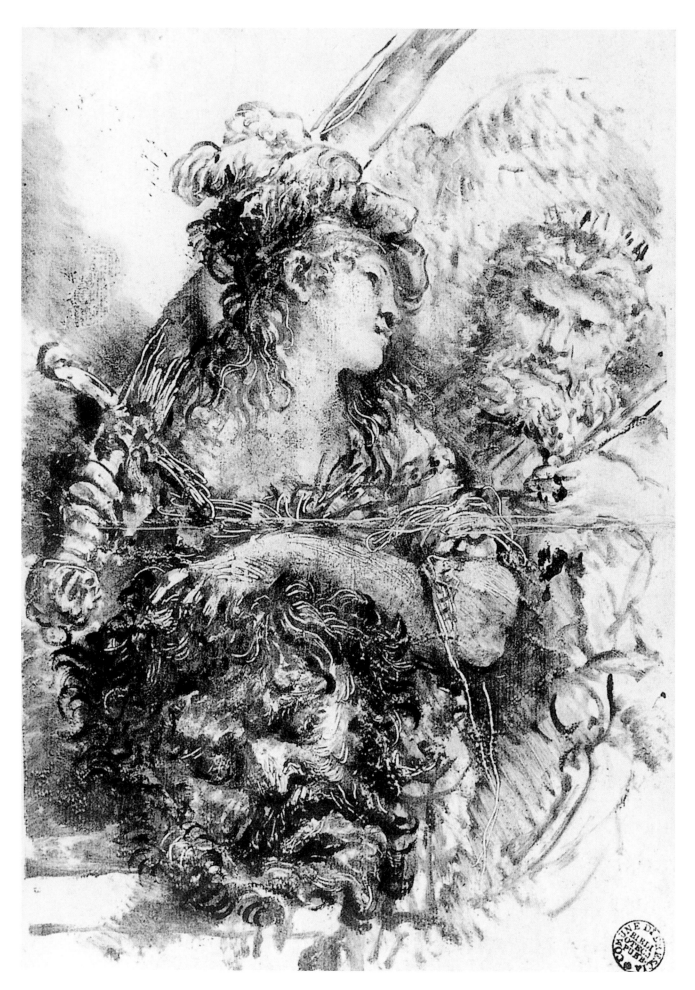

1. The Origin of the Monotype

"Whoever wishes to create a dream work must intermingle everything"
Albrecht Dürer

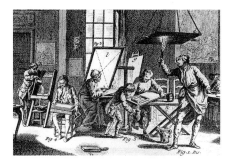

2. Diderot and D'Alembert
Encyclopédie, plate I, Paris 1779
Detail of a vignette showing the interior of
an ancient print shop; the shop's various printing
operations are illustrated

1. Giovanni Benedetto Castiglione
David with the Head of Goliath, 1650–55
Monotype in brown ink, heightened with
brown and white oils, first pull,
371 × 254 mm
Pinacoteca Civica Tosio-Martinengo, Brescia
The fine highlighting strokes were achieved
by removing colour with the dark field method

Notes on method and technique
Differing greatly in spirit from a technical manual, this history seeks to describe the birth and evolution of the monotype and provide an interpretation from the inside of the historical and artistic circumstances that led artists to adopt this medium for four centuries.

Ingenious, elaborate and innovative as they may be, the various techniques are only ways of arriving at the creation of a work of art. At the same time, the specific requirements of every technology impose their structure in many respects both on the image and on the idea underpinning it.

If we take this principle as our starting point, an important note of clarification is called for because the idea of technique is based today in general on the equally inexact and widespread assumption of its simultaneous development or temporal succession in the various parts of the world. This is a way of structuring events associated with the principle that every procedure is invented, develops and disappears to be replaced by something better.

Seeing a technique in terms of linear progression thus tends to ignore the complexity of its motivations and involves simplification of an excessive and tendentious nature.

It became clear back in the nineteenth century that the opposite is instead true, i.e., that the variant forms of the various procedures addressed in countless treatises do not follow and overlap with one another but rather give birth to a vast panorama of technical alternatives over the same span of time.

With regard to this view, the proliferation of the various methods employed in making monotypes over time cannot be separated from the circumstances—ranging from taste to necessity—prompting its adoption on the part of artists. With a view to casting new light on this medium, we shall therefore retrace the stages in its development and interweave its history with ideas and associations of a freer nature than would arise from a strictly sequential chronological approach.

In an age when the very idea of style is breaking down and necessitates more careful reference to the sources of the creative process, the first experiments regarding the "classic monotype" strike us as arcane, remote and almost unconnected with the physical appearance of contemporary works. The progress achieved through ever-faster technology and the increasing tendency for monotypes to be pro-

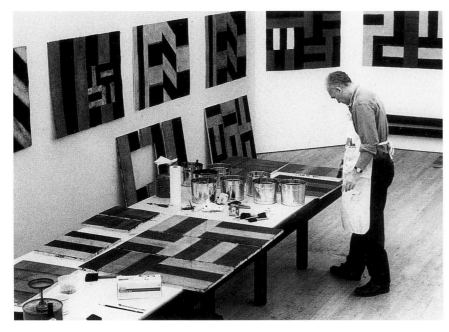

duced in workshops with previously selected materials and methods make it more
difficult to assess the influence and constraints of past technical developments as re-
gards the creation and significance of the finished work. It does, however, appear
clear that we cannot separate the technique from the result obtained, isolating
the work from the set of procedures that preceded and presided over its creation.

Despite the growing tendency of many contemporary monotypes to break
away from the context of engraving and embrace the broader sphere of unique
works on paper produced by means of mixed techniques, it appears both useful
and relevant to retrace the history of the singular development of the monotype
together with the key moments for the artistic print.

One question that arises in writing a history of this procedure regards the criteria
to be applied in speaking of one artist rather than another, describing one
work and not another, and, above all, focusing attention on a certain geo-
graphical area rather than another. For the reasons outlined above, one of our
criteria has been to select works that highlight the evolution of this procedure in
a progression that is neither linear nor purely technical, so that this can become
the expression of the historical circumstances and the concepts lying at the root
of the medium's expressive possibilities.

Since our intention is, finally, to consider the monotype as an artistic form
that intersects and interacts with the present-day notion of art criticism, anoth-
er criterion has been to discuss the monotype through works by artists for
whom this medium represents the extension of aesthetic concerns already ex-
pressed in other media, and hence primarily painters and sculptors.

If we reject the hierarchy of "major" and "minor" arts, a history of the mono-
type constitutes a separate branch of art history as well as being a living and in-
tegral part of the same. The parameters for the interpretation of a work can no
longer be based on exclusively technical criteria, as technique serves solely to de-
fine an artistic "family" of reference. We cannot therefore jumble artists whose
sole common feature is the fact of using the same tools in a single category, since
all artists differ enormously in terms of intention, style, practice and circuits. In
any case, there are few artists who have limited themselves to a single technique

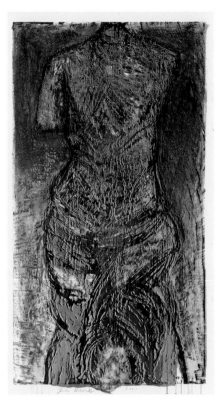

4. Jim Dine
Singing and Printing XX, 2001
Monoprint hand-coloured with acrylics
and charcoal, printed at Pace Editions Ink,
Pace Editions, Inc. (one of the twenty variations
on *Venus*), one-off impression, 1778 × 1003 mm

5. Clinton Storms in the Garner Tullis workshop,
Santa Barbara, 1989

over the last fifty years, which makes it difficult to establish the "primary" form of expression of each of them. Jim Dine and Sam Francis, for example, abandoned painting in order to concentrate on the graphic arts, whereas others initiated in the various graphic procedures subsequently switched to other forms of expression.

The works illustrated here are almost exclusively European and North American. This is not because the production of monotypes in areas such as Asia, South America and Australia is negligible but rather because a series of cultural—and economic—factors led to the exchange of ideas and influences between Europe and America developing autonomously, almost independent of the rest of the world.

A great deal of attention is focused on the French production of the nineteenth century, both because of the paramount importance assumed by France in the birth of modern art due to the Impressionists and because of the vital contribution made by Edgar Degas to the art of the monotype. Equal importance attaches to the role of the United States from the post-war period up to the closing decades of the twentieth century; this is because the country became a driving force in the field of art and switched from a net importer to exporter of trends and movements.

The market for monotypes and indeed for art prints in general was unquestionably smaller and less coherent in qualitative terms in Europe than in the United States, where both the printing houses and the works produced were more numerous and technically sophisticated in general right up to the end of the 1980s. The American artists also appear to have been more deeply aware of the potential and nature of graphic work in general, and the monotype in particular.

Up to the 1960s, or in any case until the post-war period, the historical reconstruction of the monotype is based on separation of the two main areas, Europe and the United States, as it still makes sense to proceed in terms of geographical areas. Artistic alignment within international movements, first and

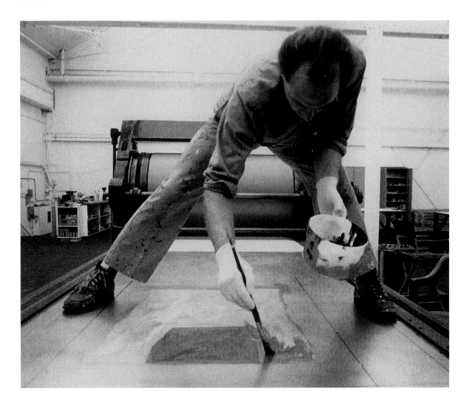

foremost Pop Art, makes it subsequently incongruous and anachronistic to speak about the monotype with specific reference to France, Italy or the United States.

Given the way that trends sweep across national borders thanks to the increasingly close-knit and dense network of cultural interconnections, what appears to have taken shape as the "monotype movement" can in fact no longer be defined on the basis of primarily geographical parameters.

In search of a definition
"In his 1919 book on etchers and etching, the American artist Joseph Pennell asked: 'What earthly merit there is in a printed squashed oil painting, it would be hard to discover…'. He did not understand why an artist would want to make a monotype when a drawing or painting is so much more direct and controllable, and when a print allows for an entire edition of an image. What does this medium offer the artist that other media do not? Why did it gain popularity among certain artists at certain times, and remain ignored by most artists until the late twentieth century?"
Joann Moser

The word "monotype" (from the Greek *monos*, 'one', and *typos*, 'impression') indicates both the procedure, the printing of a unique item, and the image itself.

Often noted as a technique midway between printing and painting, and referred to in English as the *painterly print*, in the simplest sense the monotype is a work produced by imprinting an image painted on the surface of a support—usually a metal or glass plate—onto a sheet of paper before the ink or oil paint has dried.

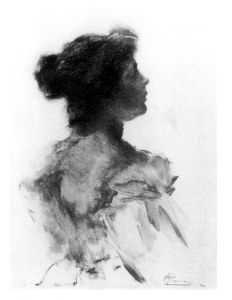

6. Pompeo Mariani
Profile of Lady in Blue, ca 1900
Colour monotype, 318 × 231 mm

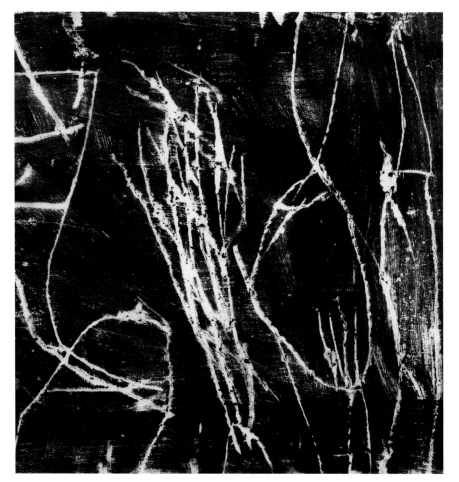

7. Cy Twombly
Untitled, 1953
Monotype produced with the dark field method,
480 × 640 mm
Private collection

The transfer from support to paper, which involves an inversion of the image, is executed with a press. It can also be performed, above all in the case of small plates, by applying simple pressure with the back of a spoon, the hand or some other means.

The monotype presents a substantial difference with respect to the traditional art print in that the work has no "matrix" and therefore cannot be reproduced.

This uniqueness makes the monotype as sought after and valuable as a painting or drawing.

The importance attached in the world of plastic arts to the particular value of the "unique and original" item is still very great today. In addition to considerations of intimate aesthetic feeling, this is also bound up with the use made of the arts to reinforce cultural and social distinctions.

The monotype should not be confused with the "sole copy" printed from an engraved plate, which therefore entails the existence of a matrix. The sole copy remains within the logic of the edition, and hence of the multiple work, and its uniqueness derives not from the characteristics of the medium but from the artist's decision to limit the number of copies.

Nor should the monotype be confused with the offset or counterproof, even though this technique is similar in some respects. As from the sixteenth century, and probably even before, it was usual to make counterproofs of drawings—above all in red chalk or sanguine—and paintings simply by pressing sheets of the paper on top of the "original" works and transferring them to the plate for engraving. This method was used above all by engravers because of the difficulty of working on an image reversed with respect to the original image, which is restored through the double inversion of the counterproof.

Generally used as a technical expedient for reproduction rather than an artistic tool in its own right, the counterproof does not possess the creative aspects of the monotype.

The history of the procedure's terminology, which remained imprecise and variable all through the nineteenth century, shows how the problem of definition began to make itself felt in its closing decades.

The term "monotype" was coined for the first time in the United States around 1880 by the American landscape painter Charles Alvah Walker and appeared, in November 1881, in the *Art Journal* in an article referring to a sales catalogue of the works of Edgar Degas. The neologism struggled to gain currency, however, and the monotypes by Gauguin and Degas—who displayed an aversion for the term—were referred to by their authors respectively as "drawings" and "drawings done in oily ink and printed". The terms "monotones" and "monochromes" were also used in the United States between 1880 and 1890. Frank Duveneck and the artists of his circle practising the monotype technique in Florence and Venice called them "Bachertypes" from the name of their companion Otto Bacher, the owner of the portable press on which they printed them. In an article of 1890, Walter Richard Sickert described a monotyped etching by Theodore Roussel entitled *June Evening* (1889) as a "monotint" and referred to his own monotypes as carbon-paper drawings painted with watercolour.

The first historical work on monotypes was by the American Sylvester Rosa Koehler, a great connoisseur and collector of prints as well as first curator of prints at the Fine Arts Museum of Boston, who addressed the monotypes of Giovanni Benedetto Castiglione, William Blake, William Merritt Chase and Charles Alvah Walker in 1891.

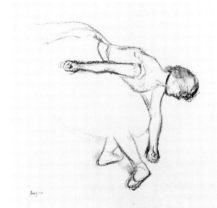

8. Edgar Degas
Danseuse en quatriéme position, 1878–80
Counterproof heightened with charcoal,
333 × 276 mm

9. Nancy Graves
Chala, 1981
Colour monoprint, 79 × 102 mm
Nancy Graves Foundation, New York

The terms "monotype" and "monoprint" were used ambiguously at least until 1917, when the American Salvatore Guarino asserted his preference for the former as corresponding more closely to the description of the procedure. The two terms were subsequently used interchangeably and in 1960 even Henry Rasmusen, the author of the first important book on the monotype, used them indifferently, noting only that many artists preferred "monoprint" to distinguish this procedure from the commercial process of typographical composition.

In America, where the production of monotypes was more intense and significant, the need was felt in the 1970s to clarify the use of terminology so as to arrive at a precise and unanimously accepted definition of the two processes.

Various American scholars of engravings put forward proposals. David Kiehl suggested in 1975 that "monoprint" should be used to indicate the single print made from an engraved plate, a deliberate limitation of the edition that has nothing to do with the procedure with which the print is made. Jane Farmer organised a touring exhibition of monotypes in 1978 and underscored in the catalogue the distinction between the "monoprint", an image produced in part by means of a fixed matrix and hence repeatable, and the "monotype", a single image no part of which comes from a matrix and which is therefore not repeatable. After the exhibition 'The Painterly Print' of 1980, devoted exclusively to the classic and modern monotype, the distinction was taken up and endorsed in 1997 by Joann Moser in what still remains the most exhaustive historical study of the American monotype. It has since become the parameter conventionally accepted in order to distinguish between the two techniques, even though the associated uncertainties have not been completely resolved.

It should in any case be borne in mind that while a general distinction between monoprint and monotype serves the purpose of eliminating confusion and inaccuracy, any overly rigid norms and definitions could easily fail to apply to the artist's work.

The classic monotype

There are two traditional ways of producing a monotype and they can also be combined, as Degas did.

The first is the "subtractive" method (also known as "dark field" or "negative" because the artist proceeds from "darkness" to light). This involves covering the support with a thick layer of ink or paint and removing it to produce the image with the aid of rags, fingers, sticks and the handles of paintbrushes, which can be used at a later stage to correct lines or create tonalities. This removal of the ink or paint uncovers sections of the support. which show after the impression as areas of light or white lines set off by the colour of the background. The fascination of the monotype derives particularly from this technique, which allows "shafts of light" to stand out in a mysterious and theatrical way. The subject is placed outside the realm of im-

10. Making a monotype
a. The drawing is made on a polished plate; the ink or colour pigments are applied with brushes, small pads or other tools.
b. *Chiaroscuro* effects can be added afterwards by removing inks with toothpicks or wooden spatulas. When some areas of the plate surface are carefully cleaned, highlights are achieved that resemble "smudging" in charcoal sketches.
c. Before the inks dry, the plate is covered with a sheet of paper and run through a press, so the pigments transfer by contact.

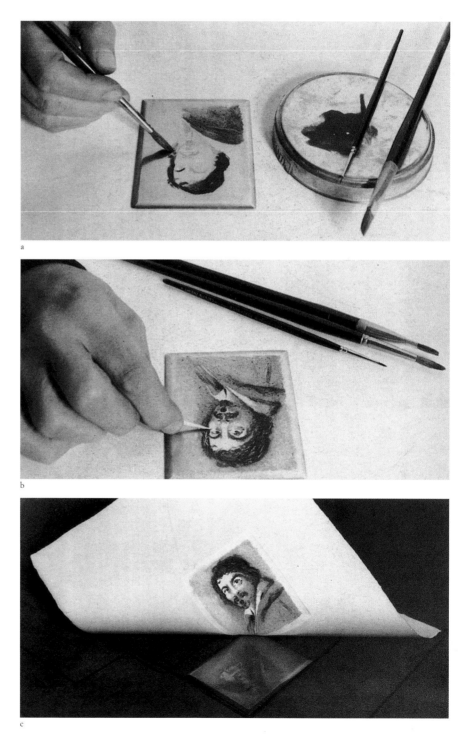

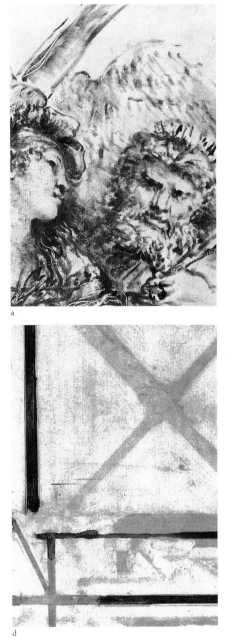

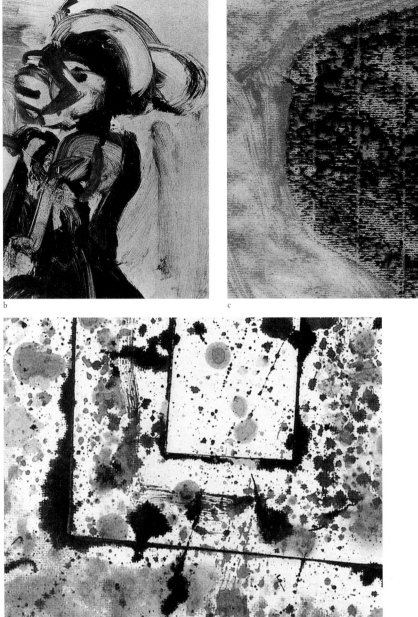

a

b

c

d

e

11. *Additive or Light-Field Methods*
a. An oil-based pigment has been applied to a clean metal plate, much like a drawing on paper. Giovanni Benedetto Castiglione, *David with the Head of Goliath* (detail)
b. Brushstrokes of oils have been used in different densities to create a more complex foundation surface.
Georges Rouault, *Clown and Monkey* (detail)
c. To obtain the surface creasing effect, ink was applied over a plate washed with turpentine. Ribbing of laid paper created a grid pattern. Milton Avery, *Pink Nude* (detail)

d. The strokes of fresh dark ink contrast with the lighter residues of a previous printing. Richard Diebenkorn, *IX, 4-13-75* (detail)
e. The oil paints were applied by spattering. The edges of metal plates stacked one on top of the other were coloured and, under pressure of the press, embossed the paper with their outlines. Sam Francis, *Untitled*, 1977 (detail)

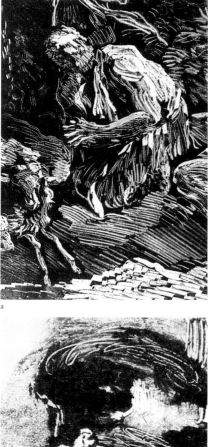

a

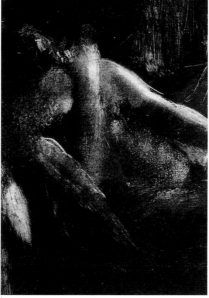

b

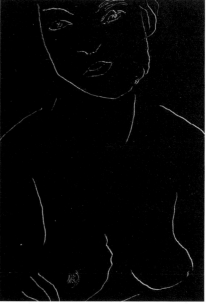

c

d

e

12. *Subtractive or Dark-Field Methods*

a. Wooden tools of varying thickness
(probably paintbrush handles) have been used to
lift the ink, thus leaving lines and white areas.
Giovanni Benedetto Castiglione, *The Annunciation
to the Shepherds* (detail)

b. Gauze, paintbrush handles and the artist's
fingers were used to bring out the light elements
from the blackened plate.
Edgar Degas, *La Cheminée* (detail)

c. The white lines are obtained by incising a thick
layer of ink with a sharp tool.
Henri Matisse, *Nu assis, les bras croisés* (detail)

d. Ink was removed to leave figures silhouetted
and enlivened with random strokes.
George Luks, *Cake Walk* (detail)

e. The thinned oil colour has been removed with
the paintbrush bristles and handle.
Milton Avery, *Birds and Ruffled Sea* (detail)

mediate experience and steeped in a shady, magical and often dramatic atmosphere. The second is the "additive" method (also called "light field" or "positive"). In this case the untouched support serves as a blank field upon which the image is drawn like a painting on a bare canvas. While the ink (or paint) used in the first method is dense and viscous, here it is made more fluid by means of a solvent (turpentine) and gives the effect of a watercolour.

These basic methods are accompanied by numerous variations, the most striking of which is known as "drawing print", also called "traced monotype". Regarded as somewhat unorthodox and classified rather as a process of offset printing until the end of the 1980s, it can, however, be considered a monotype to all intents and purposes. Subsequent to Gauguin's "printed drawings" (or "drawing prints") of the period 1899–1903, it was taken up at the end of the nineteenth century above all by British, Swiss and German artists, such as Walter Richard Sickert, Paul Klee and Oskar Schlemmer. This form of monotype, which is described below, uses a sheet of inked paper as a support and is imprinted on the back of the sheet placed upon it in the same way as carbon paper.

The first supports used for monotypes were metal plates, like those of copper employed by Giovanni Benedetto Castiglione for his engravings. Their use continued up to the Impressionists, after which artists began to use other hard and nonporous surfaces such as wood, glass, Plexiglas, marble and lithographic plates. Gauguin's "drawing prints" show how paper can also be used as a support. Many modern and contemporary painters, from Toulouse-Lautrec to Mary Cassatt and Willem de Kooning, have also pressed paper by hand against sections of canvas freshly covered in oil paint, tempera and watercolour. In these cases, the works obtained are not monotypes in the strict sense but rather fall into the category of counterproofs.

Keenly interested in all techniques for their individual characteristics and implications, Robert Rauschenberg produced over a hundred works closely akin to monotypes between 1958 and the end of the 1960s. He would assemble photographic images of objects in every sort of printed material on a sheet and bathe it in acids (first turpentine and then a lighter solvent). On attaining the desired composition, he would place a piece of dry white paper on the sheet thus processed and rub lightly with a stick to transfer the image, which is reversed with respect to the original support. The result involved a degree of unpredictability, since the artist did not use glue to secure the various elements of the composition.

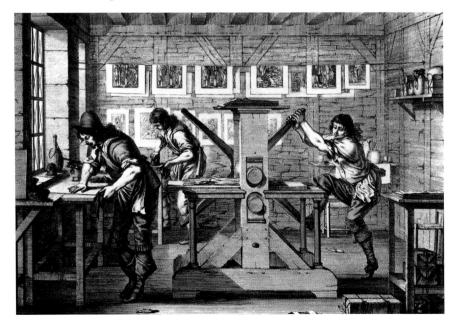

13. Abraham Bosse
L'impression en taille-douce, 1642
Etching, 259 × 317 mm

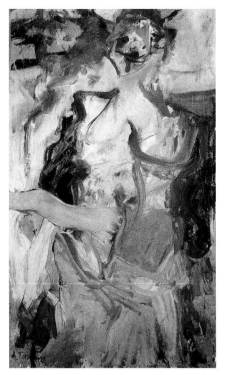

14. Willem de Kooning
Two Women, 1964
Oil on paper, counterproof of a painting on canvas
Formerly at the Hirshhorn Museum and Sculpture
Garden, Washington, D.C., current location
unknown

The artist stated in connection with this corpus of "transfer drawings", a technique halfway between monotype and collage, "I felt I had to find a way to use collage in drawing to incorporate my own way of working on that intimate scale".[1]

Felice Casorati and Toti Scialoja were among the Italian artists who experimented with techniques resembling monotype, the former with what he called "*papirocalchi*" and the latter, in the 1950s, with "*stampaggio*", which involved creating an image on a sheet of paper, placing this face down on the canvas and applying pressure with the hands.

Attention should also be drawn on the more recent *acquatipi* or "aquatypes" by Giorgio Vigna, who works with sculpture, glass and engraving and is now known above all for his explorations in the field of jewellery. Vigna's use of water as a support for printing inks enables him to control the development of the physical process. Having filled a bowl with water and thickening additives, he adds drops of ink, preferably black, to a set design so that they float on the shifting surface of the water. He then works on the image formed by blowing or with particular ingredients mixed with ink until the right combination is obtained. A blank sheet of paper is laid on the surface and the inks are transferred to it, thus creating a unique impression. While this technique has some similarity with those used for hand-made decorated paper, Vigna has essentially adopted the procedure known as *suminagashi* in Japan and *ebrû* in Turkey, into which he instils an artistic and spiritual meaning.

Enriched with new possibilities, the monotype technique has become an arena for displays of virtuosity, with the smoothness of glass and Plexiglas leading, for example, to an increasingly sophisticated handling of graphic elements. The transparency of the support also makes it possible to keep closer watch over the development of the work and add more paint where required. The procedures of monotype production have changed over the years and technology has become increasingly sophisticated and personalized. The change in format—from the traditionally small plate to larger sizes—has also played an important role in the choice of materials, and the current preference is for plates of light metal and plastic materials.

Monotypes can be produced with a printing press, using the various supports indicated above, while the leather rollers once used to prepare the tonal areas of the ground upon which the artist creates his or her image have given way to rollers of rubber and finally plastic. The latter also serve to mix as well as superimpose the paint and to separate black from coloured inks. Around 1950, in a view to obtaining different shades of the background colours, some artists began using inks of uneven viscosity, which prevents mixing of the paint applied in successive layers. The pressure of the press makes for greater compactness and uniformity of the pictorial layer, especially with the use of metal presses rather than the wooden equipment of the seventeenth century. Deft application of this pressure can serve to create reliefs, sometimes with three-dimensional results. Manual printing can instead be carried out so as to eliminate uniformity and make it possible to vary and modulate inks and paints. It is for this reason that artists prefer in certain cases to rely solely on the pressure of the hand or the back of a spoon, as in the traditional Japanese system, in transferring the image from one support to the other.

15. Robert Rauschenberg
The Red Virgin, 1969
Pencil and gouache drawing on paper, obtained
by solvent transfer, 578 × 726 mm
Los Angeles, private collection
Courtesy of the O'Hara Gallery, New York

Produced almost exclusively on paper, the monotype presents all the unknowns of works made on this type of support, which absorbs ink and other pigmented substances unevenly because of its irregular physical structure. The fibres of paper appear under the microscope as short, thin hairs curled up and interwoven with one

16. Catherine Lee
Two Fold 13, 1991
Colour monotype, 1270 × 1015 mm

17. Beverly Pepper
Untitled, 1985
Monotype, 1525 × 1065 mm

another, and this fibrous composition has a marked influence on the final image, the depth of which is accentuated on transfer to the sheet. Given the possibility of variation in the consistency and thickness of the layers of paint as well as their interaction with the paper support, the result of chromatic combination and superimposition is often only partially predictable at the moment of printing.

Under the pressure of the press, the paper fibres thus take on a porous appearance so that even the most limpid and clear-cut of images present characteristically softened and "sensual" tonalities. As happens with all the traditional chalcographic techniques, the monotype thus develops its own peculiar interference with the image captured.

The choice of the type of paper to be used varies greatly and reflects the individual artist's sensibility. Before being placed beneath the press, the paper is moistened to ensure the fluid transfer of the paint on the plate. This is a delicate operation, since insufficient and excessive wetting lead respectively to poor quality printing and smudging. In all its different types (thin, thick, sized, oriental, white or slightly coloured), paper offers modulations through its transparency and creates dramatic effects through areas of shadow. The image thus loses its concreteness and takes on a mysteriously vague and insubstantial appearance. The paper can sometimes colour rather than delineate through shading. While the thick, oily, full-bodied type of printing ink was initially used for monotypes, this has then been joined by oil paints (generally with the oily component reduced) and, less often, water-based paints such as acrylics and tempera, provided that these are not mixed with oily or greasy substances so as to avoid effects of repulsion.

"A monotype is a unique work; it can be accepted or rejected, but not changed in any way. The transformation of a layout that permits infinite variation into an unchangeable print is a process of great violence, not only because of the immense force exerted by the press, but also because it is instantaneous. The contrast between the period of endless variation and the irrevocable result is dramatic and should be most inspiring. The intervention of chance is concentrated into a fraction of a second in which everything happens at once. The artist's control can be augmented by experience, but it can never become total. It is in rejecting or accepting that the artist is the total master".
Pontus Hulten[2]

Due to its primary characteristics of spontaneity, experimentation, immediacy, vivacity and a certain degree of unpredictability, the monotype is akin to a work done from life. With respect to painting and drawing, where comparison between the representation and the model takes place during execution, the hand is freed from the eye in the monotype and the wits are sharpened. At the same time, it also possesses the qualities of the engraved work, with which it shares the double distance from the object, the double intermediary action: on the one hand, the interval between the moment in which the work is executed and the end result; on the other, the inversion of the image on the sheet.

The monotype is akin to drawing in the duality of the movements through which it is executed. While the former leads to the construction of the image, either directly or through successive stages, the latter goes in the opposite direction. Having detached itself from the representation, the artist's gesture goes back again, opposing the principle of "addition" with that of "subtraction".

Like watercolour and tempera, the monotype is a complete and autonomous form of art characterised by a peculiar intrinsic condition that it shares with musical improvisation. The artist has to identify the quickness of the rhythm and the economy of colour as well as its fullness, transparency and physical fluidity in order to find the right thickness of the luminous substance of the work, with no crushing or excess of pigments at the moment when pressure is applied through the press.

The monotype also shares some of the characteristics of the photograph. Produced on a paper support, it is made up of areas of tonal values and contrast. It maintains all the effects of surprise and expectation in that the result cannot be foreseen until the second phase of the operation—printing—delivers the finished work.

However the monotype may be executed, its key characteristic is that some residue is left on the surface of the plate after printing. In the case of the "pure monotype", this is eliminated by the artist, who regards the first result as the definitive work. In other cases, it may be decided to use these traces as a basis for reworking in order to print further copies, which are necessarily weaker and fainter due to the loss of paint or ink and have a characteristic "softness". These second (or third and very rarely fourth) impressions are called "ghosts" (or

18. Giovanni Benedetto Castiglione
David with the Head of Goliath, 1650–55
Monotype, first pull, 371 × 254 mm
Civica Pinacoteca Tosio-Martinengo, Brescia

19. Giovanni Benedetto Castiglione
David with the Head of Goliath, 1650–55
Monotype, second pull, 348 × 248 mm
National Gallery of Art, Washington, D.C.

"cognates", due to their family relationship with the first impression). The term "shadows" is much more seldom used. Gauguin was one of many artists with a particularly fondness for such prints, and Castiglione himself sometimes used his plates to produce second impressions. The "ghost" print, where the initial spontaneity is combined with an element of reflection, plays a particular role in that it develops a new range of tonal values to which further colour can be added in the form of ink or oil paint. Degas often printed second impressions for the precise purpose of retouching them with pastel, which he sometimes did to such an extent that practically no trace of the original monotype is left.

Some artists, for example Picasso, instead create an image and develop it in a temporal sequence, using the same plate repeatedly to rework and develop variations on the same theme. While preserving the traces of the previous composition, they add fresh pigments after each pressing, so that the image is fixed in the fluidity of its metamorphoses.

An elusive medium that has even been described as "perverse", the monotype cannot be pinned down to one unambiguous definition. It can be described as tonal, atmospheric and luminous for its aesthetic characteristics, and enjoys all the prestige of the painting by virtue of its unrepeatable and intuitive effects. In the hands of many artists, it offers a medium for achieving pictorial results where the physical consistency of the colour blends with the structure of the paper.

A flexible and pictorial means of visual expression open to the generative possibilities of chance and "calculated risk", within the reality of the ever-increasing technological coercion in the art world over the last thirty years, the monotype offers the contemporary artist an opportunity to restore a liberating sense of play and discovery to the artwork.

Unlike many other techniques documented and illustrated in the various temporal phases of their employment, the monotype has no codified history and the variety of its forms of execution seems to be equalled by the lack of interest in documenting them. From the very outset, in fact, the procedure has never been "taught" or "explained", but rather rediscovered and reinvented by all the artists who have taken it up and developed it through their own particular vision and ability.

Given its experimental character, there is every reason to assume that the monotype is at least coeval with the birth of engraving. The necessary technical

know-how was in place in the fifteenth century and the first sixteenth-century treatises on engraving offer descriptions of similar procedures. The first historical documentation of works executed with this technique as works of art in their own right—and not for practical and purely technical purposes, as in the case of the "counterproof"—did not appear, however, until 1821.

In the herein chapter on the graphic works of Giovanni Benedetto Castiglione, Adam von Bartsch, the celebrated curator of the Albertina print collections in Vienna, identifies a group bearing a similarity to aquatints. Given the fact that that the aquatint technique had not yet been invented in Castiglione's day, Bartsch draws attention to the novel nature of this procedure, for which he has no specific name, and attempts a reconstruction: "We believe that Castiglione cleaned a copper slab, covered it thickly with oil paint, and then used a wooden stick to remove the same in accordance with the half-tones and areas of light required by his drawing. Having thus prepared the plate, he then printed it in the usual way. The prints obtained with this system are necessarily unique because the black spread onto the plate is completely transferred onto the paper of the first impression and cannot be used to produce other copies".

Historically speaking, the monotype is an art attracting elites rather than the general public. Given the diversity of the results and the number of variants, its aesthetic appeal is recognised above all by an expert eye and felt in particular by the art lover. Comparatively distant from the official circuits, it enjoys a certain peripheral independence and has become the art of whoever delights in experiments, the aficionado, the lover of variations, the few who work for their own pleasure and for mutual exchange. By virtue of its simplicity of execution, the medium is adopted both by painters and sculptors.

Due to its difficulty of classification, the monotype had not received due consideration on the art circuits, in exhibitions or in the specialised studies on drawings or prints right up to the beginning of the 1970s.

Today, thanks to the growing popularity and success enjoyed by the monotype among collectors and to the spectacular changes that have characterised its developments since the 1980s, the time finally seems ripe to address this medium and its role in modern and contemporary art in Europe and the United States.

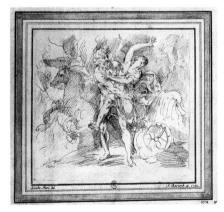

The graphic image in the sixteenth and seventeenth centuries
"And we shall speak first about the easy and excellent way that has been found to engrave copper plates instead of using the burin… The etching acid is made by taking half an ounce of sublimate, an ounce of vitriol, half an ounce of rock alum, half an ounce of verdigris and six lemons. Make sure that all these things are finely powdered, mix them with the juice of the lemons, and boil gently in a glazed pot to avoid drying out the mixture too much. If you have no lemons, use strong vinegar, which will work the same".
Benvenuto Cellini

The practice of monotyping emerged historically in the seventeenth century against a general background of critical reflection and evolution in taste. Boundless curiosity, the pursuit of "beauty" and a new passion for rarity in printmaking were the driving forces that led to the development of new expressive possibilities in this graphic medium. The roots of this evolution stretch back, however, to the previous century, when the traditional tools were technically improved in step with the emergence of a new conception of the artwork.

The taste for graphic images focused in the sixteenth century on the effect of great limpidity and a firm, clear, regular line that became practically the only tool used to obtain contours with limpid, "classical" economy. This result was obtained in engraving by working directly on the metal plate with a tool like a burin or in any case a pointed instrument. When they wanted to reproduce the effect of shading used in drawings, the sixteenth-century engravers—like those of the fifteenth century—used the contrast of tonalities to emphasise the area around the contours of objects and figures.

In order to give plastic prominence to the forms and suggest painterly values—which neither the half tones nor the shadows of cross-hatching produced by the burin are capable of fully rendering—they used a stippling procedure introduced at the beginning of the century whereby straight lines alternate with dots so as to obtain a diversification of tones. They also began to sprinkle—and then remove—a little ink on the engraved lines in order to soften the hard edges of the contours.

25. Giovanni Benedetto Castiglione
The Resurrection of Lazarus, ca 1660
Monotype heightened with brown oil,
405 × 560 mm
Museo Civico, Bassano del Grappa
The monotype, unknown until 1976,
was mentioned by G. Dillon

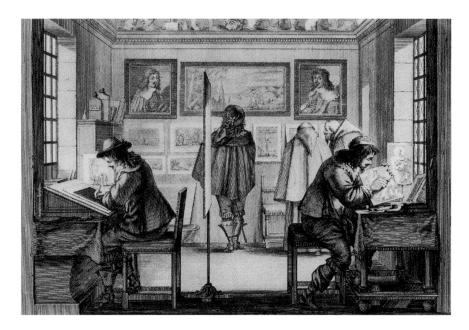

It was through this radical change in taste that the classic engraving, pursuing effects similar to those of drawing and watercolour, experimented with painterly effects that were to be most fully achieved in the monotype.

One of the first attempts to move beyond the limits of a linear medium was made by Giulio Campagnola (1482 ca–1515), who combined dots and lines of varying thickness freely in his engravings to obtain vibrant luminosity and sophisticated tonalities. Engravers working with woodcuts began to adapt their traditional technique to the soft tones of painting and the highlighting effects of drawing by means of additional blocks, which they coloured and printed over the block providing the linear outline.

When tone predominates over line, the print gives the impression of a painting. In the *camaïeu*, there were two wooden blocks at first, one for the drawing as a whole and the other with the coloured background. Then with Ugo da Carpi, who invented the *chiaroscuro* procedure in 1516, there were up to four blocks used for different functions with respect to the final effect, akin to that obtained with the various layers of watercolour.[3]

Rightly indicated as the father of Italian engraving, Andrea Mantegna (1431–1506) had been obsessed two centuries before Giovanni Benedetto Castiglione with the problem of rendering and controlling *chiaroscuro* values in the engraving. He endeavoured throughout his career to recreate effects of light allowing his forms to stand out three-dimensionally in a variety of media, including a particular form of monochrome drawing and *chiaroscuro* painting.

Italy produced more engravings than any other European country in the sixteenth century, when artists began to use etching, which was known as *acquaforte* from the old name for nitric acid. This "indirect" technique[4] obtained growing popularity due to its successful application in the reproduction of drawings, above all with the fashion of "imitation drawings" in the following century.[5] By virtue of its particular expressive qualities, it is in fact capable of reproducing the graphic poise and nonchalance of all the techniques of drawing: pencil, pen and ink, black chalk and bistre as well as the highlights in ceruse or watercolour used by artists to enliven linear contours and strokes.

Francesco Mazzola (1503–40), better known as Parmigianino, was perhaps the first in Italy to try his hand at etching, with which he succeeded in producing *chiaroscuro* effects and soft, pictorial shading that were to enable the new

technique to compete with drawing over the next three centuries. Aided in his experiments by an interest in alchemy, Parmigianino focused on the quality of sign in order to increase his mastery in the interplay of light and shadow. In his etchings, roughly sketched out by simple linear strokes, it is the sign more than the image that comes to play the leading role in the work. His sign does not describe shapes but rather suggests them with taut tonal passages, and can even take on the character of colour through its quickness and fluidity.

A matter of far greater importance than Parmigianino's "discovery" of etching is the fact that he was the first artist to engrave his own works, originals rather than translations. Working as a painter, he opened up the way to a freedom and autonomy of graphic invention previously unknown in the field of printmaking, definitively emancipating the sign from its exclusive function of delineating shapes and providing *chiaroscuro* to endow it with a "painterly" quality.

Another artist of importance for the shift in taste and technique towards colouring and the rendering of tonal values in prints was the excellent draughtsman Battista Franco (1510 – ca 1561) from the Veneto region. Inspired by Titian, he strove for ever-greater spontaneity of stroke and broader chromatic richness in engraving. Franco used much larger plates than was normal for the period and shortened the gap between the disciplined tradition of the burin and the freer technique of etching, which he combined to obtain a greater variety of tones.

The new criteria were developed also and above all by the work of Federico Barocci (ca 1528–1612), who endowed his etchings with the atmospheric qualities of his paintings. Abandoning the clear-cut sign of the burin, Barocci began to "nuance" his images and developed a technique of "multiple gradual etching" to create areas of light and shadow on the same plate. Even though this complex procedure was not adopted by the Italian engravers of the period, who preferred the spontaneity of the single etching, it played a key role in encouraging the artists of the seventeenth century to seek the characteristics of drawing and painting in etching.

The seventeenth century saw an enormous increase in graphic output and a thriving market for prints, the object of a network of production and trade extending all over Europe. Collecting got under way and the first treatises on artist-engravers appeared. Printmaking evolved towards broader stylistic parameters due to the presence of greater artistic individuality and the success of etchings.

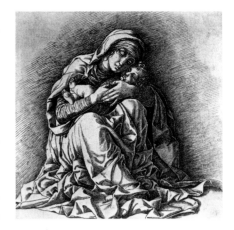

27. Andrea Mantegna
Madonna and Child, 1485–91
Engraving, 345 × 268 mm

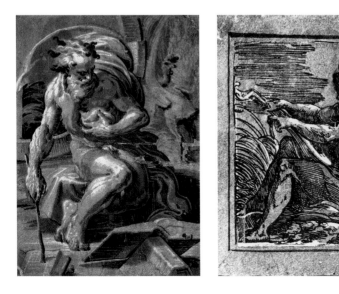

28. Ugo da Carpi
Diogenes, after Parmigianino, ca 1525
Chiaroscuro xylography using four woodblocks,
479 × 350 mm
Museo Ugo da Carpi, Carpi

29. Antonio da Trento
The Lute Player, after Parmigianino,
early sixteenth century
Chiaroscuro xylography using two woodblocks,
sheet ca 500 × 500 mm

30. A.C.Ph. Thubière de Caylus
The Deposition, 1720–25
Etching, after a drawing by Raphael,
258 × 305 mm
Istituto Nazionale per la Grafica, Rome

31. Francesco Mazzola, known as "Parmigianino"
Christ's entombment, 1524–27
Etching, 278 × 208 mm
Istituto Nazionale per la Grafica, Rome

The aesthetic canons of the new century focused on a free, jagged and sketch-like linearity capturing the spontaneity of the artistic gesture and line. There was a marked shift in taste towards tonal diversity and gradation, as well as sophisticated *chiaroscuro* effects. Since the technical experience of the burin accumulated by the beginning of the sixteenth century was not sufficient to express the values of paintings in black and white, the elements of the new art of indirect printmaking came to predominate in the graphic arts of the seventeenth century. Etching was followed by a similar technique known as soft varnish or *vernis mou* and finally by the aquatint, which uses planes of varying tonality instead of lines and hatching.

The etching is characterised by greater fluidity of application and layout, a quick, nimble and immediate technique that approaches the gestural spontaneity and freedom of drawing. And if the lines thus engraved do not possess the flexibility of thickness of those drawn in pen, they do have their freedom of movement and still greater lightness, because the point slides over the waxed surface of the shining copper without meeting the resistance of paper. An experimental method par excellence, etching leaves a great deal to chance and the unexpected. Once completed, the drawing is subjected to chemical factors over which the artist has less than total control. The acid can in fact bite too quickly or unevenly, the film of varnish can become partially detached from the plate or cover the wrong areas to produce "false biting", and the entire plate sometimes comes out of the acid completely ruined. And yet the *peintre-graveur* can turn the experimental aspect of etching to his own advantage and even succeed in turning accidents into effects otherwise unthinkable with other engraving techniques, such as the burin or woodcut. A new way of printmaking was born.

By comparison with the etchings of the sixteenth century, those of the seventeenth display greater variety and freedom of approach. Above all, seventeenth-century artists like Salvator Rosa and Giovanni Benedetto Castiglione were more inclined to regard etching as a major art and a suitable medium for the production of ambitious finished works forming part of their overall artistic

32. Federico Barocci
The Annunciation, ca 1585
Etching and burin, 420 × 310 mm
Istituto Nazionale per la Grafica, Rome

33. Albrecht Dürer
Melancholia, 1514
Engraving, 239 × 168 mm
Istituto Nazionale per la Grafica, Rome

output. The first to formulate criteria for judging the value of prints and one who recognised them as works of art in their own right, Vasari described them as *disegni stampati* ('printed drawings'), emphasising the view of the etching as an extension of drawing that was to last all through the Renaissance and the Baroque period. It was in the seventeenth century that people began to collect drawings and that this medium acquired full autonomy, with attention no longer focused exclusively on its degree of graphic invention, but also on its nature as a particular type of paper artwork with its own physicality and appearance, something different and separate from a painting.

The trend was such that the trade in drawings became brisker and more profitable than paintings and artists came under unprecedented pressure to meet the demands of an expanding market of enthusiasts.

The Comte de Caylus, a French engraver and patron of the arts, summarised this change in taste succinctly halfway through the eighteenth century: "There are works where genius alone predominates, namely sketches. We read in these the flame of the original idea instantly transposed onto the paper. The work of a moment, they are all spirit with no manipulation whatsoever".[6]

Abraham Bosse stated in 1646 that the qualities for which the first engravings of the fifteenth and sixteenth centuries were admired were "distinct, black lines and very white paper". Some time later John Evelyn praised the colouristic and tonal quality of many Italian etchings. There is a great deal of historical documentation of this new trend in taste whereby engravings were no longer required to be "black or precise or well drawn".[7]

The medium of a style seeking greater freedom and lightness in this century, etching now asserted itself within an aesthetic of sublimation of luminosity, also as offering greater capacity to capture the complex effects of light and shadow of the atmosphere and to render chromatic richness and distance in the reproduction of landscape. Thanks to the example of the northern school, landscape was in fact no longer seen as a background or complement to the figure but became a favourite subject with artists and an authentic "genre" in its own right.

Annibale Carracci (1560–1609), an artist particularly given to etching, worked with a broad spectrum of pictorial effects ranging from *sfumato* to the stark *chiaroscuro* of the revolutionary paintings by Caravaggio (1571–1610).

Guido Reni (1575–1642) and Simone Cantarini (1612–48) used etching in what we would describe today as an "impressionistic" way, in harmony with the transparent and evanescent qualities of many of their paintings. Claude Lorrain then developed complex and innovative printing techniques enabling him to render his evocative *chiaroscuro* effects, rich in transparency and luminous vibrations.

In addition to pointed tools and etching with acid, tonal effects were also obtained through a particular printing technique that characterised Italian etchings from the very outset. The surface of the plate was covered with a very thin layer of printer's ink, which is usually oilier and more diluted than ordinary ink. Transferred to the paper at the moment of printing, this thin film endows the image with a deep but light tonality and serves to give greater prominence to the precise areas of the plate intended to be darker, being carefully removed with muslin in the other lighter areas. The resulting print is described as one with "background tonality" or simply "tonal rendering".

Prints with background tonality were not common in the world of print-making until way into the seventeenth century, when Rembrandt, the greatest genius of the day, made the most creative and surprising use of this type of work. Like Seghers, the other leader of the Dutch school and one who transformed and reinvented every plate he printed, Rembrandt worked in such a way that every new state or impression explored the more recondite aspects of the image and left nothing unexpressed on the plate.

An important factor in the tonal rendering of prints is the quality of the ink used. Subjected to a great deal of experimentation, ink production underwent many changes over the centuries in the different countries, above all as regards the quantities of the pigments used. In addition to aesthetic criteria, the print is therefore also affected by the ink at the engraver's disposal, which can be removed from the plate with greater or lesser ease. The inks used by engravers in the sixteenth and seventeenth centuries were richer in pigments and thus heavier than those of the previous two centuries, and made an important contribution to the limpidity of the engravings of the period.

Italy and the northern schools used inks differing greatly in composition, with a markedly higher degree of pigment being found in the German and Dutch engravings than in Italy. Frankfurt ink in particular was renowned for its quality of absolute black and was in great demand from the seventeenth century on. As a result of the greater amount of pigment, the ink crumbles imperceptibly at the moment of application and tends to remain on the surface of the paper support without penetrating the fibres. The lines are thus generally perceived as blacker and with sharper edges. Printing in ink with less pigment has the contrary effect of weakening the intensity of the line, which proves pale and indistinct, albeit with greater tonal depth. Italian etchings, which look greyer than their Flemish or northern counterparts, have greater capacity to suggest the aesthetic qualities of the drawing by virtue of their silvery tone.

In the seventeenth century collectors began to appreciate and value prints for the various sophisticated tonalities with which they were printed, a factor deliberately designed to make them rare. The craze for these prints was a source of inspiration to the French writer La Bruyère, who created a fictitious caricatured character named Démocède in his work *Les caractères ou Les moeurs de ce siècle* (1688): "You wish to see my prints, says Démocède proceeding to pull them out and place them in front of you. You see one that is neither black nor distinct nor

34. Salvator Rosa
Oedipus Hanging from a Tree, 1663
Etching and drypoint, 724 × 472 mm
Istituto Nazionale per la Grafica, Rome

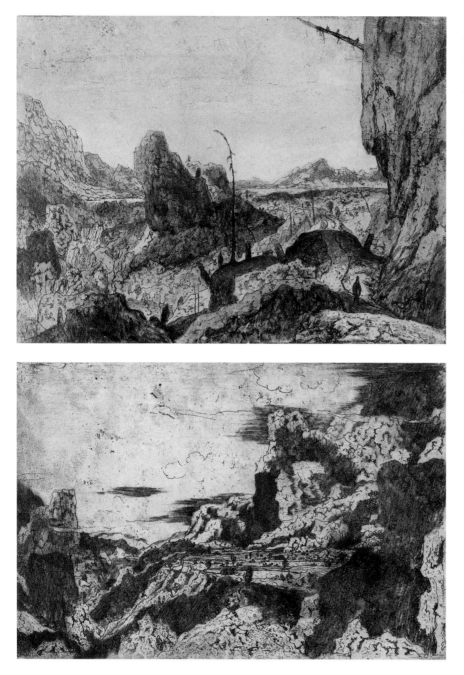

35. Hercules Seghers
Mountains and Cliffs with Man Walking, ca 1620
Etching printed in blue ink on pink-tinted paper
with hand painting, 156 × 210 mm

36. Hercules Seghers
Distant View with Branch of a Pine Tree, ca 1620
Etching printed in blue ink on dyed cotton with
hand painting, 133 × 200 mm

well drawn. He admits that the print is poor and the drawing still worse, but hastens to inform you that it is the work of an Italian artist who produced very little, that the plate was barely printed at all, that it is moreover the only one of its kind in France, that he paid through the nose for it, and that he would never ever exchange it for something far better. "I have such serious problems, he says, that this will prevent me from continuing my collection. I have all the prints of Callot but one, which is not one of his best, indeed one of his worst, but would nevertheless complete my series of Callot. I have been after it for twenty years and am not sure that I will ever find it. This makes life unbearable for me".[8]

Engravers used different types of paper in their pursuit of particular effects, often ordering it from afar. There was a preference for paper from the East, which proved particularly delicate and absorbent due to the smaller proportion of size used in its manufacture. Rembrandt was among the first to adopt it for the printings of his most valuable etchings. Intent on deepening the shadows and

37. Ludwig von Siegen
The Holy Family, after Annibale Carracci, 1657
Mezzotint, 364 × 274 mm
Istituto Nazionale per la Grafica, Rome

intensifying the dark areas to the maximum, the Dutch master used slightly yellow Japanese paper or types that left thick layers of ink on the surface on drying. The demand for these rare prints, each differing from the others, was immediate and enormous.[9]

The play of light and shadow became the channel most used to express the exuberant Baroque energy. While the approaches varied, the increasingly strong sensitivity to *chiaroscuro* in engraving was something that Italy, the classically oriented country par excellence, shared with the different schools of the north. With secondary importance now attached to line, the tonal technique developed in Germany and the Netherlands as well as Italy due to the common determination to rival the visual qualities of painting and watercolour in printmaking.

It was, however, Dutch mannerist printmaking that was characterised in particular by the pursuit of dark tonalities, and there are many references to the "dark prints" of the Dutch masters in the literary sources. The French writer Florent Le Comte stated in 1699 that an ideal collection of prints should contain above all "representations of nocturnal scenes" and "black pieces", referring in particular to the works of Hendrik Goudt, Jan van de Velde, Moses van Uyttenbroeck and Rembrandt.

The peak of the northern masters' pursuit of colourism and dark pictorial effects more or less coincided with the invention of the new direct engraving technique of the mezzotint.[10] The procedure was invented not by an artist but by Ludwig von Siegen, a soldier with a penchant for scientific experiments, who developed it in Hesse at a court more inclined towards the sciences than the arts. Von Siegen carried out his experiments in 1642, the very period in which Rembrandt began to take an interest in the effects of light and shadow obtained with the dry point technique.

Unlike the light tonalities typical of the classical-style etchings, the mezzotint—which is, as its name suggests, the engraving technique closest to "tinting" or colour—tends to impose the use of dark tonalities and the rendering of "nocturnal effects". Used above all for portraits, it proved particularly suitable for making the forms stand out like shafts of light against a uniformly black

38. Richard Earlom
Liber Veritatis,
plate VI, after Claude Lorraine,
ca 1774
Mezzotint

background. Its rich chromatic spectrum of dark and velvety tones made the transition between areas of light and shadow less abrupt. Above all, however, the mezzotint was the best of the media available at the time for capturing the physicality and consistency of matter. From the subtlest shades of grey to absolute white and black, the gradations of light could finally be expressed with no linearity whatsoever. Totally focused on tonal contrasts, the technique offered no more than limited definition of sign, however, and its results remained uncertain for a long time.

There were remarkable expressive affinities between Rembrandt's etchings and the tonal qualities of the new medium, as already noted by various writers back at the end of the seventeenth century. As Arnold Houbraken pointed out, for example with respect to certain works by the Dutch master, "the soft and gleaming shadows are ... handled as skilfully and delicately as in the mezzotint". The taste for the vivid colourism of the Dutch mannerists and in particular for etchers who "printed paintings" spread throughout Europe. By the end of the seventeenth century, printmaking was an art capable of expressing in its traditional black and white the Baroque fascination with the decorative use of colour as well as the new, modern interest in capturing physicality.

This extraordinarily innovative and fertile century saw the print rise above its original function of reproducing and popularising other works and compete with the painting in terms of size and tonal range. As a result, the attempts to render the chromatic effects of painting and drawing multiplied within the *chiaroscuro* dialectic peculiar to the medium of printmaking. The emulation of the tonalities of colour through black and white and the pursuit of the shading present in other artistic forms—and ultimately in the natural world—stimulated the discovery of new and increasingly flexible techniques. This interest in experimentation and new critical reflection on the art of printmaking laid the foundations for the formal achievements of the years to come.

Giovanni Benedetto Castiglione and the birth of the monotype
"There is, alongside a classical Italy, a magical, nocturnal Italy rich in enchantment, the work of daring poets of art that have mixed their fantasies with the historical material of time like alchemists and effected a sort of transmutation to create new spaces for the life of the mind"
Henri Focillon

The birth of the monotype is generally dated from the time of the Genoese artist Giovanni Benedetto Castiglione (ca 1601–1665), who may not have actually invented the process but unquestionably has the merit of originating the art.

Castiglione thoroughly explored the expressive potential of the monotype, inaugurating the careful and deliberate use of a technique that was akin to both printmaking and painting but at the same time new and original. Irresistibly attracted by the effects of light and shadow, Castiglione worked uninterruptedly on the continuous tone of his prints, experimenting with all possible methods of inking, cleaning and printing. He was among the first ones to use soft varnish, a technique similar to etching that he probably invented himself, and printed some plates with a horizontal rather than vertical press. Finally, he also worked with blank plates, untouched by pointed tools or acid, and "invented" what was to be called the "monotype" two centuries later. Having developed this daring procedure open to chance and the unpredictability of accidents, which was particularly suited to his dynamic tem-

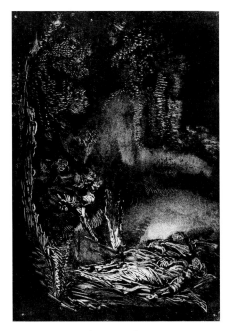

39. Giovanni Benedetto Castiglione
The Discovery of the Remains of Saint Peter and Saint Paul, ca 1640
Monotype, 297 × 205 mm
Bibliothèque nationale de France, Paris

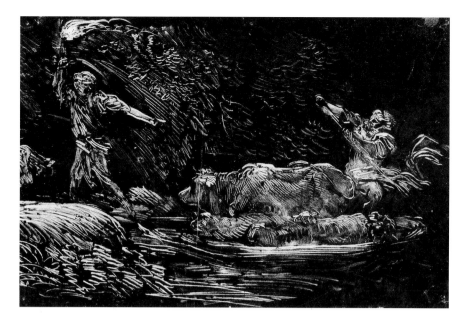

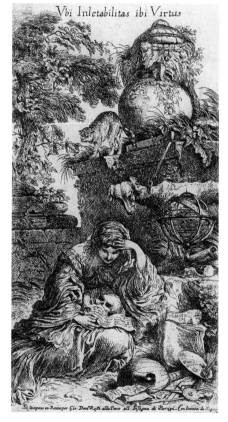

perament, Castiglione strengthened its autonomous capacities in terms of artistic vocabulary and vision to make it the most interesting fulcrum of his artistic production and his greatest claim to glory.

Known as Grechetto, probably after a costume worn during a Roman masquerade, and considered one of the best Italian etchers of the Baroque era, Castiglione was an impassioned innovator and a great *virtuoso*. Endowed with amazing technical originality, he was a brilliant *graveur en peintre*, to use the celebrated definition coined some two hundred years later by Adam Bartsch to indicate that the material author of the print is also responsible for its "invention".

Using paint brushes, pointed tools, sticks, pens, wax and acids, Castiglione thoroughly explored every procedure fostering progress towards his most pressing objective in the graphic arts, namely the creation of compositions with nocturnal subjects and the rendering of dazzling, theatrical and unnatural effects of light to organise the spaces. The eighty-odd sophisticated prints executed by means of etching and soft varnish techniques show how Castiglione suggested movement and endowed his compositions with density and vivacity through the use of curved lines interacting with a host of subtle, agitated and always irregular graphic signs. Tonal contrast was instead used for the purpose of modulating volumes.

The irresistible attraction he felt for "heightening" effects and the "shading" of colour is also evident in his drawings and sketches using the brush, a technique borrowed from Rubens which enabled him to produce a more material pictorial effect. These works display delight in a gestural use of the brush in seeking out different effects on the paper support and chromatically modulate his favourite basic colour of reddish brown. One feels above all that for Castiglione, unlike his contemporaries, the drawing was an autonomous work of art in its own right and not a preparatory stage in painting.

Stubborn and impassioned efforts to construct the image through ever-changing effects, the alternating of light and shadow and a predilection for diluted oil paint, little used at the time, all led Castiglione to the monotype. Impatience at having to wait for the effect of the acid on the wax-covered engraved plate, eagerness to see the result of the work immediately and a deliberate decision to introduce a calculated element of unpredictability may also have

spurred him to work directly on the uncut surface of the copper plate with printing inks. He would shift and modulate the plate, using spatulas and pad to remove or add ink, and then run it straight through the press. He thus varied the intensity of the ink, removed as in a negative drawing or added with the brush as in a tempera work, enriching and calibrating the theatrical lighting effects of his dramatic and pictorial monotypes.

Castiglione was trained in Genoa at a time when the city was a very important artistic centre in Italy, "far more modern" than Rome, Naples and Venice due to the contributions of Flemish painters like Rubens, Van Dyck and Jan Roos, who lived and worked there. Castiglione often left his hometown and made a long stay of nearly ten years at the Accademia di San Luca in Rome, where he completed his training. He then travelled to Naples, Venice and finally Mantua, where he entered the service of the Duke of Gonzaga, Carlo II, and ended his days. During his time in Rome, he was immersed in the unequalled atmosphere of the 1630s generated by the presence of exceptional artists from elsewhere in Italy, like Annibale Carracci and Caravaggio. Having moved to the capital in the last decade of the sixteenth century, these two artists continued to spearhead a revolutionary aesthetic focusing on the new values of emotional intensity and the psychological and spiritual dimension of light, as well as the representation of reality in an illusory and supernatural way: in short, the values that projected Italian art out of the late Mannerism towards the Baroque.

Castiglione was barely 23 when he first arrived in Rome in 1632. He worked mainly within the expressive parameters of the Baroque but also frequented the more eclectic circles and was exposed to the linguistic and formal innovations of the northern masters, assimilating the warm qualities and fluid execution of painting from the Veneto region, above all the Bassano family. In Rome Castiglione also came under the influence of Nicolas Poussin, as is shown by his first works of graphic art, produced around 1645 and impregnated with the harmonious myth of the ancient world. These were depictions of pagan themes, bacchanals with satyrs, nymphs and the god Pan, which the artist interpreted with an already pre-Romantic sensibility showing a tangible yearning to escape from the world into the dream of an unreal "golden age".

Castiglione subsequently addressed problems of a more complex and moralistic nature, drawing inspiration for his etchings from works of Stoic philosophy—then very fashionable among artists—where the presence of death and allusions to the fleeting nature of earthly things are recurrent elements.

In Rome Castiglione consolidated his technical expertise and passion for experimentation, even though the engravings of this period register no stylistic and technical changes of interest but rather a broader range of subjects, including the psychological portrait and the landscape. In these years of artistic maturity Castiglione developed his preference for nocturnal and subterranean settings, which he rendered in powerful *chiaroscuro* with overtones of Caravaggio. The tonalities are deep and the scenes are steeped in an evocative, artificial luminosity. One notes above all a change of "atmosphere" or "mood" in his depictions, which have left the early bucolic scenes far behind to focus on modern and "dramatic" events. The sun-drenched settings of an idyllic countryside are transformed into gloomy caverns where the remains of the past constitute a grim and threatening presence. His anxious faces and harsh contrasts of light betray the strict spirit of the northern schools, another point of cultural and formal reference.

Castiglione devoted himself to the monotype from the late 1630s—or 1635, according to some authorities—to the 1660s. While no important prece-

42. Jan Lievens (1607–74)
Portrait of a Man
Etching, 271 × 223 mm

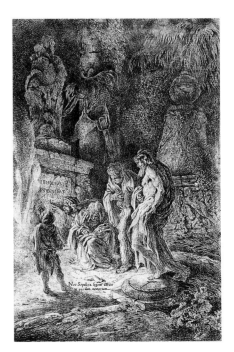

43. Giovanni Benedetto Castiglione
Temporalis Aeternitas, ca 1645
Etching, 288 × 203 mm
Istituto Nazionale per la Grafica, Rome

dents have yet been discovered for his experiments in this direction, it appears correct to place them within the broader context of the interest aroused by the Dutch masters in northern Italy. Castiglione was keenly aware of the work of these artists, which he had first encountered during the years of his training, when Van Dyck and Jan Roos both lived and worked in his hometown of Genoa. It was probably through Van Dyck and Rubens, the Flemish artists that influenced him most, that he came into contact with the works of Jan Lievens and above all the outstanding painter-engraver Rembrandt.

Twenty-five monotypes that can be safely attributed to Castiglione have been found so far, two of which are second impressions or "ghost images". Bartsch had identified five by 1821 and Ann Percy and Donata Minonzio listed twenty-four in 1985.[11] Another four remain of uncertain attribution. This is a considerable corpus in terms not only of number but also and above all of its artistic quality and of its underlying ambitious concept of finished works. Cas-

44. Giovanni Benedetto Castiglione
Nativity with God the Father, 1650–55
Monotype, first pull, 378 × 252 mm
Bibliothèque nationale de France, Paris

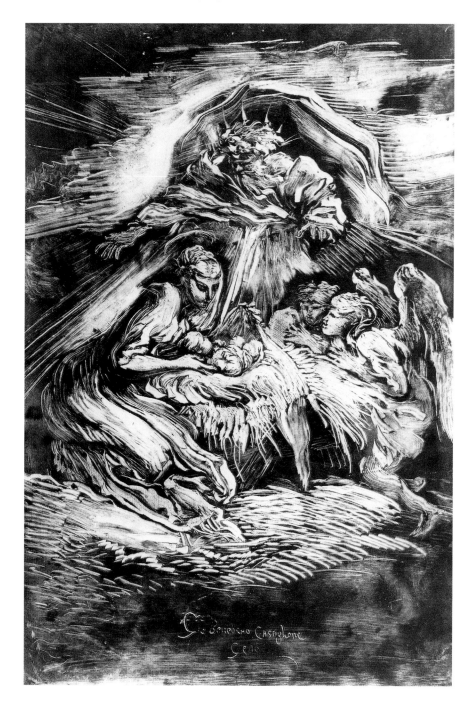

tiglione's awareness of this is shown by the inclusion of his signature on seven of these monotypes, sometimes in full and sometimes in the form of initials or a monogram. In the case of *Temporalis Aeternitas*, the name written in white against the grey background is accompanied by the year, 1645.

As for his most celebrated etchings, Castiglione drew inspiration for his monotypes from edifying episodes, generally taken from the Bible: *The Annunciation, The Flight into Egypt, The Nativity, The Crucifixion, God Creates Adam, The Allegory of the Eucharist, The Resurrection of Lazarus* (his largest monotype after *The Allegory of the Eucharist*) and *The Discovery of the Remains of Saint Peter and Saint Paul.* The latter subject had never been addressed before, and Castiglione depicted it as a supernatural event. Jagged lines seemingly scratched into the plate cause spectral figures to emerge from a black background and create an atmosphere of sorcery. Fully aware of how the choice of medium influences the interpretation and meaning of the representation, the artist repeated the composition in an etching with surprisingly different results, the gloomy, oppressive atmosphere of the monotype giving way to one of greater optimism and reassurance.

A concern for the historical and narrative implications of his works, and above all a view of the monotype as a vehicle for ethical messages, led Castiglione to develop a new iconography and to create particular psychological situations with specific effects. This happens, for example, with the inclusion of the figure of God the Father in the scene of the *Nativity* and his repeated use of torch-lit nocturnal settings.

Castiglione repeatedly addressed a limited number of subjects, mostly created directly on the plate but sometimes done first in pen and etching. In the case of *Temporalis Aeternitas* and *Noah and the Animals of the Ark*, the composition is taken up both in etching and in octagonal paintings.

Castiglione used both the "subtractive" and the "additive" monotype techniques, sometimes combined in the same work. The combination and use of new techniques together with the choice of subjects with great ethical impact earned him some moderate success among contemporaries as well as a number of followers. There were indeed repeated attempts to imitate him and copy or counterfeit his graphic works over the years.

According to recent studies, his first monotypes are the two that repeat the compositions of etchings with the same title, namely *Temporalis Aeternitas* and *Theseus Finds his Father's Sword*, both dated 1645. Due to false biting, evident above all in the plate of the first etching held at the Calcografia Nazionale in Rome, the impressions printed are very faint and incapable of expressing the dark and deep tonalities required by the nocturnal subjects. This is indeed a characteristic feature of many of Castiglione's etchings, which the artist often had

45. Rembrandt Harmenszoon van Rijn
Saint Jerome in a Darkened Room, 1647
Etching, state I, 151 × 173 mm
Rijksmuseum, Rijksprentenkabinet, Amsterdam

46–47. Rembrandt Harmenszoon van Rijn
Three trees, 1643
Etching, drypoint and burin, state I and II,
213 × 279 mm
Rijksmuseum, Rijksprentenkabinet, Amsterdam

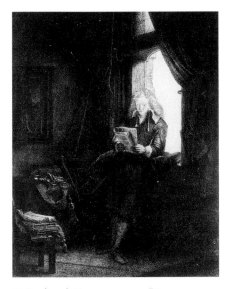

48. Rembrandt Harmenszoon van Rijn
Jan Six, 1647
Etching and drypoint, 246 × 191 mm

to retouch with a burin. It was probably due to his dissatisfaction with the etching procedure, his impatience with its laborious nature, and above all his search for more vibrant and dynamic effects, that he turned to the new technique of the monotype.

God Creates Adam, a tribute to Michelangelo's work in the Sistine Chapel and regarded as one of the Genoese artist's first monotypes, was executed between 1640 and 1645 as a work in its own right unconnected with the others of the period. Like many of his monotypes with the subtractive method, the work reveals a concern with a nocturnal setting in which the image is as though carved with shafts of light. Castiglione resorts to a theatrical use of *chiaroscuro* with flashes of light that recall Caravaggio and his Tenebrist followers. He proceeds from black to white by removing the layer of ink covering the smooth surface of the plate, and uses a pointed tool to draw lines that stand out as absolute white against the dark background of the ink. The inking is lightened, probably by means of a stiff brush, for the grey transitional areas of the composition.

Use was made in the subsequent monotypes of gauze and perhaps of tools such as feathers and pieces of bamboo or cane. He also began to print compositions painted with a brush in an oily brown pigment. The effect obtained in these "additive" monotypes resembles some of his drawings. It was by achieving the results of one technique through the use of another that Castiglione confirmed his nature as a great and complex experimenter.

The monotype *David with the Head of Goliath* instead combines the subtractive and additive techniques. Very narrow points are used to remove the oily pigment from some areas of the plate in the first impression and obtain an almost dazzling effect of light. After strengthening some signs and areas, the artist then explored the possibility of a variation on the image by printing a second impression of the plate to obtain a work with lighter contours and less marked tonality but intense emotional impact. Castiglione worked on both with a brush, accentuating and reshaping the forms and masses as though to stress the nature of every single impression as a unique work in its own right despite its close relationship with the others.

The appeal of "nocturnes"—which constituted a separate genre at the time and for which the *maniera scura* or 'dark technique' was largely developed—acted as an extremely strong catalyst in the seventeenth century. Darkness was in fact radicalised almost obsessively in this period and no longer indicated a natural moment in the course of the day but rather the opposite. This anti-naturalistic approach went far beyond any respect for the natural sources of light, and gave way to a purely ornamental function. In order to capture the contrast between the dazzling light of the exteriors and the darkness of the interiors, the great master of *chiaroscuro*, Rembrandt, used variations of the same light, alternating areas of light and shadow. He thus structured his compositions so that the scene, the stage of the action, was visible only through its juxtaposition with a dark area. It was often from the outside, through the opening of a window left ajar, that the light penetrated to animate the scene within.

At a time when the mezzotint technique was just taking its first steps, Rembrandt achieved the same effects through a profusion of lines. He used above all what was regarded at the time as a purely instrumental resource, namely the drypoint. Instead of cutting into the copper matrix with acid, he scored it with a sharpened point. The burrs raised at the sides of the grooves held the ink in a particular way to give a velvety effect on printing. It was by har-

49. Giovanni Benedetto Castiglione
The Crucifixion, ca 1650
Monotype, 380 × 250 mm
Bibliothèque nationale de France, Paris

nessing the resources of this technique as well as variations on hatching and the expressive power of the white paper that Rembrandt obtained his renowned and unequalled absolute black.

The infinite tonal gradations, the harsh and almost challenging light that glitters on the figures and steeps them in disquietude, and the effects of deep darkness of Rembrandt's etchings are not obtained solely through calibration of the various applications of acid and use of the dry point, but also by means of a thin dark layer of oily and translucent printer's ink which Rembrandt worked on with his fingers or a piece of tarlatan gauze before placing the plate in the press. Seghers also left streaks of excess ink on the surface of the plate in order to enrich the pictorial character of his prints but was unable to match Rembrandt's skill in manipulating this additional thin layer of ink.

While Castiglione differed from Rembrandt in not spreading the ink with his fingers, he shared the Dutch master's total fascination with *chiaroscuro* effects

and the physical aspect of painting. The common impulse driving them is evident in the hundreds of "pictorial" drawings made with large brushstrokes and in their etchings, where they used a granular etching process to corrode the plate and obtain a *sfumato* effect. As in Rembrandt's etchings, the light in Castiglione's monotypes holds the action suspended in a timeless bubble, emphasising the enigmatic nature of the characters, while the sign barely scratched or "painted" on the plate interprets and suggests rather than narrates. The new expressive power of darkness, another area of exploration shared by Rembrandt and Castiglione, enhances the otherworldly aura of the figures.

The mezzotint was already in use. Invented in the second half of the seventeenth century to emulate the effects of oil painting, it quickly became the ideal instrument to capture the velvety finish, physical softness and tonal values upon which the Baroque school was focused. But neither Rembrandt nor Castiglione used this system, which was in any case still technically unreliable, preferring to "paint" on the surface of the plate with printer's ink.

While Rembrandt continued to modulate the layer of ink spread over the etched plate, Castiglione abandoned this method in his pursuit of *chiaroscuro* effects and developed his experiments along a path that the Dutch master never explored. Having spread the ink over the surface of a plate untouched either by acid or by the point of the burin, Castiglione clearly separated the "tonal rendering" from the etched sign and "invented" the monotype.

Attention has recently been drawn to a group of eleven seventeenth-century monotypes on the hypothesis that they might have been executed prior to those of Castiglione. The works are by the Flemish painter Anthonis Sallaert (1590–1658), a follower of Rubens also known for his tapestries. Mainly executed on a pale blue paper, more suitable for a mellow rendering of background, they represent religious or genre scenes. Regardless of whether they precede Castiglione's monotypes, they possess neither their tonal variety nor their material richness. Above all, they do not constitute an area of in-depth artistic exploration comparable to the Genoese master's work.[12]

The monotype in the eighteenth century: William Blake
The monotypes discovered after those of Castiglione and Sallaert are sporadic specimens executed by as yet unidentified followers and imitators of the former and in any case of poor quality. Another group of monotypes has been attributed to Adrien Manglard (1695–1760), a French painter of seascapes active in Italy. The fact that many of these works were classified under the heading of counterproofs or other print techniques is indicative of the low degree of attention paid to the monotype at the time.

Between 1660, the date of Castiglione's last known monotype, and the period 1870–80, when Edgar Degas began to work with this technique, there is no evidence of its having been practised by any other major artists. While it may be that other works will be discovered in time or that some now believed lost will come to light, it would appear unreasonable to expect monotypes of any real importance in qualitative or quantitative terms during this period of silence. This is not only because those years saw the development of new print techniques capable of producing tonal effects similar to those of the monotype, such as the aquatint and the lithograph as well as photography in some respects, but also and above all because printmaking was no longer practised by artists in the eighteenth century and up to the early nineteenth.

50. Anonymous, 18th century
(attributed until 1953 to Giovanni
Benedetto Castiglione)
The Eternal Father
Monotype, 210 × 175 mm
Istituto Nazionale per la Grafica, Rome

Given its predilection for clear-cut detail and brilliant light, the eighteenth century was in any case more interested in the effects of traditional engraving rather than the soft, blurred, atmospheric effects offered by tonal procedures and above all monotypes. It was a century in which printing was appreciated almost exclusively for its capacity to reproduce duplicates and the passion for unique prints remained the preserve of collectors as sophisticated as they were rare. Piranesi, perhaps the greatest engraver of the eighteenth century, was not a painter.[13] There was in fact a growing tendency for the art of engraving to be separated from the painter's studio and hence from the fertile terrain of technical exploration and creation essential to the monotype, unquestionably the most pictorial and artistic graphic medium. The production of large numbers of "well-made" copies for a growing market was now undertaken almost exclusively by professional engravers closer in character to craftsmen or technicians than creative artists.

The foundations were not to be laid for a revival of the monotype technique until the early decades of the following century, when romantic artists like Füssli, Delacroix, Daumier and Constable returned to the use of watercolour, thus paving the way for the experiments of Degas, Gauguin and Toulouse-Lautrec.

The American Michael Mazur, a contemporary painter-engraver, explains how the manifestation of this technique was linked to particular historical cir-

cumstances. As he points out, "Monotype is a painter's medium. Although launched in the print shop, it was born of the painter's imagination and restlessness. A perfect tool for improvisation, it waited from the time ink was wiped off the first engraved plate. The only explanation for its taking so long is that the artists designed plates but rarely printed them. I'm sure there were several unique images discarded in some printer's trash, the occasional escape from the tedium of this repetitive craft. If Rembrandt and Seghers had not taken etching to the edge of the totally unique print, it might have taken still longer to improvise with ink alone".[14]

There thus appears to have been neither space nor historical continuity for the monotype for a period of about two centuries. An artist's medium par excellence, it fell into oblivion with a single brilliant exception.

William Blake (1757–1827), the visionary English poet and artist of genius, opened the chapter of modern engraving with Goya. A unique figure in the history of figurative art and literature, Blake illustrated and published his own poetic works and developed what he described in 1793 as a method of printing engraved images and text in a more ornamental, uniform and elevated style than ever achieved before.

Blake was solely regarded as a poet for a long time and remained a largely mysterious figure due to the general discredit surrounding his work for almost two centuries. Due to an official error, he was in fact registered a few years after his death in the shameful category of "Artists. Poets. Lunatics". Described as gifted but alas mad, his work was disparaged to the point that he was scarcely regarded as a painter by the majority of his contemporaries.[15]

While it is difficult to retrace the course of Blake's life, he is known to have carried out important work as a lithographer and printmaker. Among other things, he made engravings after the drawings of Greek vases produced by the sculptor John Flaxman, his friend and admirer, to illustrate classical texts. He was also the illustrator and publisher of his own work. Little is known about his paintings in oils and tempera on canvas, unlike his watercolours and the countless drawings in pen with wash and crayon, which often served as the basis for later prints. His present-day reputation rests largely on his drawings and prints.

51. William Blake
For Children: The Gates of Paradise, 1793
Etching and burin
Paul Mellon Collection, Center for British Art

As a professional engraver, Blake worked with various and sometimes complex techniques and was among the first to try his hand at the new technique of lithography, in which he soon lost interest.

Like Castiglione, he experimented with unprecedented procedures that were often too original and too closely connected with an intimate and personal expressive world to be used by others. As a result, he had no followers or disciples and remains an elusive, isolated case situated outside the trends and fashions in English art at the time. Ignored by critics and the general public, he halted the publication of his illustrated books after ten years of activity in order to devote his energies to less innovative but in any case still original works.

At the height of the Neoclassical vogue, Blake renewed the current themes by introducing subjects inspired by symbolism, mysticism and the world of the occult. He drew upon the poetics of the sublime and endeavoured in lofty tones to weld ancient myth, the occult, classical poetry and the Biblical tradition together. His formal style is devoid of plastic and volumetric effects and rather consists in a continuous and sinuous linear handling of surface, where plant and animal forms foreshadow the elegance and sophistication of Art Nouveau graphics.

A draughtsman of great talent, Blake took up the art of printmaking at a very early age and was never to abandon it, experimenting above all with techniques enabling him to illustrate his collections of poems in colour, including a particular form of relief etching. He experimented with "illuminated printing" in the *Songs of Innocence and Experience*.

He invented a singular form of monotype with water-based colours in order to provide coloured illustrations for his book, printing the entire page—title, text and coloured illustrations—in one go. Both the hand-written verses and the drawings executed directly on the plate were in relief at the moment of printing. This extraordinary development of the monotype procedure, driven by the need to achieve homogeneity and formal balance between text and image in the illustrated book, has no historical precedent. Having invented the procedure, which he claimed to have received in a dream from his dead brother, Blake jealously guarded his secret. Being himself fascinated by the results obtained, he is said to have delighted in refuting the various conjectures of would-be imitators.

The studies carried out to reconstruct the procedures used for the illustrated books and above all for the celebrated series of twelve monotypes of 1795 are based primarily on the testimony of Frederick Tatham, who recorded the memories of Blake's widow on this point: "Blake, when he wanted to make his prints in oil, took a common thick millboard, and drew in some strong ink or colour his design upon it, strong and thick. He then painted upon that in such oil colours and in such a state of fusion that they would blur well. He painted roughly and quickly, so that no colour would have time to dry. He then took a print of that on paper, and this impression he coloured up in watercolours, repainting his outline on the millboard when he wanted to take another print".[16]

Tatham's account gives no more than a partial idea of the complexity of the creative process, which was so elaborate as to require various preparatory drawings. It does, however, provide substantial evidence for subsequent reconstructions. Blake, who probably had no fondness for oil painting, made extensive use of tempera (a water-based pigment crushed and mixed with egg yolk), with which he often painted on cardboard similar to the type used for book covers. He first sketched out the composition in a single colour and printed it up to three

52. William Blake
Naked Man in Chains (from *The First Book of Urizen*), 1794
Relief etching, printed in colour, 155 × 102 mm

times so as to have a model. After the first pressing, he reworked large areas of the cardboard support with thicker colours, probably obtained by mixing tempera with carpenter's glue, before running it through the press again. Since the impressions bear no sign of the plate, it is probable that Blake used the screw press designed for woodcuts rather than the type for intaglio plates.

Between 1795 and 1805 Blake executed twelve great coloured plates in tempera constituting the core of his graphic work. Making incorrect use of Cennini's sixteenth-century terminology, he described this group of works as "frescoes", as though to emphasise their importance within a formal language of a now more pictorial character where colour played a symbolic role. While the subjects were drawn from Blake's personal mythic universe, there are also echoes of passages from the Scriptures and classic poets like Milton and Shakespeare. *Pity*, for example, illustrates these verses from *Macbeth*:

"And Pity, like a naked new-borne babe
Striding the blast, or heaven's cherubin hors'd
Upon the sightless couriers of the air,
Shall blow the horrid deed in every eye,
That tears shall drown the wind…"
(Act I, scene 7)

Two preparatory drawings have been found for this work, regarded as one of the first in the series, as well as three smaller-sized versions of the monotype proof. The latter present slight variations and are held by different museums. The one at the Tate Gallery in London can reasonably be regarded as the first impression. Apparently completed in pen and watercolour, it bears the date 1795 and is one of the twelve sold to Thomas Butt in 1805. The one at the Metropolitan Museum in New York is probably the second impression. Although the work in pen is different, there are some stylistic similarities with the previous item. Retouched with tempera to a lesser extent than the others, it gives a clearer view of the characteristic printed colours of the contours. The third, now in the Yale

53-54. William Blake
The Little Boy Lost and *The Little Boy Found*
(from *Songs of Innocence*), 1789
Relief etchings with watercolour finish,
116 × 73 and 115 × 73 mm

Center for British Art in Connecticut, is unquestionably the last version, so pale in tonality that we can hardly make out the work in watercolour and the contours drawn with a few simple lines of the pen. Apparently never completed by Blake, this copy seems to have been damaged by the application of a layer of varnish at some point in time.

Blake took up to three impressions of the monotypes printed twice, equal in all respects except the intensity of colour. He then reworked them in pen and ink and tempera to make them "unique".

His printing procedure has two primary characteristics, the first being direct inking on the element of impression. Except in the case of two "frescoes", this involves no etching of a plate with acid and hence there is no matrix. The second is the careful use of tempera colours, which must blend completely with one another, not dry out too quickly, and be thick enough to be transferred onto the paper support.

While the design is repeated and reproduced in editions stretched out over the years, the colours added after printing in tempera are instead unique and endow each proof with an unrepeatable character. According to Tatham, Blake developed this procedure for the very purpose of enabling himself to vary the colours endlessly and unpredictably, assigning a crucial role to the "accidents" generated by the different chemical combinations of pigments.

55. Ruthven Todd, Stanley William Hayter and Joan Miró printing one of the latter's works using the "Blake method"

The last attempt to solve the mystery and reconstruct Blake's procedure was made in 1947 at Stanley William Hayter's Atelier 17 in New York by Hayter himself, Joan Miró and the English poet Ruthven Todd, one of the greatest scholars of Blake's work: "In the autumn of 1946 … Ruthven Todd … arrived in New York and stayed with the Hayters for many months. Great interest had been shown as early as the 1930s at Atelier 17 in the procedure whereby the English poet transferred illuminated poems onto the plate and in his still unfathomed techniques. While the plates used by Blake for his *Illuminated Poems* were stolen by a black ingrate he had befriended[17] and sold after his death to a smith as scrap metal, a piece of one had been miraculously salvaged and came into the collection of Lessing Rosenwald in Jenkins, Pennsylvania. After intense discussions, Hayter and Todd decided to go and examine the small plate first hand. A few days after their return to New York, they were surprised to receive a package through the ordinary post with the piece on loan. Miró, who was in New York that summer and spent a great deal of time at Atelier 17, also took up the challenge. Bearing in mind the material that Blake might have had at his disposal and the shallowness of the etching furrows, the three of them printed the small section of plate in every possible way and came up with a solution after many attempts. Having prepared a sheet of paper with a soap-based substance, they wrote on it with an ink of a particularly rubbery texture and then placed the slightly dampened sheet on a plate and ran it through the press. As with a transfer, the writing slipped off and stuck to the plate back to front. They inked a hard roller and ran it over the plate, thus managing to ink only the slightly raised letters of the writing".[18]

56. William Blake
America, a Prophecy (fragment), 1793
Simultaneous print of the *intaglio* and relief produced by Atelier 17, New York, 1947,
80 × 58 mm
Private collection, Rome

Blake's work constitutes an important stage in the "painterly" use of the monotype for a number of reasons. His "printed watercolours" do not confine themselves to suggesting the possibilities of a truly artistic—and not only decorative—imagination that finds expression in the continuity of the illustrated book, but also herald the emergence of the "painter-engraver", a figure destined to assume

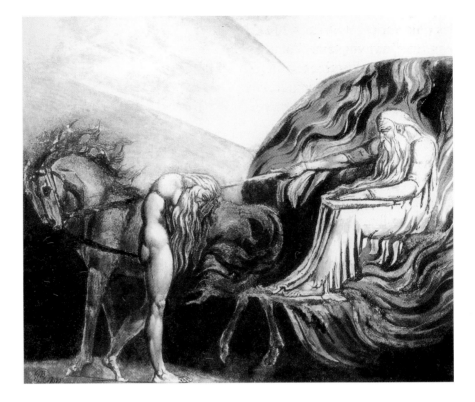

great importance in the history of art. "What [Blake] did not do in the medium that his contemporaries consider the highest art of representation (painting), he achieved by developing a technique that is his own. So doing, he went far beyond the purely mechanical character associated with reproduction printing, which had been his trade until then… Halfway between print and painting, the monotype represents for Blake the key stage whereby the painter definitively gained the upper hand over the engraver (albeit without causing his disappearance) or the artist over the technician or craftsman".[19]

With no immediate historical precedents, Blake's monotypes are the result of his explorations in the field of coloured book illustration. Not recognised as genuine monotypes until very recently, these works are now regarded not only as closely akin to this technique but also of particular importance due to the public and commercial use of it, consciously made by the artist.

Finally, it is also interesting to note that Paul Gauguin was to produce monotypes in watercolour 150 years later that resemble those of Blake in many respects, even though there is no evidence of his having known these works.

Attention should also be drawn in the English sphere to the eighteenth-century monotypes attributed to John Webber (1752–93), a small group of works by James Nasmyth (1808–90), and a few others of uncertain attribution. Nasmyth produced his works shortly after those of Ludovic Napoléon Lepic and Edgar Degas—who began to experiment with the monotype around 1874–75—and probably learned the technique from the former.

A still more convincing hypothesis is that the monotype technique reached Nasmyth through a simple artistic circuit. There were in fact many experimental sheets circulating from one studio to another that, without being the object of precise written documentation, figured in public collections or occasionally appeared on the market.[20]

Pepreuve d'etat Emile Bernard

2. Towards a Painterly Print: the Monotype in the Nineteenth Century

59. Honoré Daumier
L'Amateur, ca 1865
Oil on canvas

58. Émile Bernard
Idylle antique, 1915
Monotype with bistre ink, 400 × 300 mm
Private collection, Turin

Modern trends

"… everything is new or strives to be free in this movement [Impressionism]; engraving too is tormented with new techniques … managing to vary every plate with etching acid, which lightens it and adds mystery, and literally painting it at the moment of printing through brilliant manipulation of the ink"
Charles Duranty

The monotype went through a long period of silence from the end of the eighteenth century until the last decades of the nineteenth. While coming under the broader and ambiguous category of "eccentric" monotypes, William Blake's works constitute in point of fact the last significant example of interest on the part of an eighteenth-century artist.

The production of monotypes was apparently eclipsed by the appearance of new graphic techniques lending themselves with greater ease to pictorial rendering and effects of tone in the print, such as the aquatint, lithography and ultimately also photography. Even though the reasons for the monotype's long period of disfavour are many and complex, the primary one appears to be the crisis that struck printmaking in this period.

Regarded as a minor art, the print was gradually abandoned and left in the hands of modest craftsmen who emptied it of meaning and guided all of its formal means of expression into banality. Suffice it to recall that Paris, then the capital of European art, held very few exhibitions devoted exclusively to etchings and none of any importance until the early nineteenth century. Used above all for commercial purposes, the print became a sterile form of art and was reduced, with the odd brilliant exception, to the status of a simple tool of reproduction.

With the disappearance of the stimulating and creative terrain of the *peintre-graveur*'s studio and its climate of exploration and experimentation, the monotype fell into disuse.

Until halfway through the nineteenth century, print production was distinguished more precisely in France and Italy, as in the rest of Europe on the whole, as a technique of "translation". Art dealers purchased the most famous paintings of the day only in order to reproduce them in tens of thousands of prints. Paradoxically enough, painters earned more from the reproductions of their works than from the sale of the originals. Manual engraving, based above

60. Raphael
Slaughter of the Innocents, post 1510
Pen and brown ink, 232 × 377 mm
Istituto Nazionale per la Grafica, Rome

61. Marcantonio Raimondi
Slaughter of the Innocents , after Raphael,
post 1510
Engraving, 284 × 435 mm

all on the use of the burin, as more solid and hence better suited to the production of large numbers of copies, gave way to new mechanical procedures. The etchers could literally be counted on the fingers of two hands.

In the early decades of the century, the use of new industrial techniques for the reproduction of unique works as well as serial items accentuated the clash between the burin and etching, which points in turn to the distinction between the original engraving[21] and reproduction.[22] It was a crucial moment in the history of graphic art, a significant stage in the appraisal of all mechanical techniques. As it was the very function of the printmaking that was called into question, it will be useful at this point to provide some outline of its historical evolution.

From its appearance halfway through the fifteenth century until the age of the great German and Flemish masters like Dürer and van Leyden, the burin was used almost exclusively in order to produce "originals", which not only enjoyed the same artistic dignity as unique works like paintings and drawings but also had the advantage of being susceptible of reproduction and therefore multiplication. When Marcantonio Raimondi, an engraver of the school of Raphael, began using the burin around 1510 in order to produce copies of the master's paintings and cartoons, he thus paved the way for a form of professional specialisation but also its possible impoverishment, which ultimately relegated printmaking to the status of a minor art.

62. Félix Bracquemond
Didier Erasme, after Holbein, 1863
Etching, 248 × 197 mm
Cabinet Cantonal des Estampes, Vevey

Responsibility for the production of prints was in fact gradually handed over to an engraver who, with few exceptions, was no longer a painter but a simple "translator" or populariser of the "pictorial inventions" of others. From the seventeenth to the late nineteenth century, this use of printmaking spread throughout most of Europe and, with the aid of the academies, came to constitute a patent of "non-originality".

Despite the relaxation in control over artistic production at the end of the eighteenth century and the spread of a type of collecting no longer making any distinction between genres and techniques, the academies forbade the use of etching as a sensual, decorative technique until the early decades of the nineteenth century, while upholding the classical burin as the only "serious" form of printmaking. For example, the École des Beaux-Arts in Paris accepted only burin engravers among its pupils until 1830. Moreover, this form of engraving had a solid market throughout Europe due to the support of national chalcographies, major publishers and the juries of exhibitions.

Apart from the odd, isolated examples of etchings produced by artists like Goya, printmaking meant the use of the burin and, if not always "gelid", it was at least mechanical and boring. It was not until the decade spanning the late 1860s and the early 1870s that a more "frivolous" and pictorial taste, fostered indirectly also by the popularity of the new medium of photography, led to the burin being challenged. An excellent example is provided by Félix Bracquemond, who presented a state-commissioned print of a portrait of Erasmus at the Salon of 1863. The work used the technique of etching rather than the burin, the tool traditionally preferred for portraiture, and this "outrageous" choice was enough to ensure the artist's expulsion from the exhibition despite his renown.

The break with the academies was brought about by new aesthetic canons whereby graphic art took up the principles and ideals of romanticism, followed immediately by realism. This aesthetic was consolidated in the two precise geographical areas of France and Britain, where an immediate and pictorial form of expression came to be valued earlier than in other countries such as Italy. The aim was no longer to arrive at the finished work or masterpiece, but rather to emulate the quality of the painting in graphic art.

The traditional artistic hierarchy was jettisoned and new importance was attached to preparatory studies and spontaneous techniques such as sketching. Artists were less concerned to conceal their procedures and made use of pure colours and free, visible brushstrokes. While attention was focused on the material nature of the support and the physical peculiarities of colours and tools, renewed sensitivity to tonal richness led to interest in hitherto marginal artistic techniques like watercolour and pastel.

This new sensibility also led to interest in the monotype.

After the first half of the nineteenth century, the concept of the "painter-engraver" regained the force and the significance it possessed in the seventeenth century. At the beginning of the century, the engraver was a simple craftsman capable of copying a painting by an artist. A few decades later, printmaking was a form of expression chosen by the painter and the concept of print was reformulated in the sense of "interpretation" rather than intensive reproduction. The print acquired the character of a "painterly print" and embarked upon a pathway—of anachronistic nature for a technique of multiple copying—that led to the singular "variant", the rare and precious specimen, and the "unique form".[23] This phenomenon manifested itself clearly for the first time in France.

In the first editorial of the *Gazette des Beaux-Arts* in 1859, Charles Blanc noted how a very large public with an interest in art had built up at amazing speed in the space of just a few years: "Where does this great change come from and what is happening in the world? How has this vast public so ready to take an interest in questions of art come to take shape in such a short time? Certainly not because our organs have acquired unsuspected delicacy all at once or our spirits sudden sophistication… France has seen great fortunes spring out of nothing. Hence the extraordinary rise in the price of all objects of art".[24]

63. *Le Boulevard des Italiens*
(Paris, Richelieu-Drouot junction, heart
of the art market), late nineteenth century
Photograph on postcard printed by Goupil & Cie.,
from a painting by E.D. Granjean

The evolution in public taste and the new interest in objects of art, especially "original prints", were in fact the result of a particular combination of historical events leading to a spectacular recovery of the French economy in the 1850s. In a short space of time and in many sectors, considerable fortunes were concentrated in the hands of an emerging class that turned to art in order to assert its new social role. Merchants, high officials and also intellectuals now expressed a demand for accessible works capable of endorsing both their status and respectability. This newly prosperous middle-class gave birth to a new generation of collectors and connoisseurs involved in the process of establishing their own still-evolving identity and obtaining recognition of the same from others.

While the more conservative customers continued to appreciate the manual work of art, there was also a trend in the opposite direction. The new ranks of art lovers, made up of the most progressive social fringe, aimed at new types of artwork and revealed greater sensitivity to technical innovations.

The growing demand for images also appears to have reawakened the vocation of the traditional printmakers, often skilful craftsmen that industry was either pushing out or, paradoxically enough, transforming into artists. Trained for industrial production, many of them in fact switched from the type of manual engraving aimed at reproduction to one aimed at creative and original "interpretation" and "art for art's sake". Daubigny, for example, began his career as a cartoonist, Buhot made a living initially by painting dishes and fans, and

64. Félix Dupuis
Hotel Drouot: an Auction during the Second Empire,
1866
Oil on canvas, 520 × 720 mm
Courtesy of Ader, Picard, Tajan, Paris
The work was later engraved by Gustave Doré

65. Félix Buhot
Westminster Bridge, 1884
Etching and drypoint, 296 × 396 mm

Whistler and Meryon engraved maps. As the young lithographer and etcher Bracquemond pointed out in 1842, "If you are to make a career out of prints, you must accept the modern conditions of production and industrialisation".[25]

The new vigour of the art trade resulted in major diversification of artistic trends and techniques. These proliferated quickly and the rendering of the image opened up to distinct possibilities and pathways. A complex and often contradictory situation was created that prompted Zola to make this observation in 1867: "Art … is fragmented… The great empire has crumbled and a number of small republics have been born in its place".[26]

The art market expanded in opposite directions including the field of mechanical reproduction, photography and, in a discreet and hesitant fashion, the artist's print, which met the new demand for works characterised by authenticity, originality and uniqueness. The climate of uncertainty fostered the co-existence of such very different techniques that, for example, Alfred Cadart presented photographs of paintings in a publication of 1859 together with lithographs, an original etching and a reproduction: an authentic sampling of his wares to probe the public's tastes.

It soon became clear that the attempt to reproduce artistic objects industrially was not proving successful. The winning idea was the opposite, namely that prints could be produced as unique or at least differentiated items. The battle between photomechanical systems of reproduction—primarily photography—and the original or "artist's" print was won by the latter due to the more solid guarantees it offered with respect to mass production. Within a framework of clear distinctions between manual, artisanal and industrial production, the original print was placed in the category of objects produced in limited series. In the event of finding a market, they could then become rare and hence precious.

The market enabled artists to experiment with new ways and procedures. It also prompted them to introduce more intimate themes and subjects. It was the time of small-sized works circumscribed to private spheres of investigation, like diaries, and hence outside direct contact with the public and the market. Paintings drawing inspiration from the so-called "minor subjects" appeared in

66. Henri Laissement
Le Salon
Oil on canvas, 127 × 180 mm
Courtesy of Ader, Picard, Tajan, Paris

the *genre* category at the Salon of 1857. Baudelaire noted the importance of this crucial change, commenting that the gods had abandoned the field.

The French economy and the cultural and ideological order that had supported it for the previous twenty years was plunged into crisis between 1873 and 1880. There was no longer much space in the new order for the forms of the *ancien régime*, linked to a society of the capitalistic type, or for those of craftsmanship and manufacturing. In a climate of unrest and ambivalence towards the modernity that was in any case advancing, aesthetics broke away from the stable and defined forms of the Renaissance.

While the art market slumped, two distinct but overlapping tendencies could be perceived. The first was a growing demand for small-sized decorative works. The second, engendered by the economic recovery of the following decade, was the repositioning and consolidation of the market for artist's prints with respect to other works. The painter engraver producing such works of art now had to take into account the pressures of a public much larger than the one for paintings.

A new and modern form of market organisation took shape over the same period. Artists were no longer obliged to meet the purchasers of their works and vice versa, since all commercial transactions took place through the dealer.

The economic climate in France became less critical in the 1890s and the first effects of American economic expansion were felt on the European art market. Paul Durand-Ruel, the founder of a dynasty of art dealers, set up the Society of French Artists in London and subsequently gained a foothold in New York, where he opened a branch of his Parisian gallery in 1886. The first American collectors (Louisine and Henry Havemeyer, Erwin Davis, William H. Fuller) and dealers like James Sutton and Samuel Avery began to buy works by the Impressionists.

The new avant-garde movements took shape in a situation radically altered in economic, political and social terms, where the now elderly Degas and Pissarro played the role of patriarchs. The success of the print kept step with that of Impressionism—two factors constituting integral parts of one and the same phenomenon. The graphic channels used by Impressionism were the artist's etching and the colour lithograph.

*The rebirth of the original etching: the Société des Aquafortistes
and the Etching Club*
"Rembrandt was its true inventor, creating an art out of a simple procedure.
The engraving took on an unexpected tonality; the print became a painting
etched with acid instead of being painted in oil"
Charles Blanc

A movement known in the history of printmaking as the "rebirth of etching"
took place in the second half of the nineteenth century in France and England,
later followed also by Italy. As a result, the technique regained its popularity with
the public, critics and artists, above all painters, in the space of a few years. Already used by exceptional painter-engravers like Rembrandt, Tiepolo and Goya
by virtue of its flexibility, freedom in terms of drawing and possibility of variants,
the etching became the ideal modern vehicle for *chiaroscuro*. Based on new parameters like colour, uniqueness and originality, etching opened up hitherto unexplored paths leading it back into the artistic sphere. Its renewed popularity,
which was to last up to the very end of the 1970s, put an end to the predominance of the traditional technique of the burin, favouring the pictorial quality of
the sign with respect to its sharply defined line.

Many historians of art and printmaking, critics and progressive writers
like Charles Duranty, Philippe Burty, Théophile Gautier, Charles Baudelaire,
Émile Zola, and Victor Hugo formulated the new parameters of taste by identifying and endorsing the emerging criteria of the romantic etching with all their
authority. Charles Blanc, the author of the first history of modern art, wrote: "In
his house in Amsterdam ... Rembrandt had a press and often made his own
prints... Often, after inking the plates, he would dab them lightly to attenuate
some of the areas. In the parts where the now worn burrs no longer produced
any tone, he would artificially re-establish dark patches by spreading some
printer's ink on them with his finger. With Rembrandt the art was transformed:
the engraving took on unexpected tonalities and the print became a painting
etched in acid rather than painted in oil".[27]

Towards the end of the 1860s, after an eclipse covering the whole of the eighteenth century and the beginning of the nineteenth, the original etching was rediscovered and cultivated for its ability to express and reveal the artist's innermost depths, as in writing. In the words of Baudelaire: "It is not just that etching serves to enhance the artist's individuality. He actually finds it difficult to prevent himself from describing his most intimate personality on the plate. We can
therefore state that, after the discovery of this type of engraving, there are as
many ways of executing it as there are etchers".[28]

As the etching came to be increasingly regarded as a link between painting and
print, greater care was taken at the same time to ensure the quality of the editions
and to limit the number of printed copies. Seen as a decorative art, the print rose
above from the sphere of mass-produced artwork and each impression acquired its
own individuality (and commercial value). The criteria to judge the quality of a print
were not confined to the artistic content but now also included considerations regarding the support, inking and the number of impressions produced.

The new, sophisticated clients were guided by the aesthetic of the *belle
épreuve*, which the Impressionists took over and put into practice in the following decades. Magnifying the role of the painter-engraver in etching and focusing his attention as a critic on a difficult and unnatural concept, Philippe Bur-

67. Charles-François Daubigny
Main Room of the Galerie Durand-Ruel, 1845
Etching, 128 × 215 mm
Bibliothèque nationale de France, Paris

ty provided a very apt definition: if it is to be regarded as a work of art, the print must differ in every copy in the edition.[29]

Burty addressed his public, the new republican middle-classes, in the pages of the *Gazette des Beaux-Arts*, in the presentations of sales catalogues and Cadart's albums, initiating them in the subtle mysteries of the pressure of the press and the heat of the stove softening the ink and pointing out the importance of the choice of paper: "Charles Meryon preferred a greenish paper that enhanced the strangeness of his elongated figures, Charles Daubigny tore out the thin end papers … of eighteenth-century Dutch books. François Millet used Italian paper by preference for its large grain and robust consistency. There are superb prints by Jules Jacquemart on parchment. In his impassioned pursuit of a gallant ideal, Seymour Haden draws upon everything that is rare and precious. The states of Bracquemond's *Didier Erasme* are on a French paper … of the seventeenth century. These works on types of paper no longer available have become a privilege of the art lover".[30]

The major technical innovations of the second half of the nineteenth century led to radical changes in the manufacture of paper, which ceased to be a rare and expensive material but was now produced on large scale and finally accessible to all. While the rebirth of etching was stimulated by the efforts of modern artistic practice and the growing diversification of the products and supports introduced onto the market, it also indicated a new sensitivity to the tonal values and structure of the old types of paper made by hand out of rags as well as the history of paper itself.

Many artists, including Whistler and Meryon, were constantly on the lookout for loose sheets of precious paper and ancient books to dismember in order to print their most important works. Like Rembrandt did before them, they preferred the consistency of the thinner types of paper that, when held up to the light, assume the transparency of porcelain and reveal the etched signs perfectly. Many etchers went in search of ancient European and Eastern paper. The latter was to become increasingly available in Europe as from halfway through the nineteenth century, when Japan opened its doors to trade with the West.

Japanese paper presents a great variety of hue, thickness and calibre. Obtained from the bark of the mulberry tree, its consistency and fibrous quality can considerably vary. While the sheets can be very thick or as thin as onionskin, the colour varies from pale cream to bright yellow. As Maxime Lalanne wrote in that

68. Félix Bracquemond
Portrait of Meryon, 1853
Etching, 230 × 154 mm

69. Henri Somm
Japanism, 1881
Etching, 240 × 318 mm

period, "Warm and yellowish in hue, silky and transparent, Japanese paper is excellent for prints that require more mystery than clarity due to its more intense tones of *chiaroscuro* and the vast synergy of effects it allows".[31]

In accordance with his vision of modernity, Degas took an interest in industrial products and, unlike other contemporary artists, chose a mass-produced type of commonly used paper for his prints and monotypes. And when he did use Japanese paper, it was neither through any generic acceptance of the Japonisme then in fashion nor a question of aesthetic sophistication—as it was for Mary Cassatt and Gauguin—but in order to experiment with different tonal effects in the printing stage. Instead of adopting just one type of paper for all his print production, Degas preferred to explore the possibilities and variations in tone to be obtained with different types, including modern and everyday paper, precisely because of their new aesthetic potential. He was followed in this by Giuseppe De Nittis.

There was also growing appreciation of the delicate effects of inking, above all in connection with dry point (the famous burrs of Rembrandt's most vibrant etchings) and of everything serving to make each impression different from the others. The aim was to obtain a form of unique specimen or imprint.

French engravers discovered to their regret, halfway through the nineteenth century, that if they were to make a living, they had to accept the conditions of modern, industrialised production. Printers were also affected by this decline in the artisan sector, however, and it became increasingly difficult to find good craftsmen capable of making prints of artists' work.

In the same period, when Félix Bracquemond (1833–1914) decided to buy a press and print his own etchings "because there are no good printers left", he was consciously aiming at a new market and seeking success there through artistic quality. The decision of Bracquemond—and his imitators—to work through his own studio ensured the artist's control not only over the quality but also the quantity of each edition. Customers were thus selected that attached value to a print as a unique and authentic item through the expedient of limited production.[32]

As a historian of the period wrote with respect to Bracquemond's works, "The production varies between very rare and extremely rare ... all of Bracquemond's first states are very rare, not having been printed commercially". A letter of 1885 from Pissarro to his son Lucien contains this remark: "I have chosen the rarest prints and the artist's proofs, which explains the higher prices of some items".[33]

A contingent situation of necessity—the presses were still often made of wood and hence unreliable for large editions—gave way to a new and modern idea of "organised" rarity, which the Impressionists took over and developed to the extreme of the monotyped etching and the monotype.

The emergence of painter-engravers thus posed the problem of limiting the editions of prints, a new question that was not immediately addressed. At first even the young and dynamic Alfred Cadart paid it no heed, printing as many copies as he had customers and calculating the prices of prints primarily on the basis of production costs. Philippe Burty suggested that the original plates should be destroyed after limited use and imposed this condition in 1869 on Jean-François Millet, from whom he had commissioned an etching as an illustration for a book of his. The print as work of art began to define itself through the criterion of rarity and the more ambiguous parameter of originality. In general terms, however, it must be said that most graphic art between 1850 and 1890 consisted of illustrations and impressions executed by craftsmen who were skilful and sophisticated but not the authors of the images produced.

The differentiation of impressions, the author's signature, and the numbering at the bottom to the sheet marked a new approach to the print along the same lines as the drawing, the painting and the objects of decorative art in which the new market took an interest. If signatures in pencil and limited editions formed part of a commercial policy aimed at ensuring criteria of rarity and authenticity, they also referred symbolically to the artist's direct involvement in creating the plate. Many even left the imprint of their fingers on the plate, which was considered equivalent to a hand-written signature at the end of the nineteenth century. These marks of originality were also used in the production of uniform editions to alert a finally rediscovered public to the fact that these were works of art and not mass-produced articles.

Technical improvements made a number of important innovations possible in this period, leading to greater simplicity and precision in the practice of engraving but also to an incredible number of peculiarities, "mannerisms" and professional secrets, often jealously guarded by the individual engravers. The manuals of graphic techniques and terminology at the turn of the century contained a remarkable number of sectorial expressions and descriptions of patented procedures.

It is symptomatic that most of these works took advantage of techniques of printmaking reproduction, including above all the use of photomechanical transfer onto the plate. Therefore, it became essential for artists to define the borders and relations by means of reproductive graphics, which account in part for their stubborn attachment to the most traditional techniques. In response to a radical change in taste now in favour of the *chiaroscuro* print, there was a return among artists, especially the Impressionists, to the most pictorial and ductile form of printmaking, namely etching.

The vigorous revival of this engraving technique led, in the space of a few years, to founding important associations that took the rich and constantly varied inking of Rembrandt's prints as their model.

The print dealer Alfred Cadart (1828–75) and his partner Chevalier founded the Société des Aquafortistes in Paris in 1862 on the model the Etching Club in

70. Title page of *Eaux-Fortes Modernes*, 1 Sep 1862, first issue of the Société des Aquafortistes volume, published by A. Cadart & Chevalier Editeurs, Paris
Bibliothèque nationale de France, Paris

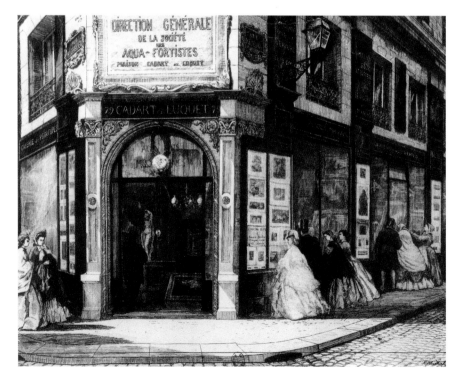

71. Adolphe Potemont Martial
Les Vitrines de Cadart
Etching
Bibliothèque nationale de France, Paris
Wording at the top reads: "Direction Général de la Societé des Aqua-Fortistes". At the time of his partnership with Luquet, Cadart had a gallery in 79 Rue Richelieu

72. Camille Corot
Le petit berger, plate I, 1855
Cliché-verre with stippling, 365 × 297 mm
Bibliothèque nationale de France, Paris

London. It had 73 founding members, including the king of Portugal and Princess Mathilde, and attracted artists with vast experience in the field of printmaking and neophytes in etching like Gavarni, Daumier, Delacroix, Corot and Courbet. With its premises in Cadart's gallery at number 66 rue Richelieu in the vicinity of the Bibliothèque nationale, the Société (1862–67) chose the Englishman Sir Francis Seymour Haden as its first president with a view to acquiring an international character.

It soon became the heart and the driving force of the rebirth of etching and Cadart acquired such solid international prestige in the space of a few years that he was able to monopolise the sector for some twenty years and to introduce original prints no longer confined to the traditional illustrative function onto the market.

Cadart undertook initiatives of an extraordinarily innovative nature for his time. He set up an engraving studio where artists could familiarise themselves with the technique freely and free of charge as well as a mail-order system that operated also outside France. According to the publisher and dealer Ambroise Vollard, the studio that Cadart opened at his premises as early as 1864 was frequented also by Renoir and Degas. It is there that the latter is supposed to have produced some monotypes reworked in pastel.[34]

As a promoter and populariser of the artist's print, Cadart managed to secure the involvement of the same avant-garde critics as wrote the prefaces for his albums. A keen collector and connoisseur of prints, Baudelaire hailed the creation of the Société with great enthusiasm: "The discredit and indifference into which the noble art of printmaking has fallen are clearly visible. …There appear, however, to be signs of revived interest in etching… Some young artists have gathered around the very dynamic publisher Cadart and called upon their fellows for support in founding a periodical publication of original etchings. We can only hope that the efforts of intelligent artists like … Seymour Haden, Manet, Legros, Bracquemond, Jongkind, Meryon, Millet, Daubigny … and others will enable etching to regain its original vitality".[35]

In the preface to the Société's first volume, Théophile Gautier specifies that the album "recognises no code other than individualism…, that no genre should predominate over another and no subject should be accorded priority". He continues: "every etching is an original design and expresses above all the aims of the association, whose charter will be imitated in the years to come by all European etching associations: The Société des Aquafortistes has been founded for the precise purpose of opposing photography, lithography, aquatint and engravings where there is a point in the middle of the crossed cuts,[36] in short, the regular, automatic and uninspired work that is alien to the very idea of the artist".[37]

Cadart, a courageous and open-minded man, became the great publisher of etchers. Abandoning the sectors of lithography and photography, to which he had previously devoted his efforts, he fought for recognition of etching as a work of art and the new role of the painter-engraver.

Specifically opposed to the use of the burin, the Société des Aquafortistes occupied the ground left free between the mostly antiquated *Salons* and the still too recent art galleries. A point of convergence and aggregation for many artists, it also marked their new economic and cultural solidarity with the publisher. From September 1862 to August 1867, the Société published three hundred etchings in five annual albums: five etchings a month at the price of one and half francs a

73. Édouard Manet
Portrait of Baudelaire, 1861
Etching, 98 × 77 mm
Bibliothèque nationale de France, Paris

74. Johan Barthold Jongkind
Soleil couchant, 1868
Etching, state before the "letter",
155 × 233 mm
Bibliothèque nationale de France, Paris

print. The appearance of the first issue was heralded by Baudelaire with two articles in *La Revue Anecdotique* ('L'eau-forte est à la mode') and *Le Boulevard* ('Peintres et Aquafortistes'). Then came reviews by Philippe Burty in the *Gazette des Beaux-Arts* and Gautier's preface in August 1863, at the end of the first year.

The short but important history of the Société is inseparable from the name of Cadart, who worked until his death in 1875 to promote the sale of original etchings at low prices in spite of business failures and difficulties of all kinds. The Société was also linked to the extraordinary printer Auguste Delâtre (1822–1907) and to the painter-engraver Félix Bracquemond, its adviser and driving force. The atmosphere of enthusiasm and emulation built up around these three figures quickly won over the new generation of painter-engravers and guided the public's taste towards the original print.

The possibility of making works known through publication in a specialised magazine was a major stimulus for many artists to take up printmaking. Having previously kept his plates for himself, Corot now stepped up his activity in the field of graphic arts, for example, and other artists began to try their hand, often with excellent results. By waging a large-scale campaign, the Société promoted the creative aspect of etching as against mammoth editions of prints. Like the seventeenth-century painter-engravers, the artist was now required to handle all the phases of the procedure, including inking and printing, even though the collaboration of a professional printed was allowed for in the latter.[38]

Maxime Lalanne, who published one of the most important treaties on engraving in 1866 and was a member of the Société des Aquafortistes, focused unprecedented attention on the quality of the "impression". Rather than confining himself to describe the types of biting used in the various *intaglio* techniques, he was the first to talk about inking and the way of pulling proofs classified as "*bon à tirer*" or approved for printing: "An etched impression often departs from uniformity; sensitive to requirements of harmony and the unique way in which it is executed, it has variable effects. It becomes an art when artist and printer combine their efforts: the craftsman careful to grasp the artist's intentions and the artist paying heed to the craftsman's experience".[39]

In the 1860s Cadart published the works of the greater etchers of the time—Bracquemond, Corot, Daubigny, Jongkind, Manet, Meryon, Millet, Whistler and

Haden—and of the artists involved in the new developments of etching, especially the printing technique. The spread of these prints played a crucial part in making the etching technique one of the most highly esteemed, even though the attitudes of the individual artists differed greatly.

Jean-Baptiste-Camille Corot (1796–1875) joined the Société at the very beginning with his friend Charles-François Daubigny (1817–78). Over a span of just a few years he executed three works that were to be among Cadart's most celebrated publications, namely *Souvenir d'Italie* in 1863 and *Paysage d'Italie* and *Environs de Rome* in 1866. Rather than the "cookery" of etching, Corot was interested in the processes connected with the graphic arts—e.g., the *cliché-verre*[40] a subtle and somewhat unorthodox combination of drawing and photography—enabling him to develop his exclusive interest in landscape.

Édouard Manet (1832–83) executed some very precious etchings for the Société but abandoned the field as a result of the controversy that raged at the time about the *virtuoso* nature of the procedure. He put an end to the question in a note to Guérard: "Etching is definitely not for me. Working the plate properly with the burin, that I'll do".[41]

Johan Barthold Jongkind (1819–91) left the Netherlands in 1860 and moved to Paris, where he spent the last 30 years of his life. Trained at the school of Eugène Isabey, he was in contact with the Honfleur colony of painters—Boudin, Monet and Corot—and joined the Société at the very beginning. Cadart put his *Six eaux-fortes. Vues hollandaises* on sale as early as 1862. The misty atmosphere of the landscapes did not escape Baudelaire: "The fascinating and candid Dutch painter has entrusted to Cadart some prints steeped in the secrets of his memories and dreams, as calm as the barges of the great rivers and the horizons of his country".[42] Edmond de Goncourt wrote in similar terms: "What strikes me is Jongkind's influence. It is this painter who gives us every landscape that counts today; the skies, the atmospheres and the fields stretching away all come from him. This is something that leaps to the eye, but nobody talks about it".

Moulins en Hollande and *Le soleil couchant, port d'Anvers*, the finest etchings that Jongkind executed for Cadart, do indeed seem to herald the new pictorial vision of Impressionism. His works are improvisations and variations.

75. Charles Jacque
Village on the Water, 1848
Etching, state III, 100 × 133 mm
Bibliothèque nationale de France, Paris

While few copies were printed, there could be as many as twenty "states". As the works in question were always practically unique creations, Jongkind began to sign them in pencil on the edge of the sheet.

76. Francis Seymour Haden
View on Thames
Etching

Auguste Delâtre, a printer working almost exclusively for the Impressionists and, earlier still, for all the painters of the modern school, operated within this cultural horizon in the course of his extraordinary career. The most celebrated plates produced at the end of the century all came from his workshop. Delâtre marked a new phase in the rebirth of etching and interpreted the new romantic and pictorial tendency in nineteenth-century printmaking. Renowned both inside and outside France, especially in England, where he ran a printing works for some time, he had four presses working uninterruptedly in Paris. His shop in Rue St-Jacques was an authentic centre of promotion and technical information about etchings as well as a stimulating meeting place for artists and aficionados.

Delâtre worked as a printer from the age of twelve and set up his own business when he was still very young by taking over the two presses of Charles Jacque. He developed his technical grounding by printing the old plates of Callot and Rembrandt and experimented, like the Dutch master, with a variety of special inking processes. After many attempts, he achieved extraordinary results in the tonal rendering of etching through a system of thick and abundant inking, variously modulated over the lines engraved on the plate. This technique, which he called "artistic impression" and which later came to be known as *retroussage*, enabled him to obtain unprecedented *chiaroscuro* effects in every printed etching.

In addition to manipulating the tones of the surface of the plate with his fingers, Delâtre changed the colour of the inks (from shades of warm brown to black) and the paper (from the yellow of Japanese paper to the grey or bluish hue of laid paper) so as to modulate the tonality of the work. The atmosphere of his individual impressions thus became warm or cold, intimate or sinister. Above all, Delâtre created special nocturnal effects that soon became his way of painting with ink. He would wipe the plate gently with a rag—or the palm of his hand, like Rembrandt—at the moment of cleaning so as to remove the ink from the scored furrows.

He then proceeded inking the surface unevenly so as to create a thin film of expressive and ever-changing character. Delâtre thus freed the etching from the enforced uniformity of the edition, focusing the printer's skill on the interpretation of each individual impression. Based almost exclusively on excessive inking, his way of printing was in tune with a changing, emotional and romantic artistic sensibility and produced the unique effects characteristic of the "*belle épreuve*".

According to Philip Gilbert Hamerton, a supporter of the new aesthetic criterion in printing, "A great part of the printer's skill consists in leaving a very thin film of ink unequally over the etched part of the plate... This tints the surface of the impression, in a way often highly favorable to its beauty".[43]

Even with the application of ink to the furrows of an engraved matrix, the lines—now increasingly light and threadlike to the point of practically disappearing—gradually lost their role as the structure of the work to become exclusively the support for a whole variety of pictorial effects. Born out of the desire to capture the different perceptions of a twilight or sun-drenched landscape, the propensity to conceal the line beneath thick layers of ink led to lack of in-

77. Henri Guérard
Moulin a Montmartre, 1870
Mobile etching, 215 × 137 mm
Bibliothèque nationale de France, Paris

78. Félix Buhot
Title page of *L'Illustration Nouvelle*, 1877
Etching, 348 × 276 mm
Bibliothèque nationale de France, Paris

terest in the stroke itself. Whole series of works were now printed in which figures, clouds and woods would appear or disappear in accordance with the desire to print a diurnal or nocturnal version of the landscape from the plate or to show a scene beneath calm rather than stormy skies.

Many sang the praises of Delâtre's genius and technical skill. Seymour Haden, who drew inspiration from the French printer for the *chiaroscuro* effects of his own compositions, stated that if Delâtre had lived in the seventeenth century, Rembrandt himself would have entrusted him with his etchings rather than printing them himself.[44] "Printers generally dislike etchings, because they make nothing of them. The French Etching Club has been peculiarly fortunate in this respect. It happened some years ago that one or two artists who etched discovered a journeyman printer "who printed their works with such taste and judgment that they declared the proofs were as much his works as theirs". Such a man was not to be lost sight of, and he became known among artists. When M. Cadart, the publisher, took up etchings, he knew where to find his printer. M. Delâtre, formerly the workman in question, has now a considerable *atelier* where several presses are always at work on nothing but etchings. He loves a good etching and is himself an etcher. No one in Europe that I know prints etchings with so much "expression".[45]

Delâtre, who was also an engraver, executed a number of small monotyped etchings at the end of his career, including *Effets de Lune*. He talked about this in his memoirs, describing himself as an artist-printer: "The printer could take up to 20, 30 or 40 different impressions from the same [plate]. In black and white etching, for example, it is already possible for the printer to change an effect of broad daylight into moonlight. In actual fact, he is the one that has to paint the work for each individual impression. The printing should really be done by the artist himself, but since this is impossible the only solution is the printer-artist".[46]

If the artist was now also required to print his or her work, thus providing confirmation of the importance attached to the moment of printing in the process of creation, the ideal printer of the Impressionists now proclaimed himself an artist. Delâtre exaggerated, however, and what was initially greeted with enthusiasm later came in for bitter criticism. Controversy broke out about his technique of *retroussage*, now described as a Dutch style or thick sauce and compared with poultices by Marcellin Desboutin. His initial supporters Whistler and Haden now complained about his "jar of molasses" and Hamerton voiced his own misgivings: "His fault is towards overprinting, … in the endeavour to give artistic richness to plates, they are liable to a loss of delicacy, extending even to muddiness".[47]

In addition to Delâtre and the artists of his circle, those practising *retroussage* at the end of the 1860s included Henri Guérard, Paul Huet and Dr Gachet, an engraver and art lover better known for having been Van Gogh's physician. Their methods of inking resulted, however, in unclassifiable prints unsuitable for sale, and the same fate awaited the works of countless amateurs who, following the example of the artists of the Société des Aquafortistes or in any case of true artists, began to produce etchings with this new type of "interpretive" inking. Rembrandt's method was applied undiscerningly and the ink was over generously applied. The technique of the "variable print", above all as an end in itself, gave rise to tiresome excess in the long run.

The Société quickly established itself on the Parisian scene and its success in financial terms was such that Cadart embarked on an American adventure, founding similar associations in New York and Boston. However, he was forced

to wind up the Société in Paris at the end of 1867 due to internal disagreements culminating in a break with Delâtre, as well as financial difficulties that also put an end to the initiatives across the Atlantic. There was, however, no let up in his activities in the fields of the graphic arts and publishing. After the Société, Cadart set up a new printing works and founded *L'Illustration Nouvelle*.

In the few years of its existence, the Société des Aquafortistes was extraordinarily successful in promoting the original etching and the collateral technique deriving from the modern conception of representation, such as the monotyped etching and the monotype. These were in any case processes sweeping through the graphic arts at the European level, so that the new ways of working and inking the plate soon spread like wildfire beyond the French sphere, not least because of the ever-increasing frequency of travel and exchanges of ideas among artists.

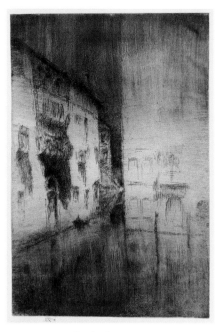

79. James McNeill Whistler
Nocturne Palaces, 1880
Etching, 295 × 200 mm
Bibliothèque nationale de France, Paris

The production of original etchings in Britain never came to a complete stop and until halfway through the nineteenth century the commercial network for printmaking was better organised and more effective not only than the Italian but also the French one. The market was so healthy that British prints constituted an important model for French painters, especially the romantics. After the economic recovery, however, there was a reversal in trends, as exemplified by the arrival in Paris from London of the American expatriate James Abbott McNeill Whistler (1834–1903), who settled in Europe and divided his time between the two capitals.

Whistler was initiated into engraving in England by his brother-in-law Seymour Haden, a surgeon by profession but also a keen etcher. With his commitment to etching as artwork and the great use of this technique, the latter injected renewed vigour into the Etching Club, an organisation founded in London in 1838 and undergoing a great revival in the 1860s. Haden was an amateur, like many of the other members, but this did not prevent him from introducing Whistler to the magical world of Rembrandt's etchings and the secrets of the print. The American showed his appreciation by dedicating his first series of graphical works, known as the *French Set*, to Haden in 1858. Whistler's debut in Paris did not escape the attention of Baudelaire: "A young American artist recently exhibited a sophisticated series of etchings at the Galerie Martinet. Carefully crafted and quick in inspiration, they depict the banks of the Thames, wonderful hotchpotches of tools, furnaces and spiral chimneys; the deep and complex poetry of a vast and outstretched capital".[48]

Whistler's career as an etcher was made. Hailed in France and England as one of the most important painter-engravers of the time, his name was indivisibly associated with the revival of etching, where he combined a tendency towards naturalism—executing his etchings *en plein air*—with a taste for spectacular and theatrical effects of backlighting. He drew his inspiration for *chiaroscuro* and atmospheric rendering from Rembrandt as well as the solution for the handling of nocturnal subjects, illuminating them from the inside with artificial lights and varying their luminous intensity to emphasise different compositional elements in the different impressions.

Burdened with the expenses of his suit against John Ruskin, the celebrated writer and art critic who attacked his painting, Whistler sought to regain financial security by accepting a commission from the London Fine Art Society for a series of twelve prints. To this end, he travelled to Venice in 1879 and reworked his vision of the city in the *Nocturnes* series. These prints, in which the etched lines constitute no more than the bare skeleton of the image, were printed with a different tonal rendering for each impression.

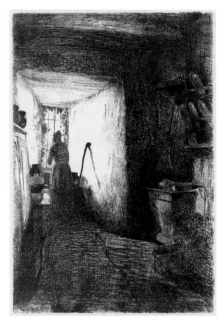

80. James McNeill Whistler
La Cuisine, ca 1858
Etching, state III, 225 × 155 mm
Bibliothèque nationale de France, Paris

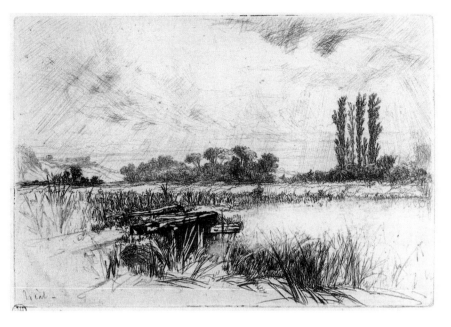

The progressive dematerialisation and the ethereal character developed to the point of dissolution in the overall tonal equilibrium of the impression mark the artist's transition from his original realism "to most unreal evanescence". Abandoning line in order to embrace a romantic form of tonal manipulation, Whistler promoted the concept of the *belle épreuve*, whereby every impression is esteemed as a rare, precious and unique work. The *Nocturnes*, no two proofs of which are alike, constitute an authentic prelude to the monotype in this sense.[49] It was Whistler himself that handled the printing of the edition, being determined to control the effects of inking and printing as an artist and to do full justice to what he called the "delicacy" of the line. In order to keep faith with his principles, which corresponded to the new aesthetic of the original print, he had no hesitation in acting against the commercial interests of the publisher, the London Fine Arts Society: "The total beauty of a single proof suffices for my reputation. Producing a series from the same plate is sheer folly".[50]

During his stay in Venice he came into contact with the monotype, a technique practised, often as a parlour game, by the community of American artists gathered around Frank Duveneck. And it was precisely on the small portable press of Otto Bacher, one of "Duveneck's boys", that Whistler ran off some artist's proofs of his Venetian etchings. Evidence of the probable influence of these American artists is provided by an article of 1920 discussing a work by Whistler, now probably lost, executed with this technique.[51]

Whistler described his Venetian etchings as "impressionistic" in 1890, and a similarity to the French avant-garde group can indeed be detected in the care taken to capture atmospheric effects of a luminous and ever-changing nature. He was, however, an artist occupying a position outside all movements. As an authentic painter-engraver, he combined a talent for painting with an instinct for printmaking and consolidated his own highly personal form of the painterly print.

Encouraged by Whistler's success and Delâtre's technical virtuosity, Seymour Haden developed a passion for etching and had a press installed in the attic of his London home with all the tools of the trade. It was there, together with Whistler, that he etched plates and printed proofs. As he stated in a letter, it was his principle to keep the plates himself, printing impressions for as long as possible and then destroying the plate.

Printed with enormous care, Haden's sophisticated etchings enjoyed considerable success not only in England but also in Paris, where the surgeon-artist made repeated stays between 1857 and 1859 with his brother-in-law. Following Meryon's example, Haden began to sign his etchings by hand in 1850 so as to authenticate them and make them unique. With the new theory of the original print, Haden also responded to the aesthetic criteria of the new art lovers, who were ready to accept printmaking on condition that it was distinguished from the mass-produced articles.

Apart from some sporadic monotypes of uncertain attribution that can be dated to a period prior to 1830, attention should be drawn to a set of about a dozen by James Nasmyth, now held by the British Museum in London and executed shortly after those by Lepic and Degas. It seems reasonable to assume that Nasmyth took over the technique from Lepic, partly through the latter's public disclosure of the same and partly through the mysterious channels whereby secrets are transmitted from one artist's studio to another.

In 1908, in opposition to the practice of the variable or tonal inking of the plate now widespread in Britain, Walter Richard Sickert took a hostile view of the "artistic print" as pointless preciousness: "An incomplete or incoherent plate can be veiled and explained by leaving tone on the printing. In this a step has really been taken in the direction of the monotype, and of course, only the etcher of the plate himself can print the first proof. But this must not be set up as a merit. It is a weakness. In the abstract, the best … etcher is he who leaves the plate in such a state that a competent printer cannot fail to give adequate and uniform proofs".[52]

82. Anonymous
Friends at Dieppe, 1895
Photograph
From the last row, left: Walter Sickert,
Ludovic Halévy, Émile Blanche and Ellen Sickert;
Edgar Degas is above right
Bibliothèque nationale de France, Paris

Some years earlier, between 1899 and 1900, Sickert himself had, however, experimented with a special type of monotype, the so-called "traced monotype", and produced a set of works that he described as "charcoal drawings tinted with watercolour" during a stay in Dieppe. Closely resembling the drawing-prints executed by Gauguin between 1899 and 1903, this technique enabled him to endow his landscapes with a soft, subdued character and can be classified as a variation on the classic monotype, subsequently taken up by various artists in Austria, Switzerland, Germany and Britain (Klee, Brauner and Adler being among the best known).[53]

As Sickert observed, the rebirth of the etching, originally due to British art lovers, was taken over by professionals for commercial purposes at the end of the century. The first to test the market and to win huge success were three Scots, namely D.Y. Cameron (1865–1945), Muirhead Bone (1876–1953) and James McBey (1883–1959), whose works were purchased by numerous collectors, not least due to their promotion by professional publishers. Like those in the other European countries, British museums began to collect graphic works by artists, thus helping to turn the best engravers into authentic celebrities. Cameron, Bone and Frank Short, for example, even received public awards. The secondary market of auction houses also became established as the steady rise in prices reinforced the confidence of collectors in the commercial value of their hobby.

This market generated a flourishing literature of guides for collectors, specialised magazines, and regular features in various periodicals. Everything suggests that in terms of profit, the contemporary graphic production was a more remunerative business than the trade in antique prints. Still suffering from an inferiority complex with respect to their European neighbours on the subject of painting, the British could now proudly assert that they were unrivalled in one field, having far more beautiful prints than any other country and in a surprisingly large quantity.[54]

The etching of interpretation and the revival of the monotype
in Italy and France

The interest in original etchings was fairly widespread in Italy but concentrated above all in Piedmont, Lombardy and Liguria, which became the hubs of its "rebirth". In Lombardy, where the rational spirit of Neoclassicism had been expressed exclusively through engraving with the burin until the end of eighteenth century, it was not so much a reawakening of interest as a sudden birth. The stylistic parameters predominant until far into the nineteenth century were in fact incompatible with etching, which requires quick execution and overall vision.

The years of national unification were marked in Lombardy and Piedmont by the swift rise of a new productive middle-class that not only took over the commissioning of works from the old clients—sovereigns, royal families and ministries—but also gave its favour in the field of the figurative arts to themes of a non-courtly nature like the landscape, the pastoral and the genre scene. When the principles of the romantic naturalism of the Barbizon School spread from France into Italy in the 1850s, they found an already fertile terrain because the Piedmontese artistic production of those years essentially focused on landscape.

With a delay of six or seven years, northern Italy borrowed from France not only the subject of the landscape but also the models of a new formal approach and the institutional organisation of technique (schools, etching associations, and so on). From the 1840s, there were many Italian painters who, having returned to their native land after working for years in Paris, maintained stable connections with France and became champions of the new trend of etching. Examples include the brothers Giuseppe and Filippo Palizzi and Count Gilberto Borromeo, who figured with the young Faruffini in the list of members of the Parisian Société des Aquafortistes in 1865. Borromeo was one of the first to take up etching in Italy and the most active populariser of this technique in the environment of Lombardy. Thanks to the movements of artists and the personal contacts between them, connections between the Dauphiné, Geneva and Savoy were very frequent as from the 1850s.

Similar in some respects to the etchings of the new generation of the French Impressionists, the corpus of Italian etchings developed by the end of the 1860s was

83. Antonio Fontanesi
Frog Hunting, 1869
Etching, 190 × 226 mm
Galleria d'Arte Ricci Oddi, Piacenza

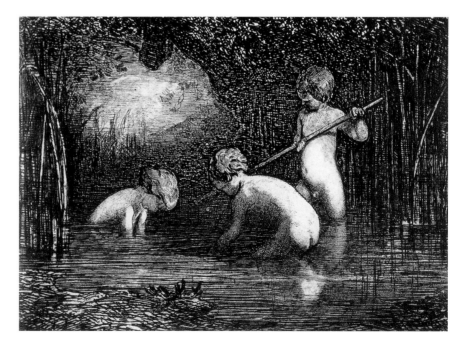

of excellent quality and "appears clearly superior on the average and in the best examples to what the French had hitherto achieved in the field of landscape etching".[55]

Apart from the Marquis Fernando di Breme, duke of Sartirana, the most important figure for the rebirth of the original etching in Italy and the one most responsible for the opening up and rejuvenation of the artistic culture in Piedmont was Antonio Fontanesi (1818–1882), perhaps Italy's greatest romantic painter. Having settled in Geneva, Fontanesi chose rustic subjects for his etchings, and created pastorals in which nature is transfigured by visionary and unreal effects of light. Working as a painter, he subjected the plate to deep, irregular etching, reworked it with the drypoint, roulette and burin, and then covered it in varnish to soften the tones of the blacks and obtain dazzling whites and uniform greys.

Like the French engravers, especially those of the realistic school, Fontanesi worked on the basis of innovative formal and aesthetic tenets and aimed at an original perception of *chiaroscuro*. He abolished the traditional hatching and went beyond the very notion of etching as a facsimile of the drawing in pen and ink. A new approach to light also enabled him to reject the line as a tool for the definition of forms through precise contours.

Two initiatives of great importance brought Italian etching into line with the parameters of originality promoted for some years by the French Société des Aquafortistes, namely the monthly magazine *L'Arte in Italia*, which appeared from January 1869 until the end of 1873, and the birth in March 1869 of L'Acquaforte, Società d'Artisti italiani, which published its first album in 1870 and the second in 1871. It featured not only old landscape painters like Perotti, Beccaria and Ardy, but also new talents like Maurizio Scarampi and Francesco Gamba, the authors of two of the best etchings in the album. The magazine *Gli Acquefortisti* also started publication in 1874, appearing in quarterly issues of 8–10 prints each.

Though short-lived, these two magazines published some of the best works of Italian nineteenth-century figurative art, making Turin the centre of original works of graphic art for the entire peninsula. It was a happy phase in the development of the newly unified country and saw fruitful relations established with other regions. This phase in Italy's artistic history was, however, short-lived: "The national unification ... acted as a steamroller with respect to all the autonomous drives tending towards a national and international dimension ... of the new culture. The Unification therefore did not mean opening up but rather withdrawal into nationalism and inaugurated the period of regionalism and parochialism for the different cities and regions".[56]

L'Acquaforte, an association founded and directed by Luigi Rocca and Carlo Felice Biscarra, was above all the work of Fernando di Breme, who worked in every way until his death in 1868 to promote the practice of original etching in Turin. In particular, he set up a free course in etching at the Accademia Albertina outside the framework of normal academic teaching, a sort of open workshop at the disposal of all those, both artists and amateurs, interested in practising the technique.

L'Acquaforte ultimately proved narrow minded and elitist in character. The founding members all belonged to the Piedmontese aristocracy and the artists published were Piedmontese. When it closed down after just two years, some of its members, including Rayper and Bignami, went on working and contributing to *L'Arte in Italia*, whose prestige constantly increased.

In point of fact, this second magazine took a very different approach and it is possible to detect the effort made by the more progressive fringe to open up and unify the cultural programme at the national level. In its five years of life, it established itself as a point of reference for those involved with etching in Italy

84. Edoardo Perotti
Autumn, ca 1865
Etching, 219 × 137 mm (plate)
Published in the first issue of *L'Illustration Nouvelle*, Cadart et Luce Editeurs, Paris
Bibliothèque nationale de France, Paris

85. Fernando di Breme, Duke of Sartirana
En Italie. La Peche aux grenouilles, ca 1869
Etching, 239 × 160 mm
Published in the second issue of *L'Illustration Nouvelle*, Cadart et Luce Editeurs, Paris
Bibliothèque nationale de France, Paris

86. Ernesto Rayper
Campagna mesta, 1869
Etching
Published in *L'arte in Italia*, Turin 1869

and reflected the period of comparative liberty enjoyed during the years of national unification by intellectuals and artists, who were now able to develop formal frameworks of a freer nature.

The national character of the association took concrete shape after 1870, the year in which the magazine published the etchings of Mosè Bianchi from Lombardy and Telemaco Signorini from Tuscany. These were followed by the engravings of the Genoese Rayper, Bignami and Raimondo from Emilia, and Lobrandi, Di Bartolo and Benassai from southern Italy.

The success of the original etching in Piedmont at the end of the 1860s laid the foundations for the immense graphic output of the Scapigliati, an avant-garde group active between the 1870s and the end of the century that initiated the most important movement in Lombardy during the nineteenth century. The production of original etchings established itself later in Milan and developed along completely independent lines with respect to Piedmont.

With the Scapigliatura movement, this took on a particular character with spiritual and intimist overtones around the end of the century. The factors guiding it indirectly towards new developments included lithography, introduced into Lombardy by a pupil of Senefelder, and photography. With their ease and rapidity of execution, these two graphic techniques highlighted the extreme slowness of the burin and led artists to focus on etching. The Milanese Scapigliati group in particular endeavoured to translate the "painterly touch" into printmaking and arrived at the monotyped etching and the pure monotype following in the footsteps of Degas.

The first works of monotyped etching in Italy were produced by the sculptor Ettore Grandi, who began to experiment with it in 1874, when the technique was so new that he was often taken for its inventor.

Luigi Conconi (1852–1917) adopted it a few years later and broke free of the isolation into which the Scapigliati had withdrawn with his monotyped etchings of 1878. Conconi was later to play an important role in the spread of the monotype in America.

The next to take up the new medium were Mosè Bianchi and above all Vittore Grubicy (1851–1920), who made exclusive use of monotyped etching for landscapes he executed in Flanders and the Netherlands. Grubicy inked the plate with great sobriety, however, and assigned it a purely tonal function. Working "day and night like a possessed man", he managed in the space of a few

87–88. Title pages of *L'arte in Italia*,
Volumes I and IV, Turin 1869

months to produce thirty-four plates including both monotyped etchings—from which he took numerous proofs—and authentic monotypes. He presented three copies of the same etching at the 1915 exhibition of Italian printmaking, differing solely in the quantity of ink on the print.

It was clearly not the subject in itself that interested him. This served solely as a pretext to portray the atmosphere, the true protagonist of all his works, in different conditions of light and with different *chiaroscuro* effects. A romantic artist with an inquiring mind, Grubicy wrote as follows in his work *L'acquaforte nell'arte moderna* (1895): "The deft personal handling of inks, paper and presses enables the artist to print his etchings so as to strike certain deep, mysterious chords and to obtain certain effects of intense darkness coupled at the same time with transparency such as no other graphic medium whatsoever can offer". He continues: "Mobile or artist's etchings … are generally based on the expression of the environment, using strong contrasts of dark and light to make a sketch".

Long overlooked, Grubicy was rediscovered by Lamberto Vitali in 1970 and by Fabio Fiorani, who described his work in 1999 as among the "most fascinating produced by original etchers in Italy". Finally seeing his importance as more than regional, Fiorani placed him in a broader panorama with Whistler working on the one side and De Nittis on the other.[57] There were in fact strong links between the Italian artists and the masters revolving around Cadart, including Degas, Lepic, Legros and De Nittis, who were experimenting with analogous methods and procedures. Also active as an art dealer and hence a great traveller, Grubicy was certainly familiar with Lepic's publication of 1875 on the *eau-forte mobile* or "mobile etching" and just as certainly involved, like others in Italy, in cultivating direct contacts and exchanges of ideas with his artistic brethren on the other side of the Alps.

Conconi and Grubicy initiated the authentically romantic phase in etching. Their tendency to steep the forms in the atmosphere of the background and to eliminate every form of defined plastic figuration led the technique to evolve towards less rigid solutions serving to correct the coldness and lack of sensitivity of the print. Through a logical and natural development of the procedure the two arrived at the mobile or variable etching, later called the monotyped etching. This combined the two different techniques of etching and monotype, the plate being etched solely with a very summary indication of contour and *chiaroscuro* and the rest being added in the final phase of inking, tonally modulated and enriched by means of brushes, sticks and pads of gauze. What disappeared was the engraving as such, the most laborious phase and the one with least pictorial potential, leaving only the inking.

The monotype was later taken up with a more intimist approach by various artists associated with Conconi and Grubicy, including Gerolamo Cairati, Giuseppe Mentessi, Paolo Carlo Agazzi, Ernesto and Leonardo Bazzaro, Giorgio Belloni and Pompeo Mariani. The latter, a nephew of Mosè Bianchi, was trained within the sphere of the Lombard culture of the second half of the century and constitutes the last representative of the Scapigliati. Focusing on the nuanced use of colour, Mariani's graphic art and paintings capture the evanescence of subtle atmospheres, the delicate emotion and the poignant settings of his Milanese masters. Keenly alive to the work of many of his contemporaries at the international level, Mariani was influenced by the cultural climate of the *belle époque*, dominated not only by French artists like Degas and Toulouse-Lautrec, but also by Italians trained in France such as Boldini, De Nittis and Zandomeneghi.

Mariani naturally took up monotyping, taking full advantage of its immediacy and capacity to express sentiment and sensation.[58] Significantly enough, he

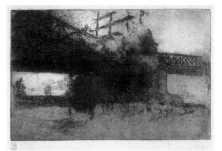

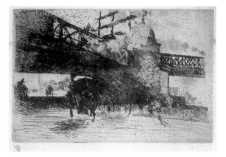

89–90. Giuseppe De Nittis
Vue prise à Londres (Sotto il viadotto Ponte di ferro)
Etching, state I and II, copies printed with ink coating and touches of *retroussage*, 140 × 220 mm
Istituto Nazionale per la Grafica, Rome

91. Pompeo Mariani
Marine Veneziane, 1900–10
Colour monotype, 290 × 558 mm
Istituto Nazionale per la Grafica, Rome

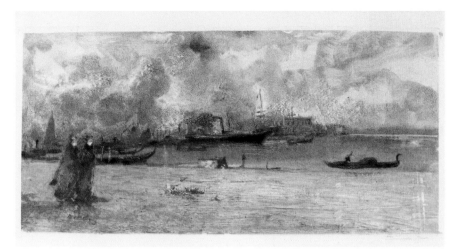

devoted his energies to this medium after making his name as a painter, and produced numerous works between 1898 and 1906 depicting his favourite subjects, namely scenes set in elegant surroundings and seascapes, which he endowed with vivacity and movement by means of quick strokes.

The most authentic developments of Piedmontese and Ligurian etching were to be found in Tuscany in the work of two members of the Macchiaioli group, namely Telemaco Signorini, who started off printmaking in strict accordance with the Piedmontese technique, and Giovanni Fattori. Though differing widely in terms of inspiration and formal solutions, the etchings of Fattori and the Lombard school share the characteristic of being addressed neither to the general public nor to a select group of art lovers, but rather confined to the spheres of avant-garde experimentation and private exercises of a completely free and spontaneous nature.

Fattori, the greatest Italian etcher of the nineteenth century, produced no fewer than two hundred etchings between 1880 and the end of the century. Like the Piedmontese and unlike the Lombards, Signorini and Fattori were not tempted by the monotype as such or its layering techniques, never abandoning either the multiple biting of the engraved line or the compact planes obtained by means of the "stable" effect of the aquatint. This choice is quite surprising in the light not only of the important developments in etching during that period but also of the vivacity and open-mindedness of the artistic and cultural life in the cities, where a wealth of ideas were exchanged between foreign communities.

Giovanni Boldini and De Nittis spent their most artistically fertile years outside Italy, in London and Paris, but it was above all in Paris that, for similar reasons, they became firm favourites with the public and with art dealers. While Boldini's highly-strung and impatient character led him to prefer the direct approach of the drypoint, De Nittis produced experimental work in the field of the graphic arts connected with the most modern aspects of the formal developments of the Impressionists. Above all, he created some authentic masterpieces in the field of monotyping.

Recent studies have identified a series of 25 monotypes by the Roman painter Antonio Mancini (1852–1930) constituting an unprecedented parenthesis within the context of his vast output. The works are of particular interest in that they reveal the artist's responsiveness to the numerous influences experienced during his lifetime.[59]

In Paris in 1877 and 1878, Mancini was a constant visitor at the home of De Nittis, an authentic haven for artists passing through France and a place where they could meet figures such as Manet, Desboutin, Daubigny and Goncourt. It

92. Antonio Mancini
Untitled, ca 1900
Colour monotype, diameter 130 mm
Gabinetto delle Stampe, Galleria degli Uffizi,
Florence

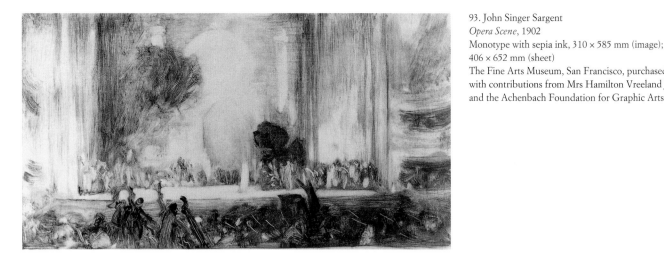

93. John Singer Sargent
Opera Scene, 1902
Monotype with sepia ink, 310 × 585 mm (image);
406 × 652 mm (sheet)
The Fine Arts Museum, San Francisco, purchased
with contributions from Mrs Hamilton Vreeland Jr
and the Achenbach Foundation for Graphic Arts

was in this period that De Nittis was introduced to the monotype technique by Lepic and Degas, and it is possible that Mancini saw these works and took part either in their experiments or just in their discussions.

Mancini had a fresh opportunity to come into contact with the monotype during a stay in Venice between 1884 and 1887, perhaps when he was the guest of the American painter Ralph Curtis in Palazzo Barbaro, the scene of very lively exchanges of ideas between artists of international high society. Curtis was one of the artists of Duveneck's circle, who stayed for a long time in Venice and experimented with the numerous expressive possibilities of monotyping. While no monotypes by the American are known as yet, he was undoubtedly familiar with the technique due to his close connections with the rest of "Duveneck's boys".

Mancini returned to the monotype through the influence of John Singer Sargent, whom he met in London. Sargent's *Opera Scene* (1902), a monotype of large size for the period executed in printer's ink, recalls the monotypes and paintings produced by Degas in the late 1870s by virtue of its theatrical iconography.

Handled with the freedom of a sketch, the Mancini series combines spontaneity and overall pictorial vision. Though dated 1900, it still shows the influence of the romantic sensibility of the turn of the century. Executed with the spirit of an intimate experience, the series was completed in a single day and printed on sheets of tissue paper of the same size. Mancini used diluted oil paint, which he spread with his fingers or a rag on round plates of differing diameter. In order to obtain a half-tone effect in the image, he often took advantage of the transparency of the paper and worked also on the back with touches of deeper colour.

These were ultimately experimental works and interesting not so much in terms of the artistic result as the elements linking them to the developments in France of the late 1870s and to the work of Duveneck's group, who experimented between 1880 and 1884 with monotypes in oil paint printed on a manual press.

The revival of etching was accompanied in the late nineteenth century by the reawakening of interest in the monotype by virtue of its free and "original" subjective character. Once the old ways of thinking and the more dogmatic and restrictive artistic models had been swept away by a general desire for personal liberation, suitable circumstances were created for more flexible and singular techniques such as etching and monotyping to be taken up as modern forms of expression in formal harmony with the times.

The role of the romantic printmakers was crucial for the use of etching. Finely honed by an ever-broader range of tonal values, it became an indis-

pensable medium for the depiction of landscapes.[60] The successive biting of the plate opened up countless ways of transcending linear limitations in the rendering of light and atmospheric nuances.

The new awareness of the work's expressive power was reflected above all in the personal approach to inking developed by the artist, working in the last few decades of the nineteenth century on the basis of his or her intuition. The *peintre-graveur* "interprets" every single impression with freedom and imagination, ready to allow the work to reflect the original artistic concept while changing every time. This attitude led to greater freedom in calibrating and modulating tonal intensity at the moment of printing and intuitively shifting or adding masses of colour on the plate.

Inking and printing are crucial in endowing each work with individuality and differentiating it from the other impressions. This is obtained through the glossy or matte quality of the ink and the tonality and calibre of the paper support, followed also by chromatic range with the subsequent introduction of colour. This foreshadows the modern concept of uniqueness in artistic production being no longer confined to the painting or drawing but also obtainable with the print, a multiple article by definition: every impression becomes a coherent and creative individual work.

The late-nineteenth-century etchers rediscovered Rembrandt and endeavoured to adapt the varied inking of the Dutch master to their own works. The change in taste was expressed in the abandonment of the conventional print and renewed sensitivity to the diversification of impressions. This predilection for the unique and the exclusive did not attract the general public but led to a sub-

stantial shift in focus whereby printing became increasingly an art for experimenters, aficionados and lovers of variation.

Legitimised by the historical model of Rembrandt, the artists of the age adopted as working parameters the principles of Impressionism, a revolutionary movement striving to capture the subtle hues of landscapes in the open air and the changes at different times of the day. In the attempt to pin down the fleeting nature of the moment and movement, the inking of the plates became sensual and expressive, what was described in the terminology of the age as "artificial" in contrast to the traditional system of "natural" printing. While tonality was obtained in the latter exclusively through the biting of the etched line, the system of "artificial" inking made it possible to obtain tonal variability of the plate etched through variations in the layer of ink left on the surface.

One of the French artists skilled in manipulating the ink on the plate and rendering the dramatic effects of *chiaroscuro* was Adolphe Appian (1818–98), who took up the monotype in 1863—a decade before Degas—and practised a system of differentiated inking for some years. Appian's monotyped impression *Un Rocher dans les communaux de Rix* was published in the album of the Société des Aquafortistes in 1868. The commercial catalogues of the period[61] and the inventories of some collections provide details of about 40 monotypes and monotyped impressions by the artist described as follows: "There are also authentic monotypes, i.e., plates that are not etched, where the forms, covered in ink, are worked only by means of the brush, tarlatan, and a pointed tool. On printing in the press, they provide a single image with very pronounced effects of night or fog. Executed between 1863 and 1864, they are mostly signed and dated by Appian, who also wrote 'sole proof' and 'with no engraving or etching' on one of these impressions".[62]

96. B.N. Cremière
Portrait of Vicomte Lepic, ca 1860
Photograph
Musée National du Château, Compiègne

The substantial number of monotypes and monotyped impressions produced by Appian indicates that this was neither a passing fancy nor an incidental, isolated episode, rather revealing the artist's stubborn determination to master the procedure even though there was as yet no market for works of this type. He was among the first ones after Castiglione to revive the pure, classical genre of the monotype.

Then there was Henri Guérard (1846–97), a highly skilled printer who gave Manet some technical advice. A prolific engraver, the author of more than 600 works, Guérard was above all a great experimenter. He produced a large number of monotypes and his reputation as a technical expert was so great that Charles A. Walker consulted him on the monotype during a stay in Paris with a view to writing an article.

The account of a visit paid to Guérard while he was working on a monotype published in 1875 by Richard Lesclide, the publisher of *Paris à l'eau-forte*, constitutes the first known description of the technique: "We entered his *atelier* without warning and found him intent on covering a copper plate with a layer of black ink. This surprised us somewhat, above all because the plate showed not the slightest trace of a design… Guérard's answer was, however, very simple: I am trying out a new way of making a print with a piece of muslin. As soon as the plate was evenly covered in black, he grabbed some dirty, oily pieces of gauze, rolling some up and folding others … and set to work on it. After a good half an hour, the plate began to gleam here and there. We began to see lighter areas as well as gradual transitions between light and shadow. Solid pillars gradually emerged from the darkness supporting the arches of an imposing crypt… In the end, when he judged that the work was ready, he took the plate … and ran it through the

97–99. Ludovic Napoléon Lepic
Le Lac de Nemi, ca 1870
Mobile etching, three of six impressions
of the plate printed, with touches of *retroussage*,
240 × 315 mm
Bibliothèque nationale de France, Paris

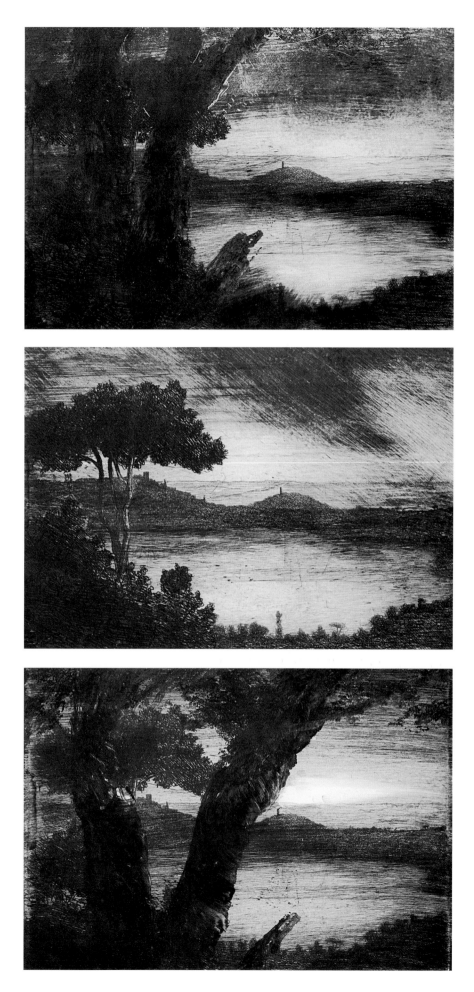

press covered with a sheet of paper… The proof triumphantly emerged from the felt covering it. It was the wonderfully tormented image of a cave".[63]

Viscount Ludovic Napoléon Lepic (1839–89) was a man of the world with a modern, inquiring and multifaceted turn of mind. Keenly interested in anthropology and archaeological excavations, as well as a breeder of dogs and a great sailor, he took up etching as an amateur and become a member of the Société des Aquafortistes. He maintained that printmakers should personally supervise the printing of their works and later, at the end of the 1860s, laid claim to the invention of a procedure wholly identical to Delâtre's *retroussage*, which he renamed *eau-forte mobile* ('mobile or variable etching'), more commonly known today as monotyped etching.

Cadart published Lepic's *L'Eau-forte mobile*, an album of etchings preceded by a sort of manifesto entitled *Comment je deviens graveur à l'eau-forte*, in 1876. The self-proclaimed inventor and apostle of a new technique, Lepic tells the reader how to remove the surplus ink from the plate with different results every time. While this places him in the ranks of Rembrandt's many imitators, he differed greatly from the Dutch master in terms of his ultimate aim. Where Rembrandt's variable impressions reflect the seventeenth-century exploration and conception of the composition through *chiaroscuro*, the *eau-forte mobile* as conceived by Lepic became a method and a result in itself.

By manipulating the printing ink without altering the design of the composition, Lepic aimed at obtaining a variety of unique and different impressions from the same matrix. The etched plate was not used to create multiple editions but rather a hybrid form of etching and monotype closely akin to what would be called the monoprint today.

Lepic provides a detailed description of his "discovery", emphasising how the variability obtained through the manipulation of ink and gauze on the plate enables him to multiply the (necessarily unique) states of the prints by varying the light and half-tones without acting on the etched line. He insists above all on the need to approach engraving as a painter and not as an engraver, and thus to paint the plate with printer's ink: "I will make prints as a painter and not as an engraver". Working on the matrix of *Le Lac de Nemi* with his technique of *eau-forte mobile*, Lepic developed a series of four impressions differing greatly in tonality and later claimed to have succeeded in printing no fewer than 85 impressions of *Vue des Bords de l'Escaut*, all differing in terms of light, weather conditions and atmosphere: "The artist who uses etching should be a painter or draughtsman who uses the point and the rag just as another would use the paint-brush and the pencil… I embellish an impression with a touch of the finger or a rag soaked in ink, while the current practitioners [of engraving] obtain only a dry and clumsy proof… The pictorial aspect of the etching is obtained at the moment of printing by means of a method that is the only one to endow the work with grace and charm. Without this, etching becomes a trade like any other… I finally achieved my dream in printing the plates of *Le Lac de Nemi* myself. I obtained the most varied and contrasting effects, a result impossible to obtain when the etching is printed by workers rather than the artist in person".[64]

These words could, however, have come equally well from Bracquemond or Degas or Pissarro, with the difference that they achieved better results without so much talk about them. In point of fact, Lepic invented nothing because the pictorial effects of inking were already commonly known among the painters-engraver of the day. By stressing the imaginative and evocative potential of the ink

with respect to the drawn line, Lepic took a step forward in the innovative direction of the late-nineteenth-century print. He remains, however, a representative of the *ancien régime*, which saw etching as a lightweight art, something to appreciate, to collect and sometimes to practise for amusement.

Lepic is remembered today not so much for the artistic quality of his works as for having introduced his friend Edgar Degas to the monotype.[65] In *Le Maître de ballet*, regarded as the first monotype by Degas and executed in either 1874 or 1875, the name of Lepic is seen with that of the artist. This was not a tribute paid by Degas to his friend, inasmuch as the signature is Lepic's own, but rather the acknowledgment of a debt for instruction in a technique that was to become one of his own natural endowments. Eugenia Parry Janis suggests that further evidence of this link is to be found in Degas's portrait of his two friends Lepic and Desboutin, which includes a piece of tarlatan in the background, presumably a reference to the artist's teacher of monotyping.

Given the similarity of the formal results obtained, the techniques of *retroussage* or *eau-forte mobile*—differing only in name—constitute the historical antecedent of the monotype, the monotyped etching. Examination of the heavily inked impressions of this period reveals the short distance between the idea of manipulating the ink so as to shroud the forms in mystery or obtain cloud effects and the conception of the monotype. The one remaining obstacle was the conception of the print as multiple, i.e., the idea that the sole purpose of executing a print was to produce an edition.

With the monotype, the print becomes an "impression" in the two senses of the term: firstly because the surface effect provides a subjective description of the scene evoked, and secondly because the image produced by means of the press is quite literally an impression. The aesthetic intentions of the printmaker combine with the demand of art lovers for a unique impression in that, by virtue of its hybrid, ambiguous and "perverse" nature, the print now takes on the characteristics of the painting or drawing, and in any case of the single sheet. The classification of the print in the category of unique works due to the monotype encouraged painters and sculptors to adopt this technique with no more reservations and allowed art lovers to purchase such works with no misgivings.

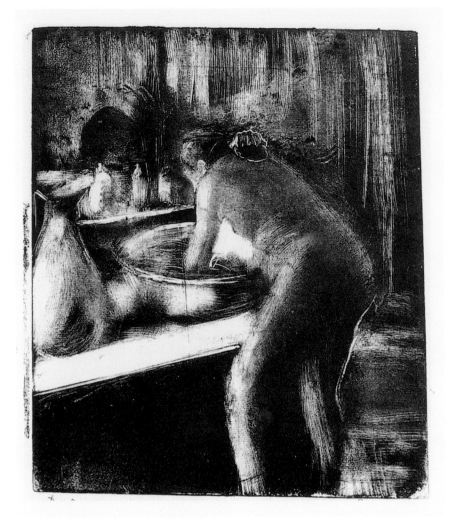

101. Edgar Degas
À sa toilette, 1885
Monotype, black ink on white paper,
first of two impressions, 313 × 278 mm
Jacques Doucet Collection,
Bibliothèque de l'INHA, Paris

The Impressionists and the New Procedures
"The leeway of the indirect printmaking is sufficient to allow an artist to take
a virgin plate, execute … a design on it solely in printer's ink, run it through
the press, and obtain a print. This is how … Degas produced many prints."
Henri Beraldi

In an essay of 1846 that was to influence a whole generation of artists, Baudelaire
described the French painting of the time as decadent and invited the new gen-
eration to draw inspiration directly from nature and modern life. Situated at the
watershed between pre-industrial and post-industrial civilisation, the young
painters increasingly identified with the nascent Impressionist movement and its
simple style of quick brushstrokes and harnessing of the new taste for technical
effects to capture the spontaneity of sensation. After the halfway point of the
nineteenth century, moving against the trend towards images reproduced in se-
ries and demonstrating the richness of the stimuli informing the art of the period,
the art print carved out a marginal but prestigious niche for itself.

 The first group of painter-engravers that can, with some simplification, be
described as Impressionists—including Bracquemond, Millet, Huet and
Legros—made increasing use of etching, drypoint and soft varnish, tech-
niques less suitable for reproduction than the burin but more versatile. Above
all, they developed an authentic passion and indeed almost a mania for re-
working the print by hand with the brush or pen to the point that it became

impossible to distinguish a print from a drawing or an oil painting. Legros, for example, offered Baudelaire a copy of his *Séance de Professeur* in 1861 in which the etching was so heavily retouched that it no longer looked like a print at first sight.

These artists focused predominantly on landscape, now an independent genre, to express the "fashionable" emotions of hazy sentiment, a sense of the fleeting nature of life, and volatile "impressions". They worked mainly on the theory of light and its pictorial rendering and multiplied their efforts for variation in terms of style, technique and calligraphy. The salient feature they shared was a drive for experimentation and the invention of new procedures.

The essential thing was no longer the work in itself or the subject but the procedure. As a result, reality was replaced by a vision of the same. Efforts were concentrated on capturing misty effects, stormy skies and sensations.

Due to its predominantly experimental character, the Impressionist print made great use of marginal procedures. It was never produced in large editions and was so limited in circulation as to be often published in collections or magazines. Closely linked to the literary output of writers and poets, it inaugurated the modern formula of the illustrated book. While the number of printed copies was a confidential matter, numerous proofs were taken, technically divided into proofs of state, printer's proofs and artist's proofs. Each of these was regarded as a unique item and the editions multiplied differences that art lovers had come to look for and appreciate.

Having printed an impression, the artist deliberately altered the plate before printing another so as to represent the subject in different atmospheres. The concept of the "state" therefore changed radically with respect to its traditional function as a way to monitor the evolution of the work or to make the most of the rarest proofs of the definitive print.

Degas and Pissarro took a very different view of their carefully signed and numbered states, as demonstrated by the latter's exhibition of such items in 1880 as works in their own right. The work thus also comprised all of the preparatory phases, which became a series of different impressions of the same subject. Subjected to no hierarchical scale of importance, they were not stages serving to arrive at a final state but equivalent versions of the same vision. The

102. Félix Bracquemond
Sunset, ca 1855
Mezzotint and drypoint, 135 × 216 mm
Bibliothèque nationale de France, Paris

states also became a way for the artist to take a further step back from the objective reality, assuming in this sense the same function as the different inkings, different types of paper, and so on.

The traditional technique of printing, based on the printer's ability to produce identical impressions all the way through the edition, became obsolete and was transformed into a sophisticated and creative way of painting. Every proof was unique, and it was in this sense that Degas spoke of original prints and Jongkind referred to his etchings as "drawings". In letters to his son Lucien, Camille Pissarro described his prints as "engraved impressions" and emphasised the rarity distinguishing them from mass-produced prints: "As regards *La Masure*, only six copies were printed, as you know. The [steel proofs] are often very beautiful but less rare… I don't believe you will have any difficulty in getting people to understand that they are not engravings, but simply engraved impressions".[66]

He continued: "*La Femme à la brouette* is rare. Remember that there are only two proofs and that only one of them is beautiful, namely the one I am sending you, which is done in the grey manner".[67]

Through an art of trial and error, the Impressionist printmakers kept away from the professional printers, who in any case greeted their works with hostility. Lemercier lost his temper, for example, when printing the lithographic proofs of Bracquemond or Manet. The history of the print during the last quarter of the century is full of misunderstandings between artists and printers, as exemplified by this outburst from Odilon Redon: "God knows how much I have suffered in the printing works, what fits of rage at the carelessness and eternal incomprehension of the printer for my work!"[68]

These feelings were shared by all the artists of the experimental fringe, including Degas, Pissarro, Gauguin and Bernard, who did most of their printing by themselves and often helped one another.

The etching became an intimate, secret and thrilling moment of artistic individuality. In particular, the Impressionist print reflected new attention onto scenes of everyday life, onto detail, and ultimately onto subjects previously regarded as "ordinary" if not indeed ugly and vulgar.[69] As a result of the crisp, annotative style used, the print on copper produced schematic figures, tersely developed in a language of black signs on a white ground, and then, with its power of synthesis, left a major part to the imagination, "queen of the faculties". As Degas remarked to his visitor Sickert in 1885, "I want to look through the keyhole".

Grounded on cultural privilege, a type of print took shape aimed at a few sophisticated connoisseurs, a sort of confidential work that was shown to the public only on rare occasions and that consolidated its technical means over the years to carve out its own niche at the end of the century. Stylistically linked to the most subjective sort of expression, this new approach intimately reflected the personality of the author. Far away from the academies, exhibitions and professional ateliers, and above all free from the pressures of the market, artists gave in to the temptation of the most various experiences, which they cultivated in secret.

A close relationship developed within this "personal" sphere that linked the rebirth of the original print in France to the vision of Impressionism and ultimately of modern art.

If the Impressionist print did not abolish the engraved or etched sign, it certainly opened a new chapter in its history. The prints now became flexible, allu-

103–104. Paul Huet
Le Cavalier (*Un orage à la fin du jour*), 1868
Etching and counterproof impression printed like a monotype, 173 × 254 mm
Bibliothèque nationale de France, Paris

sive, discontinuous and permeable to colour. And it was the most ductile techniques—like aquatint and lithograph—that best interpreted the formal principles of Impressionism, replacing the unity of matter and light upon which traditional tonal painting was based with the unity of light and colour. Amalgamated with a modulation of their tonal values, the outlines and contours of landscapes and figures thus became hazy and crumbled against the limpidity of the sheet of paper.

With Degas and Pissarro in the front line, the Impressionist engravers discovered a practically boundless field of exploration in the print. It was the era of variants, of impressions from the same plate, of the circulation of proofs in closed circuits.

The experimental drive manifested itself in Degas's work with the use of mixed techniques, the combining of traditionally antagonist elements like the print and photomechanical procedures, and the retouching of the printed image by hand with tempera or pastel. In Émile Bernard and Gauguin, it took shape as a systematic revising of the printmaker's customary practice. The inks were diluted even to an excessive degree, the runs differed from one impression to the next in terms of pressure and type of ink, and colour could be printed, added by hand or obtained through the tonality of the paper.

All in all, what the painters of the Pont-Aven school were aiming at was not so much a return to an artisanal approach or the revival of rudimentary and disused procedures as a radical revaluation of the print with respect both to status and to practice. The latter was indeed no longer bound up with one technique in particular but involved the uninhibited use of every technique at the artist's disposal, both new and traditional.

With these conditions in place and the use of tools and procedures resistant to reproduction, the stage was set for the monotype to make its reappearance.

The last few decades of the nineteenth century saw a proliferation of prints produced by means of the most disparate techniques. Essentially expressed through colour lithography, a less fragile and laborious procedure with the primary advantage of lending itself to large-scale production, the coloured print of the *belle époque* constituted the opposite extreme with respect to the elitist original etching of the Impressionists. Produced in large editions in a professional workshop, the lithographic print was the result of complex technical processing in which the handling of colour and tonality had to be entrusted to skilled technicians such as Auguste Clot and Edward Ancourt.

The Nabis group saw the lithographic print as part of a broader decorative project, taken out of the portfolios of art lovers and multiplied on city walls and theatre programmes to perform a broad-based public function. Lithograph posters proved a great success. With their large format (making sense only when seen in the open at a distance), bright, pure colours and foregrounds borrowed from Japanese prints, they constituted an aesthetic even more than technical revolution.

The colour print is linked with "publisher-dealers" like Ambroise Vollard, Samuel Bing and Sagot, who played a key role in steering the public taste towards more eclectic parameters and a painterly style.

Ambroise Vollard (1868–1939) occupied a central position in the panorama then taking shape.[70] Extremely active as an art dealer and gallery owner, he was the first to show and sell the paintings of Cézanne and Picasso, as well as funding Matisse's first solo exhibition. He also established himself as one of the

105–106. Ludovic Napoléon Lepic
L'Hiver en Hollande, 1870 (?)
Two impressions printed using the mobile etching method, 240 × 325 mm
Bibliothèque nationale de France, Paris

most brilliant publishers of illustrated books and prints of the period. The publication of Verlaine's *Parallèlement* in 1900 with lithographs by Bonnard and other artists of the École de Paris created the archetype of the illustrated book.

Vollard talked about his career and his love for prints in his memoirs: "I have always loved prints and my greatest desire when I moved to Rue Laffitte around 1895 was to have some made, but by painters. The term *peintre-graveur* has been misused through application to professional engravers who are anything but painters. My idea was to commission engravings from artists who were not professional engravers. What may have looked like a risky gamble was instead a great artistic success. This was how Bonnard, Cézanne, Denis, Redon, Renoir, Sisley, Toulouse-Lautrec and Vuillard began to produce the fine engravings that are so sought-after today… I can still see Toulouse-Lautrec, lame and small of stature with an ingenuous expression on his face, promising to depict a woman from a brothel… All these prints, in colour or black and white, were published in *Les Peintres-Graveurs*, of which two albums were made, each in an edition of 100. These sold very badly but, despite the indifference of art lovers, the painters themselves became more and more interested in this form of expression."[71]

107. Anonymous
Ambroise Vollard, ca 1930
Photograph

Bing's importance lies instead in having made Japanese prints known to artists, collectors and the Parisian public. These works played a key role in the revival of the print as from the 1880s, influencing all of the French avant-garde, from Gauguin and his Nabis followers to Toulouse-Lautrec, Degas and Cassatt. The artists now strove for linear simplification and the flattening of pictorial space as well of the perspective foreshortening of figures projected into the foreground. Above all, they used the new water-based paints, which proved more vivid, limpid and vibrant than oils.

Far more than a simple literary influence, the impact of *japonisme* had deep repercussions on the creativity of the Impressionist painter-engravers and led to an authentic movement towards colour that worked through various enticing channels to revive the print and lithographs in particular.

The protests of Odilon Redon in defence of the use of black and white in prints provide evidence of the large-scale use of colour and the fact that purists regarded it as "facile" and aimed at a second-rate public, or in any case as something to be restricted to engravings providing copies of paintings and drawings: "The print is held in very low esteem in France if not impoverished by colour, which makes it something else, negating its nature as a print and turning it into an image. Black must be respected at all costs. Nothing debases it. It does not please the eye that regards it superficially and awakens no sensuality… It is an instrument of the spirit far transcending the fine colours of the palette."[72]

108. Édouard Vuillard
Le Portrait de Mme Lucy Hessel
Monotype in brown ink, 260 × 170 mm
Bibliothèque nationale de France, Paris

Similar sentiments were voiced by the president of the engraving and lithography section of the 1898 Paris Salon: "For its principles, its origins and its traditions, the art of the print is unquestionably the art of black and white".

The timid steps taken in this direction by Bracquemond, who tried his hand at one etching in colour, were followed by the attempts of Henri Guérard, the fine results of Mary Cassatt and the aquatints of Charles Maurin. Auguste Lepère, Pissarro and all of the Nabis group instead experimented with colour above all through woodcuts.

It became clear towards the last decade of the century that the coloured print involved a contradiction in that it was aimed at a broader public than its

109. Title page of the album *Les peintres-graveurs*, Paris 1896
Published by Ambroise Vollard and printed in one hundred copies by Auguste Clot for the opening exhibition of the publisher's gallery

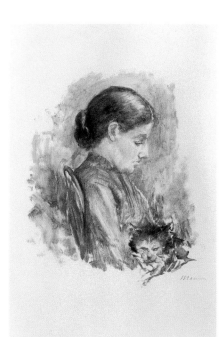

110. Charles Maurin
La Femme au Chat
Monotype, 408 × 261 mm
Jacques Doucet Collection,
Bibliothèque de l'INHA, Paris

counterpart in black and white and easier to sell, but was actually more costly to produce. It thus proved too expensive to be popular and too popular to be appreciated by art lovers, who regarded it as a luxury product in bad taste.

The coloured etching thus failed to find a market immediately and its renewal took place after a delay of 30 years with respect to the print in black and white.

In the field of lithography, however, colour was not just a simple alternative but soon became the systematic rule and by the end of the century, with posters and book illustrations, was well on the way to constituting the most daring expression and the best synthesis of the artist's work. Efforts were made to match colour to the paper support and studies were carried out on chromatic harmonies developed through transparent superimposition. Applied in the lightest and purest of layers, the water-based paints created a decorative style of greater daring and homogeneity than could be achieved with the heavier oil paints.

The new relationship between print and colour played a key role in orienting modern sensibility towards the monotype, hitherto associated with the revival of the black and white print. Very few artists had in fact understood the potential of the monotype as a medium for coloured images.

At an indirect and more complex level, the stimuli of the new print techniques and the invention of photography played an ultimately positive role in the revival of the monotype. With their focus on light and colour, these procedures worked as from the middle of the nineteenth century to shift the taste of critics and the public from line to the tonal nuances of the composition, thus creating a new pictorial aesthetic. The modern sensibility somehow freed the artist, who was now quicker to move beyond the conventional systems in the reproduction of multiple printed images.[73]

Thus it was for lithography, invented by Senefleder in Munich in 1782, which enjoyed growing success. Dispensing with the need for the complicated intaglio process, it allowed engravers to execute free and spontaneous designs on the lithographic plate. It was partly the rich tonal possibilities of this new procedure that stimulated the French taste for landscapes and rustic scenes depicted in half-light.

The photographic procedure, which came into use around 1840, made it possible to transfer *chiaroscuro* effects onto the plate by means of collodion and gel, and to give the image a slightly "blurred" effect. The ability of photography to reproduce tonal qualities extensively and in various ways led to forms of preciousness that were exploited by artists in the new *cliché-verre* technique. It also consolidated the position being carved out by the monotype.

In point of fact, various photographic techniques are similar in some respects to monotyping. The impressions obtained through transfer, for example, involve an offset process whereby the photographic image is first inked and then transferred onto a sheet of paper by means of a roller. The link between monotyping and photography was noted by many photographers, including Alfred Stieglitz, who exhibited monotypes by Eugene Higgins in 1910 at his celebrated Photo-Secession Gallery in New York, describing them as possessing the same quality and richness as a good platinum photograph.

In their formal developments and explorations, the only thing now left for artists to do in order to arrive naturally at the monotype was to remove the lines engraved on the metal plate or drawn on the lithographic stone. Already welcomed at the time of etching revival, by virtue of its uniqueness, the monotype

was understandably taken up by the Impressionists for the effect of unpredictable luminosity or "impression" appearing on the sheet where the crushed image of the inked plate is deposited.

After Giovanni Benedetto Castiglione, the most illustrious creators of monotypes were Degas, Pissarro, De Nittis and Gauguin. The technique was also naturally taken up by a great many lesser-known artists, many of whom did so intentionally when, having learned all the secrets of etching and lithography, they felt the need for a medium capable of expressing the intangible quality of the subjects chosen.

The procedure came into comparatively widespread use towards the end of the century, especially among the Impressionists. While the realistic painters focusing on the representation of precise contours and the rendering of *chiaroscuro* adapted well to the technique of etching, this no longer held for the Impressionists, whose new pictorial vision, based on the mobility of light and colour and quickness of touch, required different parameters. Alongside the linear and classic etching, the period after the 1870s saw extensive development of the more ductile techniques of printmaking and all the procedures that "are most conducive to this form of stenography with neither relief nor contour…, the mixed techniques, the etching in colour, the monotyped print and those alchemistic 'inventions' of which Degas is the master, such as the monotype".[74]

Although not intended for circulation and largely confined to the studio, the monotype increasingly became one of the favourite procedures of these artists, above all after the great economic crisis of 1879–80 left them no hope of being able to get their works known through publications or, still less, exhibitions. Left to their own devices in the solitude of their studios, Degas and Pissarro were among the first to devote their energies with whatever means were available to a type of print that had now become alchemistic in nature, and to excogitate procedures of an extremely laborious character. At the same time, they endeavoured to capture movement and the shifting of atmospheres also through the monotype.

The capturing of sensations, the core of the Impressionist doctrine, came about in the climate of intensification of personal experience, with intuition predominating over knowledge and the subjects of great art giving way to those of an intimate, everyday, incidental nature. Whistler's Venetian series focused on obscure, lesser-known views rather than such celebrated and popular subjects as the Grand Canal and the Rialto. The ballerinas portrayed by Degas in his pastels or reworked monotypes are not dancing on a stage sparkling with lights but sit modestly tying their pumps. Degas focused in actual fact on the "spectacle of intimacy" and embarked on psychological studies of private actions like the female toilette, shifting from the overstated, the magniloquent and the picturesque to the confidential and the exploration of nooks and crannies.

Pissarro presented various states of the same print at the Impressionists' fifth exhibition in 1880, around which time Degas began producing what he called "printed drawings in oily ink".

The increasing popularity of the monotype was connected with the fact that artists began to sign their prints on a regular basis with a view both to attesting their personal participation in the creation of the work and to limiting the size of editions. The monotype thus met the demand for full involvement on the part of the artist increasingly expressed by connoisseurs of printmaking. If a skilful printer like Auguste Delâtre could print an entire edition of etchings simply by varying the inking of the plate, the monotype could only be executed by the artist in person, as the acts of creating the image and working on the plate are one and the same.

111. Lorenzo il Quaglio
Alois Senefelder, Inventor of Lithography, ca 1818
Lithograph, 225 × 150 mm

The history of the monotype began to coincide with the history of the artists using this technique, appreciating not only its expressive qualities and the subtle, delicate possibilities offered but also the concept of the exclusive, individual and unique work.

Degas and the monotype
"This reactionary is an avant-garde artist. This Impressionist detests painting *en plein air*… This misogynist paints nothing but women. And the best friend of this vehement anti-semite is Ludovic Halévy."
Françoise Cachin

The French term *peintre-graveur* indicates with precision—and more comprehensively than the Italian *pittore-incisore* or the English *painter-etcher*[75]—the artist who opts for the print in order to produce images. It emphasises the concept that the works are original creations, like those of Dürer, Rembrandt, Tiepolo, Goya and the masters for whom the term was coined. It focuses attention on the fact that the *peintre-graveur* is primarily a painter but capable of creating with any tool whatsoever and crossing all frontiers.

A classic example of the category of *peintres-graveurs* is Degas, for whom the print and the monotype in particular constitute a free and autonomous form of expression with modalities and strategies differing and separate from the other mediums.

When Degas returned to Paris in 1859 after his travels in Italy, the art market was booming and the revival of etching, already at an advanced stage, had brought the original print back into fashion. Degas soon learned a lesson that was established in those years like a new reality: in printmaking as in art, the "identical reproduction" does not exist. His vocation was in any case not for craftsmanship but for transfiguration, the radical overturning of an art that he intended to open up to new visions. He was driven solely by the possibility of continuing to act on the artwork and shape its development.

With procedures abandoning any form of technical prejudice and combining everything from pastel to tempera, painting, printing and monotyping, Degas returned incessantly to the image, condemned to endless reworking by his inability to regard the work as finished. He therefore attached the same meaning to the concept of "originality" for prints as for drawings or paintings in that they were all unique works. The connection between creation and reproduction, on the margin of which the very art of the print was founded, became weaker until it finally snapped.

Degas began printmaking again in 1875 and produced a corpus of extraordinary works that, while comparatively slight in numerical terms—about 66 etchings, drypoints, aquatints and lithographs—were to place him alongside Manet, Cassatt and Pissarro as one of the more important practitioners of the Impressionist print.

Degas initially looked to Rembrandt, admiring his extraordinary freedom in handling variations of light that seem to go beyond the composition to disappear in the gleaming whiteness of the sheet or the blackness of the ink. He began by painting on the plate in watercolour in order to express the tonal values but then plunged headlong into the heart of a craft every element of which he treasured, including all the proofs, the failures and the salvaged items. He took a passionate interest in all the means of reproduction, working incessantly on old metal plates salvaged from the junk in the workshops of photo-engravers.

112. Marcellin Desboutin
Portrait of Degas, 1875
Drypoint, state II, 90 × 74 mm
Bibliothèque nationale de France, Paris

113. Edgar Degas
Jeune homme assis avec beret de velour,
after Rembrandt, ca 1857
Etching, 105 × 85 mm
Bibliothèque nationale de France, Paris

114. Rembrandt Harmenszoon van Rijn
Young Man Seated in Velvet Cap, 1637
Etching, state II, 93 × 83 mm
Bibliothèque nationale de France, Paris

Astonished at the frenetic energy and effort that Degas devoted to these highly unorthodox techniques, Marcellin Desboutin wrote as follows to his friend De Nittis in London in 1876: "Degas was the only one I saw every day, but he is no longer a friend, no longer a man, no longer an artist! He is a plate of zinc or copper covered in black printing ink, and this plate and this man have become elements run through his press in a mechanism that has swallowed him up completely! The man's eccentricities are truly phenomenal! Now at the height of the metallurgical phase of reproducing his drawings by means of a roller, he runs all over Paris in this heat in search of devices corresponding to his fixed idea! He is a poem! He speaks of nothing but metalworkers, hydraulic engineers, lithographs, … and so on. It will be your turn when you get back. I can't wait. You will take over from me! Thank God."[76]

Degas often met up with his friends Desboutin and De Nittis in the winter of 1875 at Cadart's workshop, where he went to make his prints. Having learned all the secrets of etching and lithography, the perennially restless artist also took up monotyping that year and, together with Lepic, produced his first work, *Le maître de ballet*, a subject he also addressed in painting.

Over the period from then until 1893 Degas produced over 450 monotypes, about 500 according to some estimates, a corpus of extraordinary scale that is still unmatched for its importance and influence right up to the present. It was in fact Degas that inaugurated the modern use of the monotype, showing the way to whole generations of European and American artists that are still following his example today.

A tireless and indeed maniacal experimenter, Degas explored all the possibilities of this new procedure of revolutionary importance for his art. Probably knowing nothing of its previous existence and history, he adapted it to his personal ends and made it a suitable tool for his genius. Having literally reinvented a genre, Degas extended its boundaries immeasurably so that the monotype seems to dissolve in his hands and move into the realm of illusion to the point of heralding Art Informel. This flexible, ambiguous, paradoxical, surprising and rapid technique could in any case hardly fail to enchant an artist of such a contradictory temperament as Degas.

Linked to the climate of the explorations, studio experiments and spontaneous, unorthodox techniques of the Impressionist generation, Degas's new in-

115. Edgar Degas
Homme à la pipe, ca 1876
Monotype, black ink on white paper,
80 × 71 mm
Bibliothèque nationale de France, Paris

116. Marcellin Desboutin
Homme à la pipe, 1879
Drypoint, 450 × 375 mm
Bibliothèque nationale de France, Paris

terest in the monotype began as a simple digression, experimentation carried out for its own sake and intended to remain such. By virtue of his particular taste for technique, Degas soon invented new effects and combinations so that the art also came to penetrate his work with the other media and constitute a channel for radical innovations of a formal nature.

An artist with a predominantly linear thrust, Degas began to conjure up rather than draw his images with the monotype, to suggest the details rather than mark them down, allowing the thickened and blurred contours of his figures to relax gently. The decades of the 1870s and 1880s can be read as a period of transition in Degas's work, leading in the 1890s to a more vigorous expression of mass and contrast and a looser and freer use of light and colour. Having moved away from an incisive, linear and classical style, Degas developed a quicker, annotative manner closer to that of his Impressionist contemporaries. This change was probably due to the influence of the mono-

117. Edgar Degas
Le Maître de Ballet, ca 1874
Detail of top left corner of the artist's first black monotype, showing the signatures of Lepic and Degas
Rosenwald Collection, National Gallery of Art, Washington, D.C.

118. Edgar Degas working with Ludovic Napoléon Lepic
Le Maître de Ballet, ca 1874
Monotype obtained with the subtractive method, corrected and heightened with white chalk,
560 × 700 mm
Rosenwald Collection, National Gallery of Art, Washington, D.C.

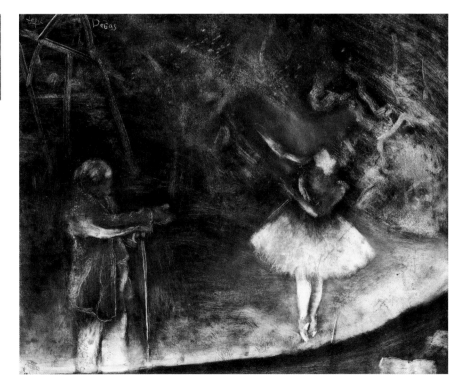

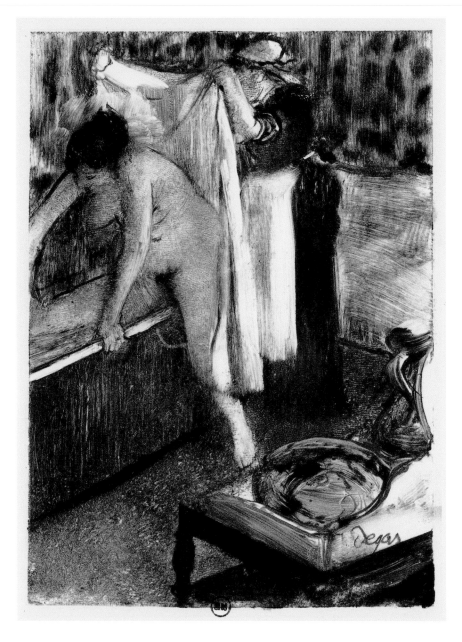

119. Edgar Degas
Sortie de bain, 1877
Monotype, black ink on white paper,
188 × 157 mm
Bibliothèque nationale de France, Paris

typing procedure over the rest of the artist's work, especially in charcoal
and pastel.

According to the evidence gathered by Denis Rouart from the artist himself,
it was during the printing of some of his etchings that Degas had the idea of ink-
ing a copper plate without engraving it and working it as a negative.[77] He thus
began to draw lines and shapes by removing the ink from the plate with a
hard, sharpened paintbrush, a piece of tarlatan or his fingers. He then printed it
on a sheet of paper just like a plate engraved with points or etched in acid. The
procedure was, however, already taking shape and the basic elements of the sub-
tractive system were also shown to him by his friend Lepic in 1875.

Unlike Lepic, however, Degas was not interested in the inking of an en-
graved plate but rather in the possibility of working even further on the still mal-
leable and unfinished stage of the sketch, in giving the work a chance to evolve,
to change into something else. The manual freedom of the monotype was a rev-
elation for an artist accustomed to leaving no room for spontaneity. Degas
soon began to use his fingers as well in order to attenuate the contrasts between
black and white, leaving visible imprints on the works. The oiliness of the

slow-drying printer's ink enabled him to work on the plate with constant changes.

Drawing by removal on a black ground initially helped Degas to solve the problem of composition. Having covered the plate completely with ink, he could work more easily on the overall compositional balance, visualising the design as a whole and establishing the positions of the figurative elements. The occasional use of sheets of transparent celluloid as plates enabled him to check on his work in its reversed state while it was still being developed.

Degas began to have problems with his sight in the 1870s and showed greater sensitivity to effects of light and shadow. Working with a simple medium like the subtractive monotype freed him from the constraints and specific focus imposed by the sharpened point of the pencil, thus allowing him to develop his compositions in larger, summarily sketched shapes and concentrate instead on tonal modulations.

In order to disrupt the rigidity of the delineation of contours and the density of matter, Degas used artificial light, which he introduced like Rembrandt from external sources such as a window, a candlestick, one lamp or stage-lights. He also created *chiaroscuro* effects on objects or figures simply by using the white of the sheet as a source of light, without having to worry about colour too at the same time.

120. Edgar Degas
Torse de femme, ca 1885
Monotype, bistre on Japanese paper,
500 × 393 mm
Bibliothèque nationale de France, Paris

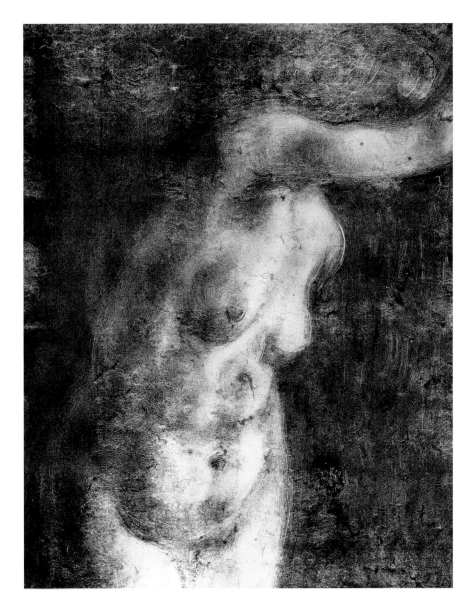

With the shading and interplay of transparency, it was in fact the paper itself that took the place of colour and enabled Degas to achieve delicate and sculptural tonal effects. One example is provided by the monotype *Torse de femme*, which assumes monumental proportions through its diagonal development and where movement is imprinted in the mass of ink that Degas shifted and calibrated with his fingers. The work, which verges on the drawing by virtue of its plastic quality, is also akin to sculpture in its effect of depth. In works such as *Chanteuse de Café-Concert*, where the dissolution of forms is indicative of a drive for transfiguration and detachment from the realistic vision, Degas achieved a dramatic, theatrical effect with overwhelming cascades of shadow.

After this first approach to monotyping, Degas began to draw on the plate in Indian ink, often diluting it with turpentine and working directly on the plate with a paintbrush. It was in this way that he executed most of the monotypes set in brothels and the series entitled *La Famille Cardinal*.

Degas often combined the two systems of monotyping and also began very soon to use the technique together with other media. Certain proofs were in fact reworked through the further addition of ink, tempera, pastel or oil paints, which sometimes took the place of the black printer's ink.

When Degas gradually began to explore colour it was with a view to decorating, shaping and filling in the intermediate values of the composition. He also used colour in order to give his shapes a three-dimensional quality and in some cases, surprisingly enough, went so far as to eliminate the black and white design completely. With the addition of pastel, Degas's monotypes soon established themselves among his greatest works and, as a result, he stopped using the more traditional oil paints around 1880.

As from his first monotype, Degas took a second impression from the plate, working in pastel on the still malleable and flexible stage of the basic composition. He would add figures or alter the composition so as to give it a different emphasis and vary the nuances of the compositional elements of the first impression. Greyer and displaying tonal values of a weaker and more evanescent nature, these second and sometimes third impressions would be reworked in pastel to create a series of correlated images assuming a sequential, narrative development like a series of cinematographic fragments.

Degas initially saw the monotype as a way of fixing colours on the paper without it being broken down by the organic components of the pastel (the bone used for black and the dark colours). Application on top of the monotype during the two days in which the paper still remained damp[78] enabled the pastels to penetrate deeply into the paper support and amalgamate with its fibres without growing mouldy.

If the use of pure pastel did not solve all the formal problems, Degas appears to have found a more congenial medium in its combination with the monotype. A quarter of his pastels are in fact produced on a monotype base.

Having taken up the monotype technique as a separate development within his oeuvre, Degas became increasingly interested in the medium in its own right because of its peculiar *chiaroscuro* qualities enabling him to obtain velvety blacks and dazzling whites. As attested by the small format reserved for monotypes—generally no larger than 30 × 40 cm—they were born as an intimate artistic form used by the artist for secret subjects such as the brothel scenes, which he addressed in no other medium. It was also through the monotype that Degas returned to a subject abandoned for decades, namely the landscape.

121. Edgar Degas
Ludovic Halévy parlant à Mme Cardinal, ca 1880
Monotype, black ink on white paper,
202 × 144 mm
Bibliothèque nationale de France, Paris

Already signed in the very pigments applied to the plate, the monotype was not, however, intended to remain as no more than a visual soliloquy or to circulate solely among the artist's friends. If this was the situation at the beginning, it was certainly not so at the end.

The grim political atmosphere of the late 1870s saw a rapid dwindling of economic resources that destabilised the fragile art market. Full of debts and with his personal fortune all spent, Degas endeavoured to recoup his finances by selling what he called his articles, including pastels, fans, unusual modern and experimental objects, and monotypes. Having emerged from the strictly confidential dimension of the studio, the latter took on a life of their own, setting off on a path that led in time from initial uncertainty to increasingly extraordinary developments with repercussions of unexpected breadth.

It is significant that someone as self-effacing as Degas, who loathed all forms of publicity and frequently reiterated to his friends the Rouarts his desire to become "illustrious and unknown", should have included monotypes in the very few exhibitions he agreed to hold during his life. The first works produced with this technique, monochromes of a predominantly linear structure, appeared as early as the Impressionists' third exhibition in 1877 alongside pastels and paintings.

The "pure" monotypes executed in printer's ink with no added pastel reflect the more nocturnal and saturnine aspect of Degas's art. Almost as though intended for a secret destination, they often respond to a vocation for social truth and an objective gaze that is sometimes tolerant and never surprised. While they add nothing to what is already known about his private life as a middle-class misanthrope and confirmed bachelor, these monotypes reveal to a far greater extent than the pastels the frankness of his vision and his modern sensibility and attention to the times in which he lived.

Left in their natural raw state without the virtuoso addition of pastel colours or tempera, these works have a quality of furtiveness or, in the case of his nudes and depictions of the female toilette, poignancy. The strokes are now brisk, the material fluid and the foreshortening surprising, almost as though Degas were jotting down the scenes impromptu, unbeknown to the figures involved. Captured by his eye as though in a snapshot, they were in fact executed from memory or imagination on the artist's return to his studio in an indiscreet re-creation of the instant.[79]

These monotypes in black and white can be divided on the basis of subject matter: the series of brothel scenes executed in 1879 and 1880; the series entitled *La Famille Cardinal* produced immediately afterward, between 1880 and 1883, as illustrations for a new edition of the book of the same name by Ludovic

122. Edgar Degas
Les Repasseuses, ca 1880
Monotype, black ink on white paper,
226 × 428 mm
Jacques Doucet Collection,
Bibliothèque de l'INHA, Paris

Halévy; the nudes (studies of the female toilette) and female figures (dancers, singers and laundresses).

The series of thirty monotypes for *La Famille Cardinal* is the only one intended for a larger public, plans having been made for reproduction by means of rotogravure. Executed with a freer and lighter technique in black ink and bistre, the series was never published due to a combination of circumstances and was purchased ten years after the artist's death by a group of art lovers. It was not until in 1938, some 60 years after their conception, that the monotypes were made public in facsimile reproductions by Maurice Potin.

There must have been over a hundred works in black and white originally. Fifty are documented but the remaining 50–70 were destroyed by the artist's brother René de Gas—who retained the aristocratic form of the family name—when preparing the sale of the studio works in November 1918, after Edgar's death. The monotypes are thought to have been left unclassified in folders by the artist pending selection for reworking in pastel or definitive abandonment.

According to Ambroise Vollard, none of the destroyed monotypes depicted brothel scenes. It would therefore not have been the unseemly subject matter of the works that René de Gas sought to suppress but rather their lack of finish, which could have damaged his brother's artistic reputation. Françoise Cachin, the author of a specific study and the first catalogue of the artist's pure monotypes, does not, however, rule out the possibility of their having been destroyed because of their erotic iconography.

Intimate indicators of the artist's love-hate relationship with women—the obsessive theme running all through his career—these monotypes also reflect the interest of the period in documentation on prostitution.[80]

With respect to the lithographs of Toulouse-Lautrec on the same subject, Degas's brothel scenes have darker and less indulgent overtones. Given their often pornographic nature, it was long believed that they were intended as illustrations for a literary work, but no evidence of any such project has yet been found.

There are many monotypes in black or coloured ink that Degas evidently regarded as finished works to the point of signing them and giving them to friends. It is more difficult to understand whether he also regarded those in colour left in the folders without the final retouching in pastel as finished works, or whether it is rather our modern eye that now, nearly one hundred years after their rediscovery, completes and appreciates them through the recent experience of abstract art.

Celebrated for his pastels, Degas also had, however, a deep relationship of expressive affinity with the black and white and tonal rendering of printer's inks.

In 1906, old and disenchanted with the sensual beauty of colour, he stated that if he had to start all over again, he would work only in black and white.

123. Anonymous
Journey from Paris to Dienay between 30 September and 19 October 1890
Colour map of the journey illustrated by four photographs showing Degas and Bartholomé in their gig
Bibliothèque nationale de France, Paris

Degas loathed the finished work to such an extent that he never had any of his sculptures cast during his lifetime, being instead enamoured of transformation, the unfolding of procedures and the diversification of cycles. Accustomed to the use of tracing paper[81] through his experience of lithography and hence skilled in transferring a work from one support to another, he strove incessantly to combine the two procedures dearest to him, namely pastel and print.

In the series of landscape monotypes of 1890–91 Degas threw himself into a still more open and "unfinished" experience than the previous one. The experimental use of colour enabled him to achieve a synthesis of drawing and tone.

He worked with the subtractive method but replaced black printer's ink with coloured pigments, mostly oil paints diluted with turpentine. This was a new and significant way of monotyping, not only because it enhanced the visionary and precarious character of the forms suggested but also because Degas used it in order to address the landscape, a highly unusual and surprising subject in the overall context of his oeuvre. It was in fact through this form of coloured monotype that the artist, so at home in the corridors of theatres and indifferent to the charm of nature, returned to this genre after an interval of over 20 years.

When this happened in the 1890s, his position with respect to the landscape was definitely very different from the classic and figurative approach. His landscapes seem to be dictated by a drive for the stark and unadorned. The faint, blurred contours verge on illegibility and it is difficult to detect any similarity with the places depicted in his basic compositions before their reworking in tempera or pastel. It was in fact through the addition of colour that Degas defined and restored decipherability to the underlying monotype background. Developed through contrasts with no precise forms, this was thus transformed into landscape. The use of unusual, intense and varied colour, simultaneously bright and glaring, lends a new and wholly unprecedented character to these works, where tonal contrast is accentuated by the reduced scale of the landscapes.

A passage in the memoirs of Georges Jeanniot, whom Degas and Bartholomé visited in the autumn of 1890 at Diénay in Burgundy, paints a precise and colourful picture of the artist using this technique and constitutes an extraordinary document quoted here in full.

"Degas was enthusiastic about his journey. He had noted various moments in his extraordinary memory and reworked them mentally during the few days he spent with us…
– Now take me to your studio, said Degas as soon as we rose from the table. On entering it, an expression of delight and satisfaction spread all over his face, even though that country studio set up at the top of the house was really very simple: an attic with a few ancient chairs, two or three easels, a divan with cushions, a press, a stove and everything needed to make engravings.

– Fine, he exclaimed. We can set to work in this Swiss clockmaker's workshop. You have paper, ink, a brush with your initials! Heavens! … Well then, it's a serious business. This pad is magnificent and fits easily into the hand. Come on! Do you have a smock?

– Yes, and a brand new printer's overall.

– Does your press have only one gear? It looks a bit stiff.

– Yes, very, but we have our muscles!

– Your studio is charming.

I helped him into the overall. He had taken off his coat and rolled up his shirt-sleeves.

– Do you have plates of zinc or copper? … Here we are. … Perfect. I will ask you for a piece of material to make a pad for my exclusive use. I've been wanting to do a series of monotypes for so long now!

Once provided with everything he needed, without wasting time or getting distracted from his idea, he began. His strong but shapely fingers seized the objects and tools and handled them with strange dexterity… Little by little everything fell into order and into place, the tones blended fraternally and the handle of the paintbrush traced light shapes in the wet paint. These beautiful things were born with no apparent effort, as though he had a model in front of him. Bartholomé recognised the places they had trotted past and was amazed to see him draw the landscapes as though they were still before his eyes.

– Just think, he said, that he did not make me stop even once so as to observe them at his leisure!…

Degas spoke after a half an hour or perhaps a little more:

– Shall we try to pull this proof? Is the paper wet? Do you have a sponge? Did you know that semi-sized paper is the best?

– Don't worry. I have some very strong China paper.

– Well, let's see it…

I placed a majestic roll on the corner of the table. When everything was ready, the plate placed on the press and the paper on the plate, Degas said:

– What a nerve-racking moment! Roll! Roll!

125. Georges Jeanniot
Le Traînard, ca 1890
Monotype, 263 × 205 mm
Note below left, under the signature,
"made following Degas's instructions"
Jacques Doucet Collection,
Bibliothèque de l'INHA, Paris

126. Edgar Degas
Village dans l'Esterel, 1890
Monotype in oils, 119 × 161 mm (image)
Bibliothèque nationale de France, Paris

It was an ancient press with a heavy cross-shaped wheel. The proofs were hung on lines and left to dry. We printed three or four per session. He always asked for pastels to finish the monotypes at that point, and it was there, even more than in the creation of the proof, that I admired his taste, his imagination and the vividness of his memory. He remembered the variety of shapes, the morphology of the landscapes, the oppositions and their surprising contrasts all perfectly. It was a spellbinding moment.

… A valley, a sky, white houses and fruit trees with black branches could gradually be seen to emerge on the surface of the plate, … and oaks, furrows full of water after recent rainfall, orange-coloured clouds scudding across the sky above the red and green earth."[82]

Degas continued to work on this series after his return to Paris and completed it few months before the show at the Galerie Durand-Ruel in 1892.[83] This experience was followed by a new series of monotypes again done from memory, this time of landscapes glimpsed from a moving train. Unlike his Impressionist friends, Degas disliked painting *en plein air*.

As a result of the greater speed of the means of transport involved, Degas now omitted every detail, all the incidental and more precise forms of what he saw, retaining only the common, basic characteristics and the general rhythm. The colouring of this new series was also different. More complex in character, it generally had a neutral, muted tonality remaining within the range of earthen hues. Thicker, drier and less fluid, appearing to have been mixed with pastel or red chalk, the colours were no longer added later but run through the press, as attested by the crushing of their molecules.

There are over 65 known monotypes of landscapes, differing in size but all more or less of the same reduced format, 29 of which bear the artist's signature instead of the red or black stamp affixed when the works in the artist's studio were sold off. Second impressions were taken from at least ten of the signed works and presumably shown alongside them in the exhibition at the Galerie Durand-Ruel.[84]

127. Anonymous
Portrait of Henri Rouart, ca 1895
Photograph
Bibliothèque nationale de France, Paris

Critics today believe, on the contrary, that it was a shrewd move on the part of the 60-year-old artist,[85] who was undoubtedly aware of the success obtained by Monet with a show of landscapes focusing exclusively on poplars and sheaves of corn. He also knew that Durand-Ruel habitually exhibited the experimental prints of Mary Cassatt and Pissarro.

His decision to show a series of prints of landscapes produced by means of an innovative technique could therefore also be interpreted as a deliberate attempt to attract attention and assume the position of a leader of the avant-garde.

This did not, however, prevent the show from being practically confidential in character due to the artist's loathing of the more glaring and vulgar aspects of direct publicity. There were in any case enough collectors and art lovers eager to buy his works and he had no need to make himself known to or popular with the general public.

With respect to the gallery's actual capacity, the show was on an almost modest scale—allowing Durand-Ruel to exhibit the works of the painter Sébastien Lépine at the same time—and occupied one of the two rooms on Rue Laffitte from the beginning of November until 4 December at least. It was, however, quite extraordinary for a number of reasons and triggered developments that can be seen in retrospect as sensational.

Although Degas's work was already well established and comparatively accessible in Paris, the exhibition marked the first official showing of his works on such a scale, comprising a score of new paintings and the series of monotypes. Still more significant is the fact that Degas chose for this rare event to present not only landscapes but landscapes produced by means of a largely unknown technique.

Despite the conditions of discretion insisted upon by Degas, opposed not only to the presence of the press but also to invitations and a vernissage, a dozen critics who normally covered artistic events and the literary avant-garde wrote positive reviews. There was one exception: "I defy anyone to tell me what it is all about at first sight. Then, if you look hard, you can see patches of red ochre or mossy green deftly combined, a small hill, a clump of trees, a path, a stream, one or two houses over the back of a cow. But the symphony still remains quite incomprehensible."[86]

Arsène Alexander interpreted these works as "sensations and distant memories of nature" rather than landscapes: "It is particularly difficult to penetrate these landscapes, mysterious fruits of the perfect, artful and captivating pulverisation of materials in which M. Degas has indulged. There is everything one can imagine: watercolour applied with a large brush as though it were oil paint, then mixed with tempera, and then reworked and accentuated in pastel; not only sponged and embellished with a piece of gauze but also squashed with the fingertips like a child making mud pies. In short, everything that could come to mind or be found ready to hand has been used to create something sharp and appetising. And supreme elegance is born out of what we can only call this brilliant cookery, in which expertise and improvisation are constantly vying with one another".

Apart from the artist's close friends—and Jeanniot and Bartholomé, who knew the exact places from which Degas had drawn inspiration for his works—the public and critics all assumed that they were imaginary landscapes. Raoul Sertat made this comment in the influential *Revue Encyclopédique* a few months after the end of the exhibition: "There are more evocations of states of mind to be found than representations of states of nature; the artistic sphere to which they belong is extremely sophisticated and accessible only to the most refined sensibilities."

Always ready to support his Impressionist friends, Mallarmé was most enthusiastic about this unusual show, where technique and subject matter were handled in such a personal way as to recall the world of dreams. It was clear to the French poet that Degas had left his contemporaries far behind with these landscape monotypes and he made great but fruitless efforts to persuade the state to purchase one of them.

As regards the artist's closest circle of friends, the Impressionist painter and great collector Henri Rouart was full of admiration, as was Camille Pissarro, who wrote in these terms to his son Lucien, albeit with some reservations: "Degas is holding an exhibition of landscapes, sketches in pastel similar to coloured prints. They are very odd, a bit clumsy but exceptionally delicate in tone".

The show was quite successful in financial terms, with half of the works exhibited being sold at Durand-Ruel's high price of 2,000 francs each in less then two years. Two-thirds of the monotypes were bought by foreign collectors, mostly

Americans. Despite his initial misgivings about this unusual technique, Durand-Ruel bought some of the works exhibited directly from the artist after the show for the remarkable figure of 1,000 francs each.

Durand-Ruel bought another series of 22 monotypes from Degas in 1893 and sold them to American collectors through his gallery in New York. The purchasers included Henry and Louisine Havemeyer, who built up what was probably the most important collection of Impressionist art in America at the time, partially on the basis of Mary Cassatt's advice.[87] There was in fact more foreign than French interest in Degas's exceptional series of landscapes and most of these works soon found homes in the United States.[88] The Boston Museum was the first to come into possession of monotype landscapes by Degas through a donation in 1909, when the artist was still alive.

After the historic exhibition at the Galerie Durand-Ruel, the monotype landscapes were shown at the Galerie Lefevre in 1958, when the lyrical abstraction movement was in full swing, and then again in Paris at the Galerie Œil in 1964.

Even though Degas's monotypes were known to many artists, including Gauguin and Toulouse-Lautrec, this part of the artist's oeuvre remained generally inaccessible.

After the showing of three monotypes in black ink at the Impressionists' exhibition of 1877, it was not until 1892 that the series of landscapes in colour reworked in pastel was presented at the Galerie Durand-Ruel. Taking the studio sale in 1918 as a starting point, Louis Delteil, one of the most important historians of nineteenth-century printmaking, published a *catalogue raisonné* of Degas's graphic work without including the monotypes. They were not presented to a limited public until 1935, a long time after the artist's death, when Ambroise Vollard reproduced the brothel scenes for his 1934 edition of Guy de Maupassant's *La Maison Tellier* and for *Mimes de courtisanes* by Pierre Louys.

Appreciated only by rare initiates like Henri Rouart's son Denis and collectors of the artist's work, the monotypes thus remained practically unknown to the general public until the last forty years, and even then the response of modern critics has varied greatly. John Rewald, for example, regards them as untypical of Degas's work of the period and no more than minor works with respect to his "incomparably more important"[89] pastels of ballet dancers or nudes.

The Fogg Art Museum, Boston, exhibited them for the first time in America in 1968, revealing the originality and breadth of Degas's explorations of the medium. The impact was enormous and made itself felt in the major art centres of the USA, including New York, Boston, Philadelphia, Los Angeles and San Francisco. The exhibition and the catalogue by Eugenia Parry Janis triggered a whole series of works and exhibitions fostering the success of the monotype among painters and sculptors in the United States.[90]

The 78 monotypes exhibited constituted a point of departure for many artists in the 1970s, for whom Degas's work prompted not imitation but deep consideration of how much the technique had to offer. Following in the French master's footsteps, many artists tried their hand at both the subtractive and the additive methods, often combining them in the same work. They printed the same composition repeatedly, reworking the "ghost image" and the counterproofs to create sequential series. While *chiaroscuro* and oil paints

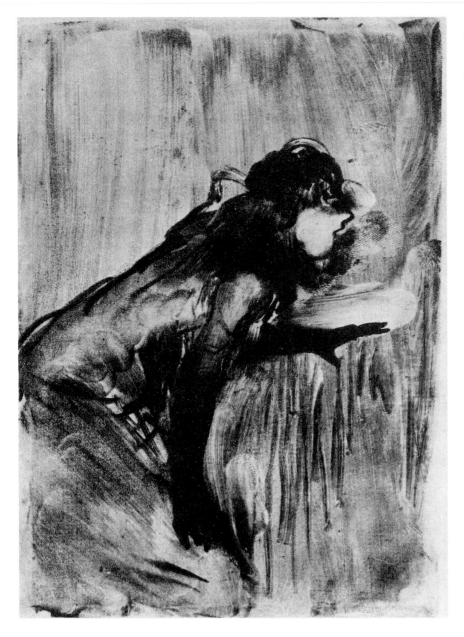

128. Edgar Degas
Chanteuse de Café-Concert, ca 1878
Monotype, black ink on laid paper,
185 × 128 mm
Formerly in the E.W. Kornfeld and Klipstein
Collection, Berne

were used in the compositional rendering of mass and above all landscapes, intimate subject matter and a reworking of the composition in pastel become an integral part of an artistic toolkit ready for use in exploring different directions.

Among the many accounts, particular importance attaches to the one provided by the American Michel Mazur, who was particularly struck by the show and became a key figure in popularising the monotype technique through his work and teaching: "One close look at Degas's *Café-Concert Singer* was all I really needed to get started. This tiny explosive image, a spontaneous gift of the artist's spirit, seemed to have breathed directly on the paper in one magical gesture. A closer look reveals Degas's labor. His fingers pushed in ink like modelling clay. His painter's cloth wiped out the black ink for luminous whites. His brush added telling contours. At just the right moment he printed his constellation of tones, not much more than a cluster of smudges. But when the paper emerged from the press, still damp and pliant, those little marks became flesh, hair, fabric: a nose and mouth in one line; a gloved hand, corrected and redrawn. They became a spotlighted café singer, bawdy and as aggressive as the

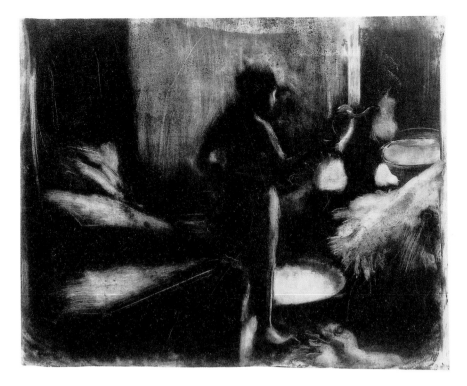

strokes that made her. The spontaneity and energy in that little print lifts the medium into art". [91]

By virtue of their character of great awareness and conceptual unity, the monotypes in colour are regarded by modern critics as encapsulating the essence of what Degas wished to show. Described as "a mirror along the way made magical by the visual intelligence of its creator", [92] they are often seen today as a visionary foreshadowing of lyrical abstraction.

The artists close to Degas

The end of the nineteenth century saw the expansion and technical evolution of the broad range of procedures and approaches characterising the art of printmaking. These new procedures focused above all on pictorial and autographic techniques also accommodating fortuitous elements, such as the *cliché-verre*, the mobile etching and the monotype.

Many artists found themselves caught up in this almost willy-nilly, like Mary Cassatt with her monotyped etching *La leçon de banjo* and Pissarro with the second state of his *Les Mendiants*, where the exuberant inking plays a new role and makes the print a singular but also unique impression.

Practically all the artists tried their hand. While some did not go all the way, e.g., Manet and Whistler, others like Bracquemond, Buhot, Cassatt, Forain, Legrand, Steinlen and Toulouse-Lautrec did produce some, albeit sporadic, monotypes.

A more systematic approach was instead taken by some artists, especially Pissarro, Gauguin and De Nittis, who took up monotyping precisely when Degas's own involvement with it was coming to an end. Gauguin, for example, began to take an interest in monotypes after he had seen Degas's works at Vollard's and bought one despite his straitened financial circumstances.

Given the large number of monotypes produced by Degas and the great recognition bestowed upon him during his life by fellow artists, it is, however, surprising that his interest in monotyping did not have a deeper impact on the artists of his immediate circle.

130. Théophile-Alexandre Steinlen
Voyage de noces
Monotype, 295 × 293 mm
Jacques Doucet Collection,
Bibliothèque de l'INHA, Paris

Due to his strong personality, Degas had no direct pupils. He was too "original" and independent to be systematically followed by others with any constancy. He had few friends, even though he did attract the new intelligentsia and acquire imitators in the literary and artistic cafés among young people in search of a master, like Jean-Louis Forain and André Gil. The serried ranks of his admirers also included Marcellin Desboutin, Camille Pissarro and Giuseppe de Nittis, as well as the younger Toulouse-Lautrec and Mary Cassatt, a rich American who had been making a tour of Europe for a few years. These were painters that Degas esteemed and chose carefully for short-lived undertakings like the magazine *Le Jour et la Nuit*, artists he encouraged and defended, artists to whom he communicated his passion for printmaking and interest in experiments and new techniques.

It was thanks to Degas that Mary Cassatt, De Nittis and Pissarro were included in the Impressionists' exhibitions, often against the wishes of others. The artist's remote Italian origins helped to make him well disposed towards De Nittis and the other Italian artists in Paris, including Boldini, Zandomeneghi and Medardo Rosso. He was also a regular guest at the soirées held by De Nittis and his wife Léontine every Saturday.

Degas displayed an attitude of particular consideration and paternal benevolence towards Gauguin, who appears to have had a knack for getting himself disliked and indeed hated. Degas introduced and recommended him to Durand-Ruel and went on believing in him even when all the others had turned their backs. "Degas is the only one that admires him". This was Pissarro's comment in a letter to his son in 1893, where he criticised an exhibition of work by Gauguin as "anti-artistic … exotic and full of too many natives". Degas was indeed unswerving in his admiration and encouragement of Gauguin: "You are on the right track". He

131. Camille Pissarro
Femme vidant une brouette, 1880
Etching, aquatint and drypoint, state XI,
319 × 235 mm
Bibliothèque nationale de France, Paris

132. Camille Pissarro
Paysanne portant une manne, ca 1889
Colour monotype, 155 × 48 mm
Private collection, Paris

also bought one of Gauguin's monotypes, which he admired, and received another, done in watercolour, as a gift from the artist with a personal dedication.

Described with Degas as "the Impressionist closest to printmaking and the most Impressionistic of printmakers", Camille Pissarro (1830–1903) discovered etching when, as he put it, "no one was doing anything else". Encouraged by the Société des Aquafortistes and various dealers, he became the most interested and active of all his contemporaries in this field, etching some 200 plates. He worked above all with coloured etchings but also with lithographs.

Apart from the need to earn a living, it was the close friendship and artistic kinship established with Degas in 1878 that steered Pissarro in this direction. He produced his first series of etchings as early as 1879. Not being able to afford his own press, he used the equipment of his more affluent friend, who indeed printed some of them for him. This is why many of the first impressions bear the indication "printed by Degas" beside the signature.

It was instead Pissarro that printed proofs for Degas after 1894, when he acquired his own press, trying out sequences of variations in colour. This common passion for printmaking preserved the close relationship between the two artists despite their differences at the personal and social level. Pissarro, the son of a grocer in the Danish Antilles, was a militant socialist; Degas, the son of a banker and an aristocrat by origin, was a conservative.

Having embraced an aesthetic in which the work of art is defined through opposition to the mass-produced article and the rarity of a work is the sole criterion of importance to its owner, Pissarro followed Degas in focusing on the "singular" nature of the print. At the moment of printing he employed particular and highly elaborate procedures leading to extreme rarefaction of the impressions to be obtained from his plates: "Many proofs are signed by Pissarro … and each of these is different. They are engraved monotypes…".[93]

This is evident above all in the works originally intended for the magazine *Le Jour et la Nuit*, Degas's utopian project that was never to see the light of day. Complex to the point of making no concessions to the requirements of publishing, these prints are practically unique works and closer in aesthetic terms to pastels and watercolours than traditional etchings.

While Degas adopted an approach midway between art and industry in an attempt to incorporate the new procedures into the artistic field, Pissarro took a more intransigent stance and rejected any technical compromise that could betray the personal nature of the work, being openly hostile to systems of mass reproduction like photogravure. It was for this reason, for example, that he clashed with Durand-Ruel in 1885 over plans to reproduce his paintings in a catalogue of the latter's gallery in the United States.

Before arriving at the monotype, Pissarro experimented with effects of carefully inking the mobile etchings so as to differentiate each impression. An example is provided by *Les Meules*, the printing of which has been described as "astonishing". Pissarro clearly saw this experience of printmaking as very different from the process of identical reproduction that still characterises the print today, even when referred to as "original". His works seem indeed to contradict the very nature of a medium born for the specific purpose of reproduction.[94]

Pissarro saw Degas's monotypes at the Impressionists' third exhibition in 1877, in which he also participated. It is, however, very probable that he ex-

amined the procedure more closely between 1878 and 1880, when working together with Degas on the project of *Le Jour et la Nuit*. The whole variety of complex intaglio techniques revised and redeveloped in that period by the two artists may well have included monotyping.

Although involved in the field of monotype to a far lesser degree than Degas, Pissarro certainly appreciated the medium and regarded his own monotypes, despite their experimental character, as finished works in their own right. By comparison with Degas, who planned his monotypes with the deliberate intention of producing artistic creations, Pissarro took a more vigorous approach and applied the ink in a much more direct way. In order either to deepen the tones or to achieve transparency, he sometimes worked with a pad soaked in a solution of petroleum (a method that he and Whistler were the only ones to use).

No monotypes have yet been found in which Pissarro uses the subtractive method to bring the images out of the dark background. His figurative contours are instead always built up with bold, thick brushstrokes and the resulting images are thus concrete, real and immediately legible.

Although Pissarro worked primarily with colour, his monotypes are mostly in black and white, albeit quite often with added touches of colour or accentuation of the dark areas in order to increase the pictorial effect. The viscosity of the inks used was such that they often left a residue on the sheet, which makes it hard to establish whether the heavy, opaque pigments were applied directly on the plate or on the paper after printing.

Barbara Stern Shapiro, who catalogued Pissarro's monotypes, suggests that the artist may have retouched the colours after printing because he was not completely satisfied with the result obtained. It is, however, hard to believe that he applied the colour after running the plate through the press, not least in the light of a precise remark made in this connection: "We want to obtain a softened image before the impression is printed".

It appears more plausible to suggest that Pissarro developed his own interpretation of the technique and worked energetically on the smooth surface of the plate to retouch the image with heavier pigments. In any case, all his monotypes present substantial layers of material and recall the way in which the artist worked the canvases of the previous decade with thick strokes of oil paint.

The monotypes reveal the artist's preference for country life in their choice of subject matter but also display attention to line, which is simply drawn, while the forms are simultaneously massive and subtle. The artist often addressed the same themes at the same time in print and painting or returned to old subjects (bathers on tree-lined riverbanks, landscapes, markets or country folk picking vegetables).

Pissarro's monotype *Paysannes nues sur l'herbe* is closely akin to Gauguin's works in terms of its decorative composition and heavy arabesques. The strangest—and technically the most puzzling—is *Paysanne portant une manne* (ca 1889), apparently the counterproof of an image painted in tempera on a small zinc plate. Pissarro appears to have taken an impression on paper and then reworked it with tempera.

The monotype *Sentier dans un champ de choux* displays many similarities with Degas's series of monotype landscapes as regards compositional approach and the flattening of space as well as the way of spreading and moving the ink on the plate.

133. Camille Pissarro
Paysannes nues sur l'herbe, 1895
Monotype, 128 × 179 mm
California Palace of the Legion of Honour,
San Francisco
Formerly part of the Orovida Pissarro Collection

In the 1890s, having become more sedentary, Pissarro began to produce studies of models, but working from photographs rather than life. The recent identification of two photographic nudes from which the artist evidently drew inspiration for one of his last monotypes, *Paysanne enfilant sa chemise* (1897), sheds new light on the development of this work. The geometric and ultimately graphic composition clearly shows a focus both on line and on volume.[95] Pissarro took the silhouette of the body from the photograph *Nu de dos* by Julien Vallou de Villeneuve, faithfully reproducing the model's hairstyle, and the bed and curtains from *Le Coucher* by Antoine Moulin.

After the first experiments carried out between 1877 and 1880, Pissarro concentrated his work with the monotype in the very short period from 1894 to 1895, after which he probably found etching and painting a more interesting outlet for his extraordinary productive capacity and work on light and pictorial effects.

Pissarro's monotypes have yet to be definitively catalogued. While only about 30 are known today, a letter written to his son shows that the actual number must have been much higher. While we do not know precisely how many, we do know the circumstances of their birth. In the winter of 1894, having finally received the press bought from Delâtre and eagerly awaiting the arrival of ink for printing, he wrote as follows with reference to his first monotypes: "I am waiting for the ink for printing. We have tried with oil paint. It will be sensational. It will rekindle my enthusiasm."[96]

Another reference is contained in a letter dated 8 April 1895: "What a pity that they don't want my prints. I find them at least as interesting as the paintings the others are doing."[97]

Responsive to the new schools and styles that took over from Impressionism—being one of the first, for example, to recognise the importance of Cézanne, Gauguin and Van Gogh—Pissarro evolved aesthetically towards starkness and idyllic themes. His figuration gradually became strong, ingenuous and primordial and his subject matter seems to suggest a sort of childhood of art.

The monotype, which had no commercial value at that time, seems by virtue of its simultaneously elementary and sophisticated technique to have

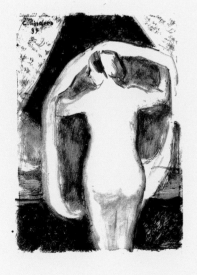

134. Camille Pissarro
Paysanne enfilant sa chemise, 1897
Monotype, 231 × 167 mm
Bibliothèque nationale de France, Paris

solved the equation of work that is both simple and in line with Pissarro's populist leanings.

"…nobody can tell if it is a painting, a drawing or a print, nor, between a print or a drawing, which is the *recto* or the *verso*".
Joann Moser

After a period of development in which he was alternately swayed by the influence of Pissarro and Degas, Paul Gauguin (1848–1903) abandoned all aesthetic safety at the beginning of the 1880s and decided to risk his all. A visionary adopting the most adversarial of attitudes towards schools and studios, he produced unpolished graphic works without the slightest concession to the bourgeois aesthetic of beauty and gracefulness, asserting their formal independence and harmony with primitive instinctiveness.

Rejecting the hierarchy of artistic values, Gauguin did not work solely within the sphere of "great art" but channelled the same passion into what are considered the "minor" arts or peripheral fields. He did not separate and distinguish techniques but, as in primitive art, aimed at a unity of meaning and form, which he rediscovered in the artisanal unity of the very gesture with which he cut into the wood to make a print or a sculpture.

Gauguin devoted himself to both painting and sculpture as from 1881. He carved furniture and objects for his apartment, produced ceramics and also planned to take up tapestry. He hung the walls of his home with panels carved in low relief and his own woodcuts, as though seeking to give them the same decorative colour and purpose through this proximity.

Gauguin produced prints, especially woodcuts, as a self-taught practitioner. If he did take conventional procedures as his starting point, he would then find a way to break away from current practice. His was a form of printmaking executed in defiance of the rules and direct opposition to the type practised in the printing works of the time, oozing "expertise" and the proliferation of technical marvels. It represents an intimate moment, a solitary artistic project. His editions were always very small and the systems used to print them were always new and above all, with a view to life on Tahiti, simple and rudimentary. He would also ink the wooden blocks selectively each time so as to vary every impression.

Gauguin's involvement with woodcut led him to produce works that he called "traced monotypes", "transferred drawings" or "printed drawings", which represent the core of his output in graphic art.

In this area, as was his habit, Gauguin paid no attention to anyone else, not even Degas and Pissarro, and obtained results with no historical precedent.[98] He combined and harmonised painting, drawing, print and ultimately even sculpture. He eliminated the distances always placed between techniques and procedures, using one or another quite indiscriminately.

Gauguin began by producing about thirty monotypes in Brittany in the summer of 1894, between two trips to Tahiti. Alone, stuck in his small hotel room due to a broken ankle, he took up his brushes and devised a system to transfer images produced with colours soluble in water—tempera, pastel and watercolour—onto another support. He placed a thoroughly soaked sheet of paper on top of the "matrix" design and rubbed it with the back of a spoon, varying the pressure, until the coloured pigments had been transferred to the second sheet as a mirror image of the original.

As a starting point for these compositions, all of reduced format and executed with simple materials, Gauguin often drew inspiration from details of his own paintings. The central figure in *L'Angelus* is thus taken from *Jeune chrétienne*, a work in oil on canvas. He sometimes took more than one impression from the support, as in the case of *Te nave nave fenua*, a monotype in three impressions of gradually increasing rarefaction and evanescence.

The subjects come above all from the exotic world of Tahiti and the characters are almost exclusively women, who are depicted talking to one another, bathing or sitting with their backs turned, indifferent to any observer. Gauguin also used Breton subjects in some cases, which prove very similar to the Tahitian ones through their focus on primitivism. Regardless of whether they depict the exotic nature of Polynesia or Brittany, Gauguin's images are no longer the fruit of direct observation. Retained in the memory and reworked in a Symbolist perspective, they are rather the product of a waking dream.

Gauguin's coloured monotypes are based on the ancient and simple procedure of the counterproof, and recall William Blake's use of millboard 150 years earlier to print his coloured illustrations for editions of books. There is nothing to suggest that Gauguin ever saw Blake's monotypes done in tempera and his artistic intention was in any case very different due to his less intellectual and more physical and primitive aesthetic.

Like Blake, Gauguin used colours taken from pigments soluble in water, which he "printed" from a paper surface, and created his composition with very strong contour lines. But while Blake used ordinary cardboard with no specific character, being obviously indifferent to the physical substance of the surface from which he transferred the image, Gauguin was very careful about the paper used. In transferring its grain onto the sheet on which his "print" appeared, he deliberately caused it to become an integral part of the work. In order to enhance the physical effect of the ground still further, Gauguin sometimes chose not to print from a single surface, like a paper sheet, but instead combined paper with what appear to have been pieces of cardboard, wood and cloth.

While Gauguin is certainly not the only one to have produced coloured monotypes in 1894, it is not certain whether he had seen those of Degas or his old friend Pissarro, which are probably later, at the time. In any case, it was in 1887 that Gauguin started pressing sheets of paper onto freshly painted images so as to obtain impressions in colour.

And even if his monotypes are similar in some stylistic and technical respects to those of Pissarro and to the landscapes Degas produced over the period 1890–91, he certainly did not allow himself to be influenced by these works, knowing well that imitation would lead him to adulteration and impotence.

With these works in watercolour, their colours slightly muted by the transfer process, Gauguin definitively abandoned the parameters of the classic print. His colour relinquished all descriptive intention and became the expression of a feeling or a symbol, thus paving the way for the Fauves. Although there is nothing spontaneous in these monotypes, Gauguin called them "sketches"[99] in order to emphasise their informal character. However, there can be no doubt of his consideration for these works, which he exhibited in his studio in December 1894 alongside the paintings of the first trip to Tahiti and the woodcuts of 1893–94.

Gauguin returned to Polynesia in July 1895 and executed numerous monotypes by means of a new system, probably with the intention of producing illustrations for a newspaper. The simple procedure was well suited to the Spartan conditions of his studio. Having neither a press nor metal plates, he used sheets spread with thick layers of sticky printer's ink or paint as a support to transfer his images in a way similar to carbon paper.

Gauguin executed a series of woodcuts for Vollard in 1899, on his return to France, followed immediately by what were then to be called "print drawings". All signed, often by means of the monotype technique, and very large in format for the time, they were unique finished works clearly intended for sale. Gauguin mentioned these monotypes in a letter to Vollard in January 1900: "I have just carried out a series of experiments with drawings that I find very satisfactory and I am sending a small specimen. It looks like a print but isn't one. I have used very thick ink instead of a pencil. That's all."[100]

Gauguin sent ten of these works to Vollard in the spring of the same year, calling them "drawing experiments". Much like Degas, who described his own works as "drawings done in oily ink and printed", he was still calling them "drawings" in 1901: "This month I am sending you 10 drawings. At the price you offer of 40 francs each, that makes 400 francs."[101]

These daring images on large sheets of paper appear to have been group studies. Not having sufficiently large sheets of paper to use as an inked support, Gauguin combined two overlapping sheets of ordinary, medium-weight paper. The technique, which he described as "child's play", could not have been simpler. He gave the following outline some years later, in 1903, in a letter to his friend and collector Gustave Fayet, then conservator at the Musée des Beaux-Arts in Béziers: "First spread printer's ink with a roller on any type of paper. Then place a second sheet on top of the first and draw whatever you like on it. The stronger and thinner the stroke (and the paper), the more beautiful and delicate the stroke produced will be."[102]

Gauguin thus inked over a sheet of paper completely and covered it with another sheet, on which he executed a drawing in pencil or blue wax crayons. The dense and very sticky ink of the second sheet captured in reverse only what was traced upon it and created a monotype on the back of the sheet.

Contrary to what might have been expected, the primary composition, the one Gauguin regarded as his work, was not in fact the original drawing but

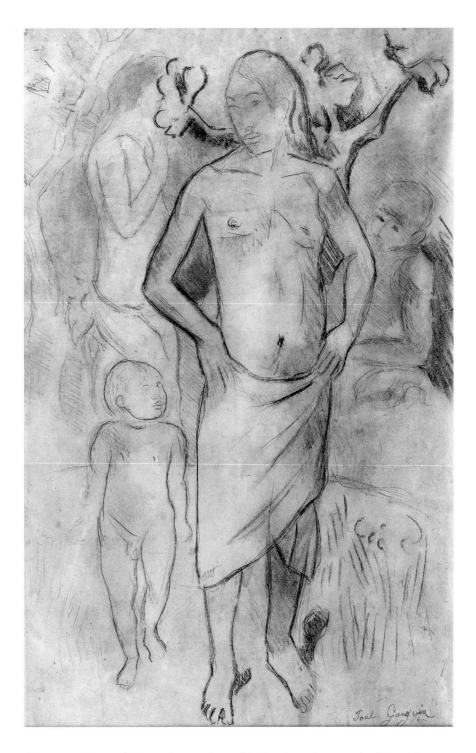

the print obtained through transfer in black ink or bistre, which he often re-touched with yellowish turpentine. Unlike Degas, who altered his plates by working directly on the original, Gauguin thus focused his interest on the re-versed image, according priority to the act of transfer and inversion.

The procedure used in these monotypes, where the ink absorbed corre-sponds to the strokes of the drawing, is not very different either from soft varnish technique or from the simultaneously comparable and opposite method of carbon paper. The use of this particular technique does, however, involve an ex-traordinary aesthetic innovation regarding Gauguin's tangible desire to give his works with their irregular surface a primitive appearance, the rugged effect of a fresco and the awkward, clumsy look of paintings made by rubbing or draw-ing on the walls of a cave: "Virtual images in which the artist's action reveals the

reactions of the material, these drawing-prints produced at the end of his life become precious as vestiges, traces of lost works or barely sketched plans and projects."[103]

While Vollard gave a very cold reception to these works, forming a unified and coherent set in terms of style and technique, he did exhibit 27 of them alongside 50 paintings by Gauguin in a show held in his gallery in November 1903. The subjects were all drawn from the artist's sad Eden and the use of vague, generic titles like *Famille Tahitienne* and *Buste de femme* does nothing to facilitate their identification. They were presumably all or at least mostly monotypes or "drawing-prints", to use the term closest to Gauguin's spirit.

Evidence of the impact of the show and its direct repercussions on the other artists in Paris in that period is to be found in the work of Picasso, who tried his hand at the monotype a few months later, adopting Gauguin's expressive model and, to some extent, his universal sentiment as regards subject matter was well as line and colour. Matisse, who had been buying Gauguin's paintings since 1898, was also clearly influenced by his work.

Paul Klee, Victor Brauner and Jean Dubuffet began to produce monotypes by very similar means some 50 years after Gauguin. Referred to as traced monotype or drawing-print, the system was taken up by many artists and constitutes an unquestionable example of an experimental practice being passed on to artists of different generations and cultural backgrounds through completely private circuits with no historical documentation.

Halfway through September 1901, after spending six years on Tahiti, Gauguin left for the Marquesas Islands and settled in Atouana. Surrounded by his few remaining paintings, a large number of photographic reproductions, blocks of wood for his woodcuts and various tools for printmaking, he tried to produce some works on paper to send to Vollard. It was in the Marquesas that Gauguin experimented for the last time with monotyping and created his last works, a few unique images in colour. These monotypes were based on details from his paintings and, though simple studies of heads or in any case incomplete figures, they display great intensity. Gauguin again differed from Degas and Pissarro in his way of making monotypes and printed from matrices of stiff and durable paper, which served him as a support instead of metal plates. As he stated in a letter to his friend Charles Morice, "Everything I have learned from others has always been an impediment. I can therefore proclaim that no one has ever taught me anything. It is true that what I know is very little, but I prefer this little, which in any case belongs to me completely. And who can say whether this very little, if put to good use by others, might not become something great?"[104]

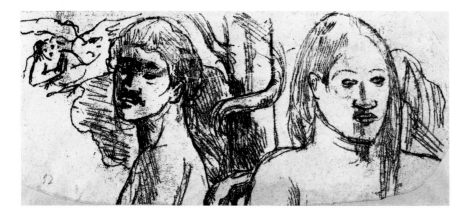

138. Paul Gauguin
Adame et Eve (Personnages de Tahiti), ca 1900
Traced monotype, 110 × 260 mm
Bibliothèque nationale de France, Paris

139. Paul Gauguin
Tête de Marquisienne, 1902
Monotype in black and bistre, 317 × 308 mm
Joan T. Washburn Gallery and
Robert Miller Gallery, New York

Gauguin is thought to have produced over two hundred monotypes, a much larger number than any of the other artists close to Degas. While about a hundred of those executed between 1899 and 1903 with the drawing-print technique have come to light, dozens of other monotypes were lost in the South Seas or destroyed. In some cases, only the drawing-matrix survives of these double works with the drawing on the front side of the sheet or recto and the monotype on the back or verso.

Richard Field organised the most exhaustive exhibition to date of Paul Gauguin's monotypes at the Philadelphia Museum of Art in 1973 and analysed the technique in close detail. Field's contribution is crucial in showing how the monotype, then a still peripheral and marginal technique, was transformed into a simultaneously direct, rich and dramatic expressive medium by an artist for whom the marginal constituted in any case a fertile and preferential terrain.

A celebrated and much-liked figure both in Paris and in London, Giuseppe De Nittis was for a long time wrongly confined to the historical dimension of the Italian painters in Paris involved in the Impressionist movement.

He settled in Paris in 1869, when the city was "a blazing furnace" for the art and the avant-garde movements, and gained the esteem of Degas in less than five years. Among the people who most counted in Paris, the latter was the first to recognise and appreciate the artist's classical draughtsmanship and fashionable iconography. Despite the opposition of Monet, Renoir and others among the "*Intransigeants*",[105] Degas ensured his participation in the Impressionists' exhibition of 1874. This marked the beginning of a brilliant career.

De Nittis was close to Degas above all in two respects, namely his use of pastel[106] and monotyping. He took up the former, then a somewhat outmoded technique, before the other Impressionists at more or less the same time as the French master. Degas adopted pastel out of a desire to revive a traditional technique and above all because it enabled him to combine drawing with colour, using it on monochrome backgrounds prepared with charcoal or a monotype base. De Nittis instead took a new approach and delineated the forms directly with the colour of the pastels. Having soaked the pigment with water, he reduced it to a paste, which he worked like oil paint and used to create his composition: "with pastel De Nittis … painted, this is the right verb, authentic paintings".[107]

He achieved this result also through careful selection of laid paper or lightweight, close-woven canvas. For the final touch, he used his fingers or a pad to spread the colour.

De Nittis began engraving in Paris between 1873 and 1874, at a time when the *taille militaire*—as the burin was ironically called—seemed somewhat antiquated, and took an interest in other more experimental forms. He worked in Cadart's atelier[108] together with Lepic, Degas and Desboutin, becoming acquainted with all the techniques and addressing the same technical problems as he encountered in painting views *en plein air*.

It was in this spirit that he began to give his prints some additional retouching in ink. He took up and completed the engraved plates by reworking them like aquatints or with monotype effects. The tonality of the inking was calibrated with quick brushstrokes so as to obtain the same delicacy of rendering in the engraving as in the pastel and watercolour.

He worked on a proof of *Donna con ventaglio* "in the same way and spirit as a monotype" in 1875. After inking the plate with the pad, he covered it with large lumps of ink and worked them with his fingers, thickening them or lightening their tonality as though painting on a canvas rather than working with printer's ink on metal.

With *Fantasie lunari*, a monotyped etching executed after 1876 and one of his most poetic female portrayals, the artist came close to monotyping in the strict sense of the term. Ink was added to the etched composition of a woman lying on a bed before running the plate through the press and manipulated with his fingers to dematerialise the forms. Above all, he created a proscenium of curtains and shafts of light of an unreal, lunar character to open the upper part of the image. The influence of Rembrandt and Degas can be seen in the central part of the composition, a female nude stretched out on a bed and seen from behind. The open curtains created by monotyping were instead probably taken from the studio set of the photographer Félix-Jacques-Antoine Moulin, where the curtains of the four-poster bed provided a theatrical frame for the model.

De Nittis produced very little in the way of monotypes with no engraving but did leave at least two small masterpieces, namely *La Gare de l'Ouest* and *La Balayeuse* (ca 1876). He succeeded in the first with a few touches of the spatula and brush in creating lights just sufficient to give a legible form to the objects and to suggest the sense of movement. The subtractive technique was used in the second to make the figure of the street sweeper in the foreground emerge from a light background and highlights were then added with quick, terse touches of the thumb and spatula.

De Nittis took this figure from a detail appearing both in his painting *Place des Pyramides* and in the etching *Quai Voltaire* (1876). The monotype

140. Giuseppe de Nittis
Lunar Fantasies (*Femme nue couchée*), post 1876
Mobile etching, ca 180 × 265 mm
Before being printed the etching was enhanced with painterly effects like patches of ink applied by hand. The drapery on the right, obtained by the subtractive method, is reminiscent of the four-poster bed used by Moulin for his photographs
Istituto Nazionale per la Grafica, Rome

141. Félix-Jacques-Antoine Moulin
Femme allongée sur un lit à baldaquin, ca 1853
Photograph
Bibliothèque nationale de France, Paris

probably constitutes an intermediate stage between these two works. Even though there is some proximity here with the experimental leanings and pictorial quality of Degas's graphic work, the Italian artist's intentions remain aesthetic and formal.

As De Nittis had only been considered in partial terms until a short time ago, his innovations in more than one area have yet to be completely explored. In particular, assessment is still required of the influence of his international experience on Italian artists at a key moment as regards the direction taken by art in France at the turn of the century.[109]

By no means the least of the artist's merits regards his role in promoting the monotype across the Atlantic. A sociable and communicative person, De Nittis was most hospitable to artist friends passing through Paris, including Telemaco Signorini, Luigi Conconi and the Tuscan sculptor Cecioni.

Meetings between artists of different countries came about in a very natural way and, given his personal experience of monotyping, De Nittis acted as a link between the work of Degas, Lepic and the American artists. According to increasingly accredited hypotheses, it was in particular to William Merritt Chase, the American artist most interested in these techniques, that the Italian painter showed the monotyped proofs of Lepic and Degas, thus possibly spurring him to take up monotyping.

Despite the favour shown to De Nittis by the upper crust in Paris and London, the focus of his iconography on elegant ladies and high society led in the end to the loss of support from old Macchiaioli friends like Cecioni.

De Nittis was mourned on his death by the figures most in the public eye in Paris and commemorated in *Le Figaro* in these terms: "A master of rare awareness, a painter of remarkable qualities occupying an important place in the front rank of the Impressionist School ... we can add that as a man of spirit, in short as an Italian, he steered clear of the deviations of those who saw this school

142. Giuseppe de Nittis
La Gare de l'Ouest, 1880
Monotype, 274 × 312 mm
Istituto Nazionale per la Grafica, Rome

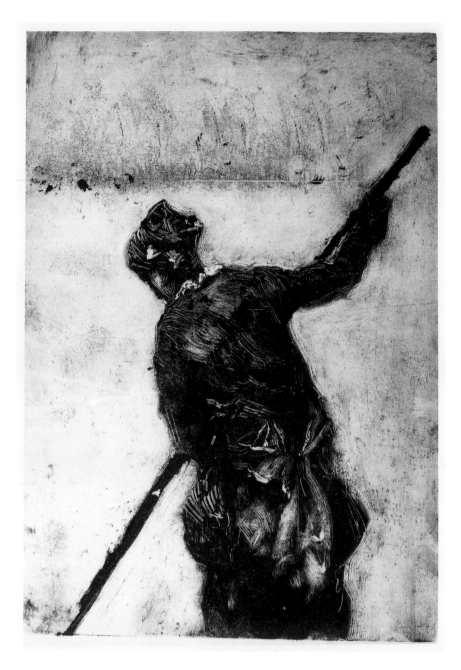

143. Giuseppe de Nittis
La Balayeuse, 1876
Monotype, 378 × 276 mm
Istituto Nazionale per la Grafica, Rome

as no more than a facilitating technique for use by painters, who confuse colour, composition and draughtsmanship with the same disdain…"[110]

Mary Cassatt (1844–1926) moved to Paris in 1874, the year of the Impressionists' first exhibition at the Galerie Nadar. She soon established close relations with Degas, who invited her to take part in the planned launching of *Le Jour et la Nuit* in 1878. Even though the magazine never got off the ground, the artists involved—who were also those recruited by Degas for the Impressionist exhibition—attached great importance to the experience as regards the consolidation and development of their engraving skills, especially Pissarro and Cassatt.

Cassatt took to engraving—etching and aquatint in colour as well as lithography—with great enthusiasm, seeking above all to improve her drawing and draughtsmanship, and worked industriously to open the print up to a more advanced and freer form of visual expression. While these explorations brought her closer to Degas and his work, she did not allow herself to be in-

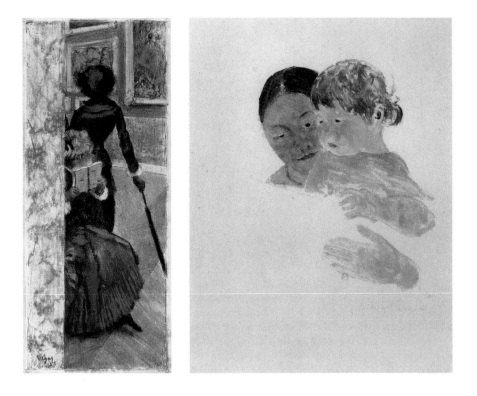

144. Edgar Degas
Mary Cassatt au Louvre: la peinture, 1879
Etching, aquatint and drypoint,
301 × 125 mm
Bibliothèque nationale de France, Paris

145. Mary Cassatt
L'Album (*Femme et enfant*), ca 1855
Colour monotype with oil pigments,
472 × 393 mm
Bibliothèque nationale de France, Paris

fluenced by his innovative techniques and adopted different procedures in complete independence. Solitary and aristocratic by taste and temperament, Cassatt nevertheless had a great deal in common with Degas, above all after the celebrated exhibition of Japanese art in 1890 at the Beaux-Arts, when the innovation of the bright water-based colours of the Japanese woodcuts and their markedly linear character made a deep impact on the work of both artists.

Due to the loss of the American archives documenting her production, it is impossible to establish precisely how many monotypes Mary Cassatt executed. Only two are recognised by critics, but her work in this field appears to have been much more substantial, albeit certainly not enormous for an artist so close to Degas. Hughes Wilhelm, a scholar of Impressionism and Cassatt's work, suggests that she produced over ten monotypes, and studies in greater depth could certainly uncover a considerably larger number.[111]

Cassatt's coloured monotype *L'Album* depicting a mother and child is the result of the artist's constant exploration of this relationship. Concentrated on the universe of female intimacy, her work consists of a small number of subjects addressed repeatedly with countless variations in the different media used.

The composition reflects the taste of the period for psychological introspection, which allowed Cassatt to instil the work with expressive opulence while avoiding sentimentalism or exaggeration. Two impressions were made with changes in composition. The images are defined in both cases by means of a tenuous figurative line and carefully organised areas of bright oil colour.

Cassatt was encouraged in her work with monotypes and monotyped etchings above all by Pissarro but does not seem to have been greatly attracted by these techniques, perhaps because they clashed with her precise, elegant and completely predetermined way of working. She did, however, execute a large number of counterproofs of her pastels—about 130—much in the spirit of monotyping when Ambroise Vollard, who started selling her works around

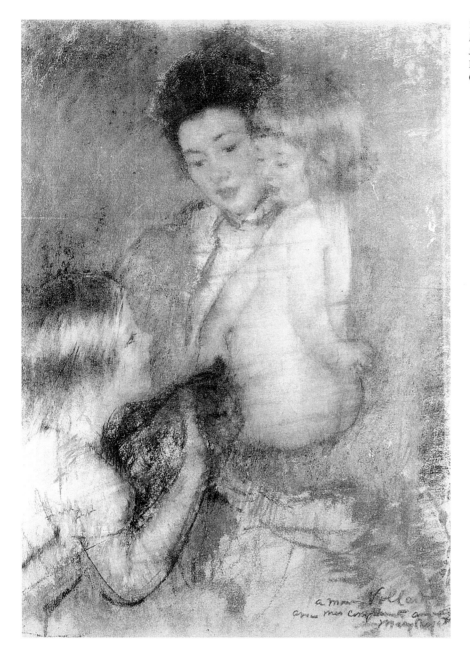

146. Mary Cassatt
Reine Lefebre with Blond Baby and
Sara Holding a Cat, ca 1902
Pastel counterproof, 800 × 590 mm
Courtesy of Marc Rosen Fine Art, New York

1900, urged her to increase her production. The transfer of a work from one support to another was in any case part of an experimental strategy commonly practised by her mentor Degas, who often made counterproofs of his pastels and charcoal drawings.

The idea of improvising within a pre-established structure and pushing it in new and unexpected directions was in any case part of the aesthetic of the period, which appreciated works produced in an evocative and individually characterised way. But while Degas retouched his counterproofs, those of Cassatt show no trace of reworking. This would support the belief of Henri Petiet—the Parisian collector and dealer who bought some of these works at the sale of Vollard's collection—that the counterproofs were made in accordance with Vollard's suggestion with a view to subsequently producing a series of lithographs.

It is in any case significant that Cassatt should have taken up a technique like the counterproof, which was used frequently until the eighteenth century but fell into disuse with Romanticism, when artists shifted towards a more robust

147. Henri de Toulouse-Lautrec
Le Clown, 1899
Monotype in oil colours, 495 × 355 mm
Formerly in the Otto Gerstenberg Collection, Berlin
Courtesy Ruth Ziegler Fine Arts, New York

aesthetic and the thicker, richer colours of oil paint. Like the Nabis and the late-nineteenth-century post-Impressionists, Cassatt instead returned to the cool tones of pastel and the surfaces flattened by the subtle and evocative colours peculiar to this procedure.

Another artist who was very close to Degas and did not conceal his admiration for and debt to the older master is Henri de Toulouse-Lautrec (1864–1903).

Like Mary Cassatt, Toulouse-Lautrec produced a splendid corpus of graphic works that made him one of the most celebrated artists of the day. In the period stretching from Goya to Picasso, only the works of Daumier and Degas can be compared with his, and nobody else comes close in terms of creative intensity. In the space of just 10 years he produced about 360 works, most of which were coloured lithographs used as posters for the theatres and cabarets he frequented. And yet, even though the first poster for the Moulin Rouge in 1891 made him famous overnight, his graphic work struggled to gain appreciation, above all due to his use of bright and glaring colours, which were regarded as shocking and "lurid" at the time. The prices of his lithographs were accordingly very low indeed.

In the practice of engraving and lithography, Toulouse-Lautrec inherited from the Impressionists a freedom and absence of artistic prejudices that allowed him to make use of all the different procedures indiscriminately. He took a very open-minded approach to the mechanical reproduction of his drawings, while being careful to ensure that this in no way interfered with the market for his original works. What he took from Degas was a passion for capturing movement and an exclusive interest for interiors with artificial lighting such as theatre balconies and brothels.

Like Mary Cassatt, however, Toulouse-Lautrec does not appear to have picked up Degas's passion for monotyping. When he did begin to take an interest it was at a very late stage, just a year or so before his premature death. In any case, it was not until later in his career that Toulouse-Lautrec found the medium most congenial to his talents in graphics, having devoted his energies to initially painting and drawing.

Four monotypes by Toulouse-Lautrec are known today, works produced in two or perhaps even three impressions probably at the end of 1899, when his physical and mental condition worsened due to fatigue and alcohol and his family had him placed in a sanatorium near Paris. It may have been in order to prove to himself, his relatives and the doctors that his artistic faculties were still intact that Toulouse-Lautrec devoted himself to an album of circus scenes drawn exclusively from memory with no preparatory sketches. And it was probably then that he produced the monotypes as well as a series of 39 vignettes in charcoal and coloured pencil.

Executed in oil paint on plates slightly larger than those of Degas, his monotypes reveal an unexpected and unusual minimalist spirit expressed in quick, unadorned brushstrokes that is typical of the stark, austere style of the artist's last compositions. While the drawings present precisely delineated figures standing out sharply against a completely white ground and producing a sinister effect through their distorted and exaggerated proportions, the monotypes communicate a sense of vitality, imagination and humour.

The works show no sign of having been run through a press. Given the particular circumstances in which Toulouse-Lautrec was working, they were printed through the simple application of manual pressure. The monogram *HTL* was

applied directly on the plate of the monotype *Le Clown* to indicate that the artist considered it a finished work.[112]

Two of the four monotypes were bought by the Berliner Otto Gerstenberg, one of the greatest connoisseurs of the period, who began by collecting the masterpieces of ancient graphic art and then went on to those by the great contemporary masters like Degas and Manet. One of the world's most important collections of the artist's graphic works for the quality of the items held, the Gerstenberg collection is still the most complete. In addition to the two monotypes, it includes above all the unique proofs and in any case those of which only rare and precious specimens exist.

Attention should also be drawn to artists occupying a more peripheral position with respect to Degas's circle but playing an important role in the spread of monotyping outside the artistic sphere of Paris.

Walter Sickert was the first English artist to accept Degas's modern vision unconditionally, regarding him as the greatest living painter and defending his work with such passion as to spearhead an authentic "pro-Degas campaign" in London. The relationship between the two artists is based on three encounters: the first in 1883, when Sickert came to Paris for the express purpose of meeting the French master, and the second in the summer of 1885 in Dieppe, where Sickert was staying and met up with Degas and his friends Halévy and Jacques-Émile Blanche. Sickert then saw him again in Paris in the autumn of the same year, and it was then that his admiration for the artist was definitively consolidated.

Sickert lived in Paris from 1898 and 1905 and met Degas frequently, soon becoming part of the Parisian artistic scene and assimilating the new trends in his work. He exhibited at the Galerie Durand-Ruel and later at the Galerie Bernheim Jeune. While establishing a considerable personal reputation, Sickert went on idolising Degas and collecting his works for the rest of his life.

Sickert is not likely to have seen the monotypes of landscapes when they were exhibited at the Galerie Durand-Ruel, and Degas may not have considered him sufficiently close to show him those produced earlier in black and white. This may account for the fact that the set of monotypes Sickert produced in Dieppe between 1899 and 1900, which he himself described as "charcoal drawings tinted with watercolour", are technically akin to the "print-drawings" executed by Gauguin between 1899 and 1903 rather than Degas's works. Exhibited at the Fine Art Society in London, Sickert's works present the tenuous and rubbing-like outlines of the underlying composition, being obtained by means of a "transfer" procedure using paper covered in ink by hand rather than carbon paper.

Sickert's interest in the monotype lasted for no more than a few years, as transpires from his dismissal of the "artistic print" as pointlessly precious in 1908: "An incomplete or incoherent plate can be veiled and explained by leaving tone on in the printing. In this a step has really been taken in the direction of the monotype, and of course, only the etcher of the plate himself can print the first proof. But this must not be set up as a merit. It is a weakness."[113]

The Australian Rupert Bunny (1864–1947) is one of the artists not strictly classifiable as "close to Degas" who took up monotyping through his influence. Bunny, who worked for over 30 years in Paris and London and began exhibiting

148. Title page of the catalogue for Walter Sickert's exhibition at the Galerie Bernheim Jeune, Paris 1907

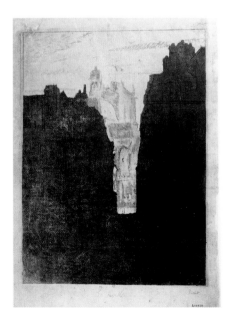

149. Walter Richard Sickert
Dieppe, la Rue Notre Dame, 1909
Etching, one of the first states,
310 × 234 mm (plate)
Bibliothèque nationale de France, Paris

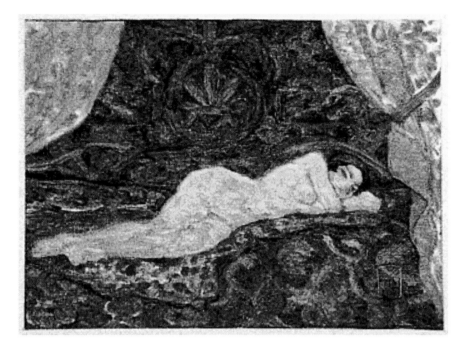

in 1887 at the Parisian *salons* as well as the Royal Academy, produced over 150 monotypes. His interest in the procedure was probably aroused by the example of Degas—he may have seen the exhibition of his landscape monotypes at the Galerie Durand-Ruel in 1892—and through the works of the American Maurice Prendergast, who was in Paris over that period.

Bunny began to work with monotypes in the late 1890s and soon moved from black and white to colour. He held a successful exhibition at the Galerie Henry Graves in 1905.[114] The Parisian gallery owner Georges Petit gave him a commission for 100 coloured monotypes in 1920 and exhibited them in 1921 and 1924. The subjects were drawn from mythology and the bright colours recall those of Delacroix, Gauguin and the Symbolists.

In 1933, having bought back all of his unsold monotypes from Petit, Bunny returned to Australia, where he played an important role in the spread of colour monotyping. He exhibited his works in Melbourne in 1941 and then in Sydney in 1943 with considerable success. Acting as a cultural link between *fin de siècle* France and his own country, Bunny had a great deal of influence on many contemporary Australian artists, who began working with monotypes back at the turn of the century.

151. William Blake
Pity, 1795
Colour monotype, tempera, heightened with pen,
black ink, and watercolour, 400 × 530 mm
The Metropolitan Museum of Art, New York,
donated by Mrs. Robert W. Goelet, 1958

152. Edgar Degas
Pianiste et chanteur, 1877
Monotype in black ink heightened with pastel
and watercolour, 160 × 120 mm
Musée Picasso, Paris, Picasso's personal collection

153. Edgar Degas
La Fête de la Patronne, 1878–79
Monotype, in black ink on white paper, heightened
with pastel, 155 × 202 mm (image)
Musée Picasso, Paris

154. Edgar Degas
Volcan (or *Le Vésuve*), ca 1892
Monotype and pastel, 250 × 300 mm
Private collection

155. Camille Pissarro
Cavalier au bord d'une rivière, 1895
Colour monotype, 230 × 168 mm
Private collection, United States

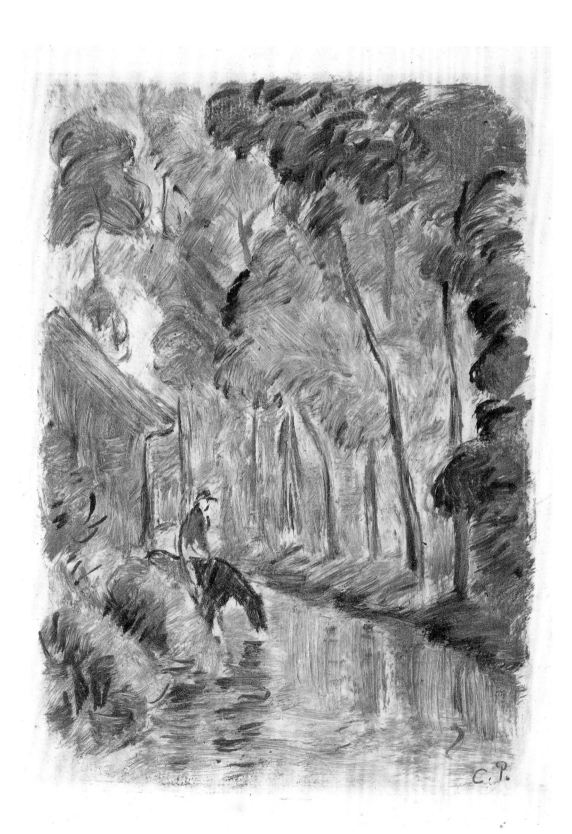

156. Camille Pissarro
Femme mettant ses bas, 1895
Colour mobile etching, 80 × 114 mm
Bibliothèque nationale de France, Paris

157. Paul Gauguin
Scène tahitienne, 1897–98
Watercolour monotype on Japanese silk
paper applied on laid paper, 250 × 325 mm

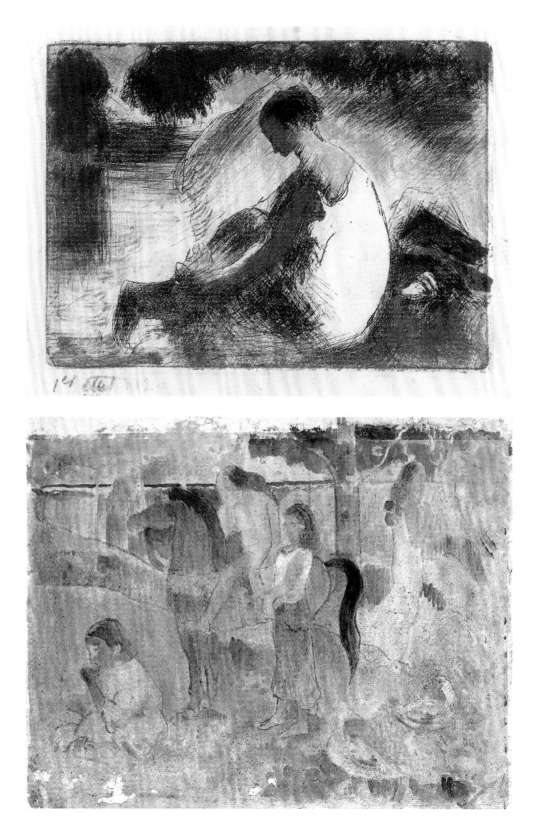

158. Paul Gauguin
Tahitienne nue de dos, assise, ca 1902
Colour monotype, 347 × 236 mm
Private collection, United States
Courtesy Ruth Ziegler Fine Arts, New York

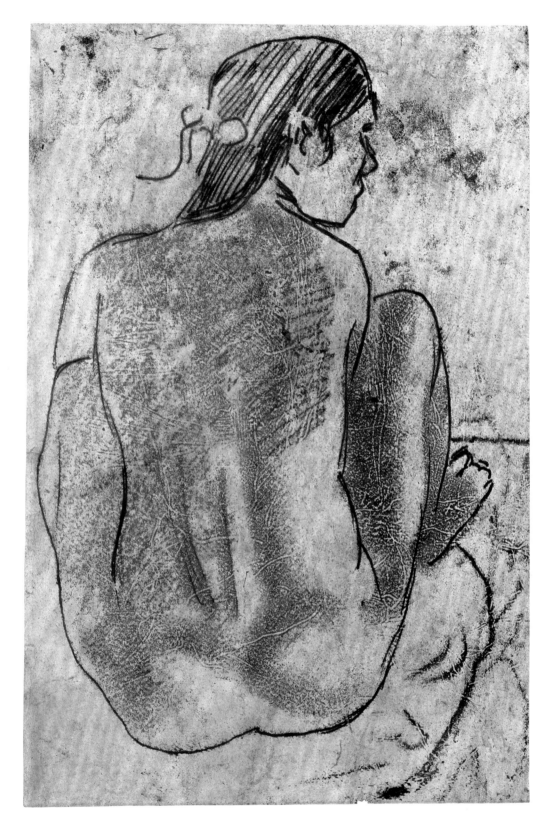

159. Mary Cassatt
L'Album (Femme et enfant), ca 1885
Monotype in oil colours,
500 × 395 mm (sheet)
Jacques Doucet Collection, Bibliothèque de l'INHA
(Institut national de l'histoire de l'art), Paris

160. Henri de Toulouse-Lautrec
Conversation, 1899
Monotype in oil colours, 495 × 355 mm
Formerly in the Otto Gerstenberg Collection, Berlin
Courtesy Ruth Ziegler Fine Arts, New York

161. Maurice Prendergast
Figures in the Park, 1895–97
Monotype in oil colours, 384 × 280 mm
Private collection, United States
Courtesy Ruth Ziegler Fine Arts, New York

162. Clark Hobart
Going to a Meeting, 1915
Colour monotype, 251 × 324 mm
Courtesy The Annex Galleries, Santa Rosa,
California

163. Abraham Walkowitz
Figures in a Doorway, ca 1908
Colour monotype, 226 × 303 mm
Smithsonian Institution, National Museum
of American Art, Washington, D.C.

164. Pablo Picasso
Flûtiste assise et dormeuse, VI, 1933
Monotype on copper plate,
first of two pulls, 148 × 187 mm
Private collection, United States
Courtesy Ruth Ziegler Fine Arts, New York

165. Pablo Picasso
Flûtiste assise et dormeuse, XXXI, 1933
Colour monotype, XXXI, 149 × 187 mm
Musée Picasso, Paris

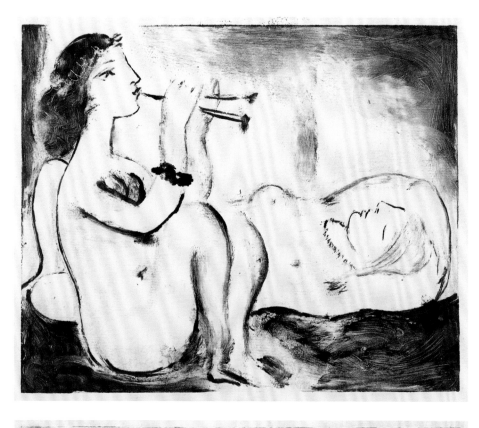

Flûtiste assise et dormeuse, VI, 1933

Flûtiste assise et dormeuse, XXXI, 1933

166. Pablo Picasso
Tête de femme de profil (or *Tête de Fernande)*,
1905–06
Colour monotype on glass, first of two
pulls, printed on wrapping paper
and heightened with touches of pink gouache,
280 × 215 mm (plate)
Musée Picasso, Paris

167. Georges Rouault
La Chevauchée, 1910
Monotype on cardboard in oil colours, heightened
with gouache and pastel, 375 × 520 mm
Fondation Georges Rouault, Paris

168. Henri Matisse
Nu assis au bracelet, ca 1916
Monotype on applied China paper, 375 × 280 mm
Bibliothèque nationale de France, Paris

169. Cyril Power
Cattawade Bridge N. 1, ca 1933
Colour monotype, 375 × 245 mm
Private collection
Courtesy Gordon Samuel, London

170. Victor Brauner
Untitled, 1948
Traced monotype and pencil, recto and verso,
206 × 240 mm
Private collection, United States
Courtesy Blue Moon Gallery, New York

171. Massimo Campigli
La veletta, 1951
Monotype in oil colours, 584 × 454 mm
Campigli Archive, Saint-Tropez

172. Jackson Pollock
Untitled, ca 1946
Monotype printed on red paper, 216 × 140 mm
Courtesy of Joan T. Washburn Gallery and the
Pollock-Krasner Foundation, Inc., New York

173. Jackson Pollock
Untitled, 1950–51
Monotype printed on silk, 216 × 140 mm
Courtesy of Joan T. Washburn Gallery and
The Pollock-Krasner Foundation, Inc., New York

174. Antoni Tàpies
Untitled, ca 1960
Colour monotype, 935 × 1400 mm
Courtesy Galerie Maeght, Paris

175. Mark Tobey
Monotype en rouge, 1961
Colour monotype, 642 × 407 mm
Cabinet Cantonal des Estampes, Vevey

176. Maurice Estève
M.58, 1964
Colour monotype, 500 × 325 mm
Musée Estève, Bourges

177. Joan Miró
Untitled, ca 1960
Colour monotype, 630 × 910 mm
Courtesy Galerie Maeght, Paris

178. Marc Chagall
La Maison du pêcheur, 1966
Colour monotype on ancient Japanese paper,
600 × 435 mm
Private collection

179. Marc Chagall
Le Coq bleu, 1966
Colour monotype on ancient Japanese paper,
620 × 480 mm
Private collection

180. Adolph Gottlieb
Untitled, 1973
Colour monotype, 610 × 457 mm
Adolph and Esther Gottlieb Foundation, Inc.,
New York

181. Georg Baselitz
Wald, 1976
Colour monotype, 610 × 430 mm
Herzog Anton Ulrich-Museum, Braunschweig

182. William Kentridge
Untitled (Waterfall), 1996
Colour monotype, 956 × 1016 mm
Printed by 107 Workshop, published by
David Krut Fine Art, London
Courtesy of William Kentridge and Lia Rumma
Gallery, Milan and Naples

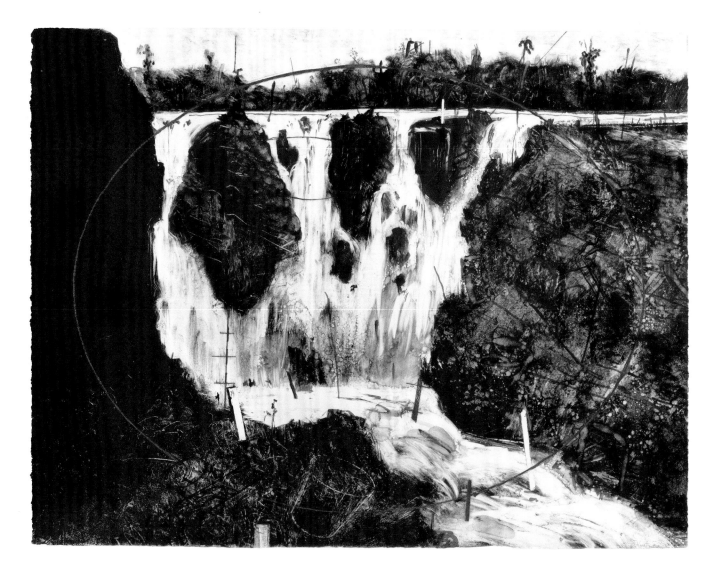

183 Sam Francis
Untitled, 1980
Colour monotype, 790 × 635 mm
Private collection, United States

184. Jasper Johns
Savarin, 1982
Colour monotype, 1250 × 950 mm
printed at ULAE
Whitney Museum of American Art, New York
Donated by the American Contemporary Art
Foundation Inc., Leonard A. Lauder, President

185. Richard Diebenkorn
VIII, 1988
Colour monotype, 660 × 510 mm
Private collection, United States

186. Helen Frankenthaler
Untitled, 1991
Colour monotype, 605 × 795 mm
Private collection, United States

187. Nancy Graves
XI/ 15/ 1992, 1992
Watercolour monotype made from pressed
organic matter (various types of fruits, vegetables,
dried sardine and squid…), 560 × 762 mm
Nancy Graves Foundation Ink Collection, New York

188. Jean-Michel Basquiat
Untitled, 1986
Monotype with printing colours, 1372 × 991 mm
Private collection, United States
Courtesy O'Hara Gallery, New York

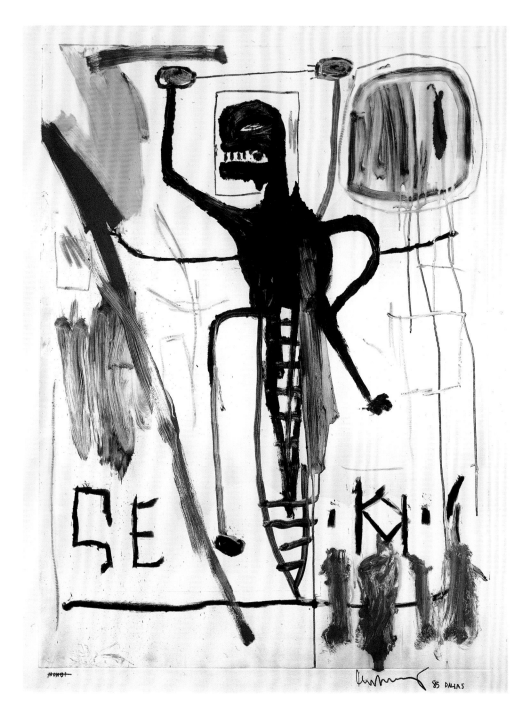

189. Robert Rauschenberg
The Red Virgin, 1969
Pencil and gouache transfer drawing,
578 × 726 mm
Private collection, Los Angeles
Courtesy O'Hara Gallery, New York

190. Mimmo Paladino
Untitled, from the *Extemporisation* series, 1997
Colour monoprint, 1585 × 2255 mm
From a series of 40 colour monoprints, Japanese
paper on canvas, printed at Alberto Serighelli's
studio, Arte 3, Milan, published by Alan Cristea
Gallery, London

191. Sandro Chia
Untitled, 2005
Monotype with oil pastels, ca 1280 × 950 mm
(with artist's frame)
Private collection

192. James Brown
Monotype Georges, 1990
Monotype in black ink on fabric, collages of
painted canvas and ink drawing,
1660 × 1300 mm
Private collection, Paris
Courtesy Frank Bordas, Paris

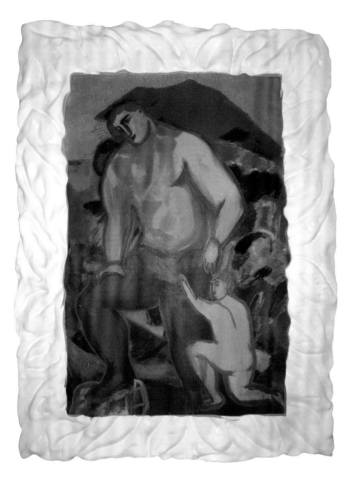

193. Jim Dine
Printing and Dancing IV, 2002
Monoprint, hand-coloured with acrylics and charcoal,
sole impression, 1630 × 1220 mm (image);
ca 1660 × 1220 mm (sheet)
Printed at Pace Editions Ink; editor Pace Editions, Inc.,
one of the variations of *Heart*
Courtesy of Jim Dine and Pace Editions Prints,
New York

194. Maurice Prendergast
Nouveau Cirque, ca 1895
Monotype in oils, 352 × 349 mm (image)
Charles Prendergast Collection,
Westport (Connecticut)

3. Modern and Contemporary Monotype

The early days of American monotype: the influences of the French model
"Stick to the French school. *Il n'y a que cela* in modern art. We are good only in as much as we derive from them [...]. I have learnt here what I couldn't have learnt in a lifetime at home."[115]
Walter Richard Sickert

As pointed out earlier, discussions of art inevitably proceed in terms of geographical areas, up to World War I at least, and focus primarily on France. If we take 1855 and 1889, the dates of the two *expositions universelles* held in Paris, as points of historical reference, the French capital's cultural and artistic supremacy is clearly evident with respect not only to the United States but also to other European countries.

Impressionism, a strictly French movement that involved printmaking as well as painting, did, however, begin to spread elsewhere as from the early 1870s. Through coming into contact with different cultures and historical and artistic situations while undergoing constant evolution in its place of origin, the French model became less imperious and its assumptions broadened and became less clear-cut.

After the disastrous Franco-Prussian war and the Paris Commune of 1871, a number of French artists chose for both political and economic reasons to take up residence in London, then at the peak of the Empire's golden age. James Tissot, Alphonse Legros and the sculptor Jules Dalou were among the first to settle in this "city of opportunity" and stays were made on a regular basis by others, including Henri Fantin-Latour and Giuseppe de Nittis. It was indeed in London that the latter found success. The older artists Ernest Meissonnier and Jean-Léon Gérôme were even to become members of London's renowned Royal Academy.

British and French artists frequently crossed the Channel during this period on visits to the neighbouring capital cities and the intensification of cultural interchange and broad impact of art criticism helped to smooth out differences in national taste. While the new trends in modern painting emerging in Paris had a major impact on the British art market and press, British artists settling on across the Channel were greeted with keen interest and respect.

Involved in organizing the first Impressionist exhibition in Paris in 1874, Degas urged his friend Tissot to take part in these terms: "Listen to me, my dear

Tissot, no wavering and no evasion. You simply must exhibit at the Boulevard. It will be good for you, as you will be seen in Paris, the town they say you are running away from, and good for us too."[116]

Though reserved and aloof by nature, Degas was well aware of the importance of exhibiting works and being known on the art market in both capitals. A letter written as early as 1871 to Tissot, who had recently moved to London, clearly shows his interest: "Why the devil haven't you written me a line? They say you're making a fortune. Give me the figures."[117]

By 1873, just two years later, Degas had built up sound commercial relations in England. He informed Tissot in a letter that he was working on a painting entitled *Le Bureau du Coton*, which the London-based dealer Thomas Agnew sold in Manchester. After the collapse of the family bank in 1874, Degas focused even more on the British art market and especially London, where he exhibited numerous paintings and made some major sales. The following year he wrote to Deschamps, a French dealer who had settled there, "The time has come for me to set off for England."[118]

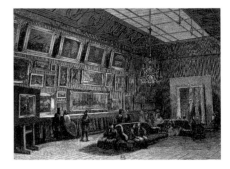

195. E. Bichon
Exposition à la Galerie Durand-Ruel, 1879
Etching

The artistic scene built up in prosperous London—not least through the contribution of celebrated French artists who settled there, including the illustrator Gustave Doré—received a further boost in 1870, when the Parisian dealer Paul Durand-Ruel opened a new gallery called the Society of French Artists. He was following in the footsteps of Adolphe Goupil, another enterprising French dealer and publisher, who had launched a print and photography gallery in Paris in 1829 before going into partnership with Hering & Remington and Gambart and opening a branch in London (Goupil & Cie) in 1841.

The works of Pissarro and Degas sold well in Britain and were also included in the prestigious collections of the Greek Constantine Alexandre Ionides and Captain Henry Hill, both of whom were particularly appreciative of modern French art. By 1876 Hill's collection boasted seven major canvases by Degas, a record never equalled by any other lover of French art.

In cities like London and Paris—crowded, bustling metropolises but resting at the same time on solid networks of contacts—a sort of ideal brotherhood was established between French and British artists, who helped one another with advice on market trends and introductions to art dealers and patrons. It was against this background that Philippe Burty wrote on contemporary French art for the British public and Henri Guérard suggested different levels of finish for artworks in accordance with the tastes of the two nations.[119]

Durand-Ruel began discussions with his first German client in 1883. Following their American counterparts, German dealers began to build up major collections of Pissarro prints in Bremen, Dresden and Munich. The German publisher and dealer Paul Cassirer went to visit the French artist in 1903 and the English magazine *The Studio* published an article on him in the same year. This was followed some years later by an in-depth study for a German journal written by the British art historian Hind.

It was, however, above all in the United States that Impressionism won unchallenged success, so much so that in 1876 Mallarmé suggested anglicizing the group's name to "*The Impressionists*".

In 1875, a year after her arrival in Paris, the young American Louisine Elder Havemeyer bought a monotype heightened with pastel by Degas entitled

196. Title page of *The Impressionists of Paris* catalogue for the exhibition organized by Durand-Ruel, New York, 1886, with the contribution of The American Art Association

Scène de Ballet on the advice of Mary Cassatt for the considerable sum of five hundred francs. She also purchased a Degas pastel through Durand-Ruel in the same year. Though not the first works to reach American soil, a number having been left in New Orleans after Degas stayed there in 1872, they acquired great symbolic value as the first to be purchased in Paris and then shipped to America. The collectors who bought the Degas prints described by Edmond de Goncourt as epitomizing the "religion of failure" were again American.

It was also in this period that Pissarro sold a set of etchings to Samuel Avery for the first time, thus making his name known across the Atlantic.

While James Whistler was greeted as a brother in art by Henri Fantin-Latour, Alphonse Legros, Bracquemond and Manet on his arrival in Paris, this was a reversal of the normal trend, as exemplified by the fact that Millet's etchings and Lepic's mobile etchings, works considered bizarre and of no market value in France, were snapped up by the American dealers Keppel and Lucas.

The United States played a key part in making the Impressionists and their aesthetic vision known and accepted. As Michel Melot points out, if we subtracted all the works by American authors from the corpus of Impressionist literature we would be left with about a third, and "not necessarily the best".

In the same period, between 1874 and 1886, the crisis affecting Impressionism began to make itself felt in France, where the movement was born. Not only aesthetic but also economic fraught with serious social implications, this crisis shook the old order to its very foundations. Capitalism conquered the West. Paris continued to be the hub of the art and printmaking world but the capitals began to switch their roles, so much so as to justify the common saying: "Paris is no longer in Paris and London is no longer in London."

At the end of the nineteenth century, the United States were no longer solely on the receiving end of European movements and operations of a cultural—and commercial—nature. On their return from formative trips to Europe, the luckier American artists would find an open and responsive environment. Though keeping a weather eye on France, the capital of the arts until the outbreak of World War II, they worked with ever-greater autonomy and creativity.

Within the new wealth structure taking shape in the United States, artworks began to symbolise the values acquired along with the recently accumulated fortunes. Prints in particular established their own artistic and commercial identity, midway between reproductions and original paintings, and increased considerably in importance and value.

The same also holds for the monotype, which began to emerge and establish itself as an art form.

The tradition of the monotype in the United States is conventionally dated as beginning in the early 1880s, when the first works started to circulate and the term "monotype" was coined. The origins of the process lay in two closely linked European phenomena, namely the renaissance of etching and the Romantic movement, which took root and were gradually established in America over a span of twenty years. The groundwork for the spread of the original etching on American soil was done by the French publisher Cadart, who sailed to Boston and New York in 1864 with a cargo including etchings by the Société des Aquafortistes as well as various sculptures and paintings by Courbet, Corot, Monet, Jongkind and others.

His journey was a success and played a decisive role in opening up many American collections to modern French art, including those of George Lucas

(who bought seventy-eight bronzes by Bayre) and Samuel P. Avery. Cadart left Paris again eight months later—this time with eight hundred works and a packed schedule of exhibitions in New York, Boston, Philadelphia and Baltimore—hoping to repeat his feat. Against all expectations, the anti-French sentiment aroused by the expansionist policies of Napoleon III in Mexico caused both the public and collectors to turn their backs. This meant the end. He took his works back to Paris after a few hurried auctions but was financially ruined and closed the Société soon afterwards, having also fallen out with Delâtre.

Etching also owed some of its popularity in America to the promotional activities of the New York Etching Club and the Philadelphia Society of Etchers, founded respectively in 1877 and 1880, and to the criticism of Sylvester Rosa Koehler. Described as "a drawing on copper made by a painter", it was brought into the artistic sphere. The criteria of evaluation for this medium shifted from utilitarian considerations of reproduction to its potential for the artistic creation of original images, and interest in its autographic quality was joined by a focus on the expressive quality of the individual prints in the editions.

The works by French *peintres-graveurs* circulating in America from 1866 on taught American artists to use *retroussage*, a painterly approach to plate preparation. By leaving a carefully controlled film of ink in different places when inking the plate, they could vary the mood and expressive approach of each individual print.

A large number of American artists travelled to Europe to make etchings, many of them arriving in France together with dealers and collectors like the New York gallery owner George Lucas, who became one of the leading promoters of Impressionist etchings on his return from Paris, exhibiting Daubigny, Jacque and Millet. These original etchings proved very successful in the United States, where there was less bias against realistic subjects and the idealisation of labour was accepted with none of the French class prejudices. The printmaking process enjoyed similar success with American art-lovers, who were free from European misgivings about its multiple nature.

The American fine art print gained ground with respect to the industrial image after 1870 to a greater extent than its French counterpart. Interest shifted to the limited edition and then, within it, to the individual print or *belle épreuve*. J. Maberly remarked in 1880 that this type of artistic expression was sure to flourish as particularly suited to the American spirit.

Favoured by the interest in the unique image and preferred to etching, still a slow, complex and linear procedure, monotyping was in keeping with the new Romantic and post-Impressionist focus on the quickly produced individual work where the subject could be captured in one go, especially in the case of landscapes. In America, however, being associated with certain aspects of the European artistic tradition, monotypes were only made by a select group of artists and appreciated by a handful of connoisseurs until the early twentieth century.

The American monotype began to emerge with the work of four artists: Frank Duveneck, William Merritt Chase, Charles Alvah Walker and Maurice Prendergast. Duveneck and Chase started making monotypes in the early 1870s while studying at the Munich art academy, where they discovered a free spontaneous approach to brushwork. Duveneck, a teacher at the Art School in Chicago, took a group of students to Italy in 1878 and stayed for six years, moving between Florence and Venice. Twachtman and Chase, who taught at the Pennsylvania Academy, joined him in Venice, where they spent

197. Frank Duveneck
Tuscan Landscape, 1883–84
Monotype, 312 × 435 mm
Cincinnati Art Museum, Cincinnati (Ohio)

198. William Merritt Chase
Self-portrait, ca 1911–14
Monotype, 200 × 152 mm
Bowdoin College, Museum of Art, Brunswick

nine months. Another of "Duveneck's Boys" (the name given to the group in Germany) was Otto Bacher, the inventor of a portable press, who described how they spent their evenings in Florence in the homes of the city's British and American colony and would often paint for amusement on a plate in burnt sienna or ivory black, either with pointed instruments or their thumbs. The plate was then run through his press, hence the name "Bachertype". Only one print could be made as the pressure absorbed all the colour. The sheets were numbered and then raffled off among those present. Some magnificent impressions were made, many of which are still in existence.[120]

Most of the works were portraits of a light-hearted, creative nature, almost the result of parlour games. Easily produced and modified and quickly executed (to prevent the ink from drying out), these early "American" monotypes had an impromptu and experimental character.

Following his return in America, Duveneck approached the technique with greater awareness and artistic ambition, as revealed by the larger dimensions and virtuosity of the works carried out in Boston and Cincinnati. Using the monotype to achieve a more pictorial print, Duveneck transferred the texture and free brushwork that typified his oil paintings to his printmaking. After heavily inking the plate, he would wipe off the surplus with bold, sweeping movements, creating figures that seem to be built up with freely applied brushstrokes.

His monotypes are characterised by silvery backgrounds and atmospheric effects closely resembling those in Whistler's Venetian etchings. It seems likely that there was a mutual exchange of ideas in 1880, when Whistler joined Duveneck and his Boys in the Casa Jankovitz in Venice. Whistler may have acted as a valuable mediator between French monotype experiences and those of the American group. Yet while Duveneck explored the unique process of the monotype, Whistler followed in the footsteps of Rembrandt and the French etchers, freely inking the plate to create unique variable prints belonging to a single edition.

The Americans left no traces of their activities in Venice and, surprisingly enough, there is no evidence of them taking any interest in the Scapigliati movement, whose members were intent at that time on applying their pictorial aesthetic to the new graphic procedures of mobile etching and the monotype. Venice still adhered in any case to the canons of the great eighteenth-century etching tradition exemplified by artists like Canaletto, Bellotto and Tiepolo, and kept its distance from daring techniques such as monotyping. Venetian artistic circles were more responsive and alive to the revitalisation of the original etching developed by the Macchiaioli, a Florentine movement led by Signorini and Fattori with support from the critic Diego Martelli, who played a key role in promoting valuable cultural contact between the different communities of foreign artists in Florence. The only link between the American community and Italian artists appears to have been the one involving John Singer Sargent, Ralph Wormsley Curtis and Antonio Mancini. This was in any case a matter of personal relations set in the broader context of French influence in the field of art at the end of the century.

The celebrated painter William Merritt Chase was among the first to appreciate the potential of the monotype. He used the technique for over thirty years and showed monotypes alongside his paintings from 1881 onwards, shortly after his return to the States. Highly skilled in his handling of colour and mass, he found the monotype a more congenial medium than the linear engraving. He

was particularly conversant with the dark-field technique, which enabled him to capture a surprising degree of luminosity in monochrome works. Working with a brush, he would remove the excess ink with rags and pointed tools or work it freely on the plate with his fingers.

His monotypes were extremely personal and intimate, seldom attaining the size or breadth of his oil paintings. The subjects were mainly self-portraits, landscapes and half-length male portraits. It was, however, not so much his artistic output as his academic activities—first in New York and then in Carmel, California—that contributed to the spread of the monotype. His propensity for spontaneous, swiftly executed techniques made the monotype the cornerstone of his teaching: hand and mind must work together; hesitation is the worst enemy of spontaneity. The work of many of Chase's students suggests that he also used the monotype to teach shading by means of *chiaroscuro*. Five monotypes by Edward Hopper, small compositional studies using *chiaroscuro*, would seem to confirm this.

Charles Alvah Walker, a Bostonian painter and printmaker, claimed to have produced numerous monotypes from 1877 on and to have invented not only the technique but also its name. Sylvester Rosa Koehler tells us that Walker discovered the process quite by chance when proofing an etching. The paper was incorrectly positioned and slipped out of true in the press. The blurred image produced as a result gave him the idea of working the printer's ink with a rag and his fingers on the plate.

199. Edward Hopper
Man's Head, ca 1902
Monotype, 108 × 83 mm
Whitney Museum of American Art, New York,
Bequest by Josephine Hopper

It is likely that Walker was also influenced by the *eaux-fortes mobiles* exhibited by Lepic at the New York Knoedler Gallery in 1880 (subsequently a part of the Philadelphia Claghorn collection). His first monotypes were monochromes and it was not until 1883 that he produced a series using oil paints. He exhibited these works alongside his etchings in 1880–81, coining the term "monotype" for the new technique. Taken up in an article in the *Art Journal* towards the end of 1881, this proved an immediate success and entered the language as the name of a procedure for which a precise term had been lacking, even though the technique itself had been in use for over two centuries in Europe.

Albion Harris Bicknell, another artist from Massachusetts, also claimed to have discovered the monotype during the same period, and an article in the *Malden City Press* attributed both the procedure and its name to him: "A new discovery in the possibilities of black and white work has been made in our midst by an artist who has been working so quietly that the result thrills Boston art circles with an electric surprise. This is the new prints of Mr. A. H. Bicknell, Malden's talented artist."[121]

201. *Une Académie de Peinture* (Académie Julian), after a painting by Rodolphe Julian, photograph published by Goupil & Cie. Editeurs Bibliothèque nationale de France, Paris

The controversy about the origins of the monotype reflects the attention that this procedure was beginning to attract: the monotype began to enter private galleries and was presented to the American public as a new invention.

Walker and Bicknell differed in their approach to the new technique from Duveneck and Chase, who focused like other European-trained artists on its potential for improvisation and spontaneity. They worked directly on small plates, inspired by the feeling that they were exploring new ground. Despite their antagonism, Walker and Bicknell made monotypes with similar characteristics, reflecting their common background in the American artistic tradition. Their creations, which showed awareness of the technique and of its limitations, were finished works of large dimensions (those of a standard canvas) based on preparatory sketches. Their subjects were mainly impressionistic landscapes displaying an attentive use of light and atmospheric tones.

The monotype was of particular interest to artists who were both painters and printmakers. They included Albert Sterner, a professional illustrator, who

became aware of the technique in Europe, where he lived for several years. After returning to his homeland at the end of the century he founded the short-lived New York Monotype Club. Rejecting the traditional hierarchy that placed painting above the graphic arts, he founded an organisation called Painter-Gravers of America. His highly pictorial and spontaneous monotypes—idyllic nudes and portraits—were nearly all produced by means of the additive technique. The artist exhibited them on two occasions alongside lithographs and paintings.

Eugene Higgins, another American, was introduced to the monotype when studying in Paris, first at the Académie Julian in 1898 and then at the École des Beaux-Arts. He was to employ the technique for the next forty years but, unfortunately, did not date his works, which makes it difficult to establish how his use of the procedure evolved. On his return to New York in 1909, Higgins exhibited about thirty monotypes and drawings at Alfred Stieglitz's Little Galleries of the Photo-Secessions (later known as Gallery 291). The review of the exhibition that appeared in Stieglitz's magazine *Camera Work* in 1910 explains why Stieglitz, who was famous for his advocacy of photography, had decided to exhibit Higgins's works: "His interest lies mostly in the silhouettes of figures moving or resting in dim lighted streets or interiors, his composition being one of spotting, of the play of dark and light masses, and some of his monotypes have all the rich quality of a good platinum print."[122]

Although Italy and Munich continued to attract American artists and students during the 1880s and 1890s, Paris was the real trendsetter of the times. American students were drawn not only to the traditional academies like the École des Beaux-Arts, but also to the ateliers of famous artists and independent art schools. So many of them made monotypes it seems likely that the technique was part of the standard academic curriculum.

Monotyping was certainly taught at the American Art Association and was soon "the rage", as contemporary newspapers put it. Monotype conferences were organised and there were even "Monotype festivals". Rupert Bunny, who went to the American Club regularly to play cards with other artists, informs us that the group there attempted to make colour monotypes. The handful of artists who continued to use the technique after returning to America seemed to do so, however, almost in a spirit of camaraderie, as a hobby among friends. This was the prevailing climate in New York's art circles, like the newly founded Monotype Club, although the Salmagundi Club, an occasional venue for monotype exhibitions, was rather more formal.

As the monotype technique became more familiar, the romantic ideals of the etching revival were gradually left behind. Artists ranging from Impressionists, post-Impressionists and Modernists to Urban Realists were drawn to it, exploring the potential of the colour image, using transparent oil glazes instead of printer's inks, and extending the monotype's palette and range of textures.

Prendergast, Modernists and the colour monotype in the United States
American artists were rather slow to appreciate the potential of colour in monotypes. The Bostonian artist Maurice Prendergast was the first to develop the chromatic rendering of the procedure and incorporate it in his work.

After moving to Paris around 1891, Prendergast absorbed the avant-garde climate, borrowing bright colours from the new artistic movements,

202. Artists making monotypes at the American Art Association of Paris, in *Revue Illustrée*, no. 19, 15 September 1904

203. Maurice Prendergast
Circus Rider, 1895
Colour monotype, 1895 × 216 mm
Private collection, United States

Les Nabis in particular, as well as discovering the works of Degas. The artist to have the greatest influence on his work was, however, Whistler. Though celebrated in the United States since the 1880s, Whistler possibly enjoyed even greater fame in the Parisian English-speaking artistic circles in which Prendergast moved.

Prendergast attended the Académie Julian, where the monotype technique was standard practice, for some time. He soon began producing monotypes himself and his first definitely datable work is *Bastille Day* (1892). After his return to the United States, he went on using the technique for fifteen years, producing monotypes alongside his other artistic activities. Around two hundred monotypes have survived, others having probably been lost or destroyed, and reveal his familiarity with this technique, which was his favourite along with watercolour.

It was the monotype that enabled Prendergast, who had never really had any formal artistic education, to leave behind the rigid academic style of so many of his fellow countrymen and turn to new areas of expression. He was strongly attracted to Japanese prints with their pure, bright watercolours and vertical compositions, both as originals and as interpreted by Vuillard, Bonnard and the many other Parisian artists influenced by them.

Prendergast's monotypes were completely unlike the monotypes being produced in Boston, New York, Florence and Paris at the time, though they drew upon the same subject-matter as the rest of his work: elegant women, people in the park, acrobats and circus animals. Unlike his other works, his monotypes contained large-scale full-length figures in a central position, adding an abstract touch to his soundly structured compositions. He developed his own personal technique to soften the colours by working on second impressions. Because the ink tended to dry on the plate after the first pull, he would soak the paper before printing, thus causing the characteristic creases and marks so often found in his works. The second impressions frequently found together with his first prints reveal his love of the hazy romantic style and are distinguished by the atmospheric tones he used to emulate the silvery glimmer and play of light of Whistler's etchings.

Prendergast transferred the oil ink onto damp paper by pressing it with his hand or the back of a spoon. By dispensing with a press he gave an intimate personal feel to his work, which was artistically aware and commercially conscious. He soon became a great success with critics and the public, exhibiting monotypes in the leading American museums and galleries from 1902 on. The works were, however, identified only by their titles with no mention of the technique employed.

In her article *Monotype in America*, Joann Moser describes Prendergast's relationship with the monotype in the following terms: "The monotype process is especially appealing to painters, many of whom have no interest in other printmaking techniques. Maurice Prendergast, for instance, made no other prints, but created a substantial and distinguished body of monotypes. Prendergast was one of the first artists to explore the possibilities of the monotype as a method of making color prints. He began to work with oil paint rather than printer's ink, which greatly expanded his palette. Inspired by Japanese woodblock prints, Prendergast wished to make color prints without the tedious process of carving a separate block for each color and registering each block precisely. The monotype allowed him to print all his colors at once with equipment as simple as the bowl of a soup spoon. Printing by hand instead of a press

also allowed him to vary the pressure on different areas of the image. Perhaps even more important to Prendergast, he often found the faint second and third pulls from the plate, known as 'ghost impressions' to be more satisfying than the more intense colors of the first impression. He had no interest in printing an edition of identical images, but preferred to explore variations from one impression to the next."[123]

Prendergast was one of The Eight, a group of eight artists celebrated for having taken part in a highly influential show at the Macbeth Gallery, New York, in 1908. While they all made monotypes at some point, their input to the procedure was secondary compared to Prendergast's. John Sloan, a painter from the Ashcan School, was the most prolific and attentive in his use of the technique, employing different colours—a maximum of two at a time—and overlapping lines to create halftones. In the three portraits of Isadora Duncan produced in 1915 he creates an underlying atmosphere and explores the pictorial possibilities of the monotype, abandoning line to work the coloured inks on the plate.

204. Albert Sterner
Bathers, ca 1931
Colour monotype, 379 × 302 mm
National Museum of American Art, Smithsonian Institution, Washington, D.C.

Towards the end of the nineteenth century, watercolours, etchings and pastel drawings enjoyed an increase in popularity among both American public and artists at the expense of the monotype. However, the renewed interest in graphic techniques soon swept up the monotype in its wake, causing it to re-emerge. The small size, speed and immediacy of execution together with its potential for experimentation distinguished it from the more formal disciplines being taught in art academies.

The monotype acquired its own pictorial identity with the Modernists, moving further away from variable ink printing. The importance of colour increased and compositions using this technique became more ambitious.

One of the American artists to create a huge corpus of monotypes during the early twentieth century was Abraham Walkowitz, who maintained a more sharply defined attitude towards European Modernism. The hundreds of works surviving from his early years in Paris (1906–10) reveal the strong influence of Cézanne in their dense sculptural composition and many of them also draw upon the bright palette of the Nabis. Walkowitz's monotypes, which favoured strong composition over picturesque detail, exist independently of his works executed using other techniques and represent his first steps towards abstraction. The artist explores the potential of the monotype by using colours that differ in terms of density and viscosity and alternating dry pigment blends with oily fluid paints.

New York continued to be an important centre for the monotype until the end of the 1950s. The Salmagundi Club offered artists various opportunities to try out the technique, and its members created a corpus of significant works. They included Salvatore Antonio Guarino, who showed sixty colour monotypes in the Public Library and in the Kraushaar Galleries in 1917. Painted in heavy impasto oils, they have the same delicacy and soft surface tones as Whistler's etchings, which were the height of fashion during that period. Both conservative and modernist artists were to adopt the monotype technique for different reasons. Some, like William Gropper, began in the 1920s because they lacked the money to buy canvas for their paintings, while Seth Hoffman saw the monotype as a way to achieve a perfect balance between control and spontaneity. Others chose the monotype because pigments could be applied using free brushwork in the Expressionist style or because it permitted accurate line-work with a print-

205. Joseph Henry Sharp
Hopi Girl, ca 1900
Monoprint with etching, 353 × 275 mm
Private collection, Akron (Ohio)

206. Edward Hagedorn
The Crowd, Two Figures, Blue and Red Eyes, 1925
Colour monotype, 381 × 282 mm
National Museum of American Art, Smithsonian
Institution, Washington, D.C.

like appearance using a method that did not involve the technical complexities of printmaking. Many artists were attracted to the monotype above all because of its apparent simplicity.

Will Barnett included the monotype in his printmaking course at the Art Student League during the mid-1930s, helping to spread the technique among the new generation of artists through his considerable artistic and personal influence.[124]

Many American artists left the centres of Boston, New York and Philadelphia for new destinations, taking with them their acquired "knowledge" of the monotype, which reached the leading American artistic communities of the first half of the twentieth century.

One such community was in Taos, New Mexico. While most of the members of the Taos Society of Artists (founded in 1915) were painters, there were also printmakers and lithographers equipped with presses. Joseph Henry Sharp, who accompanied Duveneck on his European travels, had begun producing monotypes in 1890 in Cincinnati. After moving to Taos he used this technique almost exclusively, specialising in portraits of Indians from the local reserves. Printed by means of a press, Sharp's heavily inked monotypes used the dark field technique and were distinguished by their well-balanced, refined compositions. Being aware of the commercial advantages of the unique image, Sharp developed a complex system that involved pulling impressions through the press twice. After etching the lines of his figures into the plate and pulling the first etching, he would clean the ink off the plate and paint the areas between the etched lines in different colours. After "monotyping" the plate, he placed it on top of the printed etching and ran it through the press again, obtaining a unique image with every run.

Monotypes were also being produced at the beginning of the twentieth century in the art colony in Provincetown, Massachusetts, which mainly attracted experimental painters and printmakers with abstract tendencies. The most prolific artists were Ross Moffett, Edwin Dickinson and Karl Knaths, while the most celebrated painter was undoubtedly Blanche Lazzell, who produced a large body of monotypes between 1922 and the late 1940s. A pupil of Merritt Chase, her works soon departed from the small monochrome tonal compositions of her first American mentor to make way for bright colours and abstract forms revealing the Cubist influence of Parisian artists such as Gleizes, Léger and Lhote.

The most significant group to use monotypes during the early decades of the twentieth century was made up of artists who had come to the San Francisco and Monterey Bay area from all over America. Close to the neo-Impressionist movement and skilled in the production of colour etchings, these artists sensed the affinities between the two techniques and soon appreciated the advantages of making monotypes. While etching required a new run (and plate preparation) for each colour involved, this new procedure allowed artists to create colour images without complex intermediate phases.

John Aloysius Stanton, Alfred Casella and Lee Randolph were particularly skilled in exploiting the technique's potential to produce translucent colours and bright effects of light. One of the most celebrated artists of the period was Xavier Tizoc Martinez, who had studied with Gérôme and Carrière in Paris and may have experimented with the monotype technique there. He produced a large

corpus of monotypes after his return in 1912 and exhibited a number of them, some being printed on surfaces like porcelain, in San Francisco at the Panama-Pacific Exhibition in 1915.

Many Californian artists experimented with printing monotypes on unusual surfaces and using very different kinds of paper. William Seltzer Rice used lithographic pencils to draw images on transparent celluloid sheets that he then printed onto emery paper; George Stillman printed his works on rice or mulberry paper to create softer, more diffused light effects; and Aloysius Stanton used the back of highly absorbent wallpaper.

Other early twentieth-century Californian artists making frequent use of the monotype included Perham Nahl and above all Clark Hobart.

To underline his degree of artistic commitment, Hobart signed his monotypes and gave each a title written in pencil beneath the picture. He showed these works alongside his paintings throughout his successful career.

Edward Hagedorn's modernist tendencies distinguished him from his fellow Californians, who were generally more conservative and conventional than their colleagues on the East Coast. After using thick saturated oil paints to prepare his large plates, Hagedorn would print them on thin translucent paper, thus obtaining deep warm colours. His daring, Expressionistic monotypes of the 1920s were innovative in their dynamic composition and abstract forms.

A number of commercial Californian galleries offered monotypes for interior decorating in the hope of starting a trend. Small format and bright colours made these artworks ideal for display in homes in addition to being unique items at the same time.

Despite the many exhibitions of monotypes and the visibility guaranteed by the Panama-Pacific Exhibition, this technique remained an experimental practice on the West Coast and produced only a limited number of works until the post-war period.

In 1904, when Picasso left Barcelona for Paris, the French capital became the hub of modern art. Its growing fame as a welcoming haven for artists, writers and intellectuals attracted them in growing numbers from all over the world, drawn by its energy and the dream of a Bohemian life. After the success of Impressionism and post-Impressionism, the talented and ambitious artists arriving in Paris from Spain, Eastern Europe, Russia and Japan gave rise to the École de Paris or School of Paris. A hive of creativity wider reaching and more influential than any mere trend or movement, this was to dominate the course of modern art during the first half of the twentieth century, rising to the challenges of the avant-garde and pushing the boundaries of art further than anyone could have imagined. This period also saw the emergence of a whole new generation of keenly involved and broad-minded dealers and publishers like Vollard, Petiet and Frapier, who built up ever-larger networks of contacts on the fertile terrain created by critics, bibliophiles, collectors and printers. Moreover, a series of prestigious printmaking studios had flourished in Paris since the end of the nineteenth century.

It was through this happy combination of circumstances that the French capital remained Europe's leading printing centre until after World War II. Dealers encouraged their painters and sculptors to produce prints so as to make their work better known and reach a broader public.

The following decades saw constant stream of technical and stylistic experimentation by Picasso. During this period both he and Braque were to

207. Xavier Tizoc Martinez
Valkyrie of the Sea, ca 1915
Colour monotype, 198 × 198 mm
National Museum of American Art, Smithsonian
Institution, Washington, D.C.

create their first drypoints, works in which the ambiguous representation of space and movement typical of Cubism is heightened by flexible and inventive line. Also part of this panorama were Matisse's lithographs of the 1920s and his earlier Fauve woodprints with their fine modelling as well as the colour prints that Chagall was later to produce with the printer Charles Sorlier.

A meeting point for some of Europe's most stimulating avant-garde movements, trends and schools of thought between the two wars, Paris was above all the capital of Modernism. Leo Stein described the atmosphere for his American readers in 1924: "The change in balance between the Academy and the insurgents is so remarkable that whereas twenty years ago everyone knew the names of the great official painters [...] today no one knows them."[125]

Supported by a peacetime economy, Paris was also described as "the capital of America" due to the large numbers of American artists disembarking from transatlantic liners in search of Eden. Those were the years of *An American in Paris*, Hemingway, Josephine Baker, Kiki de Montparnasse and so on. The Boulevard Montparnasse and the Café du Dôme were so thronged with Americans that they were like outposts of the USA.[126] As Stuart Davis wrote in 1929, Paris was unquestionably the place for artists, with so much of the past and the immediate present welded together in a single spot that they could ask for nothing more. There was not the slightest feeling of being cut off from America.[127]

A change was in the air, however, and as early as 1915 there were signs of a shift in areas of influence. Francis Picabia issued this statement to the press on his arrival in New York: "The war has killed the art of the Continent [...]. Since machinery is the soul of the modern world and since the genius of machinery attains its highest expression in America, why is it not reasonable to believe that in America the art of the future will flower most brilliantly?"[128]

The colour art prints of the École de Paris continued to dominate the tastes of the European public with their simple, fluid, expressive style until after World War II. These works, mainly by Picasso, Matisse, Dalí, Chagall and Miró, were printed by the leading printers of the period. The now historic Lacourière, Desjober, Mourlot and Sorlier workshops made artisanal products in which printing "transparently" reproduced a drawing, watercolour or tempera created for that purpose by the artist. The close collaboration that took place between modern artists and their printers in the workshops not only paved the way for extremely profitable alliances—Picasso and Mourlot, Chagall and Sorlier, Miró and Lacourière—but also gave rise to an explosive phenomenon that was soon to become unstoppable.

208. Anonymous
Montparnasse
Period photograph
This district initiated a new era of Parisian urban and artistic geography

209. Roger Lacourière in his Paris
workshop, ca 1942
Private collection, Paris

During the immediate post-war period, the print became a precious
object while, at the same time, losing some of its intrinsic content. No longer
interested in renewing their "inventions" and tools, artists were neglecting
their need for creative expression in their efforts to meet the demands of the
market.

Picasso
"It would be extremely interesting if we could use photography not just to
preserve the various phases, but the metamorphoses of an image. Maybe this
would help us to discover the path our mind travels along to make a dream
materialise."
Pablo Picasso

Picasso had an unbridled, insatiable passion for every form of artistic expression
and for every type of material, whether new, unusual or old-fashioned.

He was hugely curious about printmaking and while no other twentieth-
century artist comes close to him, he could be compared to Degas in terms of
his open-mindedness and creativity. Picasso explored and combined all kinds
of materials and techniques. He mastered the traditional procedures—burin,
etching, drypoint, woodcut, aquatint, lithography, lift-ground etching—and
transformed them by ripping, cutting and countless other practices, taking them
to the peaks of expression attained by the great *peintres-graveurs* of history like
Rembrandt, Goya and Degas. With his characteristic independence, he ex-
plored avenues where no others ventured and took up then marginal techniques
such as linocut and monotype.

Picasso made his first monotype in Barcelona around 1899–1900, probably
encouraged by Ricardo Canals, his printmaking mentor. The only trace of this
lost work is the entry in the catalogue of Picasso's work compiled by Zervos,[129]
where it was described as a colour monotype, probably in oil, depicting a bull-
fighter. The monotype was thus made before Picasso's brief stay in Paris in 1900,
which would appear to refute the claim that his interest in the technique was
rekindled by close study of Degas's monotypes.

210. Pablo Picasso
Sculpture. Tête de Marie Thérèse, II, 1933
Monotype on copper, printed on state IV
of the same etching, 320 × 229 mm
Musée Picasso, Paris

The latter was in any case certainly one of the French masters that the young artist most admired, being particularly impressed both by his painted ceramics and by his monotypes, of which he bought a large number after the war from Vollard as well as other sources. Eleven of these were donated to the Louvre after Picasso's death. Others are now to be found together along with their plates—including *La fête de la patronne*—in the Musée Picasso, displayed alongside the Spanish artist's own monotypes and bearing witness to their shared passion.

After settling in Paris in 1905, the period of his first prints on the *saltimbanque* theme, Picasso made four monotypes using printer's ink and tempera. The use of glass rather than metal plates (though he did use metal later in his career) suggests that Picasso was not copying the technique from Degas, who used metal plates, but either carrying out a personal experiment or using a method suggested by Canals when he was still in Barcelona.

This small set of monotypes belongs to Picasso's first experiments in the field of printmaking, when he started carving and hand-colouring blocks of wood, and using the drypoint technique to etch red-inked celluloid sheets. Unlike his etchings and drypoints from the same period, with their thin fragile lines on the verge of breaking, his monotypes have a pictorial and almost tactile quality hinting at a softer, sensual universe reminiscent of Graeco-Roman pottery.

The outlines of his pure lyrical *Tête de Fernande de profil* stand out against the paper background with all the calm of a Classical sculpture. These works, like those of his Rose Period, are markedly influenced by Greek art. There is also some resemblance between this profile and that of the statuesque maidservant holding up the mirror in the painting *La Toilette* (also from 1906). Both the subject and the unusual palette of earthen tones against a blue-violet background are taken up again, or anticipated, in a contemporary tempera. Picasso printed two impressions of each of these five monotypes: one on thick wrapping paper and the other on thin tissue paper.

His first large-scale monotype, *Plante Verte à Lueurs Oranges* (ca 630 × 470 mm), possibly also produced in 1906, was pulled twice. The first impression is affixed to a canvas support that still shows the holes where it was pinned to the wall in Picasso's studio at the "Bateau Lavoir" in Rue Ravignan. As Picasso very seldom took flowers as a subject, it seems possible to connect this work with Van Gogh's painting, *Fritillaire couronne impériale dans un vase de cuivre* (1897), which Picasso probably saw at Vollard's gallery.

Seventeen years would pass before Picasso returned to the monotype technique in 1922, by which time his formal expression was far more mature and he had fully absorbed the radical experience of Cubism. The five small monotypes made between 1922 and 1925 (all except the first measuring 120 × 60 mm or less) reflect the more playful, lively and decorative mood pervading the abstract figuration in the rest of his graphic work.

Picasso was strongly influenced by Matisse in his series, though failing to achieve his effects of light. As in the set of monotypes that Matisse produced in 1915–17 by means of the subtractive technique with no effects of volume, the white areas are those where the black ink was removed from the plate and the paper shows through. Again like Matisse, who made monotypes on the plates used for his engravings, Picasso covered zinc plates used for etchings all over with printer's ink and drew on them with a pointed instru-

ment. He was in any case already familiar with the technique of using the paintbrush handle to draw lines on the painted surface revealing the layers beneath. A progression from darker to lighter colours was already frequent in his Cubist paintings and continued up to the end of the 1960s.

Picasso's printmaking activities were intense and highly productive between 1927 and 1933. The fifty-year-old artist was at the height of his career and in perfect command of his tools, capable of drawing upon the entire range of printmaking techniques to express the variety of his work and personal artistic evolution. He produced many illustrations during this period as well as the series *Les métamorphoses de Ovide*. It was then that he abandoned painting to turn to sculpture and the graphic techniques of etching and drypoint. The *Suite Vollard* was created some years later in 1939.

His work was now closely bound up with monotype production, to which he devoted his energies as from July 1932, producing 123 monotypes (out of a total corpus of 147) in a burst of activity between January and March of the following year. They include *Tête de profil*, a series of twelve small monotypes showing the evolution of an image, and *Visage*, a one-off composition in the series of monotypes with profiles of this period. Picasso printed three examples of each monotype in printer's ink, dating them and including the serial number of the impression. He employed the same technique that he had used in 1905–06 for his *Tête de Fernande de profil*, creating the image by applying ink to the glass plate in thick but sensitive brushstrokes as though shaped with his fingers.

Like the head of 1905, these are endowed despite their small size with the intensity of prehistoric images and the powerful impact of Romanesque sculptures, and seem to retain the striving of both for a dimension above the human and the temporal. Dissociated from any general pattern, regularity of proportions and "rational balance", they are not simple illustrations but the embodiment of personal physical creation with the acid hues of burnt earth colours and rich blacks that crumble and blur to conjure up shades of grey and light.

Picasso was so absorbed by his use of acids and pointed instruments that he would often draw his compositions on the monotype plate first before etching them with acid. Many second and third impressions pulled with black ink on plates as yet unbitten by acid constitute the outlines of drypoints bearing the same titles.

The artist used the monotype above all to transform the composition. He would print a drawing made on the blank plate, make changes and then print it again. His images thus developed through sometimes numerous metamorphoses and variations. In *Flûtiste et dormeuse*, Picasso interprets the themes of the sleeping woman and the companion watching over her slumbers, one of his favourites, through a series of forty-seven elaborate transformations, most of which were printed two or three times.[130]

A global reading of these images allows us to trace the evolution of his formal style as it leaves behind a naturalistic idyllic approach to become increasingly abstract and cerebral. It is as if these images, forming a coherent whole, are intended to tell us what was going through the artist's mind day after day, or rather what dreams filled his nights.

Picasso made etchings of the same series, using the copper plate on which he had drawn and painted his monotypes in bistre and watercolour to produce a run of twenty-seven states. Evidently not satisfied with representation of a sole-

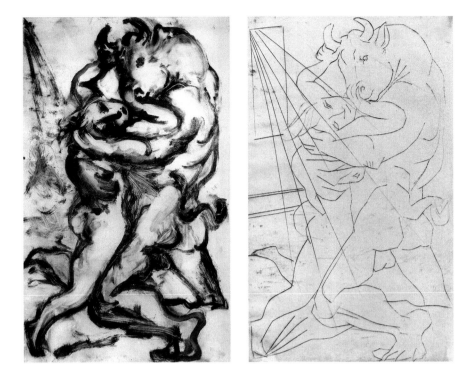

ly linear character, he used the brush to add shadows and thin films of ink, which are rendered in the etchings by means of dense cross-hatching. While continuing to draw line upon line and bite the plate with acid, he eventually decided to heighten the etching with colours added by hand, thus producing a group of unique coloured impressions and creating works that were literally midway between prints and paintings.

Mythological creatures of a half-human, half-animal nature, first centaurs then fauns and satyrs, made their dramatic appearance in Picasso's work in 1920. This realm of the imagination was dominated above all by the potent figure of the Minotaur, the Cretan monster onto which Picasso projected man's primitive energies.

He designed a minotaur for the cover of the Surrealist magazine *Minotaure*[131] in 1933 and made the monotype *Minotaure embrassant une femme* the following year, reproducing it as an etching two days by following the lines of ink left on the metal plate. While the purely linear representation of the etching captures more clearly the choreographic aspect of the scene, where the two figures are depicted in the graceful rhythm of a *pas à deux*, it does not, however, convey the passion of the struggle emerging from the violent brushstrokes of the original monotype.[132]

In his efforts to give shape to images, to clothe his dreams, Picasso moved readily back and forth between monotype, etching and drypoint. In 1935 he confided his desire to document step by step the development of the various creative processes, which he distinguished from the technical stages.[133] After World War II he created these metamorphoses through intense work on the surface of the lithographic stone.

In 1957 he made a monotype on a zinc plate that he then used to make a similar image using sugar aquatint, the most pictorial of the various printmaking techniques. He returned to the monotype many years later, in 1964, with one last, isolated work.

Matisse

"You must always seek out the desire of the line and the spiritual light
in which it lies."
Henri Matisse

The catalogue raisonné of Matisse's graphic works published in 1983 made a cru-
cial contribution to our understanding of the artist as a printmaker, making it pos-
sible to assess the unexpected scale of a body of work previously thought to be
more limited and fragmentary. Even though Matisse appears to be less spectac-
ular than Picasso in terms of graphic output, the catalogue compiled by his
daughter Marguerite and her husband Georges Duthuit lists a surprising total of
sixty-nine monotypes.

Upset at the outbreak of war in 1914, Matisse played the violin to raise his
spirits. To interrupt the effort of painting, where he addressed the models of Ingres
and Delacroix on the one hand and Cubism on the other, he began to use the
more intimate and personal techniques of printmaking such as lithography, etch-
ing and drypoint. As Marguerite recalls, "The etchings were pleasant relaxing in-

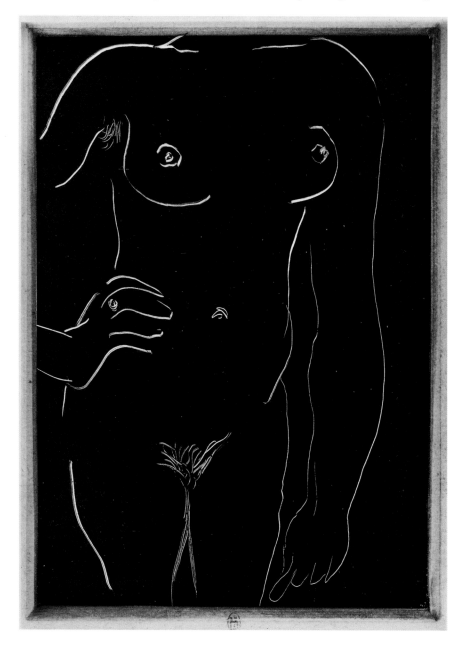

213. Henri Matisse
Nu à la bague, 1916
Monotype applied on China paper, 169 × 122 mm
Bibliothèque nationale de France, Paris, Donated
by Jean Matisse

214. Henri Matisse
Les Coloquintes, 1916
Monotype, 178 × 126 mm
Bibliothèque nationale de France, Paris

terludes that broke up his sessions of hard work […]. The clarity of the line and the luminous gleam of the plates […] were in a certain sense the immediate reward for the moments of constant, intense effort that had preceded them, offering an enjoyable distraction from the themes occupying his attention at the time."[134]

For Matisse, printmaking was a way of reappropriating reality through lines and contrasts. He would apply the skills acquired in this field to the techniques used throughout his life.

Matisse began to explore the monotype in 1914. He concentrated his efforts on this technique over the next three years and his works express and attest to his progress in the use of line to suggest rather than describe shapes. The result was sixty-nine monotypes of pure, simple lines in which the artist made exclusive use of the contrast of black and white to separate figure and background. Though quickly executed and sketch-like in appearance, these spontaneously expressive creations are finished works.

Unlike Degas, Picasso and other artists, Matisse was never tempted by colour and never used it in his monotypes, all of which were produced with the subtractive method. Having coated the plate in black ink, he would draw the image in pure, unbroken lines and then, with the help of his daughter, pull a single print, which he often heightened with China ink. This was a delicate operation. The pressure had to be exerted evenly so as to leave no undesired marks on the paper, such as those made by his son in the third monotype. Matisse used a small press that he set up in his flat on the Quai Saint-Michel in Paris to make etchings. He always made his monotypes on metal plates, which he would then use again for etchings. His daughter Marguerite describes the procedure as follows: "The monotypes were made in three phases: the delicate application of the ink on the copper, the creation of a spontaneous drawing that could not be modified, and the moment of printing with the risk of destroying the work. The most exciting moment was at the end of these three operations when the impression on the paper was revealed."[135]

Ten years before he started making monotypes, Matisse had been obsessed with the problem of colour—which, some say, he is the only painter to have understood after Cézanne—and took a keen interest in Manet, who considered black a colour and used it as such. Matisse regarded black not only as a colour and a source of light but also as a factor linking the figure with its ground. On the principle that extremes eventually meet, these monotypes seem to represent the ultimate phase of his conception of colour in that period, one that led to its own reversal.[136] Even though the artist intended no separation of figure and ground, the uniformity of the latter is such that the former is clearly detached and distant. It is almost as if the drive for abstraction expressed by the motionless black background were expressed through the sensual and concrete nature of the form penetrating its interior and not superimposed upon it.

The varying thickness of the white line, the only sign of movement, suggests the reflection of a light that comes into being and exists as volume through its value as a term of contrast.

The technical difficulties involved in an operation that does not tolerate the slightest error in the phases of inking, drawing and printing serve only to spur Matisse on in his effort to create a work with no possible mainstay, where the image appears with the utmost visibility and immediacy, still more clearly than in his other works. It was with the monotype more than the painting of this period that Matisse developed an aesthetic vision whereby the images built up out of

215. Henri Matisse
Nu de dos, ca 1916
Monotype, 198 × 148 mm
Jacques Doucet Collection,
Bibliothèque de l'INHA, Paris

light are "light in light and colour in colour"[137] and pure black is not, as he put it, a colour of darkness but of light.[138]

He arrived at this inversion of black and white in *Les Coloquintes* and three other monotypes of 1916 resembling it in composition, where the dark background is juxtaposed with a stroke that reveals the whiteness of the paper and assumes deep, vibrant resonance. He also captured the coppery, mirror-like effect of the Moroccan tray and the bright colours of the fruit featured in many of his compositions after his first stay in Algeria in 1906.

These works put down on paper in a single, sweeping gesture endowed with sinuous movement addressed a wide range of subjects including nudes, portraits, still-lifes and interiors. These were themes that he also tackled by means of other techniques and in which he expressed himself with great flexibility: "The background remains the same. Each technique helps the other [...] and [...] the work functions by itself. If it is not legible, it means that it is not clear enough or that the others are not sufficiently perspicacious."[139]

Many of his monotype portraits were previously carried out as etchings or paintings depicting friends and family. While the subject was identical, the monotypes were much smaller in format (his plates generally measured around

ca 180 × 130 mm). As a result, all anecdotal detail was abandoned and the faces were represented very schematically.

The procedure and the speed at which the artist was obliged to work made great economy and concision necessary in order to achieve the maximum degree of expression with the fewest possible elements. Once the monotype had been printed, China ink was used, albeit rarely, to strengthen some of the lines, as in the case of *Les Coloquintes*, which was retouched in about forty places.

Line and composition are everything in these works, which are primarily expressions of the artist's emotions rather than realistic representations of the subject: "The line is the purest and most immediate translation of my emotion. The simplicity of the medium permits this. These drawings are, however, more complete than they might appear to be […]. They are generators of light. When viewed in low or indirect light, they clearly contain not only the flavour and sensitivity of the line but also light and the differences in values corresponding to colour. […] You must always seek out the desire of the line and the spiritual light in which it lies."[140]

His compositions are often daring. As in the lithographs of 1906, Matisse does not draw the complete silhouette of his female figures but breaks it up to achieve greater expression, condensing the meaning—as he put it—in the pursuit of the essential lines.[141]

The Bibliothèque Doucet in Paris, whose original holdings comprise the works left by the French bibliophile and collector on his death, now owns a hundred and fifty-nine graphic works by Matisse. These include the monotype *Nu de dos* with the words "*Pour les prisonniers civils de Bohain-en-Vermansois*" written by the author on the back.[142]

Chagall

As Matisse remarked in connection with his final discovery of decoupage, "We must put all our experience behind us and preserve the freshness of instinct." This also holds for Marc Chagall, who decided to tackle the monotype when already in his seventies, an established artist with nothing to lose. The propensity to mix different techniques and the desire to achieve surprising results, evident in his etchings as from the 1920s, were confirmed by his colour lithographs of the 1950s with their focus on physicality.

The growing variety of approaches and use of increasingly bright and pictorial colours naturally led him to the monotype, in which he expressed an authentic, autobiographical lyricism with his customary mastery. Chagall himself talked about his fortunate experience with the monotype, which set him off on a path towards an unknown destination, and compared it with singing on stage: "You must be natural, have your voice well under control and not attempt to force things. Above all, despite all the requirements of the process, you must not force yourself to work fast. There is an internal speed in everyone's character that we must submit to harmoniously, leaving aside all nervous tension and haste."[143]

Chagall attached crucial importance to rhythm in creation. While he worked for months and sometimes years on some of his major paintings, he was also capable of seizing the moment of inspiration and working with great speed and vivacity. He brought these qualities to the monotype but also the confidence he reserved for complete works. He sought fullness, transparency and economy of colour as well as fluidity of his material, applied neither too thick nor too thin so as to withstand the pressure of the press.

When the monotype became one of his forms of expression, the experience accumulated in the fields of painting, graphics, ceramics and stained glass enabled him to set off quite naturally along this unknown path and ascertain the freedom of his artistic vision in the immediacy of the instant. His mastery of colour and rhythm allowed him to use thick, broad brushstrokes in exploring a world of a more pictorial than linear character permeated by the relationship of colour and light, and to embed his monotypes in this world. These works featured the artist's familiar subjects and drew upon the consolidated iconographic vocabulary of couples, clowns, Old Testament scenes, self-portraits, jugglers, still-lifes, and so on.

As his activities in the graphic arts expanded, Chagall had a press for etchings and monotypes installed in the workshop attached to his villa at Vence in May 1961 and began to produce sporadic works in this field. Forced to move by property development that limited his space, Chagall had a house built in a pinewood near Saint-Paul-de-Vence, where everything seemed conducive to inner harmony and silent creation.

In the week of transition between the old and new studios, Chagall concentrated on the monotype, as suggested by his publisher Gérald Cramer, in an effort to calm his impatience and help him get used to his new surroundings. It proved perfectly suited to his temperament and such was his enthusiasm that he realised no fewer than 308 monotypes, an outstanding corpus that few other artists have equalled, over six different periods between 1962 and 1976. After heightening two second impressions with tempera and oil paints, he abandoned this practice, which had so delighted Degas and Gauguin, as incompatible with his self-imposed rule of preserving the purity of his works by avoiding all retouching once they had left the press.

For fourteen years, the artist devoted entire days to making monotypes in his studio at Saint-Paul-de-Vence. He discarded printer's inks almost immediately in favour of oils diluted with turpentine or petrol to prevent them from drying out while he worked. He initially used plates of Plexiglas, a reactive, ductile material, but soon found it too inert, mechanical and soulless. He thus turned to plates of copper, a natural and noble support capable of bearing the pressure of the press and sensitive to touch.

His monotypes were pulled by hand by the master-printer Jacques Frélaut, who took over from Roger Lacourière as head of the renowned workshop in Montmartre. The sustained rhythm of monotypes produced and printed every day was necessitated by the very nature of the technique.

Chagall's colour monotype *Amants et deux bouquets de fleurs* (1963) shows two bunches of flowers in the foreground with two lovers glimpsed in the background on the other side of the room. This still life, one of those the artist arranged in his new studio, appears frequently also in other works.

Jean Leymarie, who compiled the complete catalogue of Chagall's monotypes, describes his vigorous gestures and use of paintbrushes and handles, fingertips and nails. As he points out, these works possess both the physicality of his paintings and the radiant colours of his stained-glass works. Though free improvisations in the musical sense of the word or themes familiar to the artist, the monotypes also enabled Chagall to try out ideas for demanding projects. The theme explored in *La Paix* was taken up in the large stained-glass window commissioned by the UN in memory of the Secretary-General Dag Hammarskjöld.

Leymarie describes three days that he spent at Vence observing the master's work in all its phases: "The hand-press is situated on the ground floor of the studio, where Cramer and Frélaut print the works with an incredible degree of con-

MARC CHAGALL

MONOTYPES 1966-1975

216. Marc Chagall
Cover of *Marc Chagall, Monotypes, 1966–1975*, by Jean Leymarie, Éditions Gérald Cramer, Vol. II, Geneva 1976

centration. First they prepare and dampen a sufficient number of sheets of suitable size and material for each monotype. The best sheets subsequently selected are those that seem to yearn for the ink and paint, [...] taking on the satin finish of precious objects after being run through the press. They prefer thin Oriental paper—China, Annam or antique, triple-milled, nacreous, laid Japan paper—to Rives or Arches. Chagall chooses one of the six gleaming red copper plates of various sizes placed at his disposal, climbs the outside staircase leading to the first floor and shuts himself up in his studio with the windows overlooking the garden to paint. He stands in the middle of the room, surrounded by easels and the paintings and drawings on which he is working. [...] Downstairs they can hear tapping and strange noises with long intervals of silence. When he has finished, he knocks on the floor. It is Frélaut in his stained blue apron that goes to fetch the plate gleaming with colour and take it down to the press."[144]

The monotype became the most fertile medium for the explosion of colour that Chagall finally permitted himself towards the end of his career. He be-

217. Marc Chagall
Amants et deux bouquets de fleurs, 1963
Monotype in oils, 585 × 420 mm (image);
845 × 620 mm (sheet)
Formerly in the Patrick Cramer Collection, Geneva

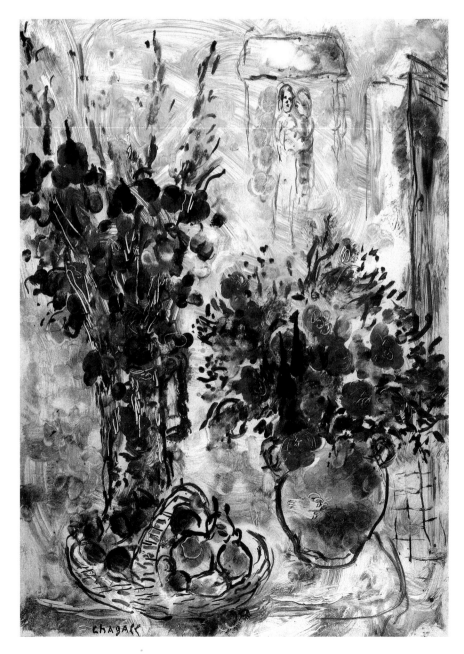

lieved that, with respect to other techniques, this one required colours that were both "more fiery" and more transparent. The pressure of the press endowed the "vibrant chemistry" of the coloured pigments with the unmistakable and more muted appearance of the printed work while preserving all of their freshness.

The monotype in Europe

Jean-Louis Forain and Alexandre Steinlen were among the many twentieth-century artists to use the monotype. Georges Rouault produced a series of monotypes in 1910 and showed eleven of them at the Galerie Druet in Paris the following year.[145]

While the Fauves took Gauguin as their tutelary deity, Georges Rouault chose to follow Degas, a master whose advice he would never forget and above all a "solitary rebel skilled in monotyping and other unorthodox methods."

Although Rouault came to printmaking late, when his career was already well underway, he gave it a central role in his oeuvre. He used procedures regarded as uninteresting by the Fauves at the time, like colour lithography and the monotype. In the latter case, works produced with the additive method were thickly heightened with tempera to obtain a markedly physical effect, a complex, atypical system that underscores both his individualism and his lack of interest in current developments. He produced one series in 1910 followed by others in 1913. With their thick, manual impasto, both the heightened works and a "pure" monotype constituting one of his first known works in this medium clearly show that the results he expected from the procedure were completely different from those sought by the Fauves, effects of a tactile and pictorial rather than graphic nature.

Forced to stop painting under the Nazi regime, Oskar Schlemmer worked in secret using materials that were easy to conceal. He thus began making monotypes on supports such as the reverse side of pages from a calendar or postcards. The shiny surface of the latter enabled him to obtain marbled effects and enhance the transparent, ethereal quality of the colours. In 1941 Schlemmer came upon a 1936 issue of André Breton's magazine *Minotaure* containing a description of decalcomania. The discovery that the French Surrealists produced images by pressing ink blots between two sheets of paper inspired him to create some monotypes, which he called *Klecksographien*, between 1941 and 1943. Using glass instead of paper, they show stylised figures in movement with characteristic flattened noses. The brushstrokes reflect the spiritual calm of the Chinese and Japanese master calligraphers rather than the immediacy and impulsive energy of the Surrealists.

Jacques Villon started using the technique in 1942 and made six monotypes. As far as we know, Jean Fautrier made only one work of this kind (ca 1943).

Julius Bissier executed various monotypes between 1947 and 1952 and saw the process as a stage of artistic growth. As he wrote, "Once again, grace enriches my works."

After producing a couple of monotypes by means of the traditional method in 1945, Jean Dubuffet made about a hundred that he called "*empreintes*" between 1953 and 1959. He described this new process as a "preliminary exploration" and an "incomparable laboratory with effective tools for invention". A lover of lowly, non-constructed art, he was attracted by the material possibilities of the monotype but most of all by its capacity to surprise. As he wrote in 1946, "[A creative act] is not a dance you do by yourself. It takes two, and chance is

one of them. […] The artist proceeds as best he can, seeking to make the best of every event that crops up and obliges him to make certain choices."

Victor Brauner loved to experiment with derivative procedures because of the soft, physical effects they offered. He often made drawings on paper and covered them with black wax, which he removed once it had hardened.[146] He made several monotypes in 1949 with the *dessein-empreinte*, or traced drawing method that Gauguin used to produce hundreds of works. Although Brauner differed from Gauguin in terms of artistic personality and altered his drawings (Gauguin never modified his plates or supports), they shared an interest in the traced monotype with its paler hues and less sharply defined outlines. With respect to the pencil drawing, Brauner considered this the true work of art.[147]

Joan Miró made a dozen works on glass plates with oil paints, most of them during a stay at Saint-Paul-de-Vence in 1977 as a guest of the publisher Maeght. Jean Messagier produced numerous monotypes and Maurice Estève over a hundred between 1963 and 1984.

219. Jean Dubuffet
Formations globuleuses, 1959
Trace monotype

An admirer of Degas's monotypes and uninterested in any other type of printmaking technique, Estève rediscovered his identity as a painter in this process and explored all of its possibilities. He traced the outlines of his drawing on a glass plate and filled in the figures with thick layers of printer's ink. In the polychromatic works, he superimposed layers of paint to produce a rich and variegated thickness to which he then applied the subtractive method. He did not use a press to make his prints, just the pressure of his hands, and often heightened the second impressions with charcoal or crayon before printing them on a different type of paper to distinguish them from the first impressions. Just as the art historians Cachin and Leymarie excluded works heightened with pastel from the catalogues of Degas's and Chagall's monotypes, Estève also felt the need to distinguish the monotypes reworked after printing, which he catalogued along with his drawings, from his "pure" monotypes.

Many Italian artists rediscovered the monotype at the end of the 1920s and the technique spread beyond the private and experimental sphere typical of the early years of the century.

220. Carlo Levi
La conciliazione, 1929
Colour monotype, ca 600 × 500 mm
Private collection, Turin

Carlo Levi, an intellectual from Turin equally gifted as a writer and painter, was one of the "Sei di Torino", a group of artists forming a link between the French Impressionists and the Italian artistic tradition.

Consisting of Levi together with Gigi Chessa, Jessie Boswell, Nicola Galante, Francesco Menzio and Enrico Paulucci, the group made its debut in Turin in 1929. Despite the renown quickly gained through its European focus, it proved short-lived and broke up only six years later. In an increasingly grim cultural and political situation, the small group found it difficult to act; the spearhead of Italian painting, they failed to develop into a movement.

Levi made around two hundred monotypes with oil paint on glass plates. This large number shows that, by comparison with works using other techniques such as paintings and drawings, his use of this procedure was by no means occasional. They are works with characteristics similar to those peculiar to his artistic oeuvre, many of them being portraits endowed with the same immediacy and psychological insight that Levi brought to his paintings.

Levi fully exploited the flexibility of this technique, managing to give his monotypes the same physical substance as his painting. Through this physicality and rich, deep, expressive colour, he conjures up complex meanings and tangible energy in his images. He learnt the technique from Spazzapan (1898–1958): "in the same year, 1928, in my studio on Piazza Vittorio in Turin, [Spazzapan] taught me his own particular monotype technique, which I used from then on."[148]

Spazzapan advised him to use glass plates because of their transparency and taught him what may have been an old and difficult technique for superimposing layers of oil paint. Applied to form a mirror image with respect to the one produced on the support, the brushstrokes suggest a procedure used in painting from the seventeenth century on, especially by Venetian painters. Traces of this technique, which probably dates from the period of Castiglione's monotypes, can also be found in primitive Yugoslavian painting, which is where Spazzapan learnt it before passing it on to Levi. Spazzapan had studied in Gorizia in the Friuli region for many years and was therefore familiar both with the work of Venetian artists and with early Yugoslavian painting. With modern sensibility and curiosity, constantly in search of particular effects of light, he partially adopted this ancient technique of superimposing colours in the production of monotypes by means of the additive method.

Levi's experience with the monotype also inspired him to develop a particular method of painting his mainly polychromatic designs in oils and leaving them to dry on the paper. Significantly enough, such designs appeared for the first time in 1928, when he was working together with Spazzapan.

Levi's monotypes are nearly always unique works, though the same plate was sometimes printed again with variations or retouching. The paper used was thin and slightly translucent. The same subject was occasionally taken up in a similar way but developed on different matrixes.

In 1930 the French critic Waldemar George organised an exhibition of Italian painters living in Paris (Corrado Cagli, Giuseppe Capogrossi and Emanuele Cavalli amongst others) in the Milanese gallery of Vittorio Barbaroux. In 1933 he presented them in Jacques-Bonjean's Parisian gallery together with other Italian artists belonging to the new generation showcased in the First Rome Quadrennial of 1931 (Fausto Pirandello, Renato Guttuso, Afro and Mirko Basaldel-

la amongst others). He coined the successful name École de Rome or Roman School, evidently understood in a very loose geographic sense, as it included artists from areas as far removed as the Marche region, Sicily, Ferrara and Lithuania. In any case, they were international artists on the move both physically and culturally, with copies of Vollard's books and issues of *Valori Plastici* or the *Nouvelle Revue Française* always to be found on their bookshelves.

George opposed the "internationalism" of the French Surrealists and turned to the Classical, especially antique Roman sculpture, in an attempt to create a particular cultural climate. From Paris, still a point of reference for Europe's artistic culture, he upheld more specifically Italian pictorial values against international ones. Central to the Mediterranean area as a whole, this new "Italian" vision had an impact on leading French figures like Picasso and Le Corbusier, whereas the influence of Futurism grew at the same time in Europe and America. The importance of Paris now hinged in any case on its capacity for dialectic intermediation, absorbing cosmopolitan input in all sectors. The city became a meeting place for the world.

223. Giuseppe Capogrossi
Self-portrait, ca 1931–32
Monotype, first of two impressions, 285 × 210 mm
Guglielmo Capogrossi Collection, Rome

224. Mirko Basaldella
L'incontro, 1949
Monotype

These factors proved crucial for the training and artistic expression of many Italians, including Giuseppe Capogrossi. His stay in Paris is poorly documented—we know neither how long he stayed there nor whom he met. His letters show that he went there in 1929 and that this was not the first time. His nephew Guglielmo refers more precisely to an initial visit between 1927 and 1928.[149] In any case, Paris made an impact on him. His paintings of 1931 show the influence of French Impressionism, Picasso and Rouault's handling of thickly applied paint.

His palette also changed under the influence of French culture in the early 1930s, with cold, light colours making way for radiant reds, oranges and yellows.[150]

For a period of twenty years Capogrossi produced works on paper with a wide range of techniques, such as drawings in pen, black or coloured pencil and red chalk, which he invariably retouched. He also experimented with charcoals, pastels, watercolours, inks, temperas and oil paints, which he would either use alone or, more often, in combinations. This period marked a tendency towards figurative painting and a growing interest in rendering tonality.

The focus on tonality also led to an interest in the monotype, a technique he had encountered in the Parisian artistic circles and practised in a form very sim-

ilar to Gauguin's *dessein-empreinte* with sticks and brushes of various kinds. *Autoritratto*, a "*monotipo-calco*" of 1931–33, was made by using a silverpoint to trace the image on a plate prepared with oil paints.

As a boy, Guglielmo Capogrossi had visited his uncle's studio in Rome and watched him making monotypes and experimenting with a wide range of techniques and materials: "He made a paste using oils and earth pigments, usually natural or burnt sienna, ivory black, Pozzuoli red, mixed together or separate. The mixture was then spread onto a sheet of cardboard (or thick paper) and left to dry slightly until a thin film had formed on the surface. He then took a blank sheet of paper and placed it on top, exerting slight pressure with the thumb and index finger of his left hand to hold it in place. He then used a stick (the handle of the paintbrush), a pencil or some other pointed object to trace his drawing on it, doing his best not to interrupt the line. This was a true test of skill, carried out blind, as it were, with no possibility of corrections or rethinking until the entire drawing had been completed. Only then did he turn the paper over and reveal the result. The tracing was sometimes done not directly on the blank sheet but on the back of the inked sheet placed on top of the blank one, in which case the result was obviously not a mirror image."[151]

Monotypes were also made by Emanuele Cavalli and Fausto Pirandello, two artists who were close associates and friends of Capogrossi. They had learnt the procedure, which was beginning to make its appearance in Roman studios at the time, from the "*Italiens à Paris*", and their approach should be interpreted accordingly.

Massimo Campigli became familiar with monotyping during the first years of his long stay in Paris (1919–39) and made over fifty works, mostly during the 1950s and 1960s, while in the French capital, where he would live on and off for the rest of his life. He used oil paint on glass plates. After pressing the paper manually on the plate and then removing the impression, he used the same colours to rework the compositions thoroughly, checking and correcting every detail until he was fully satisfied. The finished works addressed the artist's familiar range of subjects, consisting mainly of women's portraits, and he attached great importance to them:

"Dear Lella,

The monotype is coming on very well. Like all monotypes it is unique because this technique allows you to paint on glass as well. There is a lithograph from roughly the same period based on the same idea, which has undoubtedly sold out. The monotype gives you the pleasure of more spontaneous execution than a painting on canvas. The market value of this monotype is L. 2,000,000 (two million lire)."[152]

His son Nicola, who believed that the term "*monotipo*" (monotype) would still arouse doubts and confusion in Italy, called these works "*oli su carta*" (oils on paper) to emphasise their uniqueness.

Corrado Cagli, probably the most inventive artist in the group gathered around the Cavalli and Capogrossi circle, was open to all innovations and eager, with his enterprising spirit, to try out experimental techniques rather than adopt formal practices. With a considerable corpus of drawings to his credit, he realised the graphic and compositional possibilities offered by the monotype and took it up with no hesitation.

225. Roberto Crippa
Volto, 1948
Monotype, 355 × 215 mm
Formerly in the Sambonet Collection, Milan

226. Achille Perilli
Untitled, 1957
Monotype in oils (from Carla Vasio's book
Il Pescatore di Miti), 262 × 338 mm

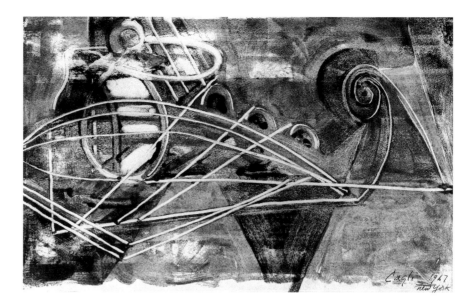

227. Corrado Cagli
Strumento e lanterna, 1947
Monotype in oils, 300 × 480 mm
Private collection, Turin

His first works date from the early 1930s, when he was still at the beginning of his brilliant and prolific career. They are compositions where he indulges in a variety of formal inventions but pursues a simplification of volume at the same time. Nearly always made with oil paints, they present a concise, almost schematic approach and a juxtaposition of light colours in large, glowing areas.

Some of these works were exhibited together with his drawings in his first solo show at the Galleria d'Arte di Roma in 1932 and then in the Galleria del Milione, Milan, the following year. A recurrent subject in these medium-sized monotypes is the human figure portrayed in solemn, classic and often even epic poses. The images are built up with vigorous linear brushstrokes that enhance their symbolic content. Tempera was applied on a glass plate, which was left completely clean after the first decisive "pull". The plates were printed on sheets of Fabriano paper without using a press, relying solely on manual pressure and sensitivity.

During his stay in America, where he fled to escape the antisemitic laws of wartime Italy, his production of monotypes increased and acquired full maturity and awareness. The early 1940s saw a series of allegories, chimeras, warriors and mythological figures (*I Macedoni*, *I Maratoneti*, *Le Termopili*). After joining the American army in 1945, he returned to Europe as a soldier and made a number of monotypes inspired by the Buchenwald concentration camp. The technique was taken up again in 1948 during a period of intense activity that also saw the use of oil paint. The subjects were mainly stringed instruments.

A show of drawings and monotypes was held at the Galleria l'Obelisco, Rome, in 1952. The larger format (ca 500 × 700 mm) of his monotypes, which were signed and dated, was indicative of their growing importance. Increasingly involved in printmaking procedures, Cagli found the monotype particularly congenial as well as a stimulating challenge to his creative capacities.

Afro Basaldella and his brother Mirko also made monotypes between 1932 and 1947, using the technique specifically to explore a purist approach responding to the expressive requirements of the time. Afro made about one hundred traced monotypes of a gestural nature with characteristics of softness and luminosity obtained by preparing the support (or paper, cardboard, etc.) with an even layer of thin oil, black ink and dark earth pigments. When the pigments had dried, a thin sheet of paper was placed on top and a pointed implement

228. Gastone Novelli
Untitled, 1934
Monotype in oils, 345 × 245 mm

(silverpoint, leadpoint, pencil, occasionally an awl or similar tool) was to make his drawing. Instead of a black mark, these tools sometimes left a thin line, with the sharp point crushing the fibres of the paper to produce a shiny and slightly indented groove. The barely perceptible image created an intriguing graphic effect. Like Gauguin and the other artists who used the traced monotype before him, however, Afro was not interested in the surface on which he was working but in the other side, where the pressure of the point transferred the image.

Catalogued as "*disegni a calco*" or traced drawings, these works always contain an element of surprise because the reversed composition, which allows no rethinking or correction, cannot be seen during the drawing process but only once it has been completed. Afro made no clear distinction between line and volume but made reference to a kind of order or architecture combining reality and imagination, the whole of "concrete and mental being".[153]

Mario Sironi experimented with the monotype in the post-war period up to the early 1950s, using only oil paints and the additive procedure. His works address different subjects—landscapes, figures and portraits—and vary in format. He also started producing successful monotype illustrations, thus paving the way for other painters. One such artist was Emanuele Cavalli, who used monotypes to illustrate various works by Dante for the Curcio publishing house during the mid-1960s, including *Le Rime Petrose, La Vita Nova* (1963) and *Il Paradiso* (1965).[154]

The monotype enjoyed considerable success in Britain in the years between the two world wars. Its characteristics of execution were appreciated above all by artists concerned with social problems and seeking to change the traditional approach to the teaching of art. In 1941, after working with adolescents in the 1930s, the Scottish artist William Johnstone published *Child Art to Man Art* and a technical handbook entitled *New Methods and Material*, in which he describes the advantages of printing monotypes from a glass plate: "This is not drawing, nor is it a painting, but the effect is stimulating and satisfies the aesthetic intuitive sensibilities in a way that hours and hours of labour would fail to accomplish. It is nature working for the artist."[155]

Johnstone also experimented with decalcomania, obtaining monoprints that he described as "Surrealist expressions of primitive Celtic landscape" and exhibited at the Mayor Gallery, London, in 1933.

The free association of ideas and focus on the chance effects of Surrealist practices were taken up by F. E. McWilliam. His first solo show included twenty-six "monoprint drawings", a particular technique that he claimed to have learnt from an artist at the Slade School of Art: "From him I learnt about monoprinting. I prefer 'transferred ink' to either 'monotype' or 'monoprint' as it is exact and doesn't emphasise printing [...]. I simply inked (printer's ink) a sheet of glass and hung a piece of paper in front, then drew (pencil) on the paper back which picked up a slightly smudged and of course unique image on the other side."[156]

Other artists using the monotype during the 1930s included Cyril Power and Sybil Andrews, primarily associated with the Grosvenor School of Modern Art and the "colour linocut movement". Like all the Vorticists, they attached great importance to the graphic and autographic quality of their works and be-

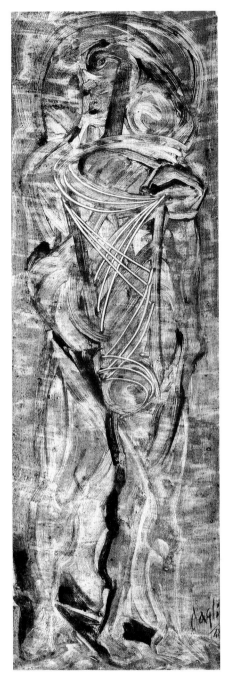

229. Corrado Cagli
Tempo d'amore, 1948
Monotype in oils on paper with canvas backing,
900 × 300 mm
Private collection, Rome

230. Paul Klee
Abwägender Künstler [Artist weighing up the pros and cons], 1919, 73
Oil impression on paper on board, 197 × 166 mm
Zentrum Paul Klee, Berne, Donated by Livia Klee

lieved that the small format of the various printmaking techniques, linocut in particular, was better suited to exploring new ideas than painting.

In 1933 they showed colour monotypes and linocuts at the Redfern Gallery, the only space in London to exhibit prints by contemporary British artists during that period. They are works that express space and movement in a new way and reflect the freedom of their authors' vision. The bright colours and daring architectural forms—Power was an architect—capture the modern dynamism of the Machine Age. Whereas most of the monotypes by Andrews were destroyed in a fire, a large number of Power's works survive. Like McWilliam's monotypes, their works were made with metal or glass plates in accordance with the now classic procedures developed by Degas.

The early 1940s saw an increase in the monotype's popularity among British artists, many of whom took the technique, adapting and varying it according to their inclinations. Although these were very important and positive years in the history of British printmaking, these artists expressed their most experimental and daring tendencies through the monotype technique, which they practised with no regard whatsoever for academic rules and current conventions. Moreover, the monotype was better suited than other techniques to the requirements of the wartime period and the precarious living conditions of many artists in years when all materials were scarce.

Another reason for its success lay in the possibility of escape from the tyranny of distribution. With no need for special materials and no traditional methods to be followed, there was also no need to find a publisher for editions of prints.

The monotype enjoyed such success during the late 1940s that several London galleries held special exhibitions on a regular basis. Alongside the traditional monotype obtained by means of the classic procedures (subtractive, additive or a combination of both), a variant involving transfer, as in Gauguin's *dessein-empreinte*, took root in Britain as from Sickert's time.

The reasons for this extraordinary flourishing are also to be sought in the influence on the British school of several foreign masters who settled in Britain and spread the technique among their pupils and the members of their artistic circles. One of the most important was the Polish artist Jankel Adler, who joined the army after working alongside Paul Klee at the Düsseldorf academy during the 1930s. In order to escape Nazi persecution, he took refuge in Spain and then in Paris (1933–37), where he frequented Stanley William Hayter's Atelier 17 and won the esteem of the leading *peintres-graveurs* of the time. Having left the army for reasons of health, he left for Britain, going first to Glasgow and then to London in 1943.

Adler acted as a link between the German and French avant-garde movements and the new generation of British artists. Isolated by the war, the latter were influenced during the 1930s and 1940s by Klee, whose artistic methods reached them through Adler more than other channels. Most importantly, he taught them the offset monotype technique.

Klee developed a personal variation of the monotype technique, called *Durchdruckzeichnung* in German, between 1919 and 1923. In experimenting with offset lithography, he began to use a sheet of handmade carbon paper, which allowed him to transfer the image onto a second sheet while maintaining the physical aspect of the drawing. Jim Jordan provides us with a detailed description of his method: "One of Klee's purposes with the transfer technique was to preserve in transparent layers the sequence of events through which the im-

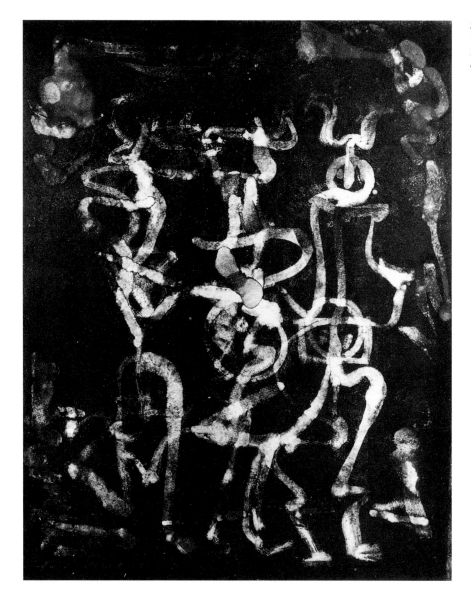

231. Adja Yunkers
Three Figures, 1951
Monotype printed on wrapping paper
covered by blue film

age had been constructed. In this technique, a preparatory drawing was traced onto another sheet, intended usually for further reworking, as a print on watercolour. An intermediate sheet that Klee had coated on the underside with an oil paint or ink was used as a 'carbon' paper. The artist traced over the original with a sharp stylus and the contours were offset in oil paint (or lithographic transfer ink) onto the paper below. The contours of the copy, however, were enriched by a soft fuzziness of the line inherent in the tracing process, and by tones and blobs, offset accidentally by the pressure of the hand."[157]

Three hundred and twenty-six works made by Klee with the "oil transfer" method have been catalogued so far. They consist of both black-and-white and watercolour works in varying formats, mostly with a support of lightweight paper mounted on cardboard.

Robert Colquhoun, who met Adler almost immediately after his arrival in Britain, learnt the monotype method from him and used the offset drawing technique from 1944 on. He later made a large number of monotypes on glass, marble or lithographic plates, which produced a cold, flat effect better suited to his monumental figures. In some of his 1948 monotypes, where he used stencil, colour was added at a later stage. In his final years, when he was too weakened

by illness to paint, the Scottish artist returned to the monotype and went on using this technique until his death.

This variant was adopted by many of Colquhoun's contemporaries. Richard Ziegler experimented with Klee's method in Cambridge during the early years of the war and Cecil Collins was interested in the possibility of reusing drawings in serial works. It proved one of the most fertile and significant paths, even though it is still hard to assess fully Paul Klee's importance and impact on British artists working with the offset monotype during the period 1930–50.

Alan Davie made great use of this method, which he found wholly congenial, and produced about a hundred works in the space of two months. As he wrote in a letter after seeing the monotypes by Klee and Jackson Pollock exhibited in 1948 at the Venice Biennial and in the Guggenheim Collection, "I have perfected the technique of monotype [...]. The secret is to use printer's ink on glass and to print on fine Ingres paper. I am really finding something in the black and white mediums—discovered a lot of Paul Klee's tricks too [...]. Through this wonderful medium I have discovered so much and developed so much so rapidly [...]. I am amazed."[158]

Like Davie, other artists of the period practised the technique with great interest, albeit sporadically. One example is Keith Vaughan (1912–77), who made about twenty black and white monotypes in 1948 but then stopped. Michael Rothenstein (1908), one of the most active and creative British *peintres-graveurs* of the time, devoted his energies to the monotype solely in the period from 1948 to 1950. Finally, some mention should be made of John Kashdan (1917), who met Adler and members of his London circle after observing Ziegler use of Klee's method. He produced works by means of the "traced monotype" technique, mostly with thick layers of oil paint on glass plates.

232. Stanley William Hayter at the first
American seat of his Atelier 17 studio, ca 1940,
in the New School of Research, New York

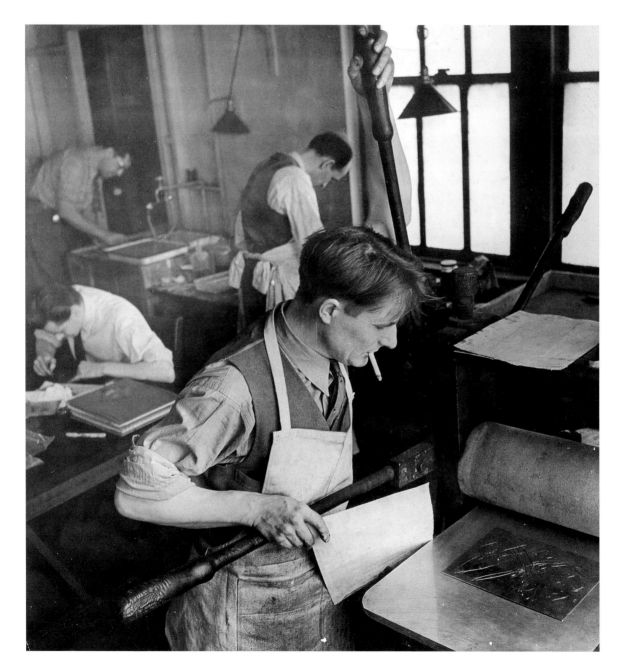

4. The Disintegration of the Traditional Model

The role of American art during the second half of the twentieth century
"… just as in politics, revolutionary ideas in art, after they are generally accepted, become a part of conservative opinion, which in turn has to defend itself against a new revolution."
Alfred H. Barr, Jr.

The close of World War II saw a dramatic end to the artistic primacy not only of Paris but also of Europe as a whole. The economic, political and diplomatic reasons for this shift of influence towards the United States are too well known to require illustration here. With some uncertainty at first and then with growing confidence as from the 1960s, artistic production found its new centre in New York, which became the stage for the most important events of the period.

The United States thus assumed an explosive avant-garde role in the visual arts while also laying the foundations for an authentic revolution in the graphic field. In just over ten years, printmaking became the linchpin of a totally innovative form of expression ready to move from the sidelines to the centre of artistic production.

Through the artists of the printmaking workshop Atelier 17, which emblematically moved from Paris to New York in 1940, the British artist Stanley William Hayter disseminated new ideas all over the United States with revolutionary repercussions for a country possessing far less of a tradition in the graphic arts than Europe. The ranks of the renowned studio were strengthened by the arrival of many "Surrealists in exile"—Matta, Ernst, Masson and later Miró, a regular presence until 1947—forming a bridge between the European tradition and the new American avant-garde generation, Motherwell and Pollock first of all. Oriented towards a direct and experimental approach, the artists discovered the pictorial potential of printmaking and also began to use abstract gesture and colour as tools of creation on the plate.

Not only engravers but also and above all painters and sculptors associated with the Abstract Expressionist movement took an interest in printmaking techniques, expanding its traditional boundaries and seeking a new way of reading the work of art—less intellectual, this was now physical and sensual, pure energy. In addition to his personal contribution as a *peintre-graveur*, Hayter is to be credited with encouraging artists to learn about printmaking and

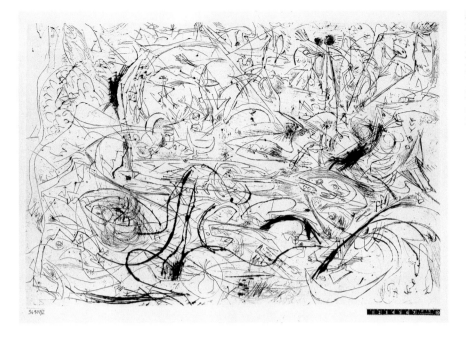

233. Jackson Pollock
Untitled, 1944
Burin and drypoint, 125 × 150 mm (image);
254 × 281 mm (sheet)
Pollock's first experimental plate, made at Atelier
17 in New York; strokes made by Hayter, who
introduced Pollock to etching, can also be
distinguished
Private collection, Rome

carry out every step of the process by themselves: from the phase of creation on the plate to inking, biting with acid and printing. With his example, he thus interrupted the long tradition—taken up by the School of Paris—of artists working with and depending on craftsmen, albeit without subordinating the formal idea of the work to the procedure.

In their search for greater flexibility in the creation of images, American artists developed new techniques and brought into the artistic sphere a number of media previously employed only for commercial purposes, such as screen-printing.

With its WPA Federal Art Project,[159] the American government launched a campaign giving new dignity and meaning to the role of artists in society and channelling new energies into this field. After the enrichment of American cultural life by successive waves of immigrants, an entire generation of Americans was now able to benefit from study trips to Europe and exposure to new artistic experiences. They flocked above all to Paris, where they soaked up the unique atmosphere of the Left Bank and Montparnasse.

Abstract Expressionism led in this sector, which was much in vogue with avant-garde painters and sculptors,[160] to what was called the "print renaissance".

As had already happened in Europe some years earlier, America experienced a shift in interest from the finished work or "masterpiece" to the procedure and the tools of expression in themselves during the late 1940s and 1950s. This trend in modern art found a congenial and responsive procedure in the monotype.

As the size of these works on paper increased to accommodate movement and expression and the range of supports expanded in step with the formal explorations of the moment, American artists attained new and unexpected results in material terms. While it was Abstract Expressionism that set the mechanism of change in motion with its emphasis on gesture and the "subjective" nature of the artistic act, however, Pop Art also promoted printmaking by taking a different course, practically in the opposite direction.

In the late 1960s, when the role of the Abstract Expressionists and the heroic gesture of their action painting was played out, a new sort of contemporary "artist-engraver" began to emerge, one who accepted the intermediation of machinery and engaged in printmaking without bothering about its technical

complexities. The artist's hand was supplanted in some respects by the machine and, at the same time, the art of printmaking became an ideal tool of technological experimentation.

With the integration of the "illusion-producing" systems into everyday life, Andy Warhol's 1962 screenprints provide an exemplary demonstration of how Pop Art replaces the object with a symbol, putting a drastic end at the same time to the empathic style and personal vision in printmaking.

Of central importance in the world of prints since the 1950s, the publication of editions went through an authentic boom in the 1960s that was to last until the middle of the following decade. The proliferation of printing workshops included Universal Limited Art Editions, founded by Tatyana Grosman on Long Island in 1957, where Helen Frankenthaler, Jasper Johns and Robert Rauschenberg worked, the Tamarind Lithography Workshop, opened by June Wayne in Los Angeles in 1960, which attracted artists like Richard Diebenkorn, Sam Francis, Ed Ruscha and Louise Nevelson, Gemini Lt., founded by Ken Tyler in 1965, the Pratt Institute and the Hollanders Workshop.

The prints produced there had none of the immediacy of the Abstract Expressionist works of the previous decade. Abandoning the formal values of European derivation espoused by their predecessors, artists adopted the new language of Pop Art, the first artistic movement of truly "American" origin, and aimed at a quality of absolute, mechanical uniformity.

The market of the 1960s tolerated no diversity whatsoever within editions. A print with a slight difference in its inking would not be bought. The new technology made it possible to create very large editions of perfect, identical prints and placed on the market colour prints of ever-increasing coldness and complexity with no trace of the artist's hand. Within the context of Pop Art, to which graphics owed their new primacy in contemporary art, there was very little interest in the single proof and the monotype, which remained within the experimental and occasional sphere of art production.

Garner Tullis bucked the trend, opening his first experimental workshop in Philadelphia in 1961 and defending the unique print to the hilt. Although the efforts of this very young champion were largely ignored in the general focus of the period on the "marketability" of artworks, they did mark the birth of a countermovement. The fine art print, pulled in a limited number of impressions, began to enjoy renewed prestige with a new art-buying public who took growing interest in the monotype.

As noted above, the interest shown in this technique by the American public and critics was very limited up to the 1950s, and the same holds for prints in general, which enjoyed nothing like the same popularity as the works of Degas, Pissarro, Toulouse-Lautrec or Gauguin in France.

It was not until 1960 that Henry Rasmusen's *Printmaking with Monotype* was published in America, providing a brief outline of the monotype from the time of Castiglione to the immediate post-war period and thus endowing it with reassuring historical legitimacy. Eugenia Parry Janis made a crucial contribution eight years later with her exhibition of Degas's monotypes at the Boston Fine Arts Museum.

The growing interest shown in the monotype in America was marked in 1980 by the Metropolitan Museum of New York and the Fine Arts Museum of Boston with an exhibition entitled *The Painterly Print*. Curated by a group of American experts, the exhibition focused on the "classic" monotype, describing

its evolution from the origins until modern times and excluding the "printed drawing". In 1997 Joann Moser organised what is still the greatest event ever devoted to the American monotype. Held at the National Museum of American Art in Washington, the exhibition *Singular Impression. Monotype in America* and its associated catalogue constitute the first exhaustive study of the fortunes of this procedure in America.

The monotype has undergone extraordinarily accelerated development over the last thirty years, with major technical innovations and an unusually large volume of works of high artistic quality making it the perfect medium to express the values of modernity.

Revitalised by the work of the leading figures on the American art scene and more specifically American than European in character until the 1990s, the contemporary monotype constitutes a key chapter in the broader history of twentieth-century graphic art.

Examination of its recent history in the United States offers a useful perspective for interpretation of the European production in this field, helping to assess the evolution of the procedure in itself and above all to pinpoint its role and function within the contemporary art scene.

234. Cover of the *Singular Impressions. The Monotype in America* catalogue, edited by Joann Moser, National Museum of American Art, Smithsonian Institution Press, Washington, D.C. 1997

The leading figures involved with the modern monotype in America

Boris Margo started using the monotype technique after experimenting with decalcomania for many years. In the summer of 1940, during a stay in Provincetown, Massachusetts, he made over fifty monotypes, loading himself with plates and ink and carrying them down to a hut on the beach, where he worked in solitude. Paying close attention to nature and little else, he inked the plates with broad strokes to suggest the dunes, the sea and the sky around him. He pressed a sheet on paper down hard on the freshly inked surface to create physical reliefs and patterns suggesting shapes and then used ink to define their outlines and develop them into compositions. He used the monotype as a "window for his imagination. It was a procedure that related to his unconscious thoughts and left a door open to his abstract, surreal imaginary".[161]

Many artists of the period saw the monotype as the visual counterpart of jazz improvisation, a form of music that influenced their work a great deal. Romare Bearden's monotypes, for example, constitute a significant starting point for his artistic approach, which was generally far more controlled in the other media. Exploring an effect of transfer from painting to monotype, Bearden suggests memory rather than immediate experience.

Milton Avery began making monotypes during the 1930s, when he was still building up his artistic vocabulary. In 1949, at the peak of his career, he lost a great deal of mobility due to ill health and returned to monotypes because they involved less physical effort. He painted in oils on glass plates bathed in turpentine and printed his works on watercolour paper or rice paper with the pressure of the hand or everyday implements like spoons. Paper already coloured or cut in unusual ways was also sometimes used, as in *Strange Birds* (1950) and *Self-Portrait* (1952).

Avery exploited the flexibility of the procedure, using colour as a creative tool and covering the plate with broad, sure brushstrokes of a gestural and economical character. Despite their richness of detail, his monotypes rise above the implications of the realistic subject and are steeped in lyricism. He made nearly two hundred in the space of just a few years, all of small format, freely combining different procedures (painting, polishing, scratching, saturation with

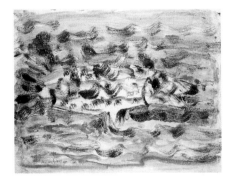

235. Milton Avery
Fish in Dappled Sea, 1950
Colour monotype using mixed techniques,
438 × 559 mm
Milton Avery Trust, United States

petrol or turpentine) and using stencil or stylus and brush to build up layers of paint. The artist, whose natural talent was greatly admired by Mark Rothko, saw the monotype as a formal complement of the new turn taken by his painting in the direction of reduced expressiveness, distortion of form, flattening of colour and calligraphic gesture. He clearly considered the monotype a vehicle for his creativity and delighted both in the imponderable, random element inherent in transferring an image from one surface to another and in the variety of effects of sign and texture to be obtained by running the printed image through the press a second time with the ink still wet.

Avery exhibited his monotypes at the Laurel Gallery, New York, in 1950 but, despite favourable reviews and marked public interest, not a single work was sold. There was clearly no market for the monotype as yet. Collectors of prints had misgivings about the nature of this work, a hybrid cross of drawing, painting and print, and about the lack of editions. Collectors of paintings regarded the monotype as a print and hence as lying outside their sphere of interest. Moreover, monotypes were still excluded from exhibitions of prints with official juries. Artists who had to make a living by selling their works were obviously discouraged from using this technique.

It was also in 1950 that Naum Gabo embarked on a singular project of monoprint wood engravings entitled *Opus 1–12*, on which he worked for over twenty years. He incised twelve woodblocks with the sparest of marks, inked them, and printed them mainly on thin, translucent Japan paper allowing the image to be read also from the other side. While the basic linear composition remained unchanged, Gabo used a system of mobile blocks constituting repeatable and interchangeable parts to obtain variation by moving the sections around.

He dismissed the idea of a large edition because of the intimate nature of these works and, after pulling few proofs from the first block, decided to print a single impression. With his characteristic enthusiasm for new, luminous and transparent materials, he worked the ink on the surface of the blocks to vary its transparency, opacity and colour. He experimented with a whole range of different material effects by printing on different types of paper and varying the degree of pressure applied with his hands, a spoon or other implements. The goal was not to find *the* way but to explore all the possible ways offered by the medium.

Gabo opted for a hybrid procedure encompassing all of his media and responding to his formal concerns. Encapsulating in two dimensions the sculptural ideas informing his work as from the 1920s, the twelve works constitute an important stage in Gabo's graphic output and resemble Rembrandt's variable prints in their serial aspect. The repeatable nature of these works, made with matrices and therefore not monotypes in the strict sense of the term, places them in the category of monoprints.

The experimental monotypes produced by Cy Twombly in 1953, covering pieces of cardboard with a thick layer of black oil paint and making rough scratches with a nail to obtain a flashing effect, constitute a special case.

Harry Bertoia produced a substantial and accomplished corpus of monotypes during the post-war period, as did Mark Tobey and Matt Phillips in the following decades. Unlike other procedures with predictable results, the monotype offered Bertoia an opportunity to introduce the element of chance. Based on the reworking of randomly produced images, his figuration derived from the Surrealist technique of automatism.

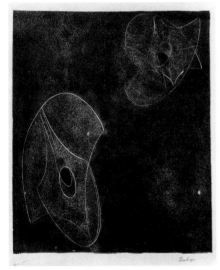

236. Naum Gabo
Opus 5, 1951
Monoprint on Japanese paper in black ink, from an engraved wood block, 241 × 203 mm
The work was subtitled *Constellations* by the artist, alluding to the Milky Way

Mark Tobey was already an established artist when he began to work with the monotype in the 1960s, prompted by a desire to obtain detachment from procedures and to transform the creation of images from intellectual compulsion into a voyage of discovery. The monotype technique seemed to offer flexibility, freedom of expression and rhythm, inspiring him to embark on a new exploration of counterpoint, forms and themes already addressed in watercolour, ink and calligraphic painting *à la détrempe* during previous years. He worked on plates of polystyrene, a light porous plastic with a rough surface, and used tempera, which is more fluid than oil paint or printer's ink and dries quickly to give the effect of crushed pigment.

With all the rapidity of a happening, Tobey applied masses of colour and drew lines with string or sometimes wax so as to heighten the imponderable character of the monotype. He often printed a second impression (ghost image) or counterproofs while the inks on the plate were still wet. Transferred from one surface to another, the colours became thinner or ran, being absorbed by the paper in a different, unpredictable manner. In order to increase the element of chance and give an image material form, the artist sometimes crumpled the paper before laying it on the support to obtain a print covered in a web-like pattern of erratic lines not present on the painted plate.

Matt Phillips has a leading role in the history of the American monotype, both for his own significant corpus of works and for his promotion of the medium through the works of other artists, especially Prendergast, Abraham Walkowitz and Milton Avery. In the introduction to his celebrated exhibition *The Monotype: An Edition of One* (1972), Phillips differs from the current art-critical approach by offering a reading based on setting the medium in its historical context rather than technical details.

Having shown the dual influence of Prendergast and Vuillard in his monotypes of the late 1950s and 1960s, Phillips later developed a form of lyrical abstraction combined with a sense of dynamics and rhythm and a feeling for decorative elements. Paying close attention to complex surface texture, Phillips prepared his plates by means of the subtractive method, using both fingers and paintbrushes, and gave the white of the paper an increasingly important role in his compositions: "I like understatement, working obliquely, and utilising the kind of whites only monotypes permit."

The artist's monotypes, his primary medium of expression, increased in size during the 1970s while his technique became simpler and more economical.

As Willem de Kooning experimented constantly with all the different ways of producing art, his interest in the monotype, or rather in a very similar offset technique, probably arose out of the painting process itself. The procedure enabled him to seek new paths for a bold and direct pictorial approach while preserving a sense of vitality and perhaps of movement.

De Kooning's artistic "manner" is closely connected with his handling of oil paint over a comparatively long period of time. Needing to prevent his oils from becoming hard to apply and superimpose from one session to the next, the artist pressed sheets of paper onto his work to dry and soak up the wet paint, which would otherwise have been too thick. On removing the sheet, he obtained a reversed image as in a monotype, and thus glimpsed in this common studio practice the possibility of modifying the direct pictorial gesture by introducing the unpredictable element of chance.

Another artist who was drawn to the monotype by its greater ease of execution was Adolph Gottlieb, who lost a great deal of mobility in 1970 due to a

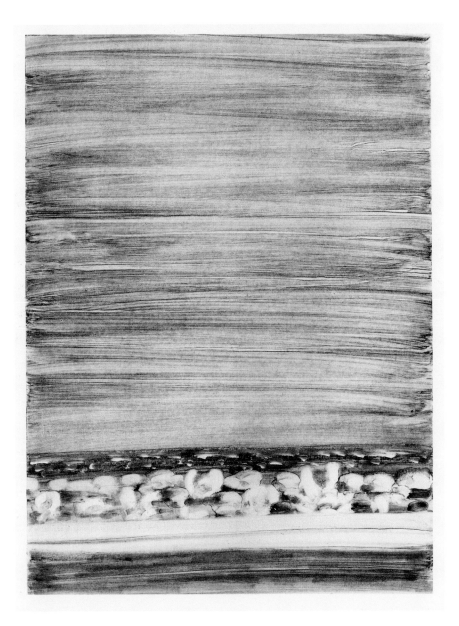

stroke but continued to work as an artist. His dealer Brooke Alexander placed a press and a printer at his disposal in his East Hampton studio and steered him towards the monotype, a technique he had already used in the 1930s. Gottlieb devoted himself fully to monotyping over the period 1973–74 and eventually began to print by himself or with the help of his wife. The small format of the paper and the smaller amounts of paint required enabled him to regain control over all the phases of the work and begin creating again.

His monotypes can be divided into two groups: one series with a horizontal format entitled *Imaginary Landscapes* and one entitled *Bursts* featuring the explosive elements also present in many of his late paintings.

The presence of two graphic elements in his *Untitled* monotype of 1973, which belongs to the latter group, recalls Gottlieb's use of pictographs in his etchings of the 1940s. While both the red circle, probably representing a sun, and the more mysterious X-shaped symbol were obtained by means of the subtractive technique of removing ink from the plate, Gottlieb "added" thickly laden brushstrokes of ink to frame the latter. Focusing attention on this compositional element enabled him to create a relationship with an otherwise flat background and expand its tonal range.

238. *The Wakeby Monotypes: A Photo Diary*, 1983
The three images document Michael Mazur's
working day, intent on printing his two triptychs
Wakeby Day and *Wakeby Night*, together with
master printer Robert Townsende at Georgetown
(Massachusetts)

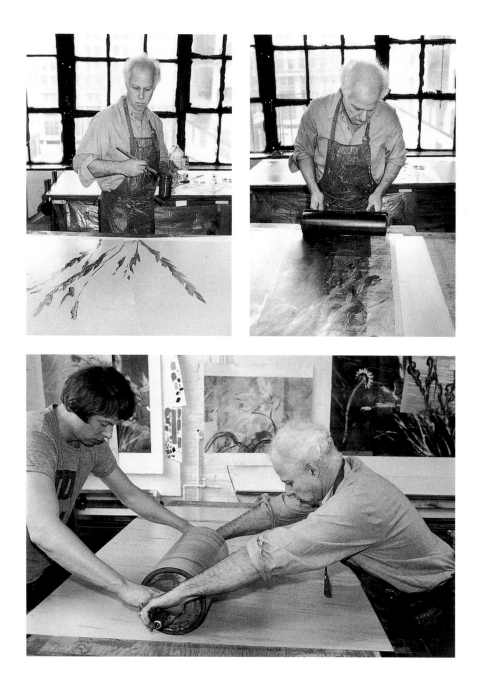

239. Richard Diebenkorn and Garner Tullis, Santa Barbara (California), 1988

240. Giorgio Upiglio in his Milan workshop

241. Alberto Serighelli with Mimmo Paladino in the Fizzonasco print shop (Milan)

The contemporary and sequential monotype

"The nature of monotype […] had all the qualities of printing I wanted, […] and it had one other: it left a remnant or ghost of the idea after the impression was made. I could enter into that image that was still malleable […] and extend that initial concept to a different state. […] By the end of the day, I would find myself visually in a place that I couldn't possibly have anticipated at the beginning."
Nathan Oliveira

Due to the peculiar volatility of modern art movements, the flourishing print market underwent severe contraction in the 1970s. Although the world of art editions was affected as a whole, the hardest hit were the more mechanical procedures like lithography and screen-printing. There was also a widespread reaction among artists against the formal values of Pop Art and a move away from the impersonal uniformity of the prints of the 1950s and 1960s with their obsessive tendency to be perfectly uniform, identical, "clean-cut" in appearance and above all produced in large editions.

As the most reactive and physical of all the graphic processes and one producing unmistakable and unrepeatable original works, the monotype logically came to attract the attention of growing numbers of artists and master-printers.

Though initially discriminated by exhibition juries as neither fish nor fowl,[162] the monotype now joined the ranks of postmodern art processes precisely because it was a hybrid. It reflected the new transgressive climate at work to expand the boundaries of the traditional media and blur distinctions, fostering combinations of mixed media, "inseminations" and crossovers.

As they became more involved with this graphic medium, artists began either exploring new ideas and then developing them in their primary media or using the monotype to address ideas already tackled in painting and sculpture.

The growing popularity of the monotype in America during the 1970s and 1980s was based not only on appreciation of its peculiar aesthetic qualities but also on solid financial grounds, especially in the case of emerging artists. While producing an edition involved a great deal of time and the high costs of professional printers, making a certain number of monotypes per day proved simpler and more productive as well as comparable in terms of economic gain to the unique work produced in other media. Having initially favoured large-scale editions to the point of complete saturation, the market now preferred the single proof and the monotype.

The development of the printmaker–publisher relationship born back in the 1960s came to revolve increasingly around the quality and type of art being produced within it. In this connection, the graphic work of artists like Jasper Johns, Robert Rauschenberg and Jim Dine can only be understood with reference to the broader context of museums and figures operating in the art market—publishers, gallery owners and dealers—who worked together to identify and filter the media and movements most likely to succeed.

This widespread interest in the monotype on the part of artists, academics and the market has two peerless champions in Michael Mazur and Nathan Oliveira. Working on opposite sides of the United States—the former in New England, the latter in California—they defend and promote the artistic potential of the procedure not only through their own innovative work but also through academic activities of considerable impact. Above all, their explo-

242. Michael Mazur
Canto III, from *The Inferno of Dante* series, 1993
Monotype, 603 × 400 mm
Artist's own collection, Boston

243. Nathan Oliveira
Duoro Valley, I, 1997–2003
Colour monotype heightened with oils,
ca 570 × 780 mm

ration of the medium is not confined to technical experimentation but represents a conceptual challenge to the traditional approaches of drawing and print-making.

While Mazur practises a wide range of techniques including sculpture, painting, installations and drawing, graphics are the heart of his work. He focused on the monotype through the 1970s to the end of the 1980s with results that are radical in terms of artistic maturity and inform his work in other media.

Mazur is fully part of the *peintre-graveur* tradition but with the particular characteristic of having started out as a printmaker rather than a painter. He initially took up monotyping in order to develop an expressive relationship between line and tone and to free himself from the burden of delineation. He wanted to reproduce the tonality of the ground by means of line and found the monotype the most direct and immediate way of achieving this.

His introduction to the concept of the one-of-a-kind print came through Gauguin's traced monotypes but especially the above-mentioned series of monoprint wood engravings by Naum Gabo, which he discovered in the 1970s. In addition to the lyrical quality and transparency of the works, he was struck by the way Gabo printed the woodblocks with varying degrees of manual pressure each time so as to obtain a unique image: "It was my attraction to his monoprints, the variant printings of his wood engravings, that was the beginning of an interest in making a different kind of print, a print that would be more responsive to change and that would not be stuck in the traditional, consistent edition format."[163]

Mazur applied his characteristic interaction of different techniques to the monotype in order to obtain a richer surface texture. Examples include the combination of woodcuts and etchings with monotypes in the *Texas Tree* series, where he made monotypes on woodcuts printed first on metal plates and then offset. He varied his tools and addressed the "memory" of the monotype with an alternation of nuances. The plate was run through the press a second time with its colours strengthened and modifications made so as to create an image that was different but nevertheless seemed to coexist with the one from which it originated. Mazur began to make his first mural-sized monotypes in the early

1980s and gradually changed from figuration to a more abstract vocabulary. He also worked with the traced monotype and above all with the monoprint in order to experiment with variants.

Nathan Oliveira began to work with monotype in 1969. During a visit to Willem de Kooning's studio, he saw the artist press sheets of newspaper onto a canvas and was very interested in the fact that after removal they were preserved, mounted in *passe-partout* frames and hung on the wall as works of art in their own right.

Unlike other more rigid and complex graphic techniques such as lithography, Oliveira sees the monotype as an opportunity for stimulating ideas, opening up the imagination, and above all developing a narrative.

Regarding formal values as more important than content and realistic appearances as purely illusory, the American artist Nancy Graves developed a personal style in the mid-1980s based on interchange between abstract forms and realistic content, between the techniques of painting and the materials of sculpture. She began to work simultaneously with various media and to add three-dimensional elements to her paintings, subsequently developing this idea both in monotypes and in the large-sized engravings she made for 2RC galleries in the New York and the Rome workshops. Graves stretched the boundaries of her formal investigation in her monotypes, painting the plate with watercolours and then placing various objects on the support prior to printing. The elements appearing in these works include vegetable matter such as leaves, roots and moss, foodstuffs (a row of sardines), cooking utensils, nails, lengths of chain and brushes. Her idea was in fact to combine items from different cultures with elements of the natural world.

The monotype reached its peak of popularity in the 1980s, being closer to the world of happenings and video art and hence less subject to rules and restrictions than other graphic techniques. A large number of artists took it up during this period for various reasons, sometimes making it their primary medium. No longer an intimate, self-referential form of expression, the monotype now assumed a larger scale, immediate visibility and a public dimension, becoming more similar in this to an easel painting or a mural than a print produced in the seclusion of a studio.

As its size increased, so did the complexity of the technique involved, with monotypes sometimes printed on offset presses using water-based inks and digital imaging. The traditional principles of the procedure also underwent modifications. For example, while it was previously thought necessary for the surface of the plate to remain wet or sticky in order to transfer the composition onto paper, artists like Dennis Olsen were now developing ways of printing dry watercolour images. A relaxation of the prejudices governing the materials used for monotyping led to a broadening of the range. As Rauschenberg commented, "every material has its history written inside it and no material is better than another. For some, the use of oil paint is the most unnatural thing possible. Artists create their materials with their own hands, extrapolating them from their own experience, familiarity or natural versatility."[164]

A number of artists also started to take an interest in the possibility of making works that follow a narrative thread and saw the monotype as a means for the sequential development of images. They invented ways of using the residual image left on the plate (so as to avoid having to start afresh each time) and created groups of compositions that were related to one another but individual and autonomous.

With the new trends in the American contemporary art of the 1970s towards a temporal reading of the work, attention focused increasingly on the sequential development of the image, i.e. its presentation in sequences with their own logic forming a temporal continuum. The Impressionist view of the journey as more interesting than the destination and the process of transformation as richer and more vibrant than the result fostered the practice of monotyping. To be more precise, it stimulated the consecutive development of images on the plate and exploration of their narrative implications. This was indeed the most intriguing aspect of the legacy left by Degas. When American artists discovered his monotypes in 1968, what interested them most was in fact the way he used his second impressions, the ghost images.

Thus it was for Oliveira, one of the artists most impressed by the Degas exhibition of 1968, along with Mazur. Won over by the procedure's capacity for sequential development, Oliveira also drew inspiration from Goya, with whom he established a dialogue built up through the ninety impressions of the *Tauromaquia 21* series.

Oliveira used the monotype to obtain new compositional dynamics based on a process of constant revision of the original image, greatly weakened after

the first printing in the press but continuing to exist on the plate as a faded memory. Using the press as a pictorial tool, Oliveira reworked and printed the ghost image repeatedly, imbuing it with new life by means of erasures and transformations that became subsequent stages in its evolution. The individual stages that would normally be obliterated by the final image in the normal process of painting exist as independent works rather than preparatory phases. Working for decades on zinc plates with lightly superimposed layers of colour and the addition and manipulation of ink, Oliveira has expanded the vocabulary of the monotype and encouraged many other artists.

Richard Diebenkorn returned to the technique when Oliveira sent him the catalogues of the Degas monotypes and of his own *Tauromaquia* series in 1974. He worked in George Page's Santa Monica printing workshop for ten days in a row, producing thirty-six black and white monotypes based on his own *Ocean Park* series of paintings. It was 1988 when he took it up again, working in Garner Tullis's workshop in Santa Barbara, this time with greater spontaneity and fluency. In the twenty colour works that survive, Diebenkorn fully exploited the possibility of saving the states that interested him and the ghost images of previous compositions: "Many artists have developed sequential imagery as much as Oliveira had done, reworking the ghost image from one impression to the next [...]. Through their understanding of the possibilities, contradictions, and ironies inherent in the monotype process, artists have created works based on a more complex framework of ideas and expressions than was used by earlier artists, who were less aware of the implications of the hybrid medium."[165]

Robert Rauschenberg and Jasper Johns were among the most important American artists to take an interest in the monotype, or at least in personal graphic transfer techniques. As mentioned above, the former made over a hundred drawings in the 1960s. He then reworked them with gouache, watercolours and

245. Kenneth Noland at the Garner Tullis Workshop in Emeryville (California), 1982

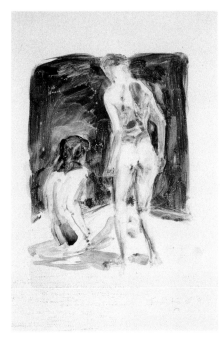

246. Eric Fischl
Untitled, from the *Scenes and Sequences* series, 1986
Colour monotype, 575 × 380 mm
Mary Ryan Gallery, New York

coloured pencils, and developed his image, as in a collage, by adding scraps of cardboard, strips of tape and other different materials, transferring and reversing the results from one support to another to create sophisticated works combining subtlety with powerful impact. The latter's contribution to the monotype was modest in quantitative terms but important for its role in establishing the medium in the world of contemporary art. Some art historians go so far as to claim that his first works, brought out by Universal Limited Art Edition in 1976, led to a revaluation of the monotype in official circles. In 1982, after a self-portrait produced by means of a more traditional system, Johns made a series of colour monotypes featuring a Savarin coffee tin, a recurring element in his iconography.

The history of these monotypes reveals the ease with which artists were now moving from one medium to another and combining techniques kept rigorously separate only a decade earlier. In December 1981 Johns decided to create a second edition of the lithographs inspired by the famous coffee tin and originally printed in 1977. After a few trial proofs, Johns and the ULAE printers realised that the Rives paper gave effects very different to those of the first edition. The manufacturer had in fact altered the composition of the paper and it was now too white. Instead of destroying the proofs already pulled, which both the publisher and the master-printers had thought inevitable, Johns decided to transform them into monotypes. He thus spent four consecutive days painting the surface of the Plexiglas plate, running it repeatedly through the press and opening the old image up to new meanings and new illusions.

Eric Fischl, one of the most successful young artists of the 1980s, uses the monotype to explore the way an image evolves, following it through its narrative development up to the final composition. The medium allows him to compose the individual scenes of his themes, to isolate the various figures within them and suggest their capacity for interaction, without having to start the images again from scratch, and to keep the chronological history of their transformation visible all through the sequence. After an initial series of prints in which the monotype was set on an aquatint background, Fischl began to work in the studio of Maurice Sanchez and made *Scenes and Sequences*. He experimented with ghost images in this second, important series of 148 monotypes, adding and removing figures and backgrounds, or moving them to different points in the compositions from one impression to the next. Printed on Sanchez's offset machine at very low pressure, the impressions were run through the press several times without losing much intensity of colour and maintaining the liquid effects of watercolour throughout the entire sequence.

New organisations: monotypes of collaboration in America and Europe
"A handful of creative people is all that is needed for a renaissance in an art, if the handful comes together at the right time, in the right place."
June Wayne

The late 1970s saw a shift in artistic orientation towards sensorial immediacy and the pursuit of more tactile surfaces, to the benefit of more physical techniques like aquatint and woodcut. Variable inking and colouring by hand were preferred in printmaking. The interest of collectors, museum curators and artists focused on the special proof, the unusual variation printed with differ-

ent inks or on different paper: in other words, on the unique proof and especially the monotype.

The renewed popularity of the monotype after almost a century of marginal interest marked a change in circumstances, ideas and values affecting a whole new generation of artists. The most salient feature of the print renaissance, when increasingly showy and daring prints competed for wall space with paintings, was the attitude of artists towards printmaking.

The new respect for graphic art led to a growing interest in handmade paper and images on coloured paper pulp. Now produced on a "fluid", organic support with irregular fibres where the colours penetrated to different degrees and sometimes ran, each print was characterised by variants making it unique, also within an edition. Prompted to take into consideration the material effects of handmade paper by what had become a collective movement (the "pulp-paper phenomenon"), artists focused on the expressive quality of the image and freedom of gesture.

During the final decades of the century, graphic production took on a galvanising role with respect to art, into which it injected new ideas and energies. For Jasper Johns, the graphic procedure made it possible to create works whose conception was totally different from traditional painting with a brush. The tools required for graphic procedures interested him in their own right and he considered them as important as concepts.

Pat Steir, who switched from drawing to printmaking as the primary medium of her artistic activity, similarly describes the print as "a way of thinking".[166]

More important than the simple proliferation of techniques like lithography, the 1970s saw a radical change in the artists' attitude to machinery and more indirect and collaborative ways of working. Now detached from the sphere of the crafts and ennobled by increases in size that knew no bounds, printmaking necessarily moved out of the artist's studio and into the professional printer's workshop.

The growing interest in experimental techniques and in non-traditional materials and formats gave the new experimental workshops a vital role in the production, publishing and distribution of American graphic art during the last decades of the twentieth century. Proliferating throughout the country in the space of a few years, these were places where artists and printers began to investigate new options and formal possibilities together.

Equipped with specialised high-tech machinery, cultured and versatile master printers with a solid, sophisticated artistic background—sometimes artists in their own right, like Garner Tullis and June Wayne, and often also publishers and distributors—worked alongside artists in a variety of fields. Their role was far broader than that of the traditional European artisan-printer and involved a new and dynamic concept of collaboration. Printmaking became a matter of teamwork.

This new situation oriented some of the leading American artists, especially painters, towards the monotype. Responsible for bringing the monotype process into the field of contemporary technology, master printers played a necessary and integral part in the spontaneous process of direct interaction with the new materials. Their working methods and personal styles left a specific mark on the prints coming out of their workshops, giving them recognisable characteristics and distinguishing them clearly from those produced elsewhere. Collaboration was conducive to the integration of chance developments into the artist's work and ultimately played a crucial role in securing commercial success through shrewd strategies of distribution.

247. Garner Tullis shows a handmade paper frame

248. Garner Tullis and his vertical press,
San Francisco, 1982

248. Garner Tullis and his vertical press,
San Francisco, 1982

Revitalised by this new bond between artist and printer, the monotype underwent a radical change in appearance. The constantly evolving stock of images, the diversification of formal demands, the new possibilities opened up and the workshops' speed of operation all helped to expand the technique and caused it to become more complex, sophisticated and varied. Series of monoprints appeared and there was a proliferation of mixed procedures, where conventional plates were used together with non-traditional surfaces in terms of shape, size, material and support.

As monotypes grew larger, so did the size and variety of the paper supports called upon to capture new effects of sign, tone and material, and express the ambiguous, liquid qualities of these works as never before. The workshops were influenced by demand and began increasingly to specialise in this procedure and offer assistance to artists employing it.

The various experimental workshops run by Garner Tullis, the original in Philadelphia being followed by others in Santa Barbara and New York, saw a proliferation of mixed techniques including encaustic relief, encaustic sculpture,

monoprint with drawing, monoprint with painting, monoprint with glue, screen-printing and woodcut. Tullis favoured the monotype over all the other graphic techniques because it enabled him to explore and develop an idea in each single work rather than repeating it in a series.

This brilliant demiurge is an emblematic figure in the history of the contemporary monotype and has a key role in the production of the most significant monotypes of the last forty years. The specialisation of his workshops in monotypes was connected with the central importance assumed by the pulp-paper phenomenon in the 1970s. Tullis produces a special handmade paper that is extremely thick and constitutes the ideal support for monotypes deeply indented by his powerful vertical press.

His preference for the monotype, described by Pat Steir as "a painting where the final brushstroke is given by the press", has had a marked influence on many of the outstanding artists coming into contact with him, including Richard Diebenkorn, Helen Frankenthaler, Jim Dine, Kenneth Noland, Sean Scully, Catherine Lee and Beverly Pepper.

249. Emilio Vedova
Untitled, 1989
Monotype in oils, 780 × 570 mm

Having started out as a typographer, Scully soon abandoned figurative art to embark on other forms of inspiration, while always maintaining a characteristic degree of classical sobriety. He explored all graphic techniques, experimenting with those involving acids, like etching and aquatint, and those on wood, which he printed, albeit briefly, with a bamboo spoon in accordance with the traditional Japanese Ukiyo method. The works he started producing in 1988 at Tullis's New York workshop combine monotyped sections with other sections engraved on woodblocks of various sizes, rearranged to make different compositions for each monotype. Using each woodblock as an interchangeable matrix, Scully creates images that reveal the recurrent pattern underlying his art: the juxtaposition of horizontal bands of varying width in a dynamic configuration of irregular shapes. These free rectangular shapes (which show Rothko's influence, while the orthogonal grids are related to Mondrian's work) are made with oil paints of limited transparency, painted over when still wet so as to soften the edges of the

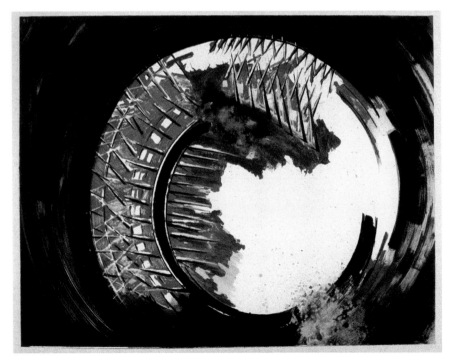

250. Arnaldo Pomodoro
Untitled, 1985
Colour monoprint, 965 × 1320 mm

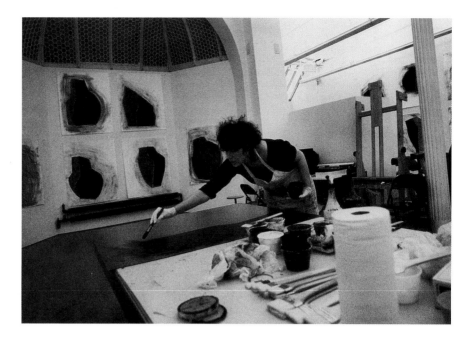

composition. With respect to his paintings, based on the "mystery of addition" with the information hidden beneath successive layers of paint, Scully loves his works on paper for the "mystery of transfer" and their "greater physicality". He prints them on very thick handmade paper with a particular tactile quality that distinguishes most of the monotypes created in Tullis's workshop.

One of the artists using the workshop after Tullis moved to New York was Emilio Vedova, who made monotypes and works on paper using similar techniques. His procedures followed no fixed pattern and the instinctive quality of the gesture predominated over technical skill to such an extent that, when interviewed about his collaboration with Tullis, he claimed that artists simply make use of techniques and then forget them.[167] The Europeans using Tullis's workshop included Arnaldo Pomodoro, who focused mainly on monoprints while there, and others who were less known at the time, like the French artist Jean-Charles Blais.

Tullis's most important collaboration during his Californian years was, however, the one with Sam Francis, which began in 1974. Francis painted directly on a plate measuring the same size as the paper, with his usual gestural approach. With the plates of increasingly large sizes accumulated on the table, he developed a grid system whereby the monotypes contain one image inside the other and can be viewed indifferently from any of the four sides. While incorporating a consolidated range of images, they also leave room for a new exploration of colour and line, rhythm, space and the speed of the gesture.

Francis's monotypes are a very revealing example of how Tullis adapted the technical procedures of his workshop to the expressive needs of this artist, whose obsession with pushing ideas further and further was so strong as to become practically madness.[168] Francis, who produced the astronomical figure of over 5,000 monotypes in his fourteen-year collaboration with Tullis, was constantly in need of new materials and ever-larger and more powerful presses to load the monotypes with pigments to the maximum. In response to his demands, Tullis explored new printing methods and managed in the space of two years to develop his famous vertical hydraulic press, ensuring greater precision than the horizontal and a superior three-dimensional effect.

When his overloaded old press fell through the floor and broke, Tullis designed a new one, the largest press ever built and capable of exerting 3,000 tons of vertical pressure. Applied simultaneously to the entire surface of the plate, the pressure drives the pigments right into the paper fibres, which are impregnated to the point of becoming one with the paint. So dense as to be in danger of becoming muddy, the pigments and dyes do not crumble but preserve their purity and intensity through exposure to enormous uniform pressure and acquire a three-dimensional effect on amalgamating with the support.[169] At the same time, the surface is made richer and more interesting by deep-cut negative relief. Due to the thickness of the paper, these monotypes become authentic bas-reliefs, works midway between painting and sculpture.

A very different artistic approach was taken by another of America's leading print shops, namely Derrière l'Étoile, founded in New York by Maurice Sanchez. Specialising in the monotype, Sanchez developed his own printing method and worked with an offset lithograph press possessing two important features. The first is that it allows a monotype to be printed with a comparatively slight diminution of pigment. This makes it possible to obtain a large number of impressions because the press transfers only extremely thin and transparent layers of ink or pigments to the paper support. The surface quality of the impression, with its stable background tones, recalls the graded nuances to be obtained in drawing with charcoal or watercolour. The second is that the image can be printed with no reversal, as it is transferred in the process from the plate to a roller and then from this to the paper. The artist is thus able to work with a very precise idea of the results to be obtained, avoiding the leap into the unknown involved in the reversal of the image.

Sanchez first uses a "viscous" application with a roller to define the areas of stable colour of the backgrounds, which recall the liquid nuances of gouache or the fuzziness of charcoal in their tonality. He then prints the monotypes with extremely thin layers of adhesive lithographic ink that create what he calls "the good ghost" and remain on the surface. These multiple layers with an evanescent quality allow him to work on the monotype image by running it repeatedly through the press and developing it over a considerable period of time.

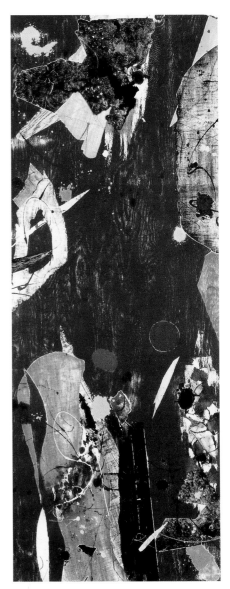

254. Sam Francis
Untitled, 1980
Colour monotype, 790 × 300 mm
Private collection, United States

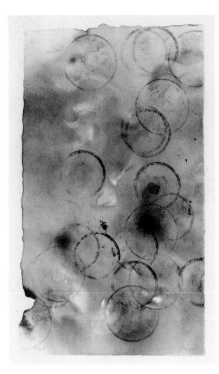

255. John Cage
Fire #9, 1985
Monotype, 508 × 286 mm

Opening the technique up to the multiple development of images with both the subtractive and additive procedures, Sanchez transformed the monotype into a receptive and sophisticated medium. David Storey, who worked with him in 1989, described the process as "reflective of a lot more input than just a single gestural drawing, which is the traditional monotype. [...] And also it is extraordinary because of the way the press is set up. You are working in the block, and then just a foot or two feet over to the side you have the paper with the emerging image on it. [...] So you are able to look at the larval print and work back and forth with a very, very clear idea of how the finished product is going to look while you are working on it."[170]

Another artist working at Derrière l'Étoile was Robert Cumming. Like Fischl and Storey, he too produced series of monotypes by creating and developing the composition on the same plate, sometimes over a period of months.

Made over a three-year period with the help of Bill Hall, the master printer of Pace Editions Ink, John Chamberlain's monotypes are of particular interest because they translate the three-dimensional quality and assemblage procedures characteristic of his sculptures into a graphic medium. He placed various three-dimensional objects—crumpled balls of silver foil, scraps of cardboard, etc.—separately on the press bed and inked them with different colours prior to printing, during which they were pressed into the damp paper to create a negative relief. The resulting images were then reworked with coloured pencils. Founded in New York in 1968 as a publishing house, Pace Editions Ink became a graphic art workshop in 1986. Contemporary artists like Jim Dine, Pat Steir and Jessica Stockholder have made monotypes and monoprints there in collaboration with master printers.

As stated, American print workshops were ready to assist the experimental spirit of the more adventurous artists producing work wide open to the unpredictable. One example is the series of monotypes made by the celebrated composer John Cage, who was also hugely influential in the visual arts field. Working at Crown Point Press in San Francisco halfway through

256. John Cage lighting a pile of newspapers on the press base in order to smoke the paper of the monotypes he was making at Crown Press Point, San Francisco, 1989

257. Pat Steir
Self Drawn as Though Picasso, 1985
Colour monotype, 230 × 230 mm (image);
610 × 470 mm (sheet), from a series of 23 portraits

the 1980s, Cage placed newspapers on the printing press and set fire to them while the staff stood by with fire extinguishers at the ready. Under the weight of the press, the previously dampened printing paper absorbed the ink from the newsprint while shrivelling up and burning at the edges. Each sheet of paper came out of the press with different burn marks and residual areas of legible print. Cage then branded the paper with the heated bottom of a Japanese iron teapot, using the *I Ching* to determine the number of rings and their positions.

In his pursuit of an art not determined by his personal taste but, like his music, by chance and the capacity of the artistic language to incorporate every type of action and material as well as natural elements like stone, fire and smoke, Cage was a key point of reference for artists like Jasper Johns and Robert Rauschenberg. He worked at the Crown Point Press from 1977 to 1992 and created a sophisticated and innovative set of monotypes and monoprints.

Another artist working at the Crown Point Press was Pat Steir, who produced a series of self-portraits there during the 1980s. She later moved to Pace Editions Ink, where she still works today, producing a series of monotypes and monoprints used as the basis for work on the image. Influenced by the technique of Chinese painting whereby the artist keeps a close watch over every phase of the work's creation while abandoning all control in an equilibrium of alternation, Steir reconciles intellectual curiosity and emotional gesture. She uses the one-of-a-kind procedure to rework her discarded screenprint proofs, which she calls "orphans". A layer of oil paint is applied and the work is sometimes taken up after months have passed, time and distance being in fact fundamental elements in her work. She describes the

258. Pat Steir
Waterfall #14, 2003
Monoprint with oils manually applied to
a screen print, 1270 × 762 m
Edited by Pace Editions Ink, New York

press as giving the paper a wonderful effect and changing the way it receives what is on top of it. The colours or whatever is placed on the support react in different ways to pressure.[171] Another American print workshop producing monotypes was the 3 EP Press. Founded in 1978 by three partners, Goldyne, Kirkeby and Margaret (artist, gallery owner and collector respectively), it took a particular interest in the possible artistic developments of the process. Magnolia Editions instead encourages individual artistic expression rather than conformity with the workshop's stylistic profile.

Starting in the mid-1990s, first in the United States and then in Europe, there was a discernable shift in interest on the part of artists and master printers towards the monoprint, which seemed to become the most popular and widespread variation of the monotype. The monoprint series *Pinocchio*, *Hearts* and *Bathrobes* by Jim Dine and *Waterfall* by Pat Steir were made at Pace Editions, innovative works of considerable quality but falling outside the category of the monotype proper, the unique print par excellence.

In recent years, Europe has instead witnessed tangible, growing interest in the monotype on the part of both artists and public, and various workshops have been making monotypes since the mid-1980s. The practice has indeed become so widespread in France and Italy that the monotype almost seems to have travelled back over the route it took on departing from the European scene over a century ago.

Emblematic of this interest is the Atelier Bordas in Paris, which turned out numerous monotypes and unique proofs during the 1990s and where artists like Jean-Charles Blais and James Brown have worked. As Franck Bordas explains, the temptation of the unique print often leads to a "quasi-monotype", proofs that are reworked or printed on backgrounds prepared by hand, or collage. In addition to limited editions, this workshop thus also turns out impressions pulled only once, variants where the image, support, design and matrix are completely changed from one print to the next.

Franck Bordas recalls the work carried out by Blais in his studio in 1995: "as well as making new lithographs and collages, in the Spring of that year Jean-Charles Blais used ink to create a series of twelve monotypes printed on Japan paper, direct impressions of a drawing made using printer's ink on a smooth plate. Each of the monotypes, which take up his familiar themes of contrasting silhouettes, figures, backs and turbans, is numbered 1/1 to show that it is a printed work, even though there is only one impression of each composition."[172]

Jean-Charles Blais, an artist belonging to the French group "Figuration", creates elements before endowing them with any meaning so as to eliminate all the concepts overburdening down the representation of a subject: "I have no ideas, no projects, no themes in my head. I paint figures that are no longer characters but objects." In the 1970s, before working with Bordas, Blais made his monotypes in Tullis's workshop in New York.

Encouraged by Franck Bordas, who handles the printing of his lithographs, James Brown has produced over a hundred monotypes since 1990. These are often very large in format, like *Monotypes Georges*, a triptych where geometric abstraction and Art Informel meet. He regards making a monotype as a moment of great tension, an opportunity for the reappropriation and transcribing of emotion.

259. Jean-Charles Blais
Santa, 1987
Colour monotype, 762 × 570 mm

260. Jean-Baptiste Sécheret
Le Vieux réducteur des minerai
(Le Vieux Soumont-Saint-Quentin), 1991
Monotype on ochre-red paper, 680 × 880 mm
Private collection

261. Marco Del Re
Arcadia ego (Paesaggio italiano) VI, 2005
Monotype in coloured inks on handmade
Nepalese paper, 3000 × 1200 mm
Galerie Maeght, Paris

"The work is carried out in three stages. James Brown brings his materials to the studio sometimes long before the session, including bundles of old maps, linen sheets and fabrics onto which he will print his works [...]. This is how we obtained the supports for the *Salt* series (1990). The second stage, which may take place some days later, is devoted to preparing the colours. With the help of the printer, the artist mixes the lithographic inks to obtain a palette of about twenty colours for use a few days or weeks later. The third stage is devoted to creating the work. On the scheduled day, there is a session lasting all morning. With his tins of paint close to hand, the artist works directly on the print bed, painting his composition on the dark cast-iron plate. When his work is finished, he chooses a support and the impression is made a few seconds later. Then he starts all over again, sometimes using the remains of the previous composition as a new starting point but more often painting a new image after cleaning the plate. These sessions, which are very intense for the artist and demand great concentration on my part, are repeated for two or three days."[173]

Jean-Baptiste Sécheret began making monotypes, which he printed by hand with the back of a spoon, when he was seventeen. In 1984, during a stay at the Casa Velázquez in Madrid, a friend taught him to engrave. This brought him back to the monotype, again with the additive method and using both printer's ink and oil paint. On his return to Paris, he used René Tazé's workshop for large-sized monotypes. He often produced three impressions, regulating the pressure to increase gradually and heightening the ghost images with pastels or oil paints. The paper is usually prepared with glue and coloured pigments and the progression goes from dark to light colours, in the manner of Titian as well as Balthus and Picasso. A reserved, self-effacing artist, Sécheret expresses himself with great naturalness in the monotype, using both colour and black and white. He was among the first contemporary artists to use this technique in France (making about sixty in 1984 alone). Adopting a figurative approach, he produces works reacting deeply to subjects observed first-hand. These include urban landscapes and interiors but also—given his conviction that "contemporary" culture has not yet made nature irrelevant—mountain landscapes, which are always passionate and intense, never gloomy.

Marco Del Re took up the monotype soon after he moved to Paris from Italy in 1990. Using an instinctive approach, he produced over two hundred works in less than ten years without regarding himself as having exhausted the technique's expressive resources. Del Re's formal concerns are a perfect example of "no texture, no tone, no chance, no accident". He begins by using a thick felt-tip pen to outline his figures and positions them spatially, using colour with no effects of transparency, relief or material texture. He does not seek interpretation, immersion or narrate but evocative distance, historicisation operating within a logic of suspension and separation from the spatial and temporal element.

The print shops working with monotypes in Italy include Alberto Serighelli's Arte 3, at Fizzonasco, near Milan, and Giorgio Upiglio's workshop. Starting out in the old commercial art branch of lithography, Serighelli specialised in screenprinting in the 1950s, when this field seemed to offer greater opportunities. He opened a modern high-tech workshop equipped with presses for large-format prints in 1973.

It was here that Mimmo Paladino made a cycle of forty works entitled *Extemporisation* in the Spring of 1997. All the same size (1585 × 2255 mm) and with many elements in common, the works are a cross between monotype and monoprint consisting of four sheets of Japan paper mounted on a gauze backing. In each of them, a lone figure etched and brushed with black aquatint is isolated on a separate sheet of *chine collé* and added in the centre of the composition as in a collage. This figure is the focal point from which the rest of the composition radiates, developed as a monotype with the artist working on individual sections like variations on the musical theme. He thus starts from a nucleus, a point, returns to it and brings it to a conclusion but then takes it up again in "a personal progression from one point to the other".[174]

262. Francesco Clemente
Untitled, 1986
Colour monotype, 914 × 508 mm
Gagosian Gallery, New York

Paladino gave this description of his prolific and intense experience a few months later: "When making monotypes, I use a rather different approach from my paintings due to the need to involve many other people […] Frames, silkscreens and all kinds of special materials have to be ready. You work together with four or five other people and turn into a kind of conductor. This is not just important as regards creating works and effects with this technique but lies at the heart of the endeavour. We all have to work together harmoniously and in the best possible conditions, and nothing can be changed. It is just like a Zen painting, capturing the instant, the ink drying, the angle of the brushstroke […]. That's why I draw a comparison with music or a jam session."[175]

In point of fact, Paladino cannot create compositions of such complexity and size on his own because the various printing techniques require a broad range of tools and supports, and above all the collaboration of master printers. The end result depends to a great extent also upon the latter, in that the figure of the composition is "vulnerable" and sensitive to the quality of their work. As he explains, it is not always a good thing for artists to work by themselves in the studio. Exchanging ideas and teamwork is very positive for the inspiration. The people he has worked with on monotypes are not simply skilled technicians but endowed with excellent intentions and sensitivity. He is not actually interested in the process of re-

263. Mimmo Paladino working on a monotype for the *Extemporisation* series in Alberto Serighelli's Arte 3 workshop, Fizzonasco (Milan), 1997

264. Sandro Chia, Filippo Chia and Alberto Serighelli at the Arte 3 workshop, Fizzonasco (Milan), 2006

production but only in this printing technique, which he uses to create the effect of a wall, a soft wall, barely a surface, a simple idea, and produces variations on all this.

Other artists making monotypes at Serighelli's workshop include Arcangelo and Sandro Chia. Arcangelo made a cycle of "epic" monotypes there,[176] presenting once again the elements that make up his magical, sacral realm of the imagination, his primary roots deeply embedded in the culture of ancient Samnium and his modes of formal expression. Sandro Chia recently started making sequential monotypes, and describes this new experience as follows: "Making these monotypes was a wonderful adventure carried through in collaboration with the printers, whose interpretive sensitivity enabled them to respect the character of my work. It was thus possible to create unique works with the monotype technique based on the experience of the masters who have gone before."[177] Giorgio Upiglio's celebrated traditional workshop in Milan is now used above all by Italian and foreign artists of the new generation, who are being drawn to the monotype technique in ever-increasing numbers.

Concluding observations

The monotype was born in the seventeenth century as an experiment very close to drawing. As far as we know, however, it was not intended as a work to be presented to the public or even a preparatory phase for another work. It originated with Giovanni Benedetto Castiglione as a way of trying out a model, produced with no commercial aims as an experiment of an individual, personal character. It is closely bound up with chance, physicality of gesture and the artist's desire to seek out new effects and transform old ones. It is therefore a spontaneous technique operating on parameters that are not predetermined.

Printmaking was involved in similar explorations during this period, albeit taking quite a different path. This was the time of the fundamental advances introduced by Rembrandt, seeking and obtaining completely different effects of light from one print to the next. It was also the time of contrasting tonal values, which developed from a dramatic characteristic of the Northern school into the chiaroscuro technique of the Romantics and has continued throughout the history of printmaking. The real change, namely the fully aware and deliberate use of the monotype, came with William Blake, who gave the technique artistic dignity in his series of illustrations and elevated it to the status of an authentic art form with effects that were necessarily richer and original tools of greater complexity.

The spontaneity inevitable in the production of a monotype did not reach the level required for recognition as a unique work in the eighteenth century. As a result, these works had no market and no clients to commission them. It should be borne in mind, however, that appreciation of the original graphic work at the time was nothing in comparison to its development in the two following centuries.

After these early forms of experimentation disappeared from view, there was a radical shift in the perception of the graphic work and everything changed for the monotype. It was in France during the latter half of the nineteenth century that this long-forgotten technique was taken up again. Reassertion of its artistic autonomy and a taste for creative gesture coincided with

the first steps taken by Lepic, Appian, Guérard and many others, experimenting with mobile etchings before going on to the monotype proper.

As had already happened in the seventeenth century, the development of the monotype in the nineteenth was again accompanied by graphic experimentation, which saw a return to Rembrandt's handling of background glazes and ultimately led to the uniqueness of the *belle épreuve*.

Degas is equal to Blake in importance and far more influential as regards the development of the contemporary monotype. It is hard to overestimate either his creative impetus around the end of the century or his impact not only on artists in Europe but also in the United States, where his work transmitted a more original form of graphic creation often characterised by a narrative sequence and extraordinary freedom and fluidity.

Whereas the European and especially the French legacy continued to play a central role between the two World Wars, there were already evident signs of crisis that would greatly change the history of the monotype. Masters such as Picasso, Chagall and Matisse, though European in origin, were working to liberate the artistic spirit all over the world, and especially in the United States.

The great wave of personalisation taking place in the history of the graphic arts in that period no longer gave rise to the creation of schools but focused rather on the individual. As is known, other more general causes brought about an altered balance after World War II, and it was then that the disbanding of the schools and the weakening of Europe caused the creative focus to shift to the United States.

In all its countless facets, the American monotype is characterised on the one hand by great freedom in the development of tools, forms and techniques, and on the other by its success in establishing itself in Europe in the 1960s and 1970s. It was precisely in this period that the monotype became a commercial artwork with its own autonomous position on the market and enjoyed enormous success fostered by exhibitions, art criticism, the rediscovery of older monotypes and overall artistic legitimisation.

As regards summing up the most recent period and attempting an analysis, it is instead difficult to identify any fully-fledged trend due to the multitude of

265. Garner Tullis Workshop, Santa Barbara (California), 1991

possibilities offered by the monotype technique today. In the postmodern era, the latest developments take on such a variety of forms and materials at such speed as to rule out any possibility of plausible summary.

Although some artists do continue to use the classic monotype techniques, most work in increasingly specialised high-tech studios, where they develop their formal investigation through a whole range of procedures. In this context, the monotype is often just the starting point of the path leading to the final image.[178]

The computer era eliminates local movements and often provides a basis for many types of intellectual and artistic production. With the disappearance of the artisanal aspect, the space for graphic art—at least as understood over the centuries in terms of absolute repetition—is contracting in favour of its conceptual implications, of the idea wholly indifferent to all forms of production. The new techniques of production are becoming more casual and undergoing radical modification, mixing with other media to the point of losing all reference to tradition and craftsmanship. Printing is now coupled with the pictorial and graphic gesture to produce works more correctly classified as mixed media.

The frequent combination of painting with graphics, sculpture and collage is a sign of the conscious acceptance of hybrid media at an ever-greater scale. In the postmodern era, with its focus on strategies of appropriation, site-specificity, impermanence, accumulation, discursiveness and hybridisation,[179] this would seem to explain the growing popularity of the monotype over the last thirty years.

Another factor can be identified in the reaction to the formal codes that preceded this medium and have affected the world of the print and its reproduction. Walter Benjamin noted at the beginning of the last century that mechanical reproduction seemed to tarnish the aura of the work of art. Today, with the increased output of hand-coloured photographs, single-proof prints, single-impression editions and above all the monotype, the unique creation par excellence, the artist is again present at the moment of creation and the aura of the artwork is restored.[180]

At the very moment when everything would appear to be steering graphic production towards results of a totally serial and automatic nature, the monotype paradoxically succeeds in maintaining its age-old original specificity as a form of the unique.

[1] L. Kachur, *Paraphrase: on Robert Rauschenberg's transfer drawings of the 1960s.*

[2] Cf. P. Hulten, *Les Monotypes of Sam Francis*, Daco Verlag, Stuttgart 1994, p. 7.

[3] Having developed a system for rendering chiaroscuro with paint through printing rather than addition by hand, Ugo da Carpi asked the Venetian authorities to recognise his rights with respect to all the works, "present and future", produced by means of this invention.

[4] Unlike direct techniques like the burin, where pointed instruments are used mechanically on the bare plate, those of an indirect nature involve the use of mordant. The surface of the plate is covered in wax, into which the design is drawn directly with a sharp instrument. The plate is then dropped into a bowl of acid, which eats into the exposed metal. In addition to etching, the major indirect techniques include lavis (wash etching), aquatint and the soft wax method.

[5] See E. Borea, "Le stampe che intendono imitare i disegni", in *Acquaforte*, Istituto Nazionale per la Grafica, Rome 2005, pp. 62–69.

[6] Comte de Caylus, "Reflexions sur la Peinture", in G. Pezzini Bernini, *Cenni Storici*, in *L'acquatinta e le tecniche di resa tonale*, Istituto Nazionale per la Grafica, Rome 1989, p. 28.

[7] J. La Bruyère, *Les Caractères o Les Mœurs de ce siècle*, Paris 1688. See the monologue of Démocède.

[8] In C. S. Ackley, *Printmaking in the Age of Rembrandt*, Museum of Fine Arts, Boston 1981, p. XLIII.

[9] See *inter alia* R. de Piles, *Abregé de la vie des Peintres*, Vol. III, Paris 1699, p. 271: "Rembrandt printed many of his proofs of slightly tinted paper, especially China paper [...] these proofs are greatly sought after by connoisseurs".

[10] In the mezzotint technique (also known as halftone, *manière noire* and *schabkunst*), the plate is roughened and the raised parts are gradually flattened with a burnisher so that the design thus created will print lighter against the dark ground. See in this connection *Bulino*, Istituto Nazionale per la Grafica, Rome 2003, p. 15.

[11] Cf. A. Percy, "Notes on Castiglione's Monotypes", in *Quaderni del Conoscitore di Stampe*, 1975, pp. 73–78.

[12] Cf. M. Rayalton-Kisch, "A Monotype by Sallaert", in *Print Quarterly*, 1988, Vol. V, pp. 60–61.

[13] Cf. S. Welsh Reed, "Monotypes in the Seventeenth and Eighteenth Centuries", in exh. cat. *The Painterly Print: Monotypes from the Seventeenth to the Twentieth Century* (New York, Metropolitan Museum of Art, 1 May–29 June 1980; Boston, Museum of Fine Arts, 29 July–28 Sep. 1980), Metropolitan Museum of Art, New York 1980, pp. 3–7.

[14] Cf. M. Mazur, "Monotype: An Artist's View", in *The Painterly Print...* cit., p. 55.

[15] *Edinburgh Review*, April 1834, cited in P. Penigault-Duhet, *Signes traditionnels, Symbole et invention dans l'œuvre graphique de William Blake*, Tours 1971 (unpublished dissertation). There are, however, exceptions to this view, one example being Dante Gabriele Rossetti, a fervent admirer of Blake.

[16] In *William Blake*, catalogue of the exhibition curated by R. Hamlyn and M. Phillips (London, Tate Gallery, 9 Nov. 2000–11 Feb. 2001), London 2000, p. 194.

[17] R. Todd, "The Techniques of William Blake. Illuminated Printing", in *The Print Collector's Quarterly*, 29, Nov. 1948, pp. 25–37.

[18] C. Esposito, *Hayter e l'Atelier 17*, Electa, Rome 1990, p. 25.

[19] B. Jobert, "William Blake et la question du monotype", in *Nouvelles de l'Estampe*, Paris, 191–192, Dec. 2003–Feb. 2004, p. 16.

[20] Cf. Anthony Griffiths, "Monotypes", in *Print Quarterly*, Vol. V, 1988, p. 59.

[21] Original prints are to be understood in the broad sense as prints obtained through a manual working of the plate and therefore not those deriving from photomechanical means of reproduction. In the strict sense, an original print is one conceived and produced by the same artist, i.e. by a painter who has chosen the graver and acid as means of expression rather than brushes and paint. In this context, importance attaches to the qualification *peintre* in the term *peintre-graveur* or painter-engraver, serving to draw a distinction with respect to the professional etcher-engraver of works by others, who is practically never a painter.

[22] The old academies, supporters of the more traditional burin technique, were challenged by the champions of etching, including Baudelaire, who saw it as the only technique in keeping with the times and capable of interpreting modern life in an autonomous and creative way.

[23] The term "unique form" is drawn from the title of the exhibition organised by Jean-François Garmier, *Monotypes, une forme de l'unique 1877–2000*, Musée Estève, Ville de Bourges 2005.

[24] M. Melot, *L'Estampe Impressionniste*, Paris 1994, p. 46.

[25] J.-P. Bouillon, exh. cat. *Félix Bracquemond, Marie Bracquemond: 1833–1914: gravures, dessins, céramiques: 1841–1916* (Chartres 1972), in M. Melot, *L'Estampe Impressionniste* cit., p. 29.

[26] É. Zola, "Édouard Manet", in *Revue du XIXe siècle*, Paris, 1 Jan. 1867.

[27] Ch. Blanc, "De la gravure à l'eau-forte et des eaux-fortes de Jacque", in *Gazette des Beaux-Arts*, Paris, Vol. IX, 1861, pp. 196–97.

[28] Ch. Baudelaire, "Peintres et Aquafortistes", in *Le Boulevard*, 14 Sep. 1862.

[29] Cf. Ph. Burty, "La Belle épreuve", preface to the album *L'eau-forte en 1875*, Cadart, Paris 1875.

[30] Ph. Burty, *op. cit.*, in M. Melot, *L'Estampe Impressionniste* cit., pp. 134–35.

[31] As the French critic notes in his *Traité de la gravure à l'eau-forte*, Paris 1866, "some artists and art lovers rummage through shops in search of old paper with yellowed edges, which gives impressions the appearance of ancient engravings."

[32] In M. Melot, *L'Estampe Impressionniste* cit., p. 162.

[33] C. Pissarro, *Correspondance de Camille Pissarro*, t. III (1891–94), Editions du Valhermeil, Paris 1988, p. 38.

[34] In A. Dragone, *Incisori piemontesi dell'Ottocento*, 1958, p. 10.

[35] Ch. Baudelaire, "Peintres..." cit., cited in R. Passeron, *Impressionist Prints*, Secaucus (New Jersey) 1974, p. 11.

[36] Théophile Gautier alludes ironically to the burin technique as interpreted in the hackneyed academic sense current at the time. Burin engravers sought to attenuate the harshness of the crosshatching used to obtain the effect of chiaroscuro

by making little dots in the diamond shapes formed by the crossed furrows.

[37] Th. Gautier, "Un mot sur l'eau-forte", preface to the first album of the Societé des Aquafortistes, Paris 1863, in M. Melot, *L'Estampe Impressionniste* cit., p. 49.

[38] Philippe Gilbert Hamerton, the influential English critic, commented favourably on the new trend in etching and appreciated the return to professional standards, pointing out that while the etcher should learn how to print with the aid of a skilled craftsman, no one should print a plate other than the artist responsible for producing it or a printer working under his or her direct control. An unskilled etcher mistakenly believes that all you have to do is send the plate to a printer of great repute and have some proofs run off, just like visiting cards. An artist's etching and a visiting card are two very different things. See *The Painterly Print...* cit., p. 13.

[39] *Ibid.*

[40] Developed at the same time in the late 1830s by Daguerre and Talbot, this process consists in covering the glass plate with a layer of collodion, which makes it opaque and gives it a yellow colour, and then engraving it with a sharp metal tool. Once the design is completed, the plate is treated as a normal photographic negative and exposed to sunlight on top of a sheet of photosensitive paper. The engraved parts allow the light to filter through and darken the paper as though by scorching to trace out the design.

[41] From a letter written by Manet to Henri Guérard, published by Adhémar, 1965, in M. Melot, *L'Estampe Impressionniste* cit., p. 51.

[42] In Ch. Baudelaire, "Peintres..." cit., in J. Bailly-Herzberg, *Dictionnaire de l'Estampe en France 1830–1950*, Paris 1985, p. 163.

[43] Ph. G. Hamerton, "Modern Etching in France", in *Fine Arts Quarterly Review*, Vol. 2 (Jan.–Feb. 1864), pp. 74–75. Hamerton wrote *The Etcher's Handbook* in 1871.

[44] Cf. the dedication of the book by P. Burty to S. Haden, in Melot, *L'Estampe Impressionniste* cit., p. 128: "À Delâtre. S'il eut veçu dans le temps de Rembrant, celui-ci, certainement l'aurait employé à tirer ses eaux-fortes".

[45] Ph. G. Hamerton, *Etching and Etchers*, London 1868, p. 349, in Melot, *L'Estampe Impressionniste* cit., p. 128.

[46] M. Melot, *L'Estampe Impressionniste* cit., p. 128.

[47] For Whistler's reservations as regards Delâtre's method of printing, see J. Pennel, *James McNeill Whistler, sa vie, son œuvre*, Hachette, Paris 1913, p. 212.

[48] Ch. Baudelaire, "Peintres..." cit.

[49] See in this connection Pennel's comment in the biography cited above: "No artist has ever gone so far in the art of printing etchings or used printing ink with such freedom [...] Without their retouching in ink, these engravings would be no more than shadows of what they are. He carried out numerous experiments on each of them, thus making it possible to obtain very different results indeed. In some proofs he even covered the fainter lines with a layer of ink."

[50] M. Melot, *L'Estampe Impressionniste* cit., p. 188.

[51] M. Renaud, "Le Monotype", in *Art et Décoration*, Vol. XXXVII, 1920, pp. 53–54: "Whistler is also represented in the rich treasure chest of the Sainsère collection with a rare coloured monotype of opalescent hues entitled *Femme vue de dos.*"

[52] "The New Life of Whistler", in *The Fortnightly Review*, 84, 1908, p. 1022.

[53] Cf. F. Carey, "The Monotype in Britain, 1900–1960", in *The Tamarind Papers*, Vol. 14, 1991–92, p. 14.

[54] See "The Year's Wood-Engraving", in *The Studio*, 101, 1931, p. 194.

[55] Cf. G. Giubbini, *L'acquaforte originale in Piemonte e Liguria 1860–1875*, Sagep Editrice, Genoa 1976.

[56] *Ibid.*, p. 77.

[57] In F. Fiorani, R. Dinoia, exh. cat. *De Nittis Incisore* (Rome 1999–2000), Artemide, Rome 1999, pp. 23–24.

[58] "This means of expression enabled him to reproduce the atmospheric sensation, the shimmering of light and colour, with no loss of emotional freshness. Only thus did he feel capable of capturing the essence of life, its delicate, trembling appearance on a golden autumn afternoon." F. Fiorani, "Pompeo Mariani", in *L'acquatinta e le tecniche di resa tonale*, Istituto Nazionale per la Grafica, Rome 2005, p. 186

[59] Cf. R. Dinoia, "Antonio Mancini et la redécouverte du monotype en Italie dans la deuxième moitié du XIXe siècle", in *Nouvelles de l'Estampe*, Paris, 191–192, Dec. 2003–Feb. 2004, pp. 17–24.

[60] Fabio Fiorani writes as follows on landscape and the transformation of a seventheenth-century aesthetic ideal into an existential vision ("Le Fonti dell'Acquaforte Originale Italiana dell'Ottocento, Le tecniche calcografiche d'incisione indiretta", in *Acquaforte* cit., p. 89): "The history of the original etching in the second half of the nineteenth century in Europe revolves around the common denominator of landscape. [...] Though regarded from the very outset as a minor and undemanding but socially pleasing genre, landscape became in the nineteenth century the most suitable medium for experiments that were to assume the most disparate labels: verism, naturalism, realism, Impressionism [...] It was a vision of the natural world whose expression no longer required a view of nature as an immobile reality [...] On the contrary, given that it was no longer regarded as a divine creation and hence immutable, but rather as a construct of the human mind, the latter made use of it precisely in order to represent the changeability and variety of phenomena."

[61] The Curtis-Prouté catalogue reviewed 73 etchings, including 14 "produced after the fashion of monotypes", in 1968.

[62] M. Melot, *L'Estampe Impressionniste* cit., p. 80.

[63] *Paris à l'eau-forte*, 28 Nov. 1875.

[64] M. Melot, *L'Estampe Impressioniste* cit., p. 123.

[65] Loys Delteil describes this relationship as follows: "Degas was also closely acquainted with two other engravers, namely the viscount Lepic and Marcellin Desboutin, and unquestionably learned some methods from these two friends, for which the first in particular had a voracious appetite." *Le peintre-graveur illustré*, Vol. IX, *Degas*, Paris 1919, unnumbered preface.

[66] C. Pissarro, *op. cit.*, t. III, p. 38.

[67] M. Melot, *L'Estampe Impressionniste* cit., p. 162.

[68] O. Redon, *À soi-même. Journal (1867–1915)*, Paris 1922.

[69] See *inter alia* D. S. MacColl, *Spectator*, 23 Feb. 1893, in A. Gruetzner Robins, R. Thomson, *Degas, Sickert and Toulouse-Lautrec: Paris and London 1870–1910*, Tate Publishing, London 2005, p. 90. The author points out that this subject was considered repugnant before Degas took it up and regards his talent for transforming base materials into wonderful art as having set a new standard in painting.

[70] Pissarro mentioned his beginnings as follows in 1894: "A young man I met at the home of John Lewis Brown has opened a small shop in rue Laffitte. There are only paintings by young artists, including Gauguin's early works, which are very beautiful, and splendid things by Guillaumin, Sisley, Redon, Raffaelli, by Groux…"

[71] A. Vollard, *Souvenirs d'un marchand de tableaux*, Albin Michel, Paris 1984 (second edition).

[72] O. Redon, *op. cit.*

[73] Impressionist publications played a considerable role in shaping the new aesthetic. Attention should be drawn to Richard Lesclide's illustrated magazine *Paris à l'eau-forte*, founded in 1873, which supported experimentation aimed at tonal rendering in prints and the revitalisation of etching. Founded in 1889, the Société des Peintres-Graveurs was decisive for the recognition of the print as a major work of art. Its leading figures included engravers such as Bracquemond, Guérard and Félix Buhot, but also painters like Boudin, Renoir and Berthe Morisot, who worked occasionally with engraving as prompted by publishers. The challenging step was to display prints alongside drawings and paintings on an equal footing. Exhibitions of prints alone began some ten years later. Léonce Bénédite, the director of the Musée du Luxembourg, opened a room devoted exclusively to modern prints in 1890. André Marty founded *L'Estampe Originale*, where he published the works of Bonnard, Toulouse-Lautrec and Ranson, in 1892. His rival Maurice Dumont founded *L'Épreuve* in 1894 and Vollard published his first *Album des Peintres-Graveurs* in 1895.

[74] J. Leymarie, *Les Gravures des Impressionistes*, Arts et métiers graphiques, Paris 1971, pp. V–VI.

[75] The English term appears to confine the printmaker's activities to etching.

[76] In M. Pittaluga, E. Piceni, *Giuseppe De Nittis*, Milan 1963, p. 359. In another letter to De Nittis, dating again from the Summer of 1876, Jules Claretie wrote as follows: "I met Degas just yesterday, back from Naples and on his way to the Gare de l'Est […] He told me about a new method of engraving he has discovered." See R. Dinoia, "Degas, De Nittis, Boldini e l'incisione", in A. Dumas, *Degas e gli italiani a Paris*, Ferrara arte, Ferrara 2003, p. 189.

[77] In D. Rouart, *Degas à la recherche de sa technique*, Floury, Paris 1945, p. 6.

[78] The paper is dampened before being run through the press so as to improve its absorption of ink from the plate.

[79] On the relationship between these monotypes and photography, in which Degas took a keen interest, see Françoise Cachin: "Even more so than the drawings and pastels of the same period, Degas's monotypes recall the photographic style in their organisation of black and white, distributed more through tonal values than lines […]; Degas's eye is essentially photographic in its capacity to freeze movement or confusion. Hence the objective detachment and a sort of distance that speak in a particular way to the modern sensibility. Hence also something furtive in the gaze, a looking for looking's sake that never gives the impression of a 'genre scene' but rather of something glimpsed through the keyhole. It is perhaps no coincidence that the technique closest to the photographic snapshot should have expressed the most intimate aspect of Degas's vision and what we might even call his 'voyeurism': the brothel scenes, nudes and studies of the female toilette." J. Adhémar, F. Cachin, *Edgar Degas. Gravures et monotypes*, Arts et métiers graphiques, Paris 1973, p. XXV.

[80] "The pact between painting and morality broke down when the brothel appeared in the paintings of Courbet, Degas and Manet with its crude display of naked bodies. Modern painting was obsessed with this subject from the second half of the nineteenth century all through the first quarter of the twentieth. Certain artists even gave it a leading role, including Degas, Toulouse-Lautrec, Grosz and the Neue Sachlichkeit movement as a whole. But what were painters actually looking for in the brothel? A new art of the nude, the portrait, and the interior. And first and foremost an antidote to 'taste', to the rule of morality over painting." E. Pernoud, *Le Bordel en peinture: l'art contre le goût*, Adam Biro, 2001, cited in *Nouvelles de l'Estampe*, 191–192, Dec. 2003–Feb. 2004, p. 101.

[81] A type of paper used to transfer a drawing from one support to another.

[82] G. Jeanniot, "Souvenirs de Degas", in *Revue Universelle*, Paris, 15 Oct. 1933, pp. 152–74.

[83] As Paul Durand-Ruel wrote in 1892, "As is known, Degas never exhibits and it is a real event to have persuaded him to show a group of his new works."

[84] As there is no catalogue of the exhibition, the number of these works remains uncertain. Some indirect sources suggest a figure of 21 monotypes and others 25 or 28, to which we should probably add the one—not on sale but probably exhibited—that Degas gave Bartholomé for having accompanied him on the trip to Burgundy.

[85] Cf. R. Kendall, *Degas Landscapes*, Yale University Press, New Haven and London 1993, pp. 185–88, and D.A. Brenneman in A. Dumas, *Degas and America. The Early Collectors*, Minneapolis Institute of Arts, Minneapolis (MN) 2001, p. 212.

[86] The quotations and information regarding the press coverage of this exhibition are drawn primarily from H. Wilhelm, "Les Critiques lors de l'exposition des monotypes de paysages de Degas chez Durand-Ruel en 1892", in *Nouvelles de l'Estampe*, 191–192, Dec. 2003–Jan. 2004, pp. 25–40.

[87] Henry and Louisine Havemeyer bequeathed their collection to The Metropolitan Museum of Art in New York on their deaths.

[88] The history of *Paysage avec rochers* is indicative of why many of Degas's landscape monotypes are now in American museums. Shortly after buying it from the artist, the Durand-Ruel Gallery in New York sold it to the New York collector Charles H. Senff, who sold it in 1928 to the dealer Knoedler. The work then came into the hands of Schab, another New York dealer, who sold it to the collector Dorothy Edinburg. Auctioned in London in 1987, the monotype was bought by a collector from Chicago. Subsequently purchased by Artemis

Fine Arts, New York, it was sold in 2000 to the High Museum in Minneapolis.

[89] H. G. Lay, "Degas at Durand-Ruel, 1892: The Landscape Monotypes", in *Print Collector's Newsletter*, IX, 5, Nov.–Dec. 1978, p. 142.

[90] After Eugenia Parry Janis, Degas's relations with monotyping have been examined more recently by Jean Adhémar, Françoise Cachin, Michel Melot and Richard Kendall, who also catalogued about seventy monotypes of landscapes.

[91] M. Mazur, "Monotype: An Artist's View", in *The Painterly Print...* cit., p. 55.

[92] F. Cachin, "Monotypes", in J. Adhémar, F. Cachin, *Edgar Degas...* cit., p. XXXV.

[93] M. Melot, "La pratique d'un artiste: Pissarro graveur en 1889", in *Histoire et Critique des Arts*, 1977, p. 16.

[94] See Michel Melot (*La pratique...* cit., p. 14): "While reproduction leaves him cold, he does like the impression. These contradictory notions have given birth to monsters: the monotypes of Degas and Pissarro, rightly referred to as 'perversions' of the print."

[95] Cf. J.-F. Garmier, *op. cit.*, pp. 26–27.

[96] C. Pissarro, *op. cit.*, t. III, p. 416.

[97] *Ibid.*

[98] Gauguin's monotypes do not conform to the traditional additive and subtractive techniques, which is why they were only recently classified as such.

[99] For their simplicity and apparently informal character, these monotypes have been compared to the sketches and watercolours produced during the North African travels of Eugène Delacroix, the greatest handler of colour in modern art, whom Gauguin knew and admired.

[100] Cf. P. Gauguin, *Letters to Ambroise Vollard and André Fontainas*, ed. John Rewald, San Francisco 1943, pp. 31–32.

[101] *Ibid.*, p. 32.

[102] Paul Gauguin in a letter to Gustave Fayet, Mar. 1902, in R. S. Field, exh. cat. *Paul Gauguin: Monotypes* (Philadelphia Museum of Art, 23 Mar.–13 May 1973), Philadelphia 1973, p. 21.

[103] Cf. *Ibid.*, p. 15.

[104] P. Gauguin, "Gauguin to Morice", in *Lettres de Gauguin à sa femme et à ses amis*, ed. M. Malingue, Paris 1946.

[105] The name initially used by the Impressionists.

[106] Having fallen into disuse in the eighteenth century, this procedure saw a rekindling of interest in the early decades of the nineteenth and was accepted for the first time ever as a genre in its own right at the Paris Salon in 1835. Its practice also benefitted from the spread of *japonisme* and the associated taste for the greater lightness and limpidity of water-based paints. It was in the same period that British manufacturers such as William Perkin, Graebe and Liebermann succeeded in producing an infinite range of hues with bright, light-stable pastels using synthetic dyes and pigments.

[107] A. Silveste, *L'Exposition des pastels de M. De Nittis au Cercle de l'Union Artistique*, Paris 1881, p. 22.

[108] See the letter written to De Nittis by Marcellin Desboutin in 1875: "We shall thus defer until your return [...] the pleasure of resuming our meetings at Cadart's." M. Melot, *L'Estampe Impressionniste* cit., p. 132.

[109] Fabio Fiorani and Rosalba Dinoia are the au-
thors of the most extensive study of the graphic output of De Nittis. See note 57.

[110] *Ibid.*, p. 30.

[111] Interview kindly granted to the author by Hughes Wilhelm in Paris, Sept. 2004.

[112] A monogram within a red circle, affixed after the artist's death, indicates his unsigned works.

[113] In F. Carey, *art. cit.*, pp. 14–15.

[114] Bunny was described as the one member of the group that actually managed to produce a surprisingly large number of coloured monotypes, of which he was very proud. See C. Reddin, "Rupert Bunny. The Final Years", in R. Butler, exh. cat. *Rupert Bunny: The Monotypes*, National Gallery of Australia, Canberra 1986.

[115] From a letter written by Sickert to Sir William Eden, collector of works by Degas and amateur painter. Cf. A. Gruetzner Robins, R. Thomson, *op. cit.*, p. 156.

[116] *Ibid.*, p. 31.

[117] *Ibid.*, p. 22.

[118] *Ibid.*, p. 26.

[119] Philippe Burty, a critic and collector of original etchings and Japanese prints, wrote a column titled "Impressionism" for the British magazine *Academy*. Burty began spreading the principles of the French movement in 1874, the year of the first Impressionist exhibition. See also A. Gruetzner Robins, R. Thomson, *op. cit.*, p. 31.

[120] In J. Moser, *Singular Impressions. The Monotype in America*, Smithsonian Institution Press, Washington, D.C. 1997, p. 13.

[121] *Ibid.*, p. 22.

[122] *Ibid.*, p. 57.

[123] The article was written as a contribution to this work in 2005. It cannot be quoted in full for technical reasons.

[124] Will Barnett made a film on the monotype process in the 1930s and used it during his courses. From an interview kindly given to the author in New York, May 2005.

[125] In *Americans in Paris: Man Ray, Gerald Murphy Stuart Davis, Alexander Calder*, Washington, D.C. 1996, p. 14.

[126] *Ibid.*, p. 13: "Whizzing round the corner of the Boul' Raspail into the Boul' Montparnasse one evening last summer on my way to a dinner engagement I was thoroughly scandalised at the size of the student mob that crowded the sidewalks, the roadway, and in fact all the intervening space between the two notorious cafés that face each other at that point. It was not a fête-day [...] but just a plain Saturday night, yet five hundred or more young people, my countrymen [...] hovered about the spot waiting to seize upon any chair that might be vacated upon the densely populated terrasse".

[127] *Ibid.*, p. 5.

[128] *Ibid.*, p. 14.

[129] Cf. Ch. Zervos, 'Pablo Picasso', *Cahiers d'Art*, Vol. VI, Paris 1954, cat. 282.

[130] There is a photograph by Brassaï showing monotypes from the *Flûtiste assise et dormeuse* series scattered around Picasso's studio. It was published in André Breton's article 'Picasso dans son element', in *Minotaure*, 1, 1933, p. 12.

[131] André Breton describes decalcomania, a technique used by the Surrealists and bearing a distant resemblance to the monotype, in a 1936 issue of *Minotaure*.

[132] Cf. C. Ives, in *The Painterly Print...* cit., p. 202.

[133] Cf. A. H. Barr, *Picasso: Forty Years of His Art*,

exh. cat. (New York, Museum of Modern Art, 1939), New York 1939, p. 15.

[134] In M. Hahnloser, 'Matisse', in *Maîtres de la Gravure*, Paris 1987, p. 52.

[135] From a letter written by Marguerite Matisse-Duthuit to Riva Castleman, March 1978, in J. Elderfield, *Matisse in the Collection of the Museum of Modern Art*, Museum of Modern Art, New York 1978, p. 103.

[136] Matisse made this observation in connection with the inversion of values between black and white: "It is possible to replace various colours in a natural way with black and white, and in any case to avoid fighting against nature in order to create light. It is necessary to find an equivalent, to explore parallel avenues, because we are using dead things." See C. Chica, 'Les Monotypes de Matisse: Le noir et la ligne', in *Nouvelles de l'Estampe*, 191–192, Dec. 2003 – Jan. 2004, p. 42.

[137] Cf. D. Fourcade, 'Henri Matisse Œuvres gravées', in *Cahiers d'art contemporain*, 16, 1984, p. XXX: "These monotypes have taken Matisse where his painting could not. While his painting endeavoured to achieve a spatial unity of form and background through the use of colour or the complete integration of the form into the background, these monotypes represent an extreme attempt from every point of view […]: the attempt to paint the world as a broad, taut, resonant colour. In other words, the world as black where the forms are flashes of light […] in a ratio susceptible of reversal by its very nature. Black is also light. There is no other choice."

[138] "And it was with this work [*Les Coloquintes*] that I started using pure black as a colour conveying light rather than darkness." See J.-F. Garmier, *op. cit.*, p. 38.

[139] H. Matisse, 'Notes d'un peintre sur son dessin', *Le point*; in D. Fourcade, *op. cit.*, pp. 242–43.

[140] Matisse in response to Georges Besson's question: "Do you believe that photography is capable of producing a work of art?" See *Camera Work*, 24, Oct. 1908.

[141] "I have to paint a woman's body. I first endow her with grace and charm, but need to instil something more into her. I therefore encapsulate the meaning of this body by seeking out its essential lines." See D. Fourcade, *op. cit.*, p. 44.

[142] In 1915 Matisse approached the collector Jacques Doucet, a long-standing admirer of his, about setting up a fund for the civilian prisoners from the town where his parents lived and where he had spent his boyhood: "I'm trying to make myself useful to the civilian prisoners from my town, four hundred people deported to Germany […]. I send them a hundred kilos of bread or biscuits every week […] and sell monotype prints or etchings in order to carry on doing so […]. I am taking the liberty of sending you a portfolio of these new prints, which will at least be of interest to you, because these monotypes are something completely new."

[143] J. Leymarie, *Marc Chagall, Monotypes 1966–1975*, Éditions Gérald Cramer, Geneva 1976, p. 8.

[144] *Ibid.*, p. 54.

[145] The exhibition was mentioned in the *Paris-Journal*, 10 Dec. 1911.

[146] From an interview kindly granted to the author by Lawrence Saphire in New York, May 2006.

[147] Brauner made the drawing in pencil on a sheet of paper placed on top of a plate covered with thick printer's ink. Pressure is applied in such a way as to transfer the image onto the other side of the paper through the ink. It is the paler "traced" monotype with its slightly blurred outlines that is regarded as the true work of art rather than the pencil drawing.

[148] Cf. G. Gromo, exh. cat. *Carlo Levi, I monotipi* (Ferrara, Palazzo dei Diamanti, 22 Oct. – 11 Dec. 1977), Comune di Ferrara, Ferrara 1977.

[149] From an interview kindly granted to the author by Guglielmo Capogrossi in Rome, June 2005.

[150] Capogrossi gave the following reply in 1931 to a critic's question about what "prompted" him: "the stimuli that all artists feel first of all inside themselves and not outside, the stimuli that caused Degas to paint his dancers […] and Gauguin to go to Tahiti in search of other skies, other colours." After quoting Baudelaire and Flaubert, he went on to list the sources of inspiration for his painting: the movement of Degas, Renoir's handling of colour and the calm, enigmatic pictorial framework of Gauguin.

[151] Guglielmo Capogrossi in B. Mantura (ed.), exh. cat. *Capogrossi fino al 1948* (Spoleto, 1986; Rome, 1986), De Luca and Mondadori, Rome and Milan, 1986, p. 20.

[152] From an unpublished letter by Campigli to Lella Russoli, Milan, 23 April 1970. Private collection.

[153] Cf. L. Cavallo, 'Nota tecnica sui disegni a calco', in *Afro. Catalogo generale ragionato dei documenti dell'Archivio Afro*, Vol. I, *Disegni dal 1932 al 1947*, edited by M. Graziani, Edizioni DATAARS-La Scaletta, Rome and Reggio Emilia 2006.

[154] The Tuscan printmaker Sigfrido Bartolini (1932) also took up the monotype between 1949 and 1953, producing approximately 150 works. He recalls the simplicity of his means and his approach: "For a time I used only three colours, namely yellow, red lake and ultramarine (together with all the combinations I could obtain), because I was short of money, and printed on sheets of paper that had been used on one side so that you'll often find geometric drawings or watercolour sketches on the back." See C. F. Carli, *I Monotipi di Sigfrido Bartolini*, Reggio Emilia 1982, p. 7.

[155] In William Johnstone, *Art and the Child*, University of London Press, London 1948, p. 115.

[156] In Frances Carey, "The monotype in Britain, 1900–1960", in *The Tamarind Papers*, Vol. XIV, 1991–92, p. 15.

[157] In F. Carey, *art. cit.*, p. 16. The article constitutes the primary source for my discussion on this point.

[158] *Ibid.*, p. 18.

[159] The WPA (Works Progress Administration) was a Federal Government programme in support of the arts launched by President Roosevelt halfway through the 1930s and operating until the mid-1940s. Over 5000 artists—including Milton Avery, Stuart Davis, Mark Rothko, Willem de Kooning and Jackson Pollock—benefitted from the programme, and two million students were able to attend free art courses. The artists queued up every week to collect their allowance, which gave them an opportunity to meet and get to know one another.

[160] A gestural style in printmaking can also be found in the work of Australian artists like

Halpern, a former pupil of Hayter at Atelier 17 in New York, Ropetec and Reddingtone, and of the Japanese artists Yoshida, Nomura and Isobe. See also L. Graham, *The Spontaneous Gesture: Prints and Books of the Abstract Expressionist Era*, The Australian National Gallery, Canberra 1987, p. 28, notes 63, 64.

[161] J. Moser, *Monotype in America*, see note 123.

[162] Cf. C. S. Ackley, exh. cat. *The Unique Print. 70's into 90's* (Boston, Museum of Fine Arts, 1990), Boston 1990.

[163] C. S. Ackley, 'Mazur's Monotypes: The Medium with a Memory', in *Prints of Michael Mazur: with a Catalogue Raisonné 1956–1999*, Hudson Hills Press, New York 2000, p. 79.

[164] B. Rose, 'An Interview with Robert Rauschenberg', in *NY Vintage*, 1987, p. 58.

[165] J. Moser, *Monotype in America* cit.

[166] From an interview kindly granted by the artist to the author in New York, June 2004.

[167] From an interview kindly granted by Emilio Vedova to the author in Venice, June 2004.

[168] From an interview kindly granted by Tullis to the author in his Italian home, Sept. 2004.

[169] In the case of pressure applied with a traditional horizontal press, the procedure is based on the colours' varying degrees of viscosity. The pigments thus remain on the surface with often uncontrollable results and the possibility of smudging.

[170] From *An Interview with Maurice Sanchez and David Storey at Derrière l'Etoile Studios*. The interview, by Donna Gustafson, took place on March 1989 at Derrière l'Etoile Studios in New York.

[171] From an interview kindly granted by the artist to the author in New York, June 2004.

[172] Cf. F. Bordas, *Charles Blais, Suites*, Atelier Bordas, 1995.

[173] James Brown, *Une séance de monotype*, interpretation of a conversation between Franck Bordas and Jean-François Garmier, in J.-F. Garmier, *op. cit.*

[174] From an interview with Mimmo Paladino by James Putnam, in *Mimmo Paladino. Extemporisation*, Alan Cristea Gallery, London 1997.

[175] *Ibid.*

[176] Cf. E. Di Martino, *Arcangelo, Monotipi*, Papiro Arte, Venice 2003.

[177] From an interview given by the artist to Vincenzo Sanfo, in Rome, June 2007.

[178] Given the constantly evolving creativity open to every type of expression and experimentation, a distinction in techinques (like the monotype and the monoprint) is hard to maintain due to the wide range of possibilities now present in procedures, which often coexist in the same work. It is therefore not always or completely adequate to describe the host of variations invented every day.

[179] On this point see *inter alia* C. Owens, 'The Allegorical Impulse: Toward a Theory of Postmodernism', in B. Wallis (ed.), *Art After Modernism: Rethinking Representation* (New Museum of Contemporary Art, 1984), New York 1984, p. 209.

[180] Cf. J. Moser, *Singular Impressions…* cit., p. 189.

Appendix

Select Bibliography

A

Ackley, C.S., *American Prints 1813–1913*, exhibition catalogue (Boston, Museum of Fine Arts, 12 April–15 June 1975), Boston 1975.

Ackley, C.S., "The Contemporary Monotype: Superstar? Stepchild? Monoflop?", in *Print Collector's Newsletter*, 21, 4, September–October 1990, pp. 142–143.

Ackley, C.S., *Printmaking in the Age of Rembrandt*, Museum of Fine Arts, Boston 1981.

Ackley, C.S., *The Unique Print Today. 70's into 90's*, exhibition catalogue (Boston, Museum of Fine Arts, 1990), Boston 1990.

Acquaforte, Istituto Nazionale per la Grafica, Rome 2005.

Acton, D., *A Spectrum of Innovation. Color in American Printmaking 1890–1960*, exhibition catalogue, Worcester Art Museum, New York and London 1990.

Adhémar, J., Cachin F., *Edgar Degas, Gravures et Monotypes*, Arts et métiers graphiques, Paris 1973.

Adriani, G., *Toulouse-Lautrec: The Complete Graphic Works*, Thames and Hudson, London 1988.

Afro. Catalogo generale ragionato dei documenti dell'Archivio Afro, Vol. I, *Disegni dal 1932 al 1947*, edited by M. Graziani, Edizioni DATAARS–La Scaletta, Rome and Reggio Emilia 2006.

Americans in Paris: Man Ray, Gerald Murphy Stuart Davis, Alexander Calder, Washington, D.C. 1996.

Art in a Mirror, The Counterproofs of Mary Cassatt, Adelson Galleries, New York 2005.

The Art of Paul Gauguin, exhibition catalogue (Washington, D.C., Chicago and Paris 1988–1989), Washington, D.C. 1988.

Ambroise Vollard éditeur. Les peintres–graveurs 1895–1913, London 1991.

Auchincloss, P., *Sean Scully: Monotypes from the Garner Tullis Workshop*, exhibition catalogue, Pamela Auchincloss Gallery, Santa Barbara (California) 1987.

B

Bacher, O.H., *With Whistler in Venice*, New York 1908.

Baer, B., Dupuis-Labbé, D., *Picasso, Gravures 1900–1942*, exhibition catalogue (Paris, Musée Picasso, 29 October 1996–20 January 1997), Réunion des Musées Nationaux, Paris 1996.

Bailly-Herzberg, J., *L'Eau-forte de peintre au dix–neuvième siècle. La Societé des Aquafortistes, 1862–1867*, Paris 1972, 2 Vols.

Bailly-Herzberg, J., *Dictionnaire de l'estampe en France 1830–1950*, Arts et métiers graphiques, Paris 1985.

Baron, W., *Sickert*, Phaidon, London 1973.

Barr, A.H., *Picasso: Forty Years of His Art*, exhibition catalogue (New York, Museum of Modern Art, 1939), New York 1939.

Barthélémy, J., "William Blake et la question du monotype", in *Nouvelles de l'Estampe*, Paris, 191–192, December 2003–February 2004, pp. 13–16.

Bartsch, A., *Le Peintre–graveur*, Vol. XXI, Vienna 1821, pp. 39–40.

Baskett, M.W., *American Graphic Workshops: 1968*, Cincinnati Art Museum, Cincinnati 1968.

Baudelaire, Ch., "L'Eau-forte est à la mode", in *Revue Anecdotique*, April 1862.

Baudelaire, Ch., "Peintres et Aquafortistes", in *Revue Anecdotique*, 14 September 1862.

Baudelaire, Ch., *Œuvres complètes*, N.R.F. (coll. "La Pléiade"), Paris 1958.

Bellini, P., *L'opera incisa di G. B. Castiglione*, Milan 1982.

Benjamin, W., *L'œuvre d'art à l'ère de sa reproductibilité technique*, 1936 (republished in *Poésie et révolution*, Lettres nouvelles, Paris 1971).

Benzi, F. (ed.), *Corrado Cagli tra figurazione e astrazione*, Editoriale Eco, Teramo 2003.

Béraldi, H., *Les Graveurs du XIXe siecle*, Paris 1885–1892.

Berger, K., *Japonismus in der Westliche Malerei, 1860–1920*, Prestel Verlag, Munich 1980.

Bergquist, J. A., *American Monotypes of the Early Twentieth Century*, Alan N. Stone Works of Art, Northampton (Massachusetts) 1976.

Blanc, Ch., "De la gravure à l'eau-forte et des eaux-fortes de Jacques", in *Gazette des Beaux-Arts*, Vol. IX, Paris 1861, pp. 196–97.

Blanc, Ch., *Manuel de l'amateur d'estampes*, Paris 1854–1890, 4 Vols.

Blunt, A., "The Inventor of Soft–Ground Etching: G. B. Castiglione", in *The Burlington Magazine*, XIII, n. 821, 1971, pp. 474–75.

Bordas, F., *Charles Blais, Suites*, Atelier Bordas, Paris 1995.

Borea, E., "Le stampe che intendono imitare i disegni", in *Acquaforte*, Istituto Nazionale per la Grafica, Rome 2005, pp. 62–69.

Bouillon, J.-P., *Félix Bracquemond, Marie Bracquemond: 1833–1914: gravures, dessins, céramiques: 1841–1916,* exhibition catalogue (Chartres, 1972), n.p. 1972.

"Bracquemond: Le Jour et la Nuit", in *Degas inédit*, actes du Colloque Degas (Musée d'Orsay, Paris, April 1988), La Documentation française, Paris 1988, pp. 251–59.

Brayer, Y., "La Technique du Monotype", in *Bulletin de la Bibliothèque Nationale*, March 1978, pp. 36–38.

Breton, A., "D'une Decalcomanie sans objet préconçu", in *Minotaure*, 8, 1936, pp. 18–24.

Breeskin, A. D., *The Graphic Art of Mary Cassatt, a Catalogue Raisonné*, New York 1948.

Breuer, K., Fine, R., Nash, S., *Thirty–Five Years at Crown Point Press: Making Prints Doing Art*, exhibition catalogue, Fine Arts Museums of San Francisco, San Francisco 1997.

Bulino, Istituto Nazionale per la Grafica, Rome 2003.

Burrus, C., "Paris come Escuela", in *Homenaje a los artistas de Montparnasse, los contemporàneos de Diego Rivera*, Museo Olmedo Patiño, La Noria, Xochimilco (Mexico) 1998.

Burty, Ph., *La Belle épreuve*, preface to the album *L'Eau–forte en 1875*, Cadart, Paris 1875.

Butler, R., *Rupert Bunny: The Monotypes*, exhibition catalogue, National Gallery of Australia, Canberra 1986.

Butlin, M., *The Paintings and Drawings of William Blake*, New Haven and London 1981, 2 Vols.

C

Cachin, F., *Gauguin, Le Livre de poche*, Paris 1968.

Camille Pissarro, the Impressionist Printmaker, Museum of Fine Arts, Boston 1973.

Capogrossi fino al 1948, exhibition catalogue edited by B. Mantura (Spoleto and Rome, 1986), De Luca and Mondadori, Rome and Milan 1986.

Carey, F., "The Monotype in Britain, 1900–1960", in *The Tamarind Papers*, Vol. 14, 1991–92, pp. 14–20.

Carey, F., Griffiths, A., *Avant–garde British Printmaking 1914–1960*, British Museum, London 1990.

Carli, C.F., *I Monotipi di Sigfrido Bartolini*, Reggio Emilia 1982.

Carlson, V., "The Painter-Etcher: The Role of the Original Printmaker", in *Regency to Empire. French Printmaking 1715–1814*, The Minneapolis Institute of Arts, Minneapolis 1984.

Carrier, D., *Garner Tullis and the Art of Collaboration*, New York 1998.

Castleman, R., *American Impressions. Prints since Pollock*, Alfred A. Knopf, New York 1985.

Castleman, R., *Printed Art, A View of two Decades,* New York 1980.

Castleman, R., *La Gravure contemporaine depuis 1942*, Fribourg 1973.

Cate, Ph.D., Grivel M., *De Pissarro à Picasso, l'eau-forte en couleurs*, Flammarion, Paris 1992.

Cate, Ph. D., Hitchings, S.H., *The Color Revolution. Color Lithography in France, 1890–1900*, Rutgers University Art Gallery, Santa Barbara (California) and Salt Lake City (Utah) 1978.

Chica, C., "Les Monotypes de Matisse: Le noir et la ligne", in *Nouvelles de l'Estampe*, 191–192, December 2003–February 2004, pp. 41–48.

Cole, S., *Milton Avery: Monotypes*, New York 1977.

Comment, B., Chapon F., *Doucet de fonds en combles: trésors d'une bibliothèque d'art*, INHA, Herscher, Paris 2004.

Coppel, S., *Picasso and Printmaking in Paris*, British Museum, London 1998.

Cy Twombly. Cinquante ans de dessins, Editions Gallimard and Centre Pompidou, Paris 2004.

D

Degas, E., *Lettres*, Grasset, Paris 1931.

Degas, E., *Lettres de Degas*, Marcel Guerin, Paris 1945.

Degas Monotypes, Fogg Art Museum, Cambridge (Massachusetts) 1968.

Delteil, L., *Le Peintre-graveur illustré*, Vol. IX, *Degas*, Paris 1919.

Denker, E., *Whistler and his Circle in Venice*, Corcoran Gallery of Art, Washington, D.C. 2003.

Dillon, G.V., "Un monotipo inedito di G. B. Castiglione", in *Conoscitore di stampe*, 31, 1976, pp. 4–8.

Dinoia, R., "Antonio Mancini et la redécouverte du monotype en Italie dans la deuxième moitié du XIXe siècle", in *Nouvelles de l'Estampe*, Paris, 191–192, December 2003–February 2004.

Dinoia, R., "Degas, De Nittis, Boldini e l'incisione", in A. Dumas, *Degas e gli italiani a Paris*, Ferrara arte, Ferrara 2003.

Distel, A., *Les Collectionneurs des impressionnistes. Amateurs et marchands*, n.p. 1989.

Doctorow, E.L., *Scenes and Sequences: Recent Monotypes by Eric Fischl*, Hood Museum of Art, Dartmouth College, Hanover (Texas) 1990.

Donson, Th., *Prints and the Print Market*, New York 1977.

Dragone, A., *Incisori piemontesi dell'Ottocento*, Saluzzo 1958.

Dragone, A., *Antonio Fontanesi: l'opera grafica*, Museo Civico di Bologna, Bologna 1980.

Dragone, A., *Spazzapan: catalogo generale,* Vallecchi, Firenze 1995.

Dumas, A., *Degas and America. The Early Col-*

lectors, Minneapolis Institute of Arts, Minneapolis (Minnesota) 2001.

Dumas, A., Dinoia, R., *Degas e gli italiani a Paris*, Ferrara arte, Ferrara 2003.

E

Eagle, M., *Rupert Bunny: An Australian in Paris*, Australian National Gallery, Canberra 1991.

École romaine, 1925–45, Les Musées de la Ville de Paris, Paris 1997.

Eitner, L., *Nathan Oliveira: A Survey of Monotypes, 1973–78*, Baxter Art Gallery, California Institute of Technology, Pasadena (California) 1979.

Elderfield, J., *Matisse in the Collection of the Museum of Modern Art*, Museum of Modern Art, New York 1978.

Esposito, C., *Hayter e l'Atelier 17*, Electa, Rome 1990.

The Etching Renaissance in France, 1850–1880, Utah Museum of Fine Arts, Salt Lake City (Utah) 1972.

The Etchings of James McNeill Whistler, Yale University Press, New Haven–London 1984.

F

Farmer, J.M., *New American Monotypes*, Smithsonian Institution Traveling Exhibition Service, Washington, D.C. 1978.

Fehrer, C., *The Julian Academy, Paris 1868–1939*, Shepard Gallery, New York 1989.

Field, R., "The Monotype: A Majority Opinion?", in *Print Collector's Newsletter*, 9, 5, November–December 1978, pp. 141–42.

Field, R., *Paul Gauguin: Monotypes*, exhibition catalogue (Philadelphia Museum of Art, 23 March–13 May 1973), Philadelphia 1973.

Field, R., *Matt Phillips: Monotypes 1976–1977*, Washington, D.C. 1978.

Fiorani, F., *Le fonti dell'acquaforte originale italiana dell'Ottocento, acquaforte*, Istituto Nazionale per la Grafica, Rome 2005.

Fiorani, F., Dinoia, R., *De Nittis Incisore*, exhibition catalogue (Rome, 1999–2000), Artemide, Rome 1999.

Fourcade, D., *Henri Matisse Œuvres gravées*, Cahiers d'art contemporain, no. 16, Paris 1984.

Forman, N., "Gauguin's Experiments with Monotype", in *ARTnews 72*, no. 6, summer 1973, p. 84.

G

Garmier, J.-F., *Monotypes, une forme de l'Unique, 1877–2000*, Musée Estève, Ville de Bourges 2005.

Gauguin, P., *Letters to Ambroise Vollard and André Fontainas*, edited by John Rewald, San Francisco 1943.

Gauguin, P., *Lettres de Gauguin à sa femme et à ses amis*, edited by M. Malingue, Paris 1946.

Gauguin, exhibition catalogue, Paris–Washington 1988.

Gautier, Th., *Un mot sur l'eau–forte*, preface to the first album of the Société des Aquafortistes, Paris 1863.

Il genio di Giovanni Benedetto Castiglione, il Grechetto, exhibition catalogue (Genoa, 1990), Genoa 1990.

Giubbini, G., *L'acquaforte originale in Liguria e Piemonte, 1860–1875*, Genoa 1976.

Goldman, J., *Jasper Johns: 17 Monotypes*, Universal Limited Art Editions, West Islip, New York 1982.

Goldman, J., *Matt Phillips: Monotypes 1976–1977*, Iowa, Phillips Collection and Des Moines Art Center, Washington, D.C., 1978.

Graham, L., *The Spontaneous Gesture: Prints and Books of the Abstract Expressionist Era*, The Australian National Gallery, Canberra 1987.

Griffiths, A., "Monotypes", in *Print Quarterly*, V, 1988, pp. 56–60.

Gromo, G., *Carlo Levi. I Monotipi*, exhibition catalogue (Ferrara, Palazzo dei Diamanti, 22 October–11 December 1977), Comune di Ferrara, Ferrara 1977.

Gruetzner Robins, A., Thomson R., *Degas Sickert and Toulouse-Lautrec: London and Paris 1870–1910*, Tate Publishing, London 2005.

Guérin, M., "Notes sur le monotipes de Degas", in *L'Amour de l'Art*, 5, 1924, pp. 77–80.

Gusman, P., "Les Monotypes de G.B. Castiglione", in *Byblis,* II, 8, 1923, pp. 153–54.

H

Hahnloser, M., "Matisse", *Maîtres de la gravure*, Paris 1987.

Hamerton, Ph.G., *Etching and Etchers*, London 1868.

Hamerton, Ph.G., "Modern Etching in France", in *Fine Arts Quarterly Review*, 2, January–February 1864, pp. 74–75.

Hansen, Trudy V., *The Prints of Michael Mazur with a Catalogue Raisonné 1956–1999*, Hudson Hills Press, New York 1997.

Heyman, Th.T., *Monotypes in California*, Oakland Museum, Oakland (California) 1972.

Hughes, W., "Les critiques lors de l'exposition de paysages de Degas chez Durand–Ruel en 1892", in *Nouvelles de l'Estampe*, 191–192, December 2003–February 2004, pp. 25–40.

Hulten, P., *The Monotypes of Sam Francis*, Daco–Verlag, Stuttgart 1994.

I

Ives, C., *The Great Wave: The Influence of Japanese Woodcuts on French Prints*, Metropolitan Museum of Art, New York 1974.

J

Janis, E. Parry, "An Autumnal Landscape by Edgar Degas", in *The Metropolitan Museum of Art Bulletin*, Vol. 31, n. 4, pp. 178–80.

Janis, E. Parry, "The Role of Monotype in the Working Method of Degas", in *The Burlington Magazine*, CIX, 766, January–February 1967, pp. 20 27, 71 81.

Janis, E. Parry, *Degas Monotypes. Essay, Catalogue and Checklist*, Fogg Art Museum, Harvard University, n.p. 1968.

Janis, E. Parry, "Degas and the 'Master of

Chiaroscuro'", in *Museum Studies*, 7, The Art Institute of Chicago, 1972, pp. 52–71.

Janis, E. Parry, "Deviation and its Imperatives – The Plight of the Unique Print", in *Print Collector's Newsletter*, 21, 6, January–February 1991, pp. 211–13.

"Japonism: Early Sources and the French Printmaker 1854–1882", in *Japonism. Japanese Influence on French Art 1854–1910*, exhibition catalogue, Cleveland Museum of Art, Cleveland 1975.

Jeanniot, G., "Souvenirs sur Degas", in *Revue Universelle*, 15 October 1933, p. 152–74.

Jean-Michel Basquiat: Works on Paper, Galerie Enrico Navarra, Paris 1999.

Jobert, B., "William Blake et la question du monotype", in *Nouvelles de l'Estampe*, 191–192, December 2003–February 2004, pp. 13–16.

Johnson, R. Flynn, *American Monotypes: 100 Years*, Marilyn Pearl Gallery, New York 1979.

Johnson, U.E., *Ambroise Vollard éditeur Prints, Books, Bronzes*, Museum of Modern Art, New York 1977.

K

Kendall, R., *Degas Landscapes*, Yale University Press, New Haven–London 1993.

Klausner, B., *Contemporary Monotypes*, Santa Barbara Museum of Art, Santa Barbara (California) 1976.

Koehler, S.R, "Das Monotype", in *Chronik für vervielfaltingende Kunst*, IV, no. 3, 1891, pp. 17–20.

Kramer, L. Konheim, *The Aesthetic Vocabulary of Nancy Graves*, Ameringer Yohe Fine Art, New York 2005.

L

Lalanne, M., *Traité de la gravure à l'eau–forte*, Paris 1866.

Lay, H.G., "Degas at Durand–Ruel, 1982: The Landscape Monotypes", in *Print Collector's Newsletter*, IX, 5, November–December 1978, pp. 142–47.

Le Comte Florent, *Cabinet des singularités d'architecture, peinture, sculpture, et gravure*, Paris 1699–1700.

Lemoisne, P.-A., *Degas et son œuvre*, Paris 1946–49, 4 Vols.

Leymarie, J., *Les Gravures des Impressionnistes*, Arts et métiers graphiques, Paris 1971.

Leymarie, J., *Marc Chagall, Monotypes 1961-1965* and *Monotypes 1966-1975*, 2 vols., Éditions Gérald Cramer, Vol. I, Geneva 1966; Vol. II Geneva 1966.

Lieberman, W.S., *Matisse. 50 Years of his Graphic Art*, George Braziller, inc., New York 1956.

Lochnan, K.A., *The Etchings of James McNeill Whistler*, Yale University Press, New Haven-London 1984.

M

"Marcellin Desboutin and his World", in *Apollo Magazine*, 65, June 1972, pp. 496-500.

Mariani, G. (edited by), *Bulino, puntasecca maniera nera*, Istituto Nazionale per la Grafica, Rome 2003.

"Mary Cassatt's Color Prints and Contemporary French Printmaking", in *Mary Cassatt: The Color Prints*, exhibition catalogue, Abrams, New York 1989.

Melot, M., "La Pratique d'un artiste: Pissarro graveur en 1889", in *Histoire et Critique des Arts*, 2, June 1977, pp. 14-19.

Melot, M., "Tirage limité: pourquoi l'œuvre d'art est-elle définie par sa quantité?", in *Unique: L'épreuve unique, un paradoxe*, Cabinet cantonal des estampes, Musée Jenisch, Vevey 2002.

Melot, M., Griffith, A., Field, R., Beguin, A., *L'Estampe, Histoire d'une art*, Skira, Geneva 1981.

Melot, M., *L'Estampe Impressioniste*, Flammarion, Paris 1994.

Mercurio, G. (edited by), *Afro il colore*, Skira, Milan 2003.

Miquel, P., *Le Marché de l'art en France, 1800-1900* (Art et Argent, L'École de la nature, tome VI), Editions de la Martinelle, Maurs-la-Jolie 1987.

"Les Monotypes d'Appian", *Nouvelles de l'Estampe*, 25, January–February 1975, pp. 13–17.

"Le Monotype", *Nouvelles de l'Estampe*, special issue, 191–192, December 2003–February 2004.

"Les Monotypes", in Guillaud, Jacqueline and Maurice, *Degas, le modèle et l'espace*, Centre culturel du Marais, Paris 1984.

Monotypes, une forme de l'unique 1877–2000, Musée Estève, Ville de Bourges 2005.

Moser, J., *Singular Impressions: The Monotype in America*, Smithsonian Institution Press, Washington, D.C. 1997.

Moser, J., "Collaboration in American Printmaking before 1960", in *Printmaking in America: Collaboratives prints and Press 1960–1990*, exhibition catalogue, New York 1995.

Moulin, R., "La Notion d'originalité et son importance dans la définition des objects d'art", in *Sociologie de l'art*, La Documentation française, 1986, pp. 191–202.

N

Nordland, G., *Richard Diebenkorn Monotypes*, Frederick S. Wight Art Gallery, University of California, Los Angeles 1976.

"Notes sur les monotypes de Degas", in *L'Amour de l'art*, 5, 1924, p. 77.

O

O'Brien, M., Mandel Patricia, *The American Printer-Etcher Movement*, Parrish Art Museum, Southampton–New York 1984.

Oliveira, N., "The Monotypes: Printing as Process", in *The Tamarind Papers*, 13, 1990, p. 58.

P

Paglialonga, B., *La calcografia*, Eugenio Riccitelli Editore, Pescara 1985.

The Painterly Print: Monotypes from the Seventeenth to the Twentieth Century, exhibition cat-

alogue (New York, The Metropolitan Museum of Art, 1 May–29 June 1980; Boston, Museum of Fine Arts, 29 July–28 September 1980), The Metropolitan Museum of Art, New York 1980.

Passeron, R., *Impressionist Prints*, Dutton, New York 1974.

Penigault-Duhet, P., *Signes traditionnels, Symbole et invention dans l'œuvre graphique de William Blake*, Tours 1971 (Ph.D. dissertation).

Pennel, J., *James McNeill Whistler, sa vie et son œuvre*, Hachette, Paris 1913.

Percy, A.., *Giovanni Benedetto Castiglione, Master Draughtsman of the Italian Baroque*, Philadelphia 1971.

Percy, A.., "Notes on Castiglione's Monotypes", in *Quaderni del Conoscitore di Stampe*, 1975, pp. 73–78.

Pernoud, E., *Le Bordel en peinture: l'art contre le goût*, Adam Biro, n.p. [Paris] 2001, cited in *Nouvelles de l'Estampe*, 191–92, December 2003–February 2004, pp. 101.

Pernoud, E., *Estampes des fauves*, Editeurs des Sciences et des Arts, Paris 1994.

Petrucci, A., *L'opera del genio italiano all'estero*, Istituto Poligrafico dello Stato, Rome 1958.

Pezzini Bernini, G., "Cenni Storici", in *L'acquatinta e le tecniche di resa tonale*, Istituto Nazionale per la Grafica, Rome 1989.

Phillips, M., "About Monotypes", in *Prometheus*, Newsletter of the Makler Gallery, Philadelphia, March 1962.

Phillips, M., *Maurice Prendergast. The Monotype*, William Cooper Practer Art Center, Bard College, Annandale, New York 1967.

Phillips, M., *The Monotype: An Edition of One*, The Smithsonian Institution, Washington, D.C. 1972.

Piles, R. de, *Abregé de la vie des Peintres*, Paris 1699.

Piles, R. de, *The Art of Painting and the Lives of Painters*, London 1706.

Pissarro, C., *Correspondance de Camille Pissarro*, Éditions du Valhermeil, Vol. III, Paris 1988.

Pittaluga, M., Piceni, E., *De Nittis*, Milan 1963.

"Les Portraits à l'eau-forte de Bracquemond et leurs sources photographiques", in *Nouvelles de l'Estampe*, 38, March–April 1978, pp. 4–10.

Plous, Ph., *Collaborations in Monotypes I et II*, University Art Museum, Santa Barbara (California) 1988.

"La Pratique d'un artiste: Pissarro graveur en 1880", in *Histoire et critique des arts*, 2, June 1977, pp. 14–38.

Putnam, J., *Mimmo Paladino. Extemporisation*, Alan Cristea Gallery, London 1997

R

Rasmusen, H., *Printmaking with Monotype*, Chilton, Philadelphia 1960.

Rayalton-Kisch, M., "A Monotype by Sallaert", in *Print Quarterly*, V, 1988, pp. 60–61.

Reddin, C., "Rupert Bunny. The Final Years", in R. Butler, *Rupert Bunny: The Monotypes*, exhibition catalogue, National Gallery of Australia, Canberra 1986.

Redon, O., *À soi-même. Journal (1867–1915)*, Paris 1985.

Reff, Th., *The Notebooks of Edgar Degas: A catalogue of the thirty–eight notebooks in the Bibliothèque nationale and other collections*, Hacker Art Book, New York 1985.

Rewald, J., *Histoire de l'impressionnisme*, Paris 1955.

Ross, C.H., "The Monoprint and the Monotype: A Case of Semantics", in *Art Voices South 2*, no. 4, July–August 1979, pp. 89–91.

Rouart, D., "Paysages en monotypes", in *L'Œil*, 117, September 1964 pp. 10–15.

Rouart, D., *Degas à la recherche de sa technique*, Floury, Paris 1945.

Rouart, D., *Edgar Degas, Monotypes*, Quatre Chemins, Paris 1948.

Russell, J., "Adolph Gottlieb: Late Works and Monotypes", in *The New York Times*, 17 February 1978, C23.

S

Shackelford, George T.M., Freches-Thory, C., *Gauguin Tahiti*, Museum of Fine Arts, Boston 2004, pp. 217–21.

Schneider, R., "The American Etching Revival: Its French Sources and Early Years", in *American Art Journal*, 14, no. 4, autumn 1982, pp. 40–65.

"Setting the Tone, the Revival of Etching, the Importance of Ink", in *The Painterly Print: Monotypes from the Seventeenth to the Twentieth Century*, exhibition catalogue (New York, The Metropolitan Museum of Art, 1 May–29 June 1980; Boston, Museum of Fine Arts, 29 July–28 September 1980), The Metropolitan Museum of Art, New York 1980, pp. 9–28.

Sferrazza, A., *Il Monotipo. Tecnica e stampa*, Rome 2005.

Sickert, W.R., "The New Life of Whistler", in *The Fortnightly Review*, 84, 1908, pp. 1022.

Silveste, A., *L'Exposition des pastels de M. De Nittis au Cercle de l'Union Artistique*, Paris 1881.

Sloane, J.C., *French Painting Between the Past and the Present: Artists, Critics and Traditions from 1848–1870*, Princeton University Press, Princeton (New Jersey) 1951.

Souvenirs d'un marchand de tableaux, Paris 1937.

Sofer, K., "Monotypes from the Garner Tullis Workshop", in *Art News*, 86, no. 9, November 1987.

Stern Shapiro, B., Melot, M., "Les Monotypes de Camille Pissarro", in *Nouvelles de l'Estampe*, no. 16, January–February 1975, pp. 16–23.

Stieglitz, A., "Photo-Secession Exhibitions. Monotypes by Eugene Higgins", in *Camera Work*, no. 29, January 1910, p. 51.

T

Tallman, S., "David Storey: Reduction Ad Absurdum", in *The Print Collector's Newsletter*, 21, no. 3, July–August 1990.

Tallman, S , *The Contemporary Print. From Contemporary to Postmodern*, Thames and Hudson, London 1996.

Terrasse, A., *Degas et la photographie*, Editions Denoël, Paris 1983.

Todd, R., "The Techniques of William Blake Illuminated Printing", in *The Print Collector's Quarterly*, 29, November 1948, pp. 25–37.

U

Unique: L'épreuve unique, un paradoxe, Cabinet cantonal des estampes, Musée Jenisch, Vevey 2002.

V

Vitali, L., *Incisioni Lombarde del Secondo Ottocento all'Ambrosiana 9*, Vicenza 1970, p. 45.
Vollard, A., *Souvenirs d'un marchand des tableaux*, Albin Michel, Paris 1984 (II ed.).

W

Walker, B., *The American Artist as Printmaker*, Brooklyn Museum, New York 1983.
Walker, B., "The Single State", in *ArtNews*, 83, pp. 60–65.
Walker, B., *Public and Private: American Prints Today*, Brooklyn Museum, New York 1986.
Weisberg, G.P., *Japonisme: Japonise Influence on French Art 1883–1910*, The Cleveland Museum of Art, Cleveland (Ohio) 1975.
Weisberg, G.P., *The Etching Revival in France*, Salt Lake City (Utah) 1971.
Weisberg, G.P., "Philippe Burty, a notable critic of the nineteenth century", in *Apollo Magazine*, 91, 1970, pp. 296–300.
Welsh Reed, S., "Monotypes in the Seventeenth and Eighteenth Centuries", in *The Painterly Print: Monotypes from the Seventeenth to the Twentieth Century*, exhibition catalogue (New York, The Metropolitan Museum of Art, 1 May–29 June 1980; Boston, Museum of Fine Arts, 29 July–28 September 1980), The Metropolitan Museum of Art, New York 1980, pp. 3–7.
Welsh Reed, S., Stern Shapiro, B., *Edgar Degas The Painter as Printmaker*, Museum of Fine Arts, Boston 1984.
Welsh Reed, S., Wallace, R., *Italian Etchers of the Renaissance and Baroque*, Museum of Fine Arts, Boston 1989.
Wilhelm, H., "Les Critiques lors de l'exposition des monotypes de paysages de Degas chez Durand-Ruel en 1892", in *Nouvelles de l'Estampe*, 191–92, December 2003–February 2004, pp. 25–40.
William Blake, exhibition catalogue edited by R. Hamlyn, M. Phillips (London, Tate Gallery, 9 November 2000–11 February 2001), London 2000.
Winiesky, K., *Monotype/Monotint, History and Techniques*, Bullbrier Press, Ithaca (New York) 1995.
Wittrock, W., *Toulouse-Lautrec. Catalogue complet des estampes*, ACR éditions, Paris 1985, 2 Vols.

Z

Zervos, Ch., "Pablo Picasso", in *Cahiers d'Art*, Paris 1954, Vol. VI, cat. no. 282.
Zola, É., "Édouard Manet", in *Revue du XIXe siècle*, 1 January 1867.

Index of Artists

Index of Art Critics, Writers, Art Dealers, Collectors, Gallery Owners, Printers, Publishers